The Best of

WEDDING PHOTOJOURNALISM

Techniques and Images
for Professional Digital Photographers

2nd edition

AMHERST MEDIA, INC. ■ BUFFALO, NY

Published by:
Amherst Media, Inc.
P.O. Box 586
Buffalo, N.Y. 14226
Fax: 716-874-4508
www.AmherstMedia.com

Publisher: Craig Alesse
Senior Editor/Production Manager: Michelle Perkins
Assistant Editor: Barbara A. Lynch-Johnt
Editorial Assistance from: Sally Jarzab, John S. Loder, Carey Anne Maines

ISBN-13: 978-1-58428-273-0
Library of Congress Control Number: 2009903899
Printed in Korea.
10 9 8 7 6 5 4 3 2 1

TABLE OF CONTENTS

Foreword

LANDMARKS IN WEDDING PHOTOGRAPHY8

WPI and WPPI .8

Denis Reggie .9

The Digital Revolution10

Adobe Photoshop .10

Times Have Changed11

1. THE NATURE OF

WEDDING PHOTOJOURNALISM12

The Old *vs.* The New12

Powers of Observation13

The Beauty of Reality15

Storytelling .15

Posed Shots .16

Using Assistants .16

Anticipation and Preparation19

Reaction Time .20

Capturing the Emotion20

Sidebar: Dressing for Success20

Making the Average Extraordinary21

Uniqueness .22

Style .23

Awareness .23

People Skills .24

Having Fun .25

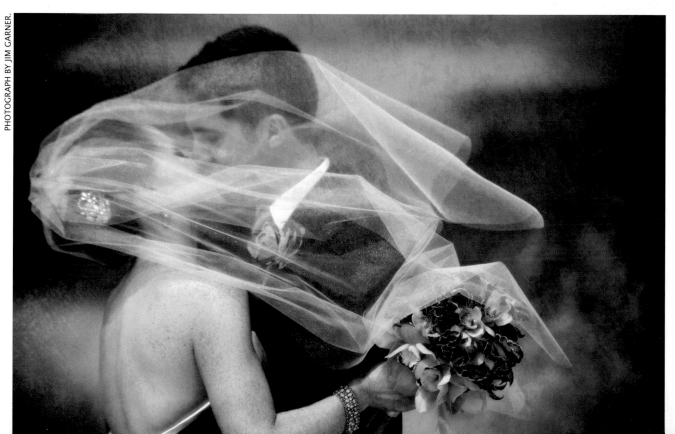

PHOTOGRAPH BY JIM GARNER.

2. EQUIPMENT .27
The 35mm DSLR .27
 Autofocus Technology29
 Instant Feedback31
 ISO Settings .31
Lenses .33
 Zoom Lenses .33
 Prime Lenses .35
 Wide-Angles .35
 Telephotos .36
Sidebar: Mike Colón's Approach36
 Focal Length and Chip Size37
Flash .37
 On-Camera Flash37
 Off-Camera Flash38
 Bounce-Flash Devices38
 Barebulb Flash .39
 Studio Flash Systems39
Lighting Accessories .41
 Flashmeter .41
 Remote Triggering Devices41
 Light Stands .42
 Reflectors .42
Backup and Emergency Equipment42

3. PREPARATION AND THE WEDDING DAY43
Meet with the Bride and Groom43
Scout the Wedding Locations43
Plan the Timing .47
Engagement Portraits47
Sidebar: Get Information on the Vendors48
Pre-Ceremony Coverage49
 The Bride .49
 The Groom .51
 Watch for Details52
Photographing the Ceremony52
 The Bride's Arrival52
 The Procession .52

TOP PHOTOGRAPH BY MARCUS BELL.
BOTTOM PHOTOGRAPH BY JESSICA CLAIRE.

PHOTOGRAPH BY KEVIN JAIRAJ.

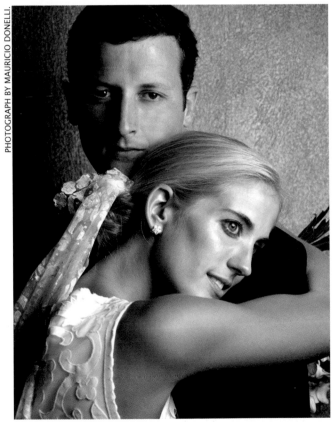

PHOTOGRAPH BY MAURICIO DONELLI.

The Ceremony .52

The Couple's Exit .53

Sidebar: Don't Get Too Caught Up in the Emotion . .55

Photographing the Reception56

Your Approach .56

Room Overviews and Details57

The Key Players .57

Scheduled Events .57

Cutting the Cake59

The First Dance59

The Bouquet Toss59

Leaving the Reception60

Sidebar: Table Shots .60

Lighting .60

Pole Lighting .60

Videographer's Lighting60

Rings .61

Little Ones .61

4. COMPOSITION AND DESIGN62

The Rule of Thirds .62

Direction .65

Pleasing Compositional Forms65

Subject Tone .66

Focus .66

Lines .67

Shape .68

Tension and Balance69

5. POSING FOR "FORMALS"72

Posing Principles .74

 The Head-and-Shoulders74

 Face Positions .74

 The Seven-Eighths View75

 The Three-Quarters View75

 The Profile View76

 The Gaze .76

 The Arms .77

 The Hands .77

 The Feet .78

Portrait Lengths .80

 Full-Length Portraits80

 Three-Quarter-Length Portraits80

 Head-and-Shoulders Portraits80

Camera Height .80

Sidebar: Scheduling the Important Formals81

Formal Portraits of the Bride81

Formal Portraits of the Groom82

Formal Portraits of the Bride and Groom85

6. GROUP PORTRAITS90

Types of Groups .90

Backgrounds .90

Composition .93

Groupings .93

 Couples .93

 Trios .94

 Even-Numbered Groups97

 Larger Groups .97

 Really Big Groups99

Sidebar: Panoramic Groups99

Focus and Depth of Field100

After You've Snapped the Shutter100

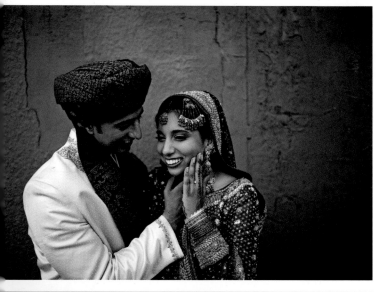

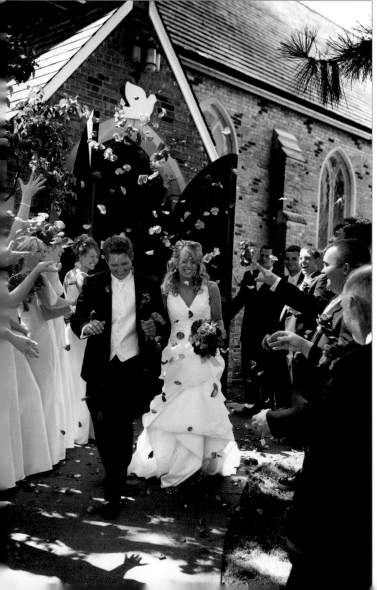

TOP PHOTOGRAPH BY JESH DE ROX.
BOTTOM PHOTOGRAPH BY JEFFREY AND JULIA WOODS.

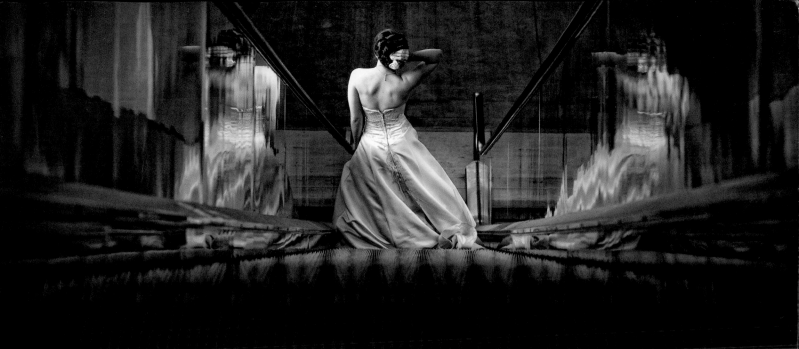

PHOTOGRAPH BY DAVID BECKSTEAD.

7. WEDDING ALBUMS AND SPECIAL EFFECTS ..101

Basic Design Principles101
 Title Page101
 Left and Right Pages101
 Variety103
 Visual Weight104
 Reading Direction105
Traditional Albums105
 Post-Mounted Albums105
 Bound Albums105
 Library Binding106
Magazine-Style Digital Albums106
 Covers106
Sidebar: Creativity Counts106
 Layout106
 Storytelling107
 David Anthony Williams109
 Charles Maring109
 Design Templates111
 The Design Factor111
Sidebar: Mini Albums111
 Signing Off on the Design112
Special Effects113
 Borders113
 Cross-Processing115
 Infrared Photography115
 Handcoloring116
 Panoramics and Gatefolds116
 Tilting the Camera116
Fine Printing117

GLOSSARY118

THE PHOTOGRAPHERS120

INDEX123

ABOUT THE AUTHOR

Bill Hurter has been involved in the photographic industry for the past thirty years. He is the former editor of *Petersen's PhotoGraphic* magazine and currently the editor of both *AfterCapture* and *Rangefinder* magazines. He has authored over thirty books on photography and hundreds of articles on photography and photographic technique. He is a graduate of American University and Brooks Institute of Photography, from which he holds a BFA and Honorary Masters of Science and Masters of Fine Art degrees. He is currently a member of the Brooks Board of Governors. Early in his career, he covered Capitol Hill during the Watergate Hearings and worked for three seasons as a stringer for the L.A. Dodgers. He is married and lives in West Covina, CA.

LANDMARKS IN WEDDING PHOTOGRAPHY

*N*ot that many years ago, wedding photographers were known as "weekend warriors; they were wedding photographers on wedding days and worked at other full-time jobs the rest of the week. The status of the wedding photographer—both among other photographers and the public at large—was very low. They were often insufficiently equipped to provide first-rate photographs of the wedding and photographed almost everything with on-camera flash. In some cases, not only was their photographic technique suspect, so were their business practices. The phrase "fly by night" often described the struggling weekend warrior.

Of course, there existed the reputable studio photographers who also offered expert wedding coverage, but it was markedly different than the wedding coverage one sees today. These photos—90 percent of them anyway—were posed, and if they weren't posed, the people in the photos were aware of the presence of the photographer and often "mugged" for the camera.

WPI and WPPI

In 1981, an organization was formed (coincidentally, an organization I currently work for) to upgrade the techniques and business practices of the wedding photographer. WPI (Wedding Photographers Interna-

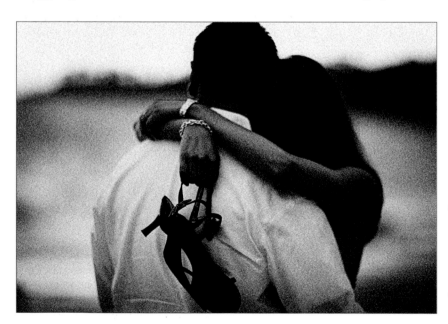

Fernando Basurto created this intimate engagement portrait in Laguna Beach, CA. Note that you cannot even see the couple's faces. Fernando says, "Rather than trying to pose the subjects, I let them do their own thing and work around them, looking for the right moment to capture their emotional impulses. This image is a perfect example of my photographic style. Although the couple was photographed from the back, their intimate interaction suggests a feeling of romance." The image was treated with a heavy dose of grain by master printmaker Jonathan Penney. (Canon EOS-1D Mark II; EF 85mm f/1.2L II USM lens; available light; ISO 800; ⅟₆₄₀ second at f/1.2)

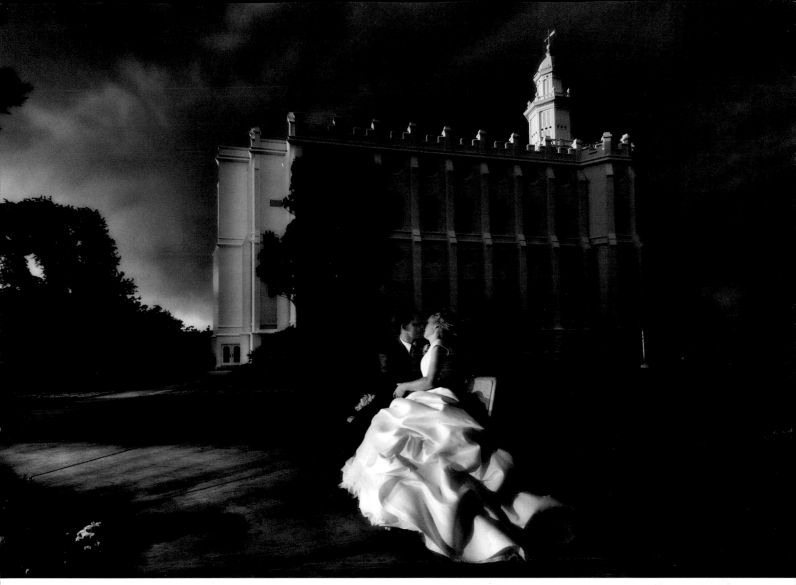

Digital technology has revolutionized wedding photography. In this image, made by Nick Adams in the photojournalistic tradition, the couple is unaware of the photographer's presence. He used a remote speedlight fired from camera left to provide dramatic light that defines the subjects and the folds of the gown. He synchronized the flash exposure with the daylight exposure of $^1/_{160}$ second at f/6.3. This technique is known as dragging the shutter and allows the ambient light to record naturally. (Nikon D2X; AF-S DX Zoom-Nikkor 12–24mm f/4G IF-ED lens; ISO 100)

tional), as it was known then, brought together these photographers for an annual convention, which provided excellent networking opportunities and speakers from all over the world to educate them on the art and technique of wedding photography. It was an organization that came along at the right time; it was instantly accepted and provided a home and never-before-experienced status for the disenfranchised weekend warriors. The creation of WPI (and subsequently WPPI; portrait photographers were later added into the organization's fold to create Wedding and Portrait Photog-

raphers International) was a turning point in the evolution of wedding photography.

Denis Reggie

Another landmark was the emergence of a former sports photographer named Denis Reggie, who proclaimed himself a "wedding photojournalist." Like WPI, Reggie's words and images were well received by both photographers and brides. He was like a breath of fresh air, instantly giving this brand of photography credibility and salability—and gradually enhancing the

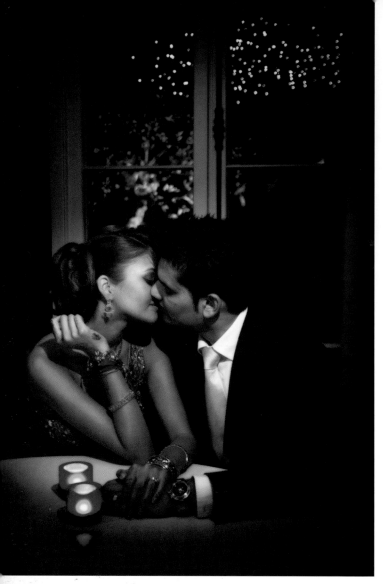

Almost no light is needed for a fine digital exposure like this one made by Stuart Bebb. The image was made by candlelight and the light of a small handheld video light (50W) held by the photographer. (Nikon D200; Sigma 18–50mm f/2.8 EX DC Macro lens at 31mm; ¹/₁₀ second at f/2.8; ISO 400)

status of those who practiced this unique brand of documentary photography. Reggie's purpose was (and is) to provide brides with their own unique and personal story, not a generic version of someone else's wedding.

The Digital Revolution

Another important factor that has completely changed the landscape of wedding photography is the overwhelming acceptance of digital as the format preferred by both brides and photographers. Remarkable convenience and flexibility are the obvious benefits of digital photography over film, but rapid-fire improvements in

the technology have not only aided in the transition, they have also spurred manufacturers to become more innovative and competitive with each other in new product development.

While on-camera flash and plenty of batteries were wedding-day staples in days gone by, today most photographers don't even reach for the flash except in near total darkness or when a special flash effect is desired. Previously unimaginable ISO settings—up to 102,400 on the Nikon D3S—are now at the disposal of every photographer, making natural-light photography more accessible than ever. Image-stabilization technology, both in-camera and in-lens, has also made it possible to shoot sharp hand-held images in extremely low light. Additionally, multiple remote flash units can be controlled via the camera's on-board Flash Commander (Nikon) so that an entire room or location can be lit up like a Hollywood set—with the photographer orchestrating everything from the camera position using a few simple menu commands.

The film-based wedding photographer would often worry about the amount of film that was being exposed; this presented a cost that could only be controlled by shooting less. With digital, this is not a concern; because there is no lab fee for processing and proofing digital images. Free of that cost, the photographer, especially the wedding photojournalist, is at liberty to make many more exposures and to experiment liberally without the worry of escalating lab fees.

The net result of this torrent of technology is that wedding photojournalists can now be virtually invisible if they want to—prowling the wedding, experimenting at will, and recording moments unobserved from afar or right up close as they see fit.

Adobe® Photoshop®

Without a doubt, Adobe Photoshop has permanently changed the style and look of wedding imagery. The photographer, in the comfort of his home or studio, can now routinely accomplish special effects that in years past could only be achieved by a master printer.

Photoshop, and its many plug-ins and companion applications, has made wedding photography the most creative venue in all of photography—and brides love it. Digital albums, assembled with desktop-publishing hardware and software or in Photoshop, are quickly becoming the preferred album type, and the style these albums bring to the wedding experience helps to make every bride and groom a celebrity—and every wedding album a one-of-a-kind book.

Times Have Changed

Many wedding photojournalists have attained a superstar status no one would have dreamed of twenty years ago. Their work is routinely featured in the top magazines around the country and they are in demand fifty-two weeks a year. They have a large staff, a network of like-minded colleagues and, most importantly, today's wedding photojournalists have won over the hearts and minds of brides of every age and ethnicity. Celebrities seek them out to photograph their weddings and parties, and the circle of acceptance grows wider each day. No location is too remote for these photographers, and the successful wedding photojournalist now may only work in their own country part of the time.

As its acceptance has grown, wedding photojournalism has also come to be important enough to encompass other styles of photography. It is now much more than pure documentary photography. You will also see elements of editorial and fashion photography and more than a touch of fine-art photography in the work of the contemporary wedding photojournalist. You will even see healthy helpings of posed images—although photojournalists approach these moments as choreographed scenes in which the subjects are natural players.

Times have changed, and they will change again. But for now, wedding photojournalists are among the highest paid and most well-respected photographers on earth. And the incredible images these talented artists are producing have changed the face of wedding photography forever.

Today's wedding photographers can quickly rise to the stature of rock stars. Such is the happy fate of Seattle wedding specialist Jim Garner, who is known for his exciting, emotion-filled wedding coverage. This kind of portrait exemplifies the photojournalist's approach: bring about the emotion of the moment, but where possible, adhere to the elements of good posing and design.

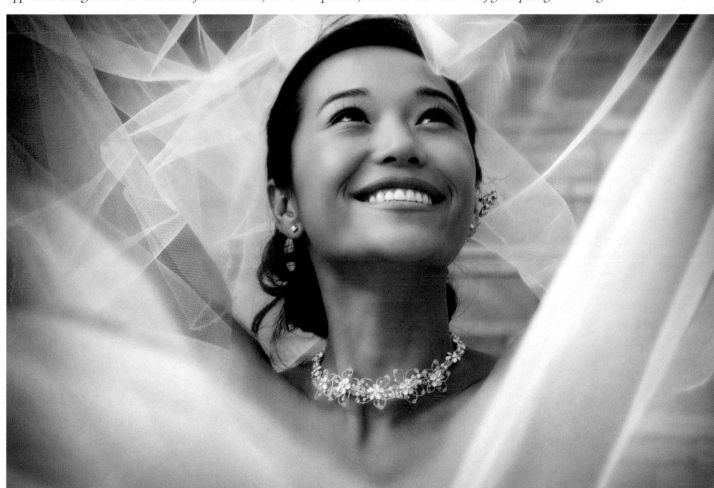

1. THE NATURE OF WEDDING PHOTOGRAPHY

One of the reasons wedding photography has achieved such high regard is that it is the permanent record of an important day in the couple's lives. It is also the culmination of months of preparation and countless expenses. Additionally, it is often the day when the bride will feel her most beautiful and the groom his most handsome. It is a once-in-a-lifetime event.

The Old *vs.* the New

According to the traditional approach, wedding photography features dozens and dozens of posed pictures culled from a "shot list" passed down by generations of other traditional wedding photographers. There may be as many as seventy-five scripted shots—from cutting the cake, to tossing the garter, to the father of the bride walking his daughter down the aisle. In addition to the scripted moments, traditional photographers fill in the album with "candids," many of which are staged or at least made when the subjects are aware of the camera. A typical candid might be made when the bride and groom are dancing, see the photographer, and turn to the camera while making the appropriate funny faces. Because the traditional photographer intrudes on the

"Seeing is the real key to harnessing the potential of any given scene," says David Beckstead, who aims to create photographic uniqueness in all of his images. He says of this scene, "I immediately saw the potential of the reflections and the 'X' style lead-in lines. The bride reached up to fix her flower and I told her to stop and leave her hand there. It seemed so natural and much better than any pose I could have come up with." (Canon EOS-1D Mark II; Canon EF 70mm–200mm f/2.8L IS USM; Nik ColorEfex Pro 3.0 filter)

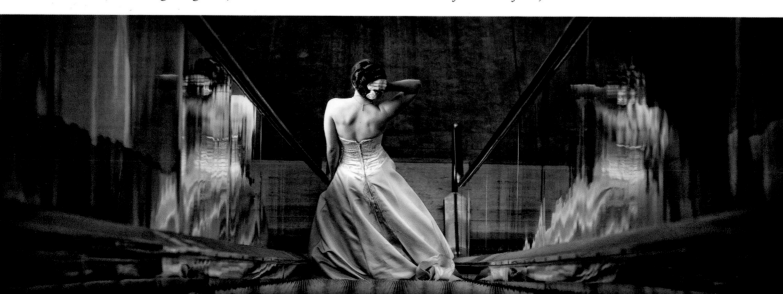

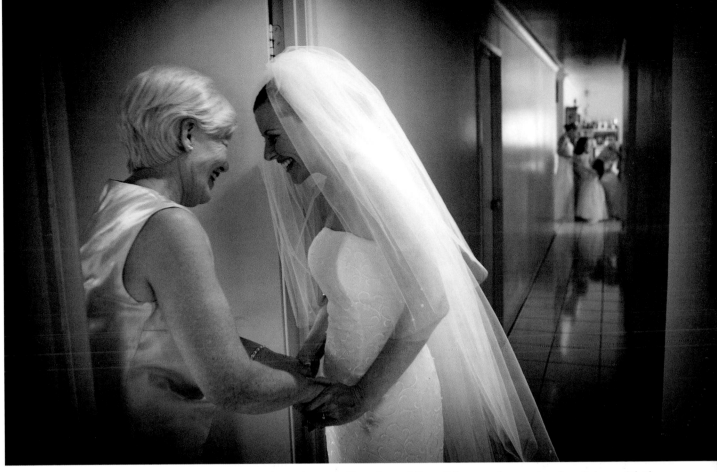

The families often forget that Marcus Bell is even there photographing the wedding. Of course, he spends a lot of time with the couple before the wedding building their confidence in him, but once the day's activities begin, he's almost invisible. That's how he gets priceless shots like this.

naturalness of the scene, the coverage is structured and, in the view of many, fictional.

The photojournalistic approach is quite different. While the photojournalist covers the same events, he or she usually does so without interference and intrusion. Working at a distance with longer-than-normal lenses and (normally) no flash allows the scene to unravel with all of the spontaneity and genuine emotion that naturally occurs at such wonderful events. Instead of being a part of every moment, the photojournalist tends to fade into the background so the subjects are not aware of his or her presence. This results in images that are spontaneous and lifelike. Many wedding photojournalists even photograph groups with this non-intrusive approach, preferring to wait until things "happen."

As you can imagine, creating wedding images in the non-obtrusive, photojournalistic style requires a completely different approach—and set of skills—than traditional wedding photography. That is the subject of the rest of this chapter.

Powers of Observation

Like any form of photojournalism—whether it be news photography, fashion photography, or sports photography—one of the prerequisites to success is the skill of observation, an intense power to concentrate on the events before you. Through keen observation, a skill that can be enhanced through practice, the photographer begins to develop a knack for predicting what will happen next. This is partially due to understanding the intricacies of the event, the order in which events will occur, and partially a result of experience. The more weddings one photographs, the more accustomed one becomes to their rhythm and flow—but the sense of anticipation is also a function of clearly seeing what is transpiring in front of you and reacting to it quickly.

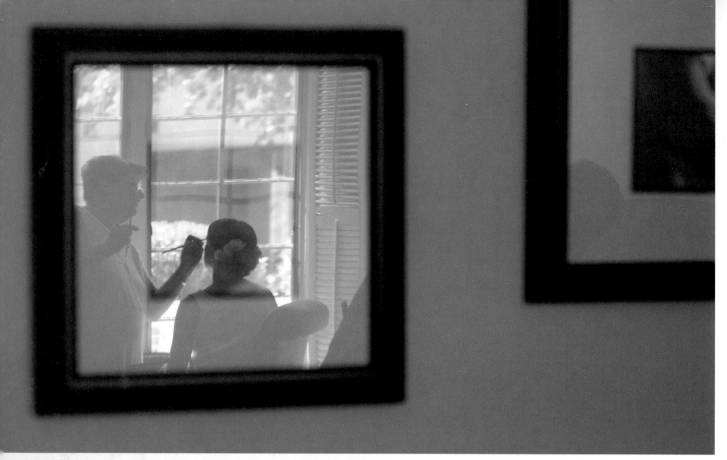

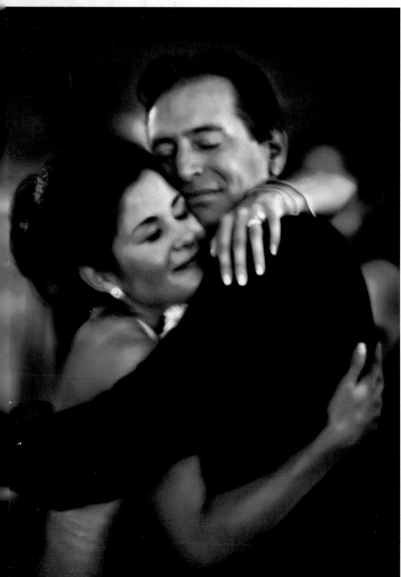

Above—The photographer's powers of observation must be well-tuned on the wedding day. Here, David Beckstead caught sight of the bride having her makeup applied—an image that was reflected in a picture frame in the room. It is one of those details of the day almost no one else would have seen.

Left—This is an image of the last dance of the evening by Greg Gibson, a highly acclaimed photojournalist. The scene was lit by dim strands of Christmas lights that bathed the couple in a golden light. According to Greg, "They are so lost in each other that they're completely unaware of their surroundings." Gibson, who generally carries a Canon 85mm f/1.2 EF-L lens on his shoulder during the reception, managed to get the camera to his eye and shoot three frames before the couple was interrupted by a departing guest. The image was made at $^1/_{10}$ second at f/1.2 at ISO 1600. In postproduction, he bumped up the saturation, softened the details a bit, and added a slight vignette.

There is an ebb and flow to every action. Imagine a pole-vaulter ascending at one moment, reaching the peak, then falling at the next—that moment of peak action is what the photographer strives to isolate. Although today's cameras make it possible to capture numerous frames per second, blanketing a

scene with high-speed exposures is not the key to success. Success is the result of remaining calm and quiet, paying close attention, and learning exactly when to press the shutter release. With a refined sense of timing and good observational skills, you will drastically increase your chances for successful exposures.

The Beauty of Reality

Traditional wedding photography is, to some, the quest for perfection. The pose, the lighting, and the expression are all designed to idealize the subject. This is a viable, artistically relevant pursuit, but it is not in the mind-set of the photojournalist. Instead, the ideal is to capture the reality of the situation with as little interference as possible. The true wedding photojournalist believes that flaws are part of nature—part of what makes a moment real and natural. This is not to say that the reality captured by the wedding photojournalist is harsh or otherwise unappealing. To the contrary, the photojournalist's record of the day should be a sensitive, flattering portrayal of the events that highlight the true emotions elicited.

Storytelling

Above all, the skilled wedding photojournalist is an expert storyteller. The wedding day is a collection of short episodes that, when pulled together, tell the story of an entire day. A good wedding photojournalist is aware of the elements of good storytelling—a beginning, middle, and end—as well as the aspects that make a story entertaining to experience—emotion, humor, tension, and resolution.

Gene Higa is a destination wedding photographer whose specialty is blending the culture of the destination into his wedding images. Gene calls this image "a typical Peruvian moment." The bride and groom arrived at the La Catedral in the Plaza Mayor of Lima late in the afternoon. They were immediately surrounded by a crowd of local shoppers who wanted to offer their blessings or to touch the bride. Rather than trying to clear the crowd, Gene incorporated all the diverse personalities into an image that became the couple's favorite. Gene, who shot this image with a Canon 1D Mark II and a 24mm f/2.8 lens, never crops his images. He likes each one the way he framed it.

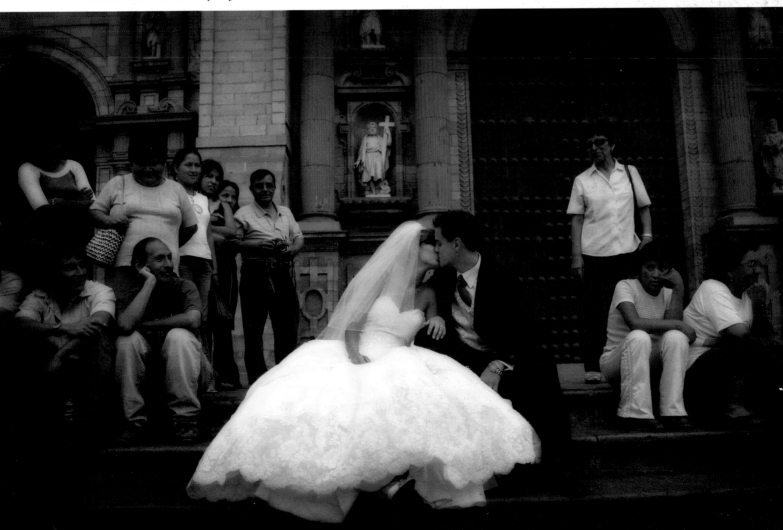

According to wedding photographer Charles Maring, a good story includes many details that go unobserved by most people, even those attending the event. He says, "Studying food and wine magazines, fashion magazines, and various other aspects of editorial images has made me think about the subtle aspects that surround me at a wedding. Chefs are preparing, bartenders are serving, waiters are pouring champagne or wine. My goal is to bring to life the whole story from behind the scenes, to the nature around the day, to the scene setters, to the blatantly obvious. In short, I want to capture a complete story."

Posed Shots

Virtually every wedding—even the purest photojournalistic effort—includes some number of posed images. These are the "formals," the pictures that every bride (and bride's parent) will want. These may include a group portrait of the bride and groom with the groom's family, and one with the bride's family. Also frequently requested is a group portrait of the wedding

Facing page—*Here is a Jeff Hawkins formal that performed two purposes. First, it is a lovely emotional portrait of the bride and groom. Second, it is a beautiful portrait of their rings. Notice the elegant hand posing—a very traditional element done very well.*

party, and sometimes the entire wedding assembly—including all the guests. These formal, non-photojournalistic images may be done with editorial flair or more traditionally, but they are part of the wedding photojournalist's pictorial obligation and can often be done in as little as fifteen minutes before or after the ceremony. Often, these images are not featured in the photographer's own promotional materials, but be assured, they are an important ingredient in every wedding and an expected part of the package.

Using Assistants

Even a photojournalist who possesses extraordinary powers of observation paired with razor-sharp timing and reflexes can still miss a moment when someone steps in the way or one of the principals in the scene

Formals are part of even the most ardent photojournalist's wedding coverage. Here a little something different was done to handle the formals and groups. Jeff Hawkins combined a lot of small group formals with two large, decidedly informal images to create an interesting two-page album spread. The contrast of big and little, formal and informal gives the spread a unique energy.

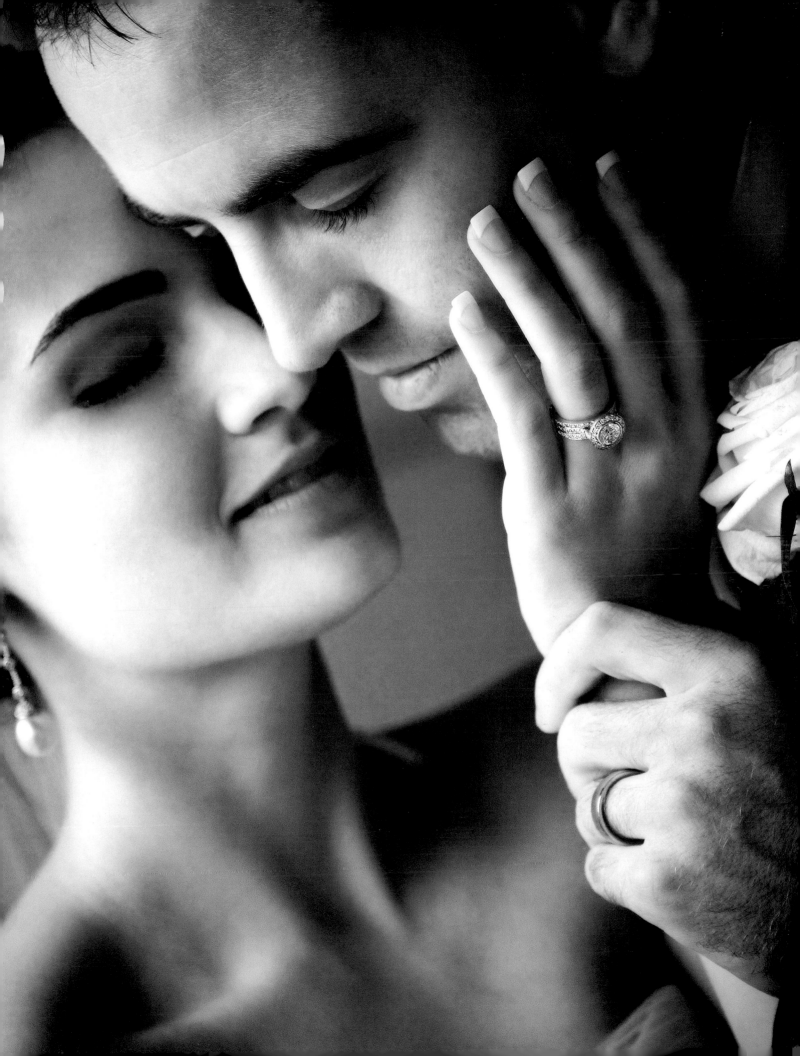

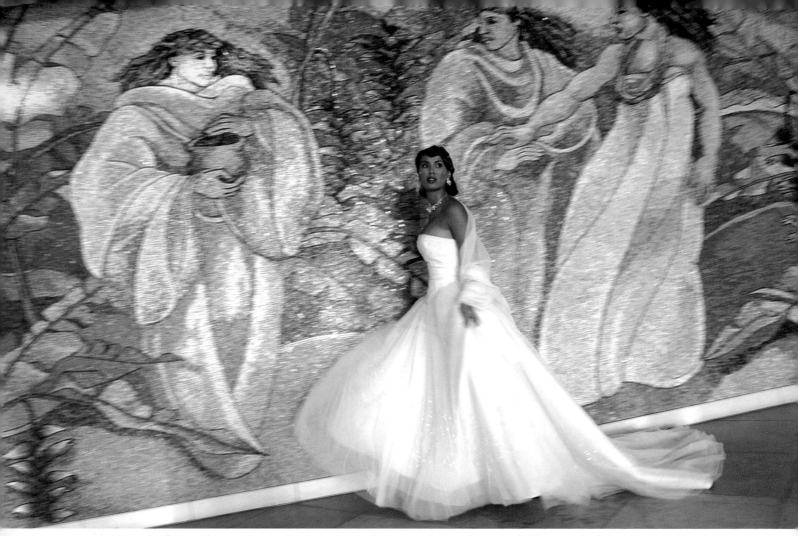

Great wedding photojournalists can freeze a fleeting moment in time and space. Here, the bride—seemingly in a hurry and with a note of concern in her face—casts a look over her shoulder, completely unaware of photographer Joe Buissink. The many things happening in this moment are revealed in a split second.

turns away at the last moment. Even with the best-laid plans, some great shots still get away. As a result, many wedding photographers feel that one person cannot adequately cover a wedding—there's simply too much action going on at once.

An assistant is invaluable at the wedding. He or she can run interference for you, change or download memory cards, organize guests for a group shot, take flash readings and predetermine exposure, tape light stands and cords securely with duct tape, and tackle a thousand other chores. Your assistant can survey your backgrounds looking for unwanted elements—or even become a moveable light stand by holding your secondary flash or reflectors.

If you decide to work with an assistant, make sure that he or she is trained in your photographic and light-

ing styles. The wedding day is not the time to find out that the assistant either doesn't understand or—worse yet *approve*—of your techniques; you should both be on the same page. A good assistant will even be able to anticipate your next need and keep you on track for upcoming shots.

Eventually, most assistants go on to become full-fledged wedding photographers. After you've developed confidence in an assistant, he or she can help with the photography—particularly at the reception, when there are too many things going on at once for one person to cover. Most assistants try to work for several different photographers to broaden their experience. It's not a bad idea to employ more than one assistant; if you get a really big job you can use both of them—or if one is unavailable, you have a backup assistant.

Assistants also make good security guards. I have heard many stories of gear "disappearing" at weddings. An assistant is another set of eyes whose priority it should be to safeguard the equipment. On that note, it is a very good idea for you and your second or third shooters to be using the same gear, or at least the same brand of gear, so that lenses can be borrowed for special situations. It also helps minimize confusion during the download process and postproduction workflow.

Many husband-and-wife teams cover weddings together, creating different types of coverage (formals vs. reportage, for example). These teams may also use assistants to broaden their coverage into a team effort.

Anticipation and Preparation

Preparation is the key to anticipating photographic opportunities. By being completely familiar with the format of the ceremony and events, you will know where and when an event will take place and be prepared for it. This kind of planning must take place long before the wedding day.

It is a good idea for the photographer to scout all of the venues at the same time of day as the events will actually take place. Many photographers take extensive notes on ambient lighting, ceiling height and surfaces, placement of windows, reflective surfaces (like mirrors or wood paneling), and other physical conditions that will affect the photography.

In addition, it is advisable to meet with the principal vendors, such as the florist, caterer, band director, hotel banquet manager, and so on, to go over the wedding-day plans and itinerary in detail. This information will assist you in developing a game plan for photographing each of the day's events.

Another good practice is to schedule an engagement portrait. This has become a classic element of wedding coverage, and one that is often included free of charge. The engagement portrait can be made virtually anywhere and allows the couple to get used to the working methods of the photographer. Then, on the wedding day, they are already accustomed to their photographer's rhythms and style of shooting. The experience also helps the threesome get to know each other better, so that on the wedding day the photographer doesn't seem like an outsider.

Drawing on all of this information, the photographer will be able to choreograph his or her own movements, taking the optimum position to document each

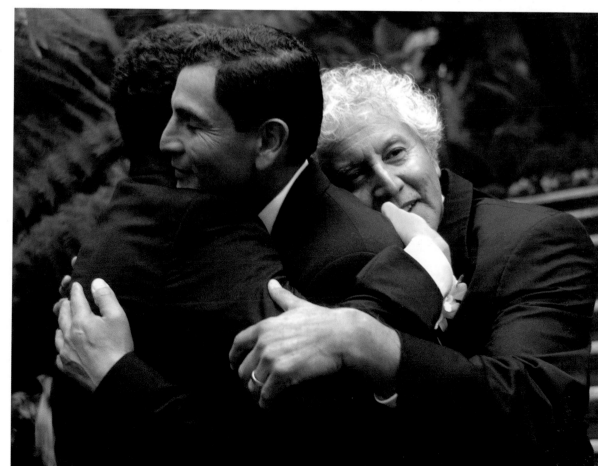

Moments like this don't wait for the photographer to get ready. They happen and then they're over. If you know the principals, their relationships, and the details of the moment, though, you can anticipate a scene like this. If you have truly great reflexes, it can even become an award-winning image—like this one by Joe Buissink.

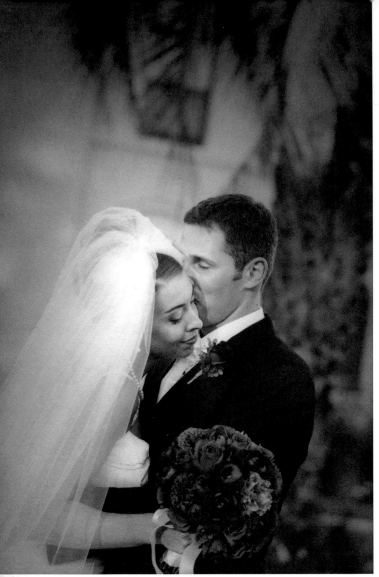

Alisha and Brook Todd are known for creating images brimming with emotion. They immerse themselves in the day and are aware of the subtle nuances that the couple use to express their affection for one another.

Additionally, there is an intangible aspect to reaction time that all photographers must hone. This is instinct—the internal messaging system that triggers you to react. Developing this means trusting yourself to translate input into reaction, analyzing what you see and are experiencing and determining the critical moment to hit the shutter release.

Joe Buissink, master at anticipation and timing, works remarkably fast when he shoots. A former assistant told me once that the first time he saw Joe shoot, he thought, "He couldn't possibly know what he's doing, he shoots so incredibly fast." The fact is, Buissink *does* work quickly—and definitely knows what he's doing. Buissink trusts the process, saying, "Trust your intuition so that you can react. Do not think. Just react or it will be too late."

Capturing the Emotion

Perhaps the most obvious characteristic of wedding photojournalism, and also the most difficult to attain consistently, is the ability to capture the emotion of the moment. Some of the items discussed above, like working unobserved, anticipation, and preparedness, are all part of this mind-set. However, there is another key ingredient: the ability to immerse oneself in the events of

phase of the wedding day. The confidence that this preparation provides is immeasurable. (*Note:* It also helps to put in the time. Arriving early and leaving late is one way to be assured you won't miss great shots.)

Reaction Time

Sports photographers rely on timing—a skill developed through preparation, observation, concentration, and anticipation. Being a wedding photojournalist requires the same skills. In short, the better you know the event and the more you can focus on what's happening around you—whether it is a basketball game or a wedding—the better your reflexes will become.

DRESSING FOR SUCCESS

One might expect that a wedding photojournalist would dress down for the wedding—maybe not like the sports photographer with a photographer's vest and jeans, but casual. Tony Florez, a successful wedding photographer from San Juan Capistrano, CA, recommends otherwise. He believes that one of the keys to upscaling his wedding business was to live the motto "dress for success." To say he has upgraded his wardrobe is an understatement. He only wears Armani tuxedos to weddings; like the couple he is there to photograph, he looks like a million dollars. This is not to say that this is the secret to his success—he is also a gifted photographer—but simply dressing well has added to his confidence and enhanced his reputation.

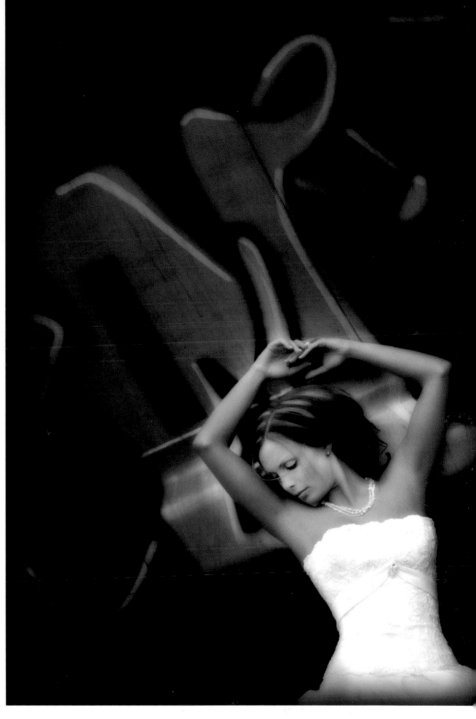

Michele Celentano believes that one should "have fun with the brides." In a session that spanned two-and-a-half hours, Michele took this couple to their high school, a cemetery, a John Deere factory, and a train yard where there was a large wall mural. That's where this image was made. While the bride was not initially enthusiastic about the location, Celentano communicated her vision and pretty soon the bride got into it, too. Michele reminded the couple that they wouldn't have hired her if they didn't trust her instincts. She used two plug-ins in postproduction: Imagenomics Portrait for retouching and Nik Color Efex Pro 3.0's Glamour Glow. She also did a light once-over with Ron Nichols Production Retouching Palette to paint in a soft-edged vignette.

the day. The photographer must be able to feel and relate to the emotion of the moment. At the same time, you cannot be drawn into the events to the extent that you either become a participant or lose your objectivity, which is required to analyze the events with a clear head.

All of one's photographic, journalistic, and storytelling skills go into making pictures that evoke in viewers the same emotions experienced by those present on the wedding day. The photographer must move silently and alertly, always ready to make an exposure—listening, watching, sensitive to what is happening and what could happen in the next instant.

To Brook and Alisha Todd, two San Francisco-area wedding photographers, capturing emotion is what the wedding day is all about. In fact, it's why they enjoy photographing these timeless rituals. Their goal in all of their combined coverage is to produce a remembrance of how the bride and groom, as well as their family and friends, felt on that wedding day.

Celebrated wedding photojournalist Michele Celentano feels the same way. "I will never give up weddings," she says. "I love brides, grooms, the flowers, the fanfare, the symbol of new life and the idea of a new beginning."

Making the Average Extraordinary

Dennis Orchard has a lighthearted approach to his weddings. He calls them "lifestyle weddings" and his coverage combines informal black & white reportage with

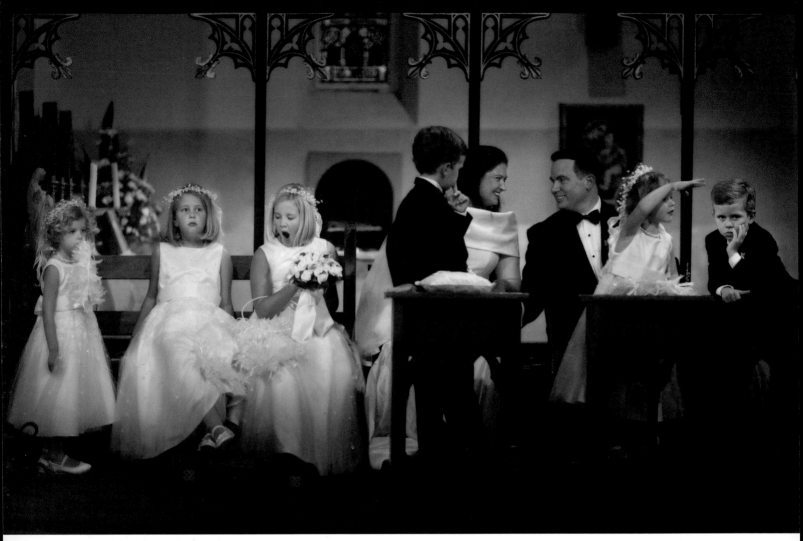

Look at this award-winning panel of stories all unfolding simultaneously. The group is completely unaware of the photographer, Marcus Bell, and he probably had the opportunity to make only a few frames before they noticed him and became self-conscious. (Canon EOS 5D; Canon 85mm f/1.2 EF-L lens; ISO 500; ¹⁄₅₀ second at f/2)

creative, natural-color photography. Like most photojournalists faced with photographing family groups, he grins and bears it; he tries to give them a friendly, relaxed feeling rather than the formal structure that most group photos exhibit. What really appeals to Dennis, though, is the challenge. "I love to make the ordinary extraordinary. I thrive on average brides and grooms, Travelodge hotels, and rainy days in winter," he says. Orchard recently photographed an overweight bride who was "so frightened of the camera that every time I pointed it at her she would lose her breath and have a little anxiety attack." Using long lenses, he photographed her all day long without her being aware of the camera. He said he couldn't believe the final

shots—she was beautiful in every frame. The bride later wrote him a note in which she said, "I never thought I could have pictures like this of me!" It was Dennis' best wedding of the year.

Uniqueness

No two weddings are ever the same, and it is the photographer's responsibility to capture the uniqueness of each event. This is also the fun part; with the abandonment of the cookie-cutter style of posed portraits, every wedding is a new experience with all-new challenges for the wedding photojournalist. Because wedding photojournalists work at a distance and avoid intruding on events, they can capture the true outpourings of emo-

tion between the participants. Documenting these natural and genuine moments is one of the primary means of documenting a wedding's uniqueness.

Style

One of the traits that separates wedding photojournalists from traditional wedding photographers is the element of style, an editorial feel pulled from the pages of today's bridal magazines. Because weddings—with all the associated clothing and jewelry—are big business, these magazines have flourished into behemoth issues each month. This is what brides see as they are planning their weddings, so it's how they expect to see their own wedding documented.

Noted Australian wedding photographer Martin Schembri calls the magazine style of wedding photography "a clean, straight look." It is reminiscent of advertising/fashion photography. In fact, if you study these magazines, you will quickly notice that there is often very little difference between the advertising photographs and the editorial ones (the images used to illustrate the articles). By studying consumer trends in wedding apparel, you can better equip yourself with an understanding of what contemporary brides want to see in their wedding photographs.

Some wedding photographers take style to the next level. Michael Schuhmann says of his work, "It's different; it's fashion, it's style. I document a wedding as a journalist and an artist, reporting what takes place, capturing the essence of the moment."

Awareness

Most wedding photojournalists greatly revere the work and philosophy of Henri Cartier-Bresson, who believed in the concept of "the decisive moment," a single instant that is released from the continuity of time by the photographer's skills. This moment is life defining; it's a moment like no other before or since, that defines the reality of the participants. As noted many times throughout this book, revealing the decisive moment can only be accomplished through a complete aware-

ness of the scene. This attitude requires concentration, discipline, and sensitivity.

Many fine wedding photojournalists are also masters of full awareness. Photographers like Joe Buissink are able to become one with their equipment, the moment, and the emotion of the wedding couple. Buissink considers his equipment to be an extension of his body, his eye, and his heart. He says of the state, "My sense of self fades away. I dance with the moment . . . capturing the

Michael Schuhmann created this very stylish portrait using a variety of effects, including a very strong vignette and treatment with a variety of filters in postproduction. It is indicative of the stylish and dramatic look now being sought by the wedding community.

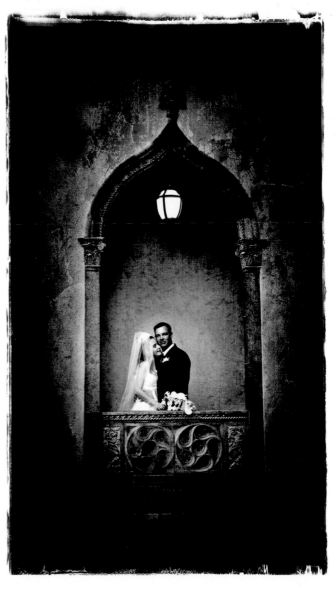

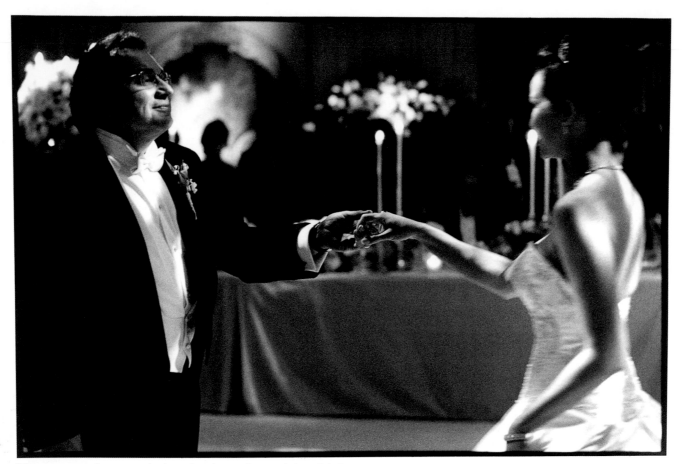

There are certain moments that rise above others as being "the" moment of the hour. So it is with this moment captured by Joe Buissink. The bride's body language reflects pure joy and heightened anticipation. The man's expression is one of pure respect and adoration. It is priceless moment, right down to the nuances of the hands.

essence of a couple." Buissink says the state of full awareness is not that difficult to find. "You must relax enough to be yourself and exhibit your pleasure in creating art. Do not look for the flow. It will find you. If you try to force it, it will be lost."

People Skills

Any wedding photographer, whether journalistic or traditional, needs to be a "people person," capable of inspiring trust in others. Generally, photojournalists are more reactive than proactive, but they cannot be flies on the wall for the entire day; interaction with the principal participants is crucial. Often those interactions occur at stressful moments, and that is when the photographer with people skills really shines.

Joe Buissink, for example, has been blessed with a "salt of the earth" personality that makes his clients in-

stantly like and trust him. That trust increases his freedom to capture the event as he sees it. It also helps that Buissink sees weddings as significant and treats the day with great respect. Buissink says of his mental preparations for the wedding event, "You must hone your communication skills to create personal rapport with clients, so they will invite you to participate in their special moments." And he stresses the importance of being objective and unencumbered. "Leave your personal baggage at home. This will allow you to balance the three roles of observer, director, and psychologist."

Building a good rapport with your couple, the family, and people in general helps in the making of great pictures on the wedding day. While wedding photojournalists must be great observers and possess a keen sense of timing, there are also times when the photographer's interaction is the impetus for a great "staged

moment." This might be when formal portraits of the bride or groom (or both) are required, or when certain planned phases of the wedding are upcoming.

Rather than rejecting such situations as non-photojournalistic, the seasoned photojournalist embraces these moments and may or may not stage their outcome. He or she may even direct the overall action, just as a film director choreographs the elements of a scene to be filmed.

Having Fun

Because of the romantic nature of the event, it helps if the photographer is also a romantic—but it is not completely necessary. Beyond the romance, the wedding is a celebration for the couple's family and friends. The wedding photographer gets to be part of this joy and create pictures that tell the story of the fun.

Many wedding photojournalists feel blessed to be able to do what they do. For a great number of them, the appeal of photographing weddings is not the fees or even the prestige, it's simply that it is an occasion to have fun and to be a part of a meaningful and beautiful ritual. Photographer Michael Schuhmann, for example, truly loves his work. He explains, "I love to photograph people who are in love and are comfortable expressing it, or who are so in love that they can't contain it—then it's real." For the romantically inclined, wedding photojournalism is almost its own reward.

This fashionable image is an example of the way in which wedding photojournalism is moving toward a fashion/editorial look. JB Sallee created this image using available light, then worked it quite extensively in Photoshop using a variety of filters and effects. The severe cropping and tilt of the image make it not only different but extremely edgy. Brides love this style of imagemaking.

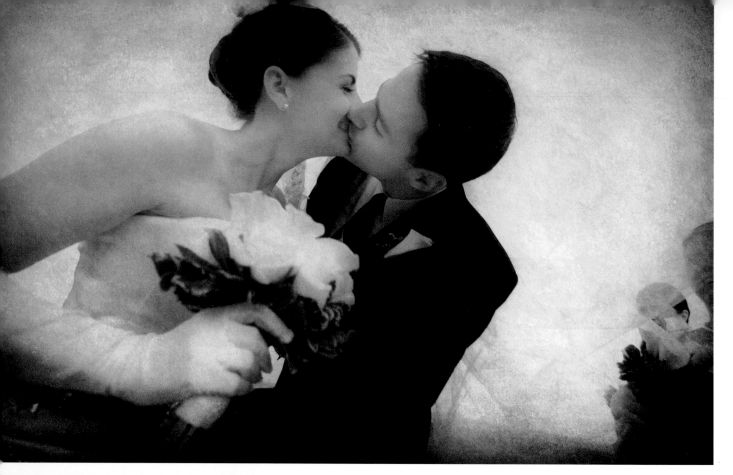

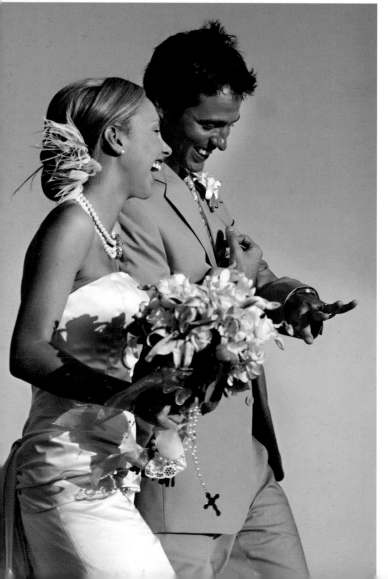

Above—Michael Schuhmann created this image of the couple kissing and then treated it to a host of postproduction effects including a patterned layer that gives the image a textured appearance. Notice, too, that while kissing her groom, the bride is also laughing, making the image even more charming.

Left—Fast reflexes are needed to be a good wedding photojournalist. As photographer Jessica Claire tracked the bride and groom walking, a spontaneous notion of "Hey, we're married!" came over the couple and Jessica had the good instinct to capture it. (Canon EOS 20D; 70mm focal length; $^1/_{1000}$ second at f/4)

*D*igital capture is, overwhelmingly, the choice of today's wedding photojournalists—for a number of reasons.

Every film photographer is wary of the number of rolls shot and the number remaining—and it is human nature to, at some point during the day, calculate the cost of all that film and processing. With digital, no such internal dialogue occurs. Wedding photographer Bambi Cantrell shoots more than a thousand exposures at every wedding. Because you can download your memory cards to a laptop and then reuse them, without having a huge lab bill for processing and proofing, you can shoot as much as you want without increasing costs.

Kevin Kubota hasn't shot a wedding on film since he purchased his Nikon D1X digital camera, saying that the quality is at least as good as 35mm film and that the creative freedom digital affords him is mind boggling. He can take more chances and see the results instantly, immediately knowing whether or not he got the shot. And the digital tools he has come to master in Photoshop make him a better, more creative photographer.

Joe Buissink, on the other hand, shoots both digital and film. He says he still prefers the look of film and the high-quality, fine-art aspects of a good fiber-base

Joe Buissink, shoots both film and digital. Here, the image was made digitally (on a Canon EOS 5D), but Joe used several types of Photoshop grain to simulate a silver-halide image.

print made from a film negative—but he also recognizes that he has to keep up with changing technology.

The 35mm DSLR

The days of exclusively medium-format cameras being used for wedding photography are at an end, particu-

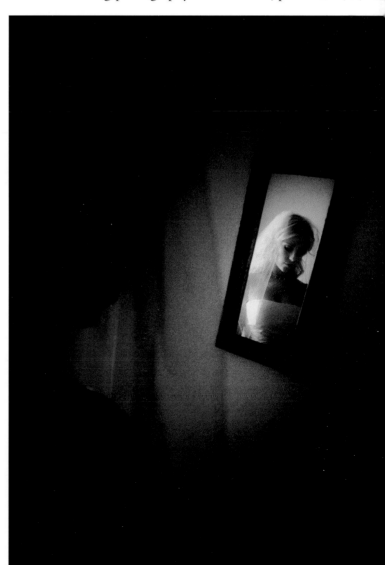

By far the greatest attribute of the 35mm DSLR is that it gives the wedding photographer the speed and flexibility to capture the wedding's spontaneity in real time. Marcus Bell made this delightful portrait with a Canon EOS 5D and EF 24–70mm f/2.8L USM lens. Marcus' exposure was 1/80 second at f/4 at ISO 800. The children were primarily lit by a picture window opposite to them, plus the ambient light in the room.

larly for wedding photojournalists. Faster lenses, cameras that feature eight-frame-per-second motor drives, and incredible developments in digital technology have led to the 35mm DSLR becoming widely accepted by professional wedding photographers. With the speed and mobility offered by these cameras, photographers are equipped to capture the wedding's spontaneity and excitement in real time. They can also capture more of the shots they envision—shots that might have slipped away with traditional, slower medium format gear.

Beyond ease of use, the consumer has come to accept 35mm as a viable choice for weddings. In the not-too-distant past, a wedding photographer might not be considered for a wedding if he or she wasn't shooting with a Hasselblad. This brand had become so entrenched in the mind of the public as the one-and-only camera for wedding photographers that it became a symbol for excellence in wedding photography.

Currently there are eight manufacturers of full-fledged systems: Canon, Nikon, Olympus, Fuji (which uses Nikon autofocus lenses), Pentax, Sony, Minolta/Konica, and Sigma (which uses the radically different Foveon X3 image sensor). Each manufacturer has several models in their product line to meet varying price points. Many of the pre-digital lenses available from these manufacturers for their film cameras also fit the

digital cameras, although sometimes with a corresponding change in effective focal length, depending on the size of the imaging sensor (for more on this, see page 37). In addition, a number of lens manufacturers also make autofocus lenses to fit various brands of DSLRs. These include Tokina, Tamron, and Sigma.

Autofocus Technology. Autofocus (AF), once unreliable and unpredictable, is now extremely advanced. Most cameras feature multiple-area autofocus so that

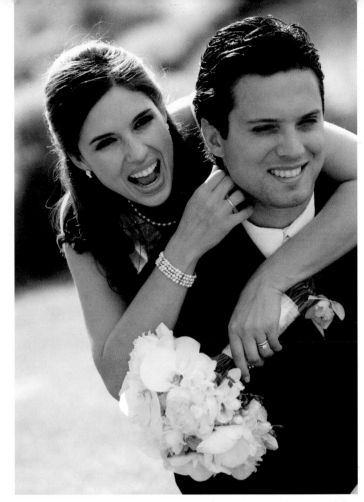

Right—The couple is spontaneous and completely unaware that they are being photographed by Mark Cafiero. The wealth of focal lengths available on state-of-the art DSLRs provides almost complete anonymity to the working photographer. (Canon EOS 1D Mark II; EF 70–200mm f/2.8L USM lens at 100mm; ¹⁄₃₂₀₀ second at f/2.8; ISO 400)

Below—The accuracy of both the exposure-metering systems and predictive AF make the DSLR the only choice for capturing the fast-moving pace of today's weddings. Mark Cafiero made this image with a Canon EOS-1D Mark II N and EF 70–200mm f/2.8L USM at the 70mm setting. The exposure was ¹⁄₅₀₀ second at f/3.5 at ISO 320.

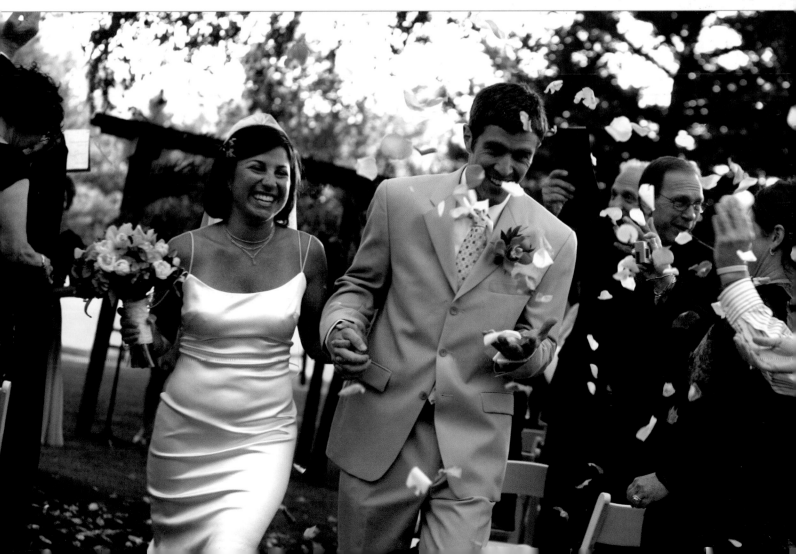

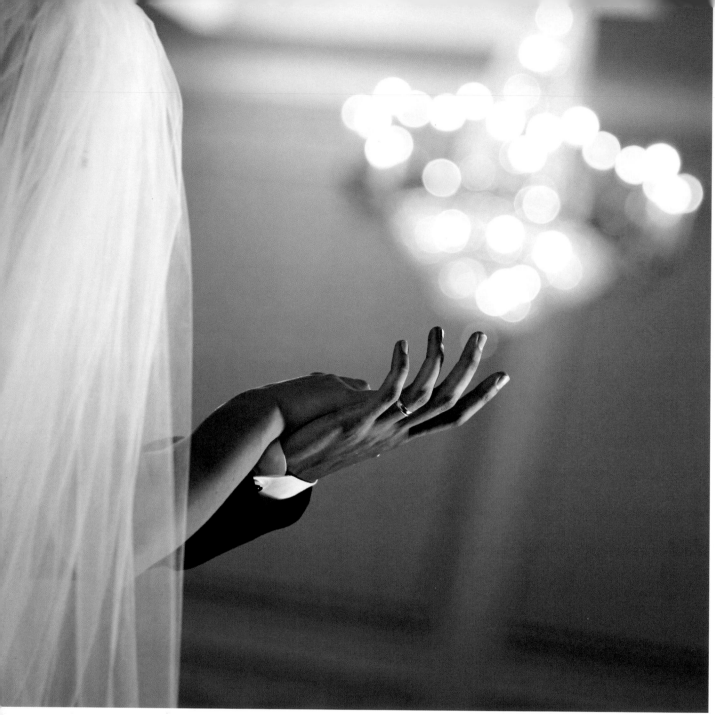

The ability to isolate details within the frame and blow out background details into a soft pastel palette is uniquely the property of the 35mm DSLR and fast, very wide-aperture lenses. Note that just the couple's fingers are sharp in this delicate image. Photograph by Jessica Claire. (Canon EOS 20D; EF 85mm f/1.2L II USM; ¹⁄₃₂₀ second at f/2; ISO 400)

you can, with a touch of a thumbwheel, change the AF sensing area to one of four or five different areas of the viewfinder (the center and four outer quadrants). This allows you to "de-center" your images and create more dynamic compositions. Once accustomed to quickly changing the AF area, this feature becomes an extension of the photographer's process.

Using autofocus to photograph moving subjects used to be an almost insurmountable problem. While you could predict the rate of movement and manually focus accordingly, the earliest AF systems could not. Now, however, AF systems use a form of predictive autofocus, meaning that the system senses the speed and direction of the main subject's movement and re-

acts by tracking it. This is an ideal feature for wedding photojournalism, which is anything but predictable.

A relatively new addition to autofocus technology is dense multi-sensor area AF, in which an array of AF sensor zones (up to 51 [Nikon] or 45 [Canon] at this writing) are densely packed within the frame, making precision focusing much faster and more accurate. These AF zones are user-selectable or can all be activated at the same time for the fastest AF operation.

Instant Feedback. Perhaps the greatest advantage of shooting digitally is that when the photographer leaves the wedding, the images are already in hand. Instead of scanning the images when they are returned from the lab, the originals are already digital and ready to be imported into Photoshop for retouching or special effects and subsequent proofing and printing. The instantaneous nature of digital even allows photographers to put together a digital slide show of the wedding ceremony that can be shown at the reception, literally moments after events occur.

Instant feedback also frees you from constant anxiety over whether or not you "got" the shot. If you didn't get it, it's right there on the camera's large LCD screen. The image can be magnified and scrolled corner to corner on the LCD to inspect for sharpness and expression. There's almost no excuse for missing the moment.

ISO Settings. Another reason digital has become so popular with wedding photographers is that you can

The ability to shoot in very low light with relative assurance of success is the province of the 35mm DSLR system. This image, by Jessica Claire, was made at 0.8 second at f/9 handheld with an EOS 5D and EF 50mm lens. Jessica chose a relatively small aperture to provide the depth of field required to keep the striking mural on the wall sharp—as well as the nervous groom.

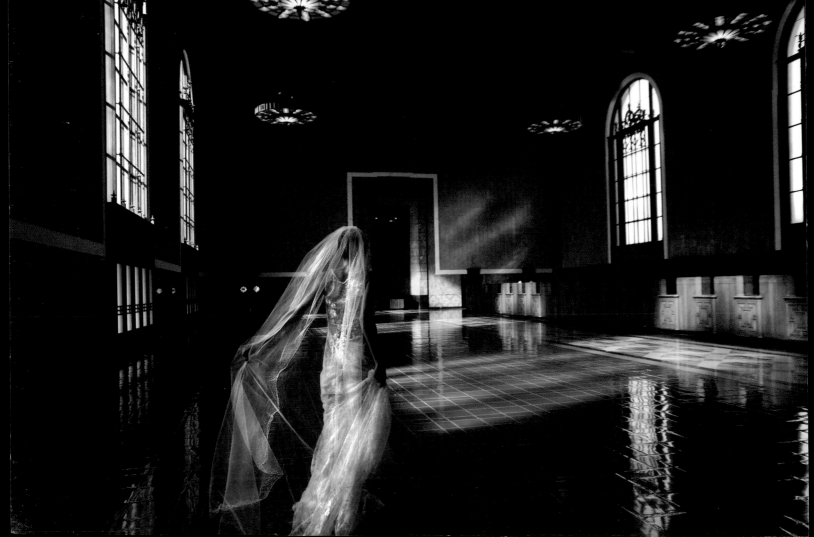

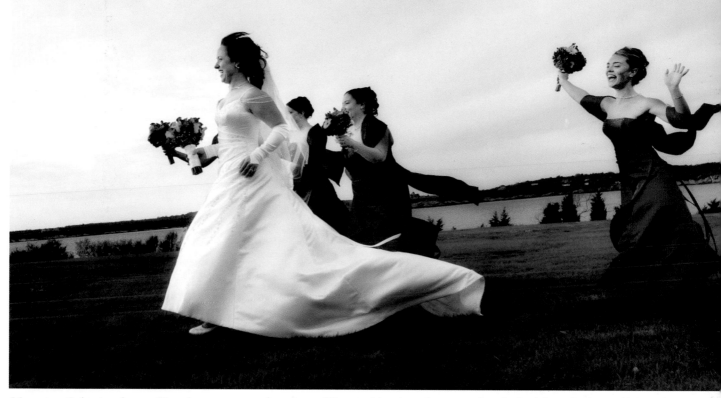

Many pros feel prime lenses offer advantages over zoom lenses. They consider them sharper and optimized for a single focal length. Here, Dan Doke used a Canon EF 24mm f/2.8 lens with his Canon EOS 1-D Mark II at an exposure of $^1\!/_{3200}$ second at f/4.5 at ISO 800 to capture this one-of-a-kind shot.

change your ISO on the fly. For example, if you are shooting a portrait of the bride and groom before the ceremony and you are working outdoors in shade, you

Facing page (top)—The range of digital zoom lenses designed for the smaller APS-C-sized image sensors is phenomenal. This image, made by Cherie Steinberg Coté, was made with a Nikon AF-S DX VR Zoom-Nikkor 18–200mm f/3.5–5.6G IF-ED lens at 18mm. A single lens such as this features an 11x zoom ratio, providing an amazing array of useable focal lengths. This image was made with a Nikon D300 by available light at ISO 250. The exposure was $^1\!/_{200}$ second at f/6.3.

Facing page (bottom)—Los Angeles' cavernous Union Station provided the perfect test for the low-noise, high-ISO Nikon D700 DSLR. This image, made at ISO 1600 in RAW mode, is virtually noise-free. Inspect the highlight regions on the floor and the shadows on the bride's arm. Notice, too, the detail throughout the highlights, midtones, and shadows of the image —a function of perfect exposure and the chip's ability to render a long dynamic-range image with relative ease. Photograph by Cherie Steinberg Coté.

might select an ISO setting of 400. Then you might move to the church, where the light level would typically drop off by two or more f-stops. In this case, you would simply adjust the ISO to a higher setting, like 1600 (or faster), to compensate for the lower light levels. Unlike film, where you would have to change rolls or cameras to accomplish this, the selected ISO setting on a digital camera only affects the individual frame being recorded.

The latest generation of DSLRs, the Canon EOS 1-D Mark IV and the Nikon D3S boast incredible ISOs up to 102,400. I have inspected color images made at ISO 102,400 with these cameras and couldn't believe the minimal noise in the images; at that setting, the grain resembles Kodak Tri-X film.

Lenses

Zoom Lenses. Another reason that 35mm digital is the format of preference for wedding photojournalists is the

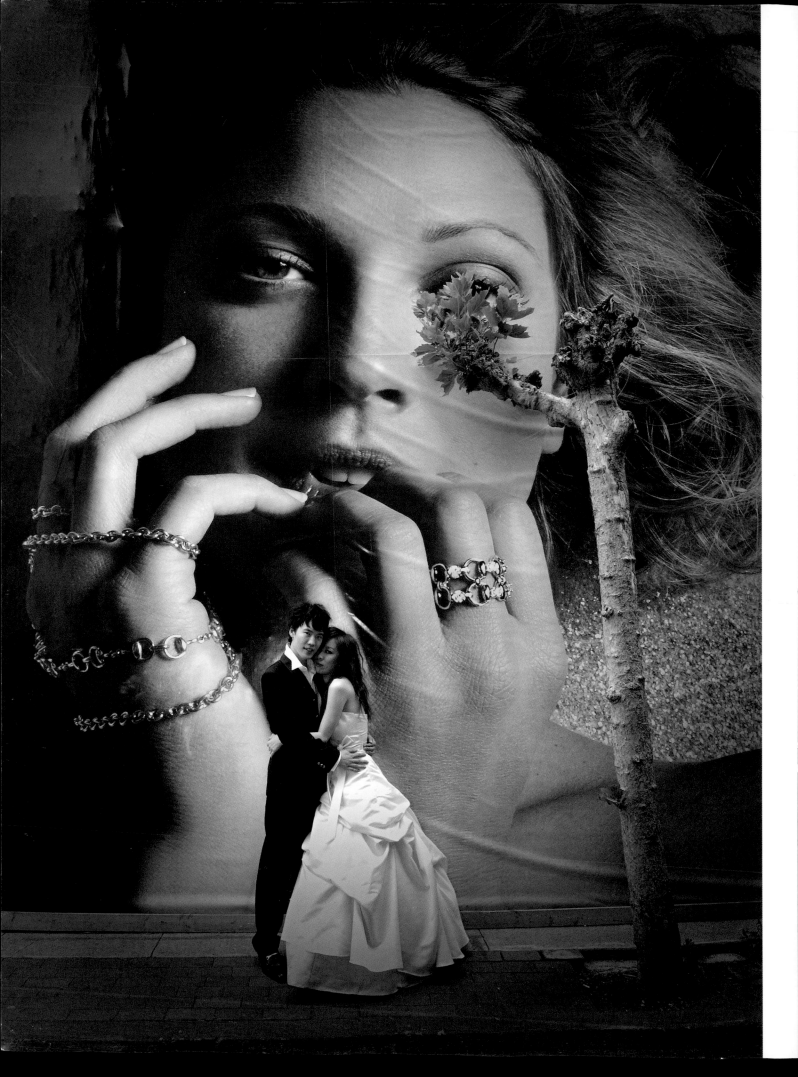

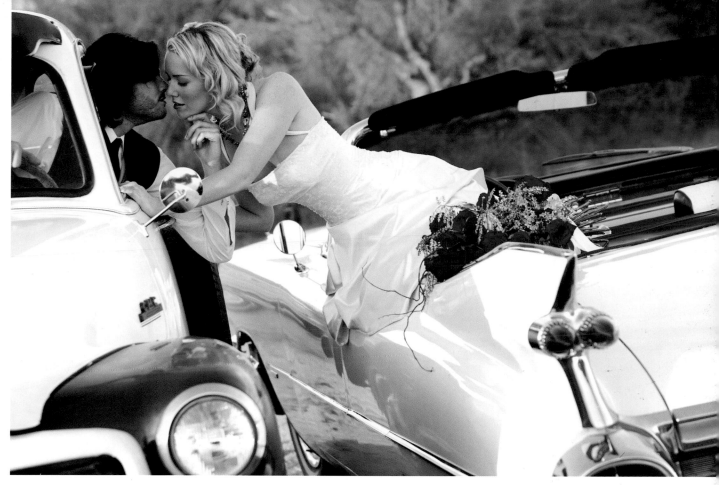

No, it's not a strictly photojournalistic shot (yes, it was set up), but the work of Bruce Dorn does have a pure cinematic feel to it—as if you just happened upon this unlikely scene. The image was shot with a Canon EF 70–200mm f/2.8L IS USM lens (at 115mm) and a Canon EOS 1D Mark II. As a long-time filmmaker, Bruce is more than a little familiar with working with fast, high-quality zoom lenses, which are regarded highly in the industry.

range of ultrafast and versatile zoom lenses available. The lens of choice seems to be the 80–200mm f/2.8 (Nikon) and 70–200mm f/2.8 (Canon and Nikon). These are very fast, functional lenses that offer a wide variety of useful focal lengths for both the ceremony and reception. They are internal-focusing, meaning that autofocus is lightning fast and the lens does not change length as it is zoomed or focused. At the shortest range, 70mm, this lens is perfect for full-length and three-quarter-length portraits. At the long end, 200mm, it is

Facing page—While not strictly a photojournalistic moment, it certainly is a great use of wide-angle lenses, in this case the Nikon AF Nikkor 24mm f/2.8D coupled to a Nikon D700. The 24mm provides a healthy dose of depth of field, thus tying the giant background poster to the couple in the foreground. A moderate aperture of f/6.3 was used to ensure both areas of the image were sharp. Photograph by Cherie Steinberg Coté.

ideal for tightly cropped candid coverage or head-and-shoulders portraits. These zoom lenses also feature fixed maximum apertures that do not change as the focal length is varied. This is a prerequisite for any lens to be used in fast-changing conditions.

Prime Lenses. Fast fixed-focal-length (or prime) lenses (f/2.8, f/2, f/1.8, f/1.4, f/1.2, etc.) will get plenty of use on a wedding day, as they afford more "available light" opportunities than slower speed lenses. Any time the wedding photojournalist can avoid using flash, which naturally calls attention to itself, he or she will do so. So, the faster (wider) the maximum aperture of the lens, the more desirable the lens is to the wedding photojournalist.

Wide-Angles. Other popular lenses include the range of wide angles, both fixed-focal-length lenses and wide-angle zooms. Focal lengths from 10mm to 35mm

are ideal for capturing the atmosphere, as well as for photographing larger groups. These lenses are also fast enough for use by available light at moderate ISOs.

Telephotos. At the other end of the focal-length spectrum, many wedding photojournalists use ultrafast telephotos, like the 300mm f/2.8 or f/3.5 lenses. These lenses, while heavy, are ideal for working unobserved and can isolate some wonderful moments. Even more than the 70– or 80–200mm lens, the 300mm throws the backgrounds beautifully out of focus and, when used wide open, this lens provides a sumptuously thin band of focus, which is ideal for isolating details.

MIKE COLÓN'S APPROACH

Mike Colón uses prime lenses (not zooms) in his wedding coverage and shoots at wide-open apertures most of the time to minimize background distractions. He says, "The telephoto lens is my first choice because it allows me to be far enough away to avoid drawing attention to myself but close enough to clearly capture the moment. Wide-angle lenses, however, are great for shooting from the hip. I can grab unexpected moments all around me without even looking through the lens." Mike's favorite lens these days is the AF-S VR NIKKOR 200mm f/2G IF-ED prime lens from Nikon. It is blazingly fast and remarkably sharp and offers vibration reduction (VR) technology, which offers stability (lack of camera shake) equivalent to using a three-stops-faster shutter speed. Mike uses it when he 1) wants to be invisible to his subject and 2) wants to blur the background out by shooting wide open at f/2.

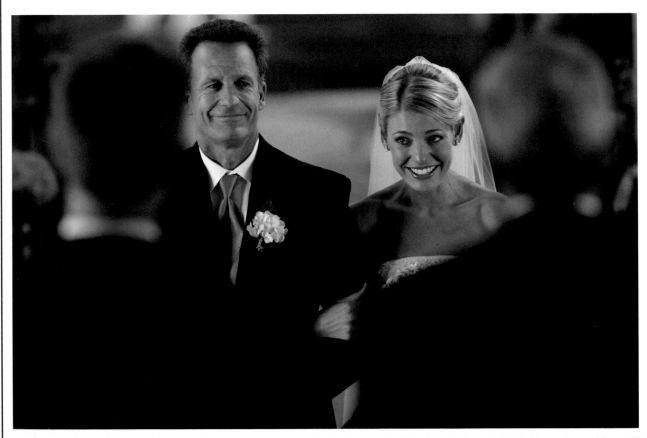

Armed with his Nikon D2X and Nikon 200mm f/2.0 AF-S VR, a remarkable piece of glass, Mike Colón positioned himself on a choir bench facing the oncoming bride and her dad. "I was standing so I could get the right angle to shoot directly between the heads of the groom and the pastor—they made a perfect frame," he says. Mike was thrilled at the result and the outpouring of emotion as the father worked to keep from losing his emotions and the bride is thrilled to see her husband and is already tearing up. The lens Mike was using incorporates VR technology, which allow the photographer to shoot at a longer than normal shutter speed without camera shake. The exposure was 1/60 second at f/2 at ISO 500.

A comparison between Nikon's DX- and FX-format sensors. The DX is an APS-C sized sensor, measuring 15.8x23.6mm. DX sensors are 1.5X smaller than the FX-format sensors and 35mm film, which both measure 24x36mm.

Another favorite lens is the 85mm (f/1.2L and f/1.8 for Canon; f/1.4 and f/1.8 for Nikon), a short telephoto with exceptional sharpness. This lens gets used frequently at receptions because of its speed and ability to throw backgrounds out of focus, depending on the subject-to-camera distance.

Focal Length and Chip Size. There are a number of full-fledged professional 35mm digital systems available with a full complement of lenses, flash units, and system accessories. Most of these cameras can be used with system lenses that a photographer may already own. The focal length, however, may not be the same, depending on the size of the camera's image sensor. If the image sensor is smaller than the 24x36mm film frame for which the lens was designed, the lens will function as a longer (more telephoto) lens. For example, the APS-C chip, which is smaller than a full 35mm film frame, changes the effective focal length of your existing lenses by a factor of 1.3x–1.5x. This is not usually a problem where telephotos and telephoto zooms are concerned, but when your wide-angles become significantly less wide on the digital camera body, it can be somewhat annoying.

There are a number of full-frame image sensors available in DSLRs (Nikon, Sony, and Canon). While the cost of production and manufacturing of full-size chips is higher than with the APS-C chips, they provide full frame coverage, so that your 17mm wide-angle continues to function as a 17mm wide-angle.

Some camera manufacturers who have committed to chip sizes that are smaller than full-frame 35mm have also started to introduce lens lines specifically geared to digital imaging. The circle of coverage (the area of focused light falling on the image sensor) is smaller to compensate for the smaller chip size. Thus, the lenses can be made more economically and smaller, while still offering the same wide range of focal lengths and lens speeds as the company's traditional lenses.

Flash

The wedding photojournalist must also be prepared for those times when the available light levels are too low to work without artificial light sources. Most of the top camera manufacturers also make a line of sophisticated TTL flash units, which can be used on-camera, in bounce mode, or off-camera as part of a multiple-flash TTL array. While very sophisticated, such flash units are quite simple to use and produce astonishingly accurate results.

On-Camera Flash. On-camera flash is used sparingly at weddings because of its flat, harsh light. As an alternative, many photographers use on-camera flash brackets, which position the flash over and away from the lens, thus minimizing flash red-eye and dropping

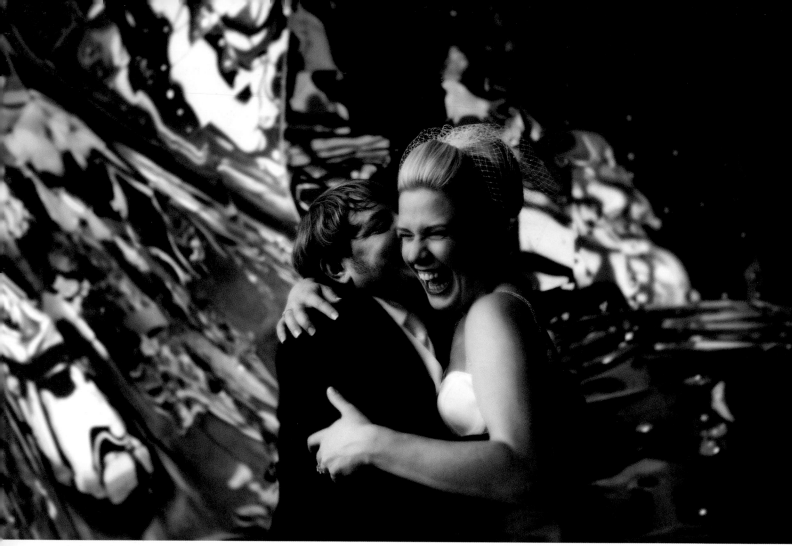

Flash can be bounced off the ceiling, a side wall, or a reflector. Once diffused in this way, it becomes a soft light source. Here, photographer Jim Garner bounced a remotely fired flash into a reflector for soft directional light. (Canon EOS 5D; EF 24-70mm f/2.8L USM lens; ¹/₁₀₀ second at f/2.8; ISO 800)

the harsh shadows behind the subjects—a slightly more flattering light. On-camera flash is often used outdoors, especially with TTL-balanced flash exposure systems. With such systems, you can adjust the flash output for various fill-in ratios, thus producing consistent exposures. In these situations, the on-camera flash is most frequently used to fill in the shadows caused by the daylight, or to match the ambient light output, providing direction to the light.

Off-Camera Flash. The same units used on-camera can be used off-camera and triggered with a radio-remote or by the camera's internal WiFi circuitry. Nikon, for example, uses its on-board Flash Commander mode to make the SB line of Nikon Speedlights off-camera flash units. A WiFi signal is emitted from the camera

when the in-camera flash is used to trigger the off-camera flash. Off-camera SB Speedlights can be clustered in groups and set to fire at predetermined ratios to one another—a very sophisticated system that is relatively easy to master. Many photographers attach an SB unit to a monopod, creating a versatile lighting device that can be used for TTL bounce flash or direct flash, but from an overhead or side angle, producing a more dynamic light source. Such gear is being used quite frequently by today's wedding photographers to produce great quality light on location.

Bounce-Flash Devices. Many wedding photographers bounce their on-camera flash off the ceiling. This produces soft lighting, but it comes from high above the subject, which is rarely flattering. With high ceil-

ings, the problem is especially pronounced; the light comes from almost directly overhead.

A number of devices on the market have been created to address this problem. One is the Lumiquest ProMax system, which allows 80 percent of the flash's illumination to bounce off the ceiling or other reflective surface, while 20 percent is redirected forward as fill light. The system includes interchangeable white, gold, and silver inserts as well as a removable frosted diffusion screen. This same company also offers devices like the Pocket Bouncer, which enlarges and redirects light at a 90-degree angle from the flash to soften the quality of light and distribute it over a wider area. While no exposure compensation is necessary with TTL flash exposure systems, operating distances are somewhat reduced. With both systems, light loss is approximately 1⅓ stops. With the ProMax system, using the gold or silver inserts will reduce the light loss to approximately ⅔ stop.

Barebulb Flash. One of the less frequently used handheld flash units at weddings is the barebulb flash, such as Dyna-Lite's NE-1 flash, which provides 360-degree light coverage as well as a 1000 watt-second barebulb pencil-style flash tube. This great location tool is compact and lightweight and can literally fit in your pocket. These units are powerful and, instead of a reflector, use an upright mounted flash tube sealed in a plastic housing for protection. Since there is no housing or reflector, barebulb flash generates light in all directions. It acts more like a large point-source light than a small portable flash. Light falloff is also less than with other handheld flash units, and they are ideal for flash-fill situations.

These units are predominantly manual flash units, meaning that you must adjust their intensity by changing the flash-to-subject distance or by adjusting the flash output. Many photographers mount a series of barebulb flash units on light stands, using ball-head adapters to infinitely position the light in the reception for doing candids on the dance floor.

Studio Flash Systems. You may find it useful to have a number of studio flash heads with power packs and umbrellas. You can set these up for formals or tape the light stands to the floor and use them to light the reception. Either way, you will need enough power (at least 50–100 watt-seconds per head) to light large areas or produce smaller apertures at close distances.

High ceilings can negate the use of bounce flash. For this image, Jerry Ghionis opted to increase his ISO setting and shoot using only the available light. (Canon EOS 5D; EF 135mm f/2L USM lens; ¹⁄₁₀₀ second at f/3.2; ISO 800)

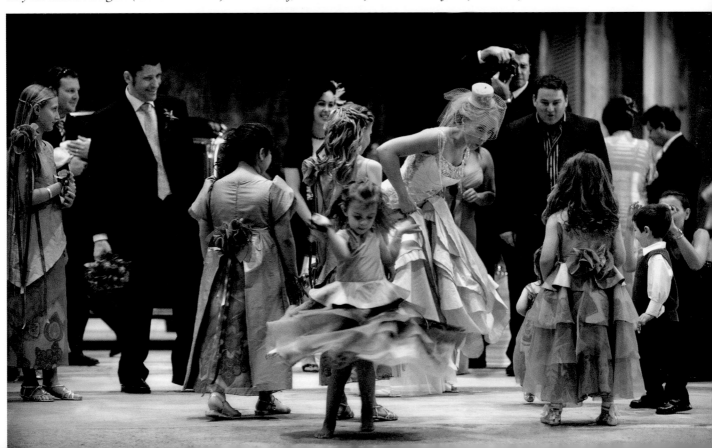

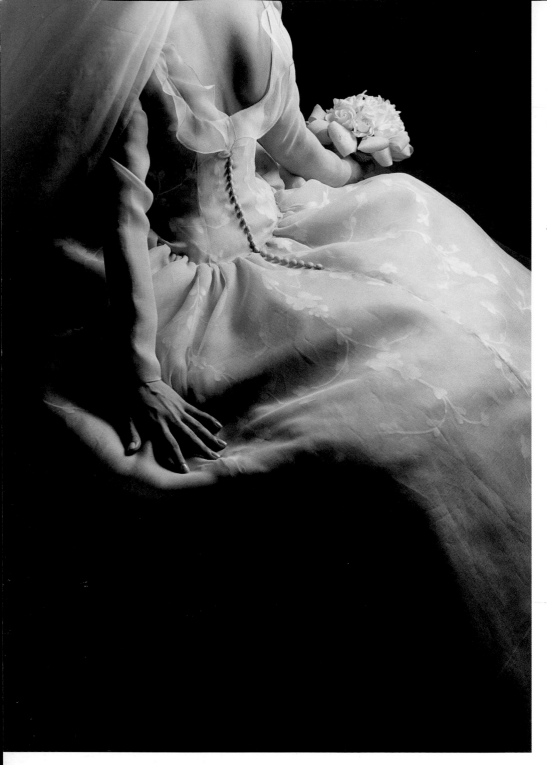

Mauricio Donelli takes studio strobes with stands (and assistants to position the lights for him) to every wedding. Here, he photographed the beautiful back of the gown with all its texture and elegance using a single softbox-mounted strobe that produced an aperture of f/16. No fill was used to create the dramatic falloff to black on the shadow side of the image.

The most popular of these type of lights is the monolight, which has a self-contained power pack and usually has an on-board photo cell, which will trigger the unit to fire when it senses a flash burst. All you need is an electrical outlet and the flash can be positioned anywhere. Be sure to take along plenty of gaffer's tape and extension cords. Tape everything in position securely to prevent accidents.

One such monolight, preferred by many wedding photographers, is the Dyna-Lite Uni400JR. This is a 3.5-pound compact 400 watt-second unit that can be plugged into an AC outlet or used with the Dyna-Lite Jackrabbit high-voltage battery pack. The strobe features variable power output and recycle times, full tracking quartz modeling light, and a built-in slave.

Studio flash units can be used with umbrellas for lighting large areas of a room. Be sure, however, that you "focus" the umbrella—adjusting the cone of light that bounces into and out of the umbrella surface by moving the umbrella closer and farther away from the light source until the umbrella is illuminated fully out to its perimeter. The ideal position is when the light fills the umbrella but does not exceed its perimeter. Focusing the umbrella also helps eliminate hot spots and maximize light output.

Lighting Accessories

Flashmeter. A handheld flashmeter is essential for work indoors and out, but particularly crucial when mixing flash and daylight. It is also useful for determining lighting ratios. A flashmeter will prove invaluable when using multiple strobes and when trying to determine the overall evenness of lighting in a large room or on a large group. Flashmeters are also ambient-light meters

of the incident type, meaning that they measure the light falling on them and not light reflected from a source or object.

Remote Triggering Devices. If using multiple flash units, some type of remote triggering device will be needed to sync all the flashes at the instant of exposure. There are a variety of these devices available, but by far the most reliable is the radio-remote-triggering device. These devices use a radio signal that is transmitted when you press the shutter release and received by the individual receivers mounted on each flash. Radio remotes transmit signals in either digital or analog form.

Digital systems, like the Pocket Wizard Plus, are state of the art. Complex, 16-bit digitally coded radio signals deliver a unique code, ensuring the receiver cannot be triggered or "locked up" by other radio noise. The built-in microprocessor guarantees consistent sync speeds even under the worst conditions. As part of their standard equipment, some photographers include a

Bruce Dorn has no fear of mixing light sources. He might use hot lights and strobe in the same image, or he might use daylight and two different kinds of strobe in the image. When such variables exist, a digital flashmeter allows the ratios between light sources to be determined. It also makes it possible to determine the exact output of the light sources for a final exposure formula.

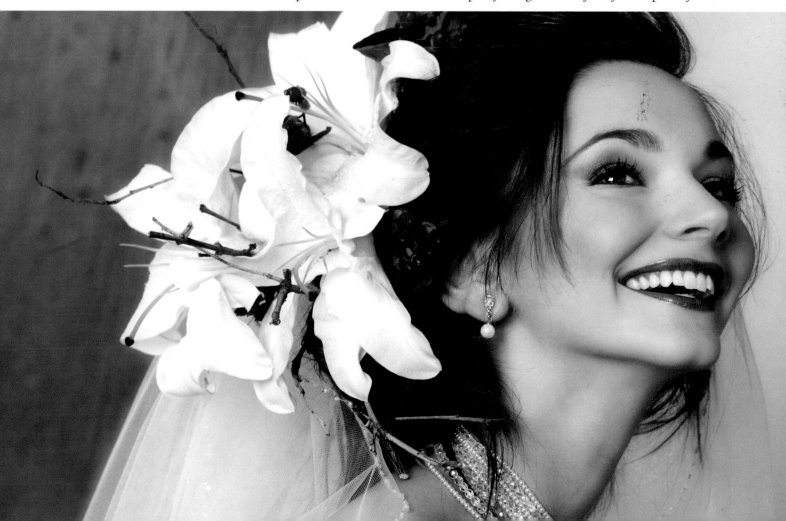

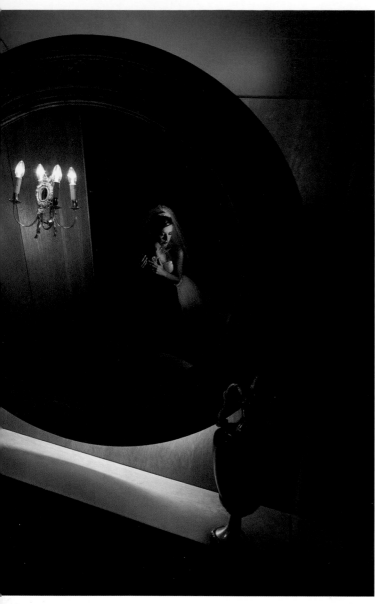

There are three light sources in this image by Jerry Ghionis: the light behind the mirror, the wall sconce, and the handheld video light illuminating the couple from just out of view of the mirror. All of these are tungsten light sources with slightly different color temperatures. Obviously, the photographer selected the white balance closest to normal for the bride and groom.

separate transmitter for as many cameras as are being used (for instance, an assistant's camera) as well as a separate transmitter for the handheld flash-meter, allowing the photographer to take remote flash readings from anywhere in the room.

Light Stands. Light stands are an important part of location lighting. You should use heavy-duty stands and always tape them firmly in place. Try to hide them in corners of the room. The light stands should be capable of extension to a height of twelve to fifteen feet. Lights should be aimed down and feathered so that their beams criss-cross, making the lighting as even as possible. The lights can be set to backlight the people at the reception, and an on-camera flash used to trigger the system.

Reflectors. When photographing by window light or outdoors, it is a good idea to have a selection of white, silver, gold, and black reflectors. Most photographers opt for the circular disks, which unfold to produce a large-size reflector. They are particularly valuable when making portraits by available light.

Backup and Emergency Equipment

Wedding photographers live by the expression "If it can go wrong, it will go wrong." That is why most seasoned pros carry backups and double backups—extra camera bodies and flash heads, extra transmitters, tons of batteries and cords, double the anticipated number of storage cards, and so on. In addition, if using AC-powered flash, extra extension cords, several rolls of duct tape (for taping cords to the floor), power strips, flash tubes, and modeling lights need to be backed up. An emergency tool kit is also a good idea.

3. PREPARATION AND THE WEDDING DAY

The wedding photojournalist's best weapon, so to speak, is preparedness. Knowing each phase of each couple's wedding day, when and where every event will happen, and the details of each mini-event during the day, will help build mutual confidence and rapport. It will also increase the percentage of successful shots that will be made.

Meet with the Bride and Groom

Arrange a meeting with the couple at least one month before the wedding. Use this time to take notes, formulate detailed plans, and get to know the couple in a relaxed setting. This initial meeting also gives the bride and groom a chance to ask any questions they may have. They can tell you about any special pictures they want you to make, as well as let you know of any important guests that will be coming from out of town. Make notes of all the important names—the parents, the bridesmaids, the groomsmen, the best man, and the maid of honor—so that you can address each person by name. Note the color scheme, and get contact information for the florist, the caterer or banquet manager, the limo driver, the band, and so on.

Scout the Wedding Locations

Scheduling a pre-wedding meeting allows you a month to check out the locations and introduce yourself to the people at the various venues. As you do so, you may

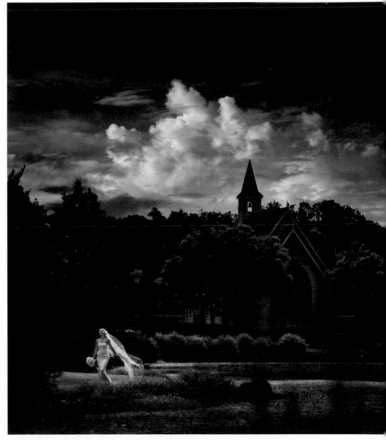

The more time you spend with the bride and groom prior to the wedding, the more likely it is that you'll be able to plan for an amazing photograph like this. Photograph by Marcus Bell.

find out interesting details that will affect your time-table or how you must make certain shots.

When you meet with the minister, priest, or rabbi, make sure you ask about any special customs or tradi-

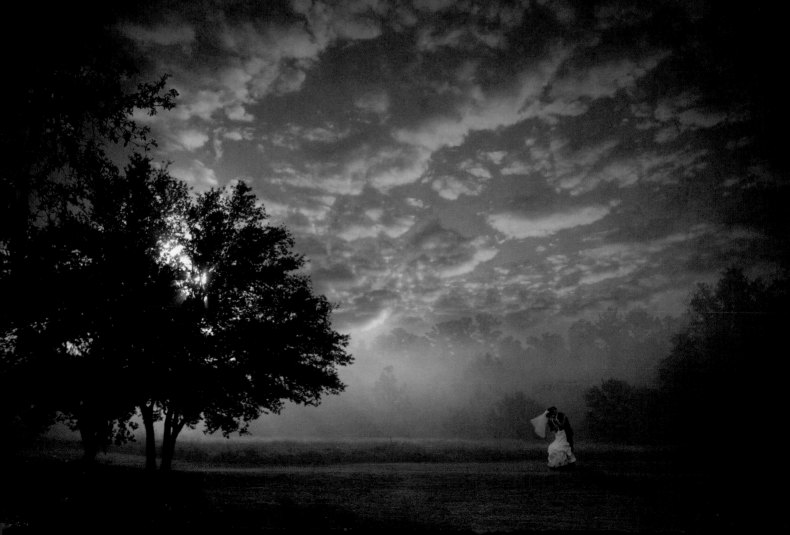

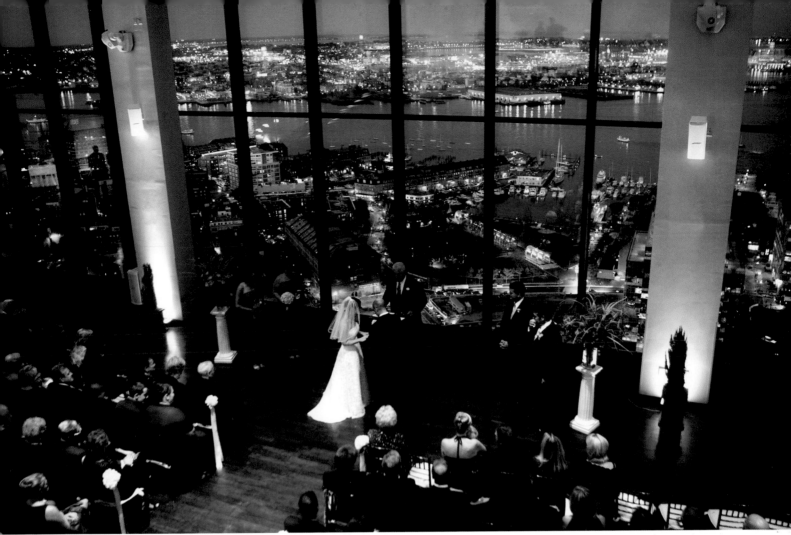

Here's a unique location that shows the ceremony and, in the background, the beautiful city of Boston. Dan Doke got lucky; the ceremony took place when the outside and inside illumination levels were pretty much the same. The image was shot at ISO 1000 and exposed for ¼ second at f/2.8 with an EF 16–35mm f/2.8L II USM lens. The people were lit by tungsten light at 2800K, so Dan changed the white balance of his EOS 1-Ds Mark II to the same color temperature, which, in turn, made the outside sky and water render as very blue in the final image.

tions that will be part of the ceremony. At many religious ceremonies you can move about and even use flash, but it should really be avoided in favor of a more

Facing page (top)—The level of trust that the photographer builds with the bride and groom by repeated contact before the wedding is easily transferred to family members and members of the bridal party. As you can see, photographer Jim Garner has these boys' complete trust and cooperation.

Facing page (bottom)—Visiting each venue, sometimes more than once and at different times of day, may uncover a perfect location. Jim Garner made the image with a Canon EOS 5D and EF 24–70mm f/2.8L USM lens. It was exposed in RAW mode for ¹/8000 second at f/3.2 at ISO 400. In RAW file processing, the saturation was increased and a vignette applied.

discreet, available-light approach. Besides, available light will provide a more intimate feeling to the images. At some churches you may only be able to take photographs from the back, in others you may be offered the chance to go into a gallery or the balcony. In some cases, you may not be able to make pictures at all during the ceremony.

If you have not been there before, try to visit each venue at the same times of day that the wedding and reception will be held so that you can check the lighting, make notes of special locations, and catalog any potential problems you might foresee. Make detailed notes and sketches of the rooms and include information like the color and height of the ceiling, windows

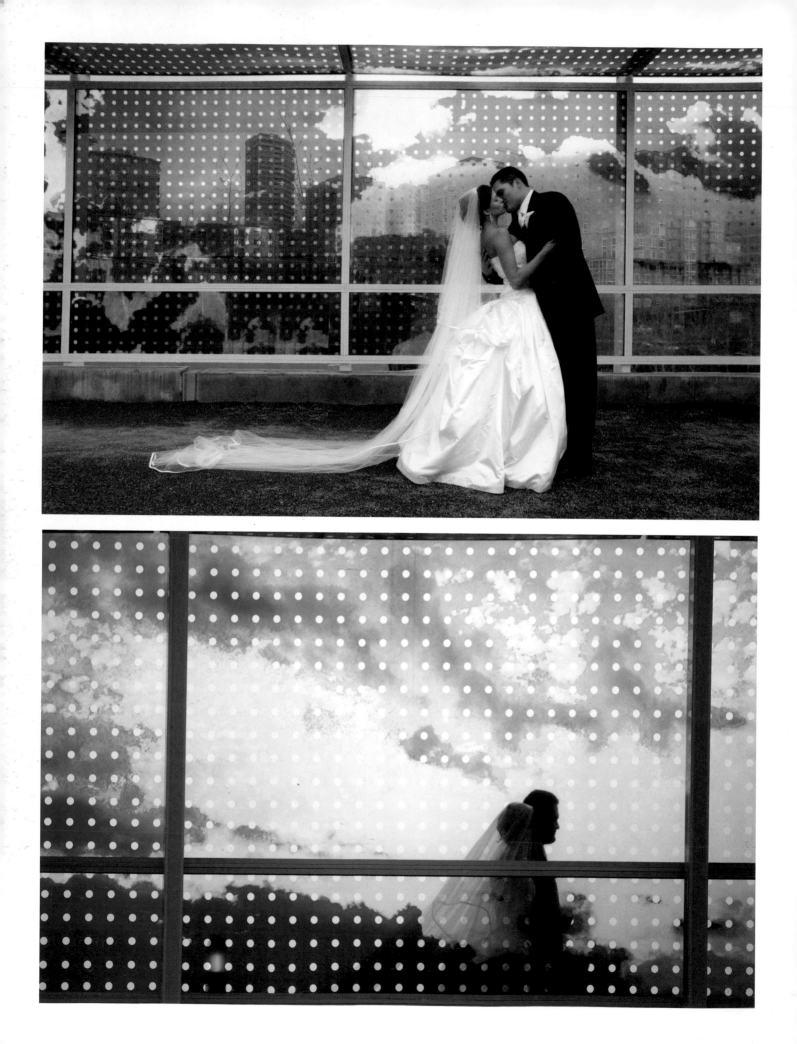

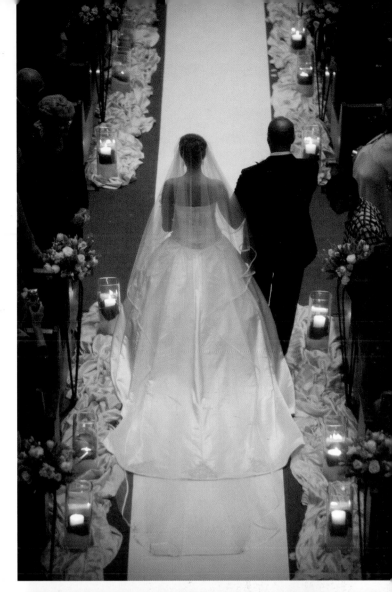

Facing page—Here's another great location that Jim Garner found and used throughout the couple's album.

Top right—Choir lofts make great vantage points, especially for entrance or exit photos. Because they take the photographer out of the main action, consider having an assistant shoot these images from up above. Photograph by Jim Garner.

Bottom right—Joel and Rita Wiebner made this lovely engagement portrait outdoors in open shade. The bride and groom were both looking up into the sky, which filled in the unflattering shadows that would have been created by the overhead lighting if they had their heads down. *(Canon EOS 5D; EF 35mm f/1.4L USM; 1/250 second at f/1.4)*

and their locations, walls and wall coverings, and where tables and chairs will be positioned.

Look for locations for special pictures. For instance, if your couple has requested a big group portrait of all the family members and wedding party, then you might look for a high vantage point, such as a balcony over a courtyard. If you can't find such a location, you'll know you need to bring along a stepladder. The more of your shots and locations you can preplan, the smoother things will go on the wedding day.

Plan the Timing

You should determine how long it will take to drive from the bride's home to the ceremony. Inform the bride that you will arrive at her home (or hotel room—wherever she is getting ready for the ceremony) about an hour before she leaves. You should arrive at the ceremony venue at about the same time as or a little before the groom, who should arrive about a half-hour to forty-five minutes before the ceremony. At that time you can make portraits of the groom, groomsmen, and best man. Bridesmaids will arrive at about the same time. You should also determine approximately how long the ceremony will last.

Engagement Portraits

The process of creating an engagement portrait can play a significant role in forging a good relationship with the bride and groom. Since this one image is so important to establishing a good rapport between photographer and couple, many photographers include the engage-

ment portrait as part of their basic coverage. In other words, they don't charge extra for it.

Once Alisha and Brook Todd book a wedding, they call the couple once a month to check in and see how they are doing. When the contract goes out to the cou-

GET INFORMATION ON THE VENDORS

Getting the names and addresses of the vendors can also be used to generate referrals. After the wedding, send each vendor a print (or a digitally printed card) of their specialty—a close-up of the floral display, an overview of the reception before the guests arrive, a place setting, a shot of the band, etc.—with a note of thanks. It is a special touch that can help cement you and your business in the minds of important wedding specialists.

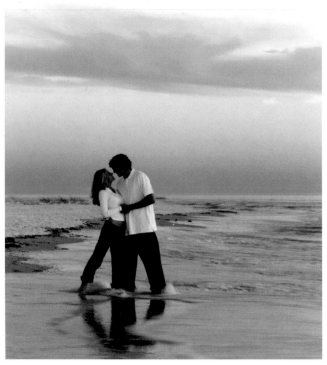

This is a fairly traditional engagement portrait done by Florida's Al Gordon. The idea is to convey the emotion between the couple using traditional posing methods and the coordination of outfits, if possible. Al likes to work at dusk, just after the sun has gone past the horizon.

Vendors take great pride in their work and appreciate a high-quality print of their efforts. It's good public relations for you as wedding photographer, as it often leads to referrals. Photograph by Dan Doke.

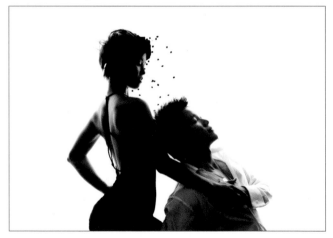

This sensual image is a great example of the type of shot some couples love for an engagement portrait—even though, in this case, the couple was already married. Jerry Ghionis photographed fellow photographers Dave and Quin Cheung (from DQ Studios) against a white hotel-room curtain. There was a five-stop difference between the highlights and the skin tones, which Jerry metered for. The curtains, quite naturally, took care of themselves. The final touches—Quin placing her hand on her hip and Dave closing his eyes—made all the difference.

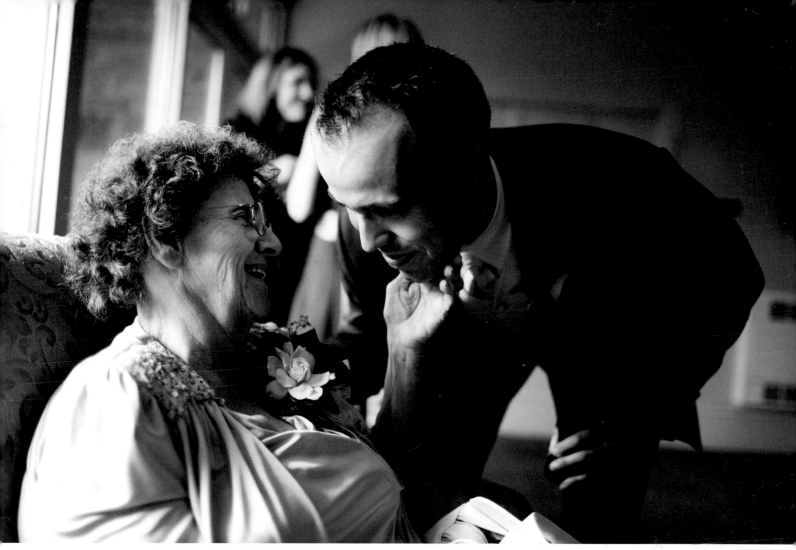

There are many touching stories occurring around the house or hotel room as the bride and groom are getting ready for the wedding. Photograph by Joel and Rita Wiebner. (Canon EOS 5D; EF 35mm f/1.4L USM; 1/500 second at f/1.4; ISO 800)

ple, they send a bottle of Dom Perignon with a handwritten note. They soon schedule the engagement portrait, which is a stylized romantic portrait of the couple made prior to the wedding day at the location of their choice. Once the wedding day arrives, they have spent quality time with the couple and have been in touch numerous times by phone and in person. "We really try to establish a relationship first," says Brook. "It's how we do business."

Many couples choose to use their engagement portrait for newspaper announcements, and often the photographer will produce a set of note cards using the engagement portrait. The couple can use these as thank-you notes after they return from the honeymoon (they can be delivered to the bride's mother before the wedding or while the couple is away).

Pre-Ceremony Coverage

The Bride. Generally, the actual wedding photography begins at the bride's home (or hotel room), as she is preparing for her big day. Some of the most endearing and genuine photographs of the day can be made at this time. By being a good observer and staying out of the way, you are sure to get some great shots, as everyone wears their emotions on their sleeves. Don't forget to include the maid of honor and/or the bride's mother, both of whom are integral to the bride's preparation.

It is important to look beyond photographic clichés (the bride gazing into the mirror as she gets ready, for example) and instead be alert for the unexpected moment. For the alert photographer, there is usually an abundance of good photo opportunities. Since the ceilings of most homes are quite low, and upstairs bed-

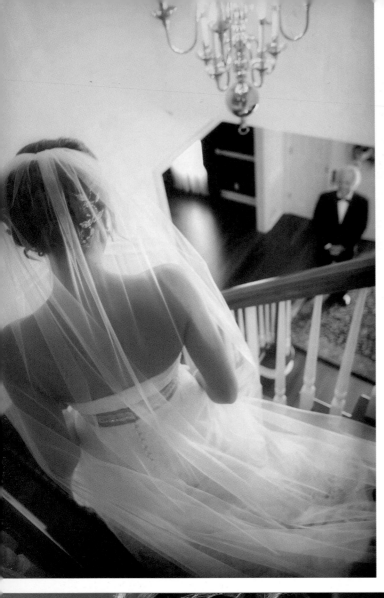
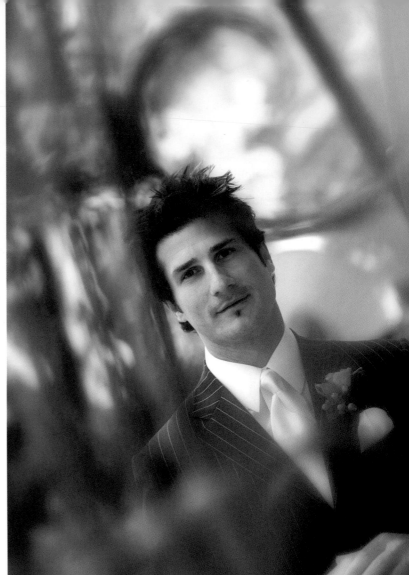
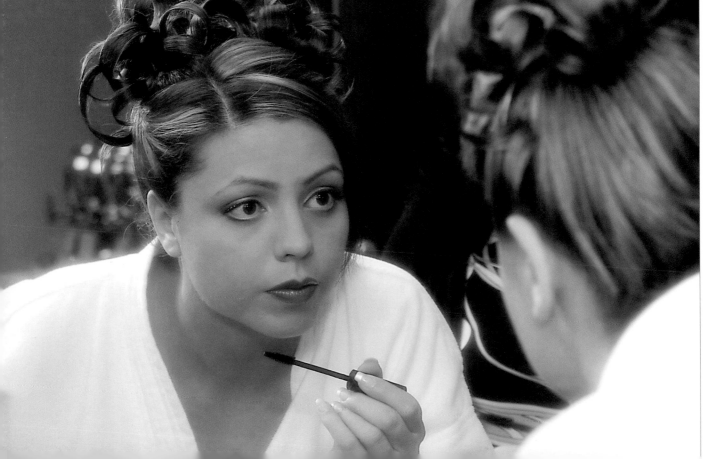

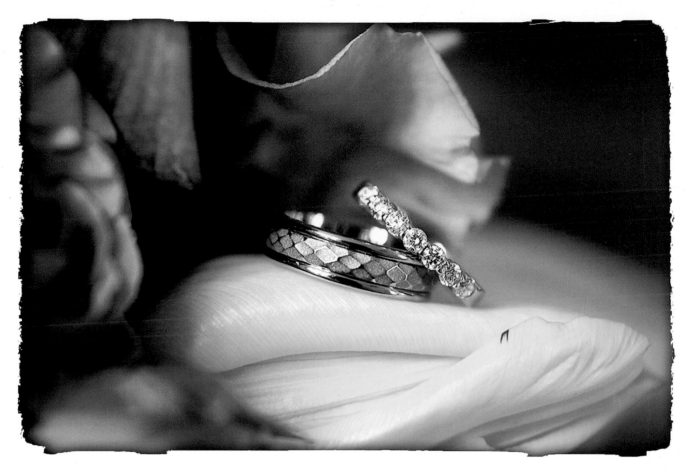

Above—*If you arrive early at the bride's home, use the time to create some detailed still lifes. This beautiful image of the bride's rings was taken by Marc Weisberg.*

Facing page, top left—*When Jeff and Julia Woods arrived at this bride's house, the parents gave them a guided tour of the home, relating many fond memories as they went. Julia decided it would be a great shot if she could include the proud father in the image as the bride descended the stairs. She used a Canon EOS 1-Ds Mark III and EF 16–35mm f/2.8L USM lens to incorporate the staircase, the chandelier, the bride, and her father in the photo.*

Facing page, top right—*It's essential to get some great portraits of the groom before the ceremony. This image was made by Jeff and Julia Woods with a Canon EOS 1-D Mark II and an EF 70–200mm f/2.8L USM lens set to 130mm. It was shot at f/3.2 to knock the foreground and background out of focus.*

Facing page, bottom—*This is a classic portrait of the bride getting ready. It was made by Denis and Regina Zaslavets. In these situations, you are reliant on window light and bounce flash. The technique here is excellent and so is the intensity of the bride's expression.*

rooms often have multiple windows, you can expect to expose these images either by bounce flash or available light.

During this process, tensions are high and you must tread lightly. Choose your moments and don't be afraid to step back and get out of the way once you have been admitted, which will usually be when the bride is almost ready. It is important not to wear out your welcome in the bride's home.

The Groom. Be prepared to depart from the bride's home in time to arrive at the ceremony at the same time as the groom. Photographing him before the ceremony will produce some wonderful shots—and it's a great time to create both formal and casual portraits of the groom and his groomsmen. Although he won't admit it, the groom's emotions will also be running high and this usually leads to some good-natured bantering between the groom and his friends.

If you have an assistant or are shooting the wedding as a team, you may decide to have your counterpart be

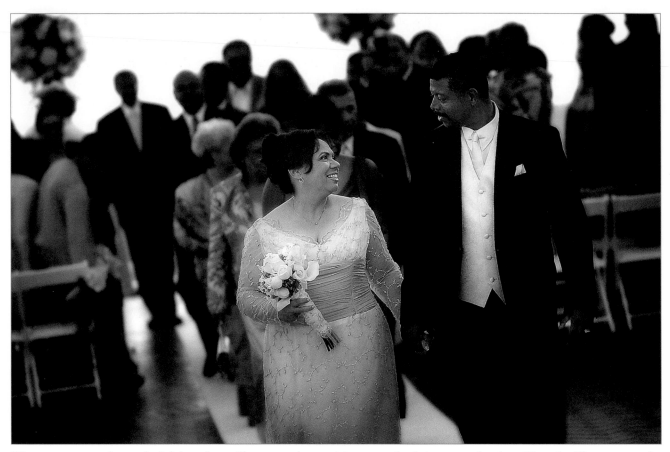

There are some truly wonderful shots that will occur as the participants make their way to the altar. Here, Joe Photo captured a unique and tender moment between these two. (Nikon D1X and AF Zoom Nikkor 80–200mm f/2.8D ED at 135mm)

prepared to handle the groom at the ceremony, while you finish up with the bride at her home.

Watch for Details. Before the ceremony is also a good time to capture many of the details of the wedding day. The flowers being delivered to the bride's home, for instance, can make an interesting image, as can many other accessories for the wedding-day attire. The groom's boutonniere is another stylish image that will enhance the album.

Photographing the Ceremony

Before the guests arrive, create an overall view of the church. No two weddings ever call for the same decorations, so it's important to document the couple's choices. If there is an overhead vantage point, like a choir loft, this is a good place to set up a tripod and make a long exposure with good depth of field so that everything is sharp. This kind of record shot will be im-

portant to the historic aspects of the wedding album.

The Bride's Arrival. When the bride arrives at the ceremony and is helped out of the car, sometimes by her dad, there are ample opportunities for good pictures. It isn't necessary to choreograph the event as there is plenty of emotion between the bride and her father. Just observe, be ready, and you will be rewarded with some priceless images.

The Procession. When the bridesmaids, flower girls, ring bearers, mother of the bride, and the bride herself (sometimes with her dad) come up the aisle, you should be positioned at the front of the church so that the participants are walking toward you. If you are working as part of a shooting team, you should have the other photographer(s) positioned elsewhere so that you can get multiple viewpoints of this processional.

The Ceremony. While the ceremony will present many emotion-filled moments, its sanctity is more im-

portant than the photographer or even the pictures, so show your respect for the event by working unobtrusively. Once the ceremony begins, you should be as discreet and invisible as possible, shooting from an inconspicuous or even hidden vantage point and working by available light. Often, a tripod will be necessary, as the exposures, even with a fast ISO setting, may be on the long side—like ¹/₁₅ second. Do be alert for surprises, though, and pay special attention to the children, who will do the most amazing things when immersed in a formalized ritual like a wedding ceremony.

For the ceremony, try to position yourself so that you can see the faces of the bride and groom, particularly the bride's face. This will usually place you behind the ceremony or off to the side. This is when high ISOs and fast, long lenses are really needed; you will almost surely be beyond the range of an 80–200mm zoom, one of the wedding photojournalist's most-often-used lenses. Look for the tenderness between the couple and the approving expressions of the best man and maid of honor. Too many times the photographer positions him- or herself in the congregation so that the person performing the ceremony is facing the camera. Quite honestly, the minister or rabbi will not be purchasing any photographs, so it is the faces of the bride and groom that you will want to see.

The Couple's Exit. If you are behind the officiant, of course, you cannot immediately bolt to the back of the church or synagogue to capture the bride and groom walking up the aisle as man and wife. This is when it is important to have a second shooter who can be in position to capture the bride and groom and all of

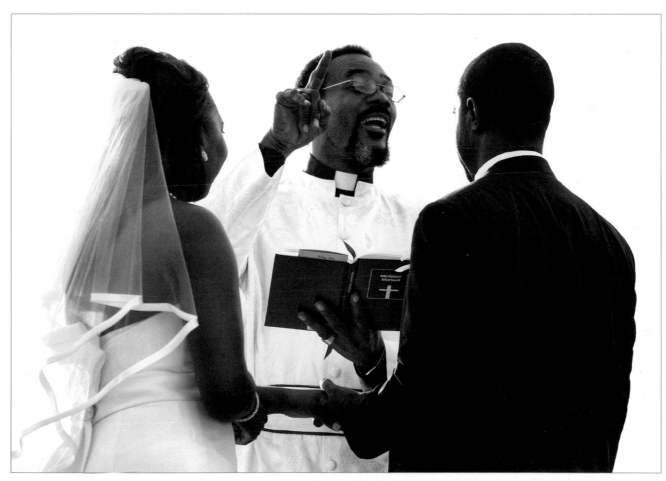

Visiting the venues before the ceremony will prepare you for where you can and cannot stand to get good shots during the ceremony. While it is best to shoot from behind the minister, here Emin Kuliyev captured the spirited minister at work. (Canon EOS 1Ds Mark III; EF 70–200mm f/2.8L USM at 155mm; ¹/₃₂₀ second at f/5.6; ISO 400)

the joy on their faces as they exit the church or synagogue for the first time as man and wife.

Be aware of changing light levels on these shots. Inside, the church will be at least three to four stops darker than the vestibule or entranceway. As the couple emerges toward daylight, the light will change drastically and quickly. Know your exposures beforehand and anticipate the change in light levels. Many a gorgeous shot has been ruined by the photographer not changing exposure settings to compensate for the increased light.

When photographing the bride and groom as they are leaving the church, include the door frame as a reference. If photographing from the side, try to position yourself on the bride's side, so she is nearest the camera.

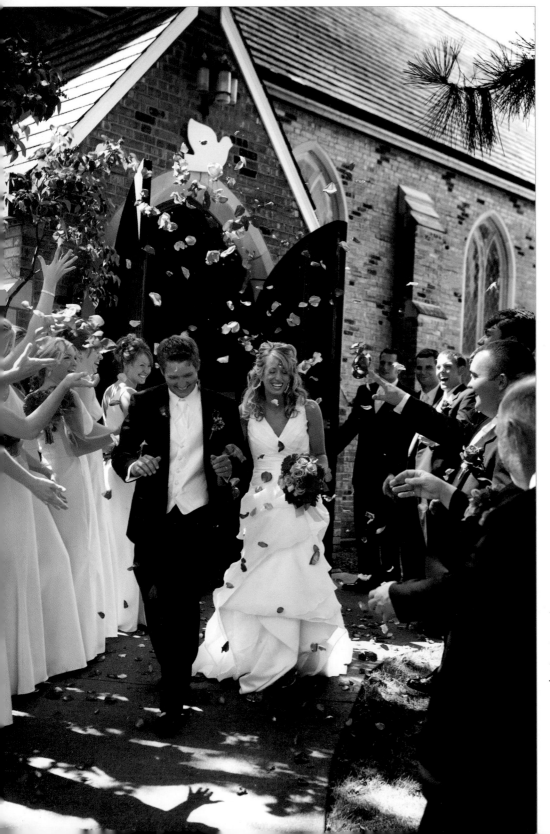

In Western weddings, the exiting couple is showered with anything from rice to jelly beans—and, in this case, rose petals. Using a Canon EOS 1-D Mark II and a $\frac{1}{2000}$ second shutter speed, photographers Jeff and Julia Woods froze the in-flight rose petals to produce a memorable image.

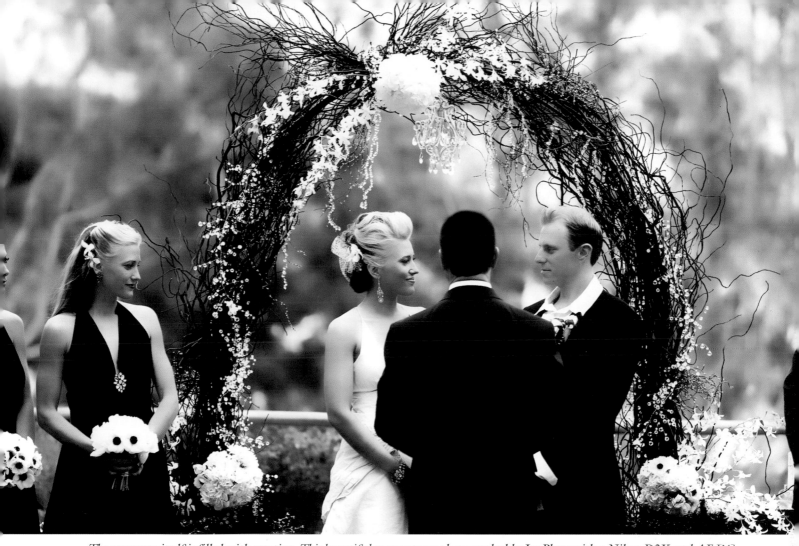

The ceremony itself is filled with emotion. This beautiful moment was photographed by Joe Photo with a Nikon D2X and AF DC-Nikkor 135mm f/2D lens.

Because of diminishing perspective, if the groom is in the foreground of your picture, the bride will look even smaller than she might be in reality—or she might be blocked from the camera view.

If there is to be a rice/confetti toss (or bubbles), these are best photographed with a wide-angle lens from close up, so that you can see not only the bride and groom, but also the confetti (rice or bubbles) and the faces of the people in the crowd. While the true photojournalistic purist would never choreograph a shot, many such successful shots have been made by working with the outdoor crowd so that they toss their confetti (or whatever) on your signal. Be sure to tell them to throw the stuff above the head height of the bride and groom so that it descends into your photograph. Give them a signal count—something like, "On three—one . . . two . . . three!" While it may be choreographed, it will look unstaged as the bride and groom

DON'T GET TOO CAUGHT UP IN THE EMOTION

Many photographers who love shooting weddings have told me that they sometimes get overwhelmed by the emotion of the event. This is easy to do, particularly if you relish the ritual and the tenderness of the wedding ceremony—in short, if you're a hopeless romantic. The best way to keep your emotions in check is to intellectually focus on every detail of the events around you. Immersing yourself in the flow of the wedding and its details and not in the emotion of the ceremony will help you to be more objective. Because it allows you to remain sensitive to all of the nuances, this mindset will not hinder your performance.

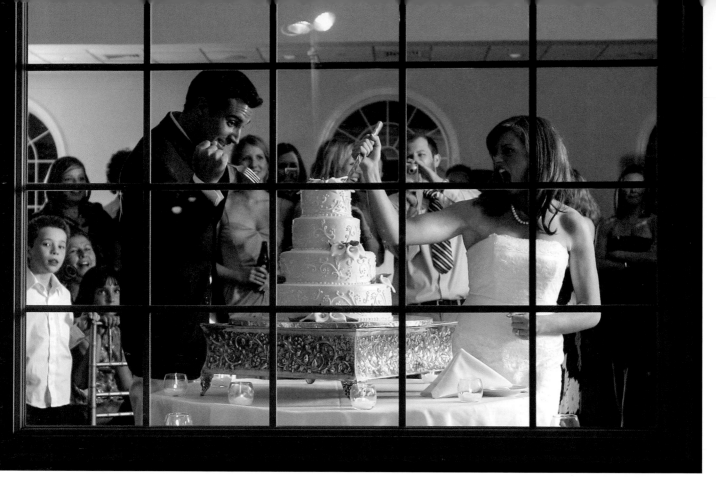

This is one of the more unusual cake-cutting shots you'll see. Emin Kuliyev photographed it with a Canon EOS 5D and EF 35mm f/1.4L USM lens at ISO 1600 (¹/₂₀₀ second at f/3.5). The interior strobe (camera right) was triggered remotely by the photographer.

will be unaware of your planning and will undoubtedly flinch when they see the rice/confetti in the air. This type of scene is best photographed with two photographers, both shooting cameras with high burst rates and using fast shutter speeds or strobe.

Photographing the Reception

For the bride and groom, the reception is such a whirlwind of activity that they usually see and remember very little of it. Therefore, they will depend on your pictures to provide them with priceless memories. You will want to photograph as many of the details and events of the reception as possible.

Your Approach. Photographing a reception calls upon all of your skills and instincts. Things happen quickly. Don't get caught with an important event coming up and only two frames left on your memory card. Use two camera bodies and always have plenty of

exposures available—even if it means changing cards when they are not completely full. People are having a great time, so be cautious about intruding upon events. Watch the flow of the reception and carefully choose your vantage point for each shot. Coordinate your efforts with the wedding coordinator or banquet manager, whoever is in charge. He or she can run interference for you as well as cue you when certain events are about to occur, often not letting the event begin until you are ready.

The wedding photojournalist must learn to get shots without alerting the people being photographed. Some photographers walk around the reception with their camera held low, but with both hands in position on the camera so that they can instantly raise the camera to eye level, frame, and shoot. Still others will use a wide-angle lens prefocused at an intermediate distance like eight feet (or set to autofocus) and set to the proper ex-

posure settings. With the camera at waist or hip height, the photographer will wander around the reception, mingling with the guests. When a shot seems to be taking place, they will aim the camera up toward the people's faces and fire, never even looking through the viewfinder. It's a great way to get unobserved expressions. Autofocus and autoexposure modes will take care of the technical side of things and all the photographer has to do is concentrate on the action and the scene.

Room Overviews and Details. Before anyone enters the reception, you should make several good overviews of the decorated room. This should be done just before the guests enter, when the candles are lit and everything looks perfect. Be sure to photograph the details—table bouquets, place settings, name cards, etc., as these help enrich the finished wedding album.

The Key Players. The photographic opportunities at the reception are endless. As the reception goes on and guests relax, the opportunities for great pictures will increase. Be aware of the bride and groom at all times, as they are the central players. Fast zooms and high ISO settings will give you the best chance to work unobserved.

Scheduled Events. Be prepared for the scheduled events at the reception—the bouquet toss, removing the garter, the toasts, the first dance, and so on. If you have done sufficient preparation, you will know where and when each of these events will take place and you will have prepared to light and photograph them. Often, the reception is best lit using a number of corner-mounted umbrellas, triggered by an on-camera flash on rapid remote. That way, anything within the perimeter of your lights can be photographed by strobe. Be certain you meter various areas within your lighting perimeter so that you know what your exposure will be everywhere within the reception area.

The reception will be full of surprises. It's good to be prepared and have a chair or stepladder to stand on—or in this case, hold the camera above your head and fire away. Photograph by Joe Photo. (Nikon D2X; AF Fisheye-Nikkor 16mm f/2.8D lens; Nikon Speedlight fired from camera position; 1/30 second at f/2.8; ISO 800)

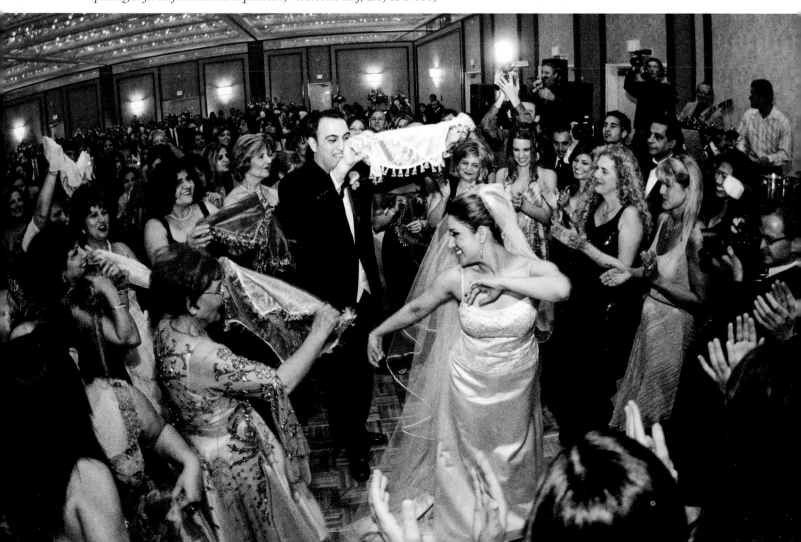

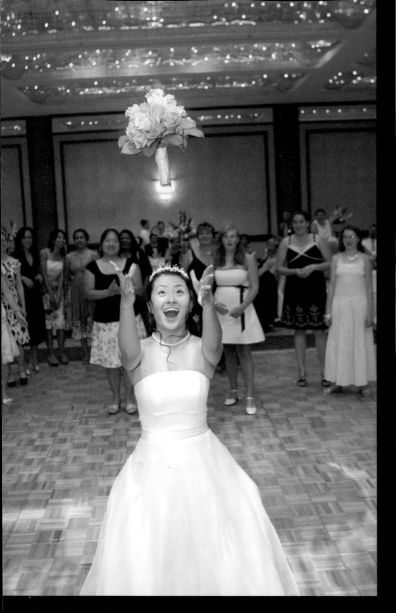

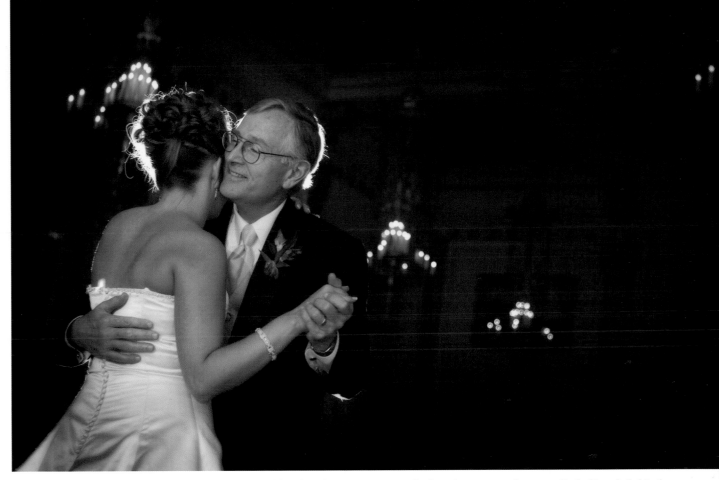

This is a great image of the father of the bride and his daughter. Two remote flash units were used: a raw flash directly behind the couple and a diffused, off-camera flash to camera left. The skin tones were warmed in postproduction to match the warm ambience of the room. Photograph by Jeff and Julia Woods.

Cutting the Cake. One of the key shots at the reception is the cutting of the wedding cake. This is often a good opportunity to make an overhead group shot of the crowd surrounding the bride and groom. Bring along a stepladder for these types of shots. A second

Facing page, top left—One of the key shots is the bouquet toss. It should be a fun shot and will require flash—in this case, camera-mounted diffused flash. The photographers dragged the shutter so that the strobe output would match the room light (1/60 second at f/2.8). The camera, an EOS 20D was set to automatic white balance so the light of the strobe was correctly color balanced. Photograph by Denis and Regina Zaslavets.

Facing page, top right—Believe it or not, the bride and groom rarely get a chance to kiss on their own wedding day. Marc Weisberg makes sure that this shot is part of his coverage.

Facing page, bottom—Marc Weisberg is fond of wedding cakes and always makes beautiful still lifes of the cake—or, in this case, a triptych of three wedding cakes.

shooter is a good idea in these situations so that details and priceless moments won't be missed. (*Note:* Be sure to get a still life of the cake before it is cut. Both the couple and the baker/caterer will want to see a beautiful shot of their creation.)

The First Dance. The first dance is another important moment in the reception, and one that you will want to document thoroughly. Don't turn it into a cliché. Just observe the interactions and you will be rewarded with emotion-filled, joyful moments. Try to use multiple shooters so you don't miss the good expressions.

The Bouquet Toss. The bouquet toss is one of the more memorable shots at any wedding reception. Whether you're a photojournalist or traditionalist, this shot always looks best when it's spontaneous. You need plenty of depth of field, which almost always dictates a wide-angle. You'll want to show not only the bride but also the expectant faces in the background. Although

Details of the wedding day opulence are a great idea, especially for spicing up the album. Photograph by Marc Weisberg.

Leaving the Reception. The final shot of the day will be the couple leaving the reception, which is usually a memorable photo. Like so many events at the reception, planned and spontaneous, it is best to have as many angles of the event as possible, which is why so many wedding photojournalists work with a shooting partner or assistants.

Lighting. *Pole Lighting.* Many photographers employ an assistant at the reception to walk around with a barebulb flash attached to a monopod. The strobe is slaved and can be triggered by a radio transmitter on the camera or by an on-camera flash. The pole light can be positioned anywhere near the subjects and can be set to overpower the on-camera flash by one or two f-stops so that it becomes the main light. Your assistant should be well versed in the types of lighting you like to create with this rig. For instance, if he or she is at a 45-degree angle to the subject and the light is held about four feet over the subject's head height, the resulting lighting will resemble Rembrandt-style portrait lighting. If you prefer to backlight your subjects, then your assistant can position himself behind the group to create a rim lighting effect.

Videographers' Lighting. If a wedding video is being produced, you will have the luxury of the videographer rigging and lighting the reception hall with hot lights—usually quartz halogen lights, which are very bright and will make your reception photography much easier. The only problem is that you will have to color correct each

you can use available light, the shot is usually best done with two flashes—one on the bride and one on the ladies hoping to catch the bouquet. Your timing has to be excellent, as the bride will often "fake out" the group (and you), just for laughs. Try to get the bouquet as it leaves the bride's hands and before it is caught. If your flash recycles fast enough, get a shot of the lucky lady who catches it, too. Of course, if you have enough light to shoot this scene by available light, then blast away.

TABLE SHOTS

Table shots are the bane of every wedding photographer's existence. They rarely turn out well, are almost never ordered, and are tedious to make. If your couple absolutely wants table shots, ask them to accompany you from table to table. That way they can greet all of their guests, and it will make the posing quick and painless. You might also consider talking the couple into one big fun group that encompasses nearly everyone at the reception. These are always fun to participate in and to photograph.

scene. A way to get around that is to use the camera's automatic white balance setting and, if necessary, adjust the color balance again in RAW file processing.

You can also carry your own videographer's light, either 50W or 100W, for the reception and formal portraits. In situations where there isn't enough light (or good light in general), this light adds a kiss of golden illumination to the subject, which is very appealing. The most popular such lights are the Lowell ilights.

Rings

The bride and groom usually love their new rings and would surely like a shot that includes them. A close-up of the couple's hands displaying their new rings makes a great detail image in the album. You can use any type of attractive pose, but remember that hands are difficult to pose. If you want a really close-up image of the rings,

you will need a macro lens, and you will probably have to light the scene with flash, unless you make the shot outdoors or in good light.

Little Ones

One of the best opportunities for great pictures comes from spending some time with the smallest attendees and attendants—the flower girls and ring bearers. They are thrilled with the pageantry of the wedding day, and their involvement often offers a multitude of picture opportunities.

The flower girl was first a member of the bridesmaids portrait, but when Cherie Steinberg Coté noticed how adorable she was, she became the portrait. From your initial idea for the picture, more and better opportunities are sometimes born.

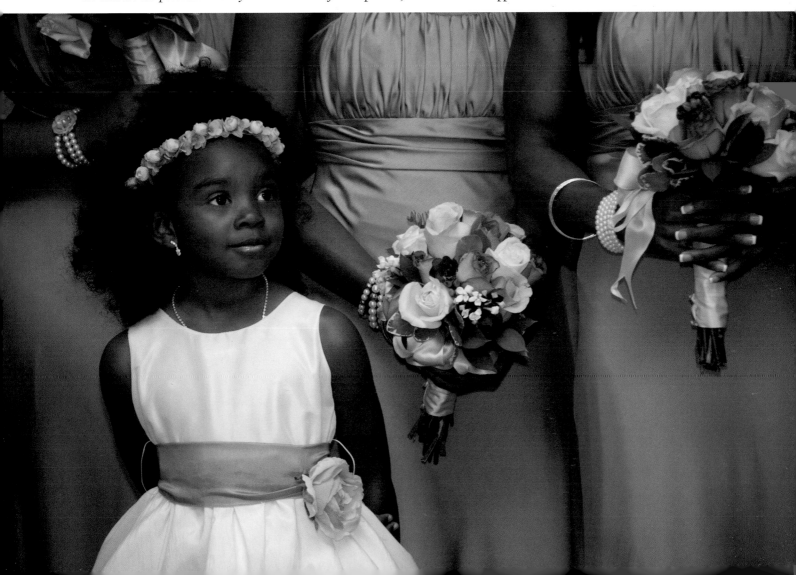

4. COMPOSITION AND DESIGN

*G*ood composition is little more than proper subject placement within the frame. Good design is a logical and pleasing arrangement of the elements within the photograph. The combination of good composition and design is crucial for creating vivid, dynamic images (and album-page layouts, as covered in chapter 7).

The Rule of Thirds

Even many accomplished photographers don't really know where to place the subject within the frame, leaving it to be a consequence of good timing, observation, and instinct. As a result, subjects can often end up dead-center in the picture. This is the least dynamic subject placement you can produce.

The easiest way to improve your compositions is to use the rule of thirds. To apply this rule, mentally divide the rectangular area of the viewfinder into nine separate zones using a tic-tac-toe grid. The point at which any two lines intersect is an area of visual interest—an ideal spot to position your main point of interest. The main point of interest does not necessarily have to fall at an intersection of two lines, however; it could also be placed anywhere along one of the dividing lines.

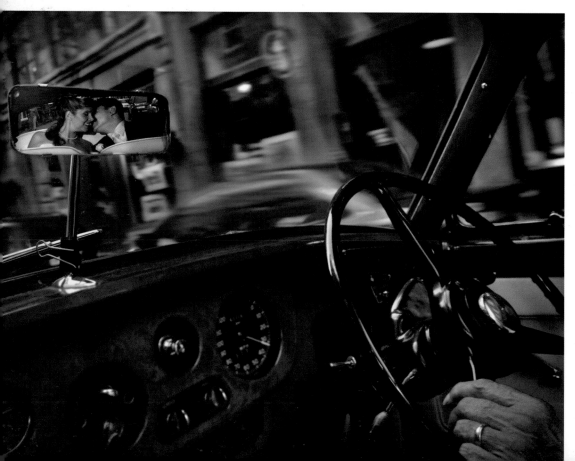

This image by Michael Greenberg utilizes small and large areas of the frame in opposing quadrants of thirds. The subjects (the bride and groom, pictured in the rear-view mirror) are small, while the limo driver's hands and interior of the car are prominent. The car was lit by daylight; the couple was lit by off-camera flash aimed over the photographer's shoulder. The image was made with a 17mm lens and Nikon Speedlight at an exposure of 1/50 second at f/5.6.

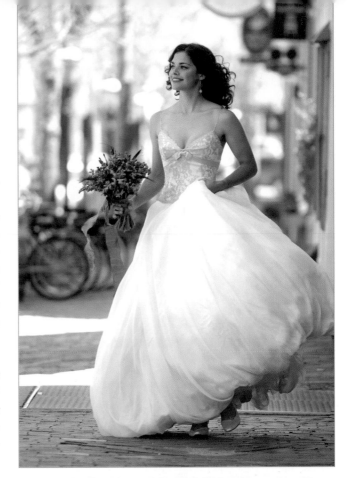

Right—In this lovely portrait of a bride on the streets of Nantucket, Claudia Kronenberg composed the bride off-center and captured her gazing to her right, as if smiling to an admirer across the street. By putting more room in the direction the bride is looking, Claudia not only created a dynamic composition using the rule of thirds, but also gave the image a sense of direction and movement. Claudia used a Nikon D2X and an AF Nikkor ED 180mm f/2.8D IF lens at 1/320 second at f/3.2, which caused the background to softly blur at the wide aperture.

Below—The S shape of the bride is highly apparent in this image by Stuart Bebb, especially since all the horizontal and vertical lines are aligned perfectly so that the S shape contrasts and opposes the straight lines. Because of the two contrasting modes, the image has its own unique sense of tension and balance, heightening the visual interest of the photograph.

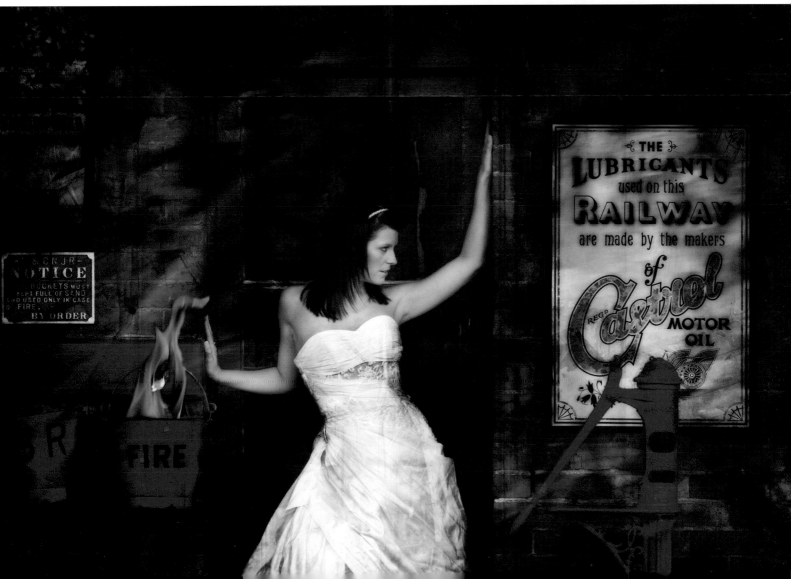

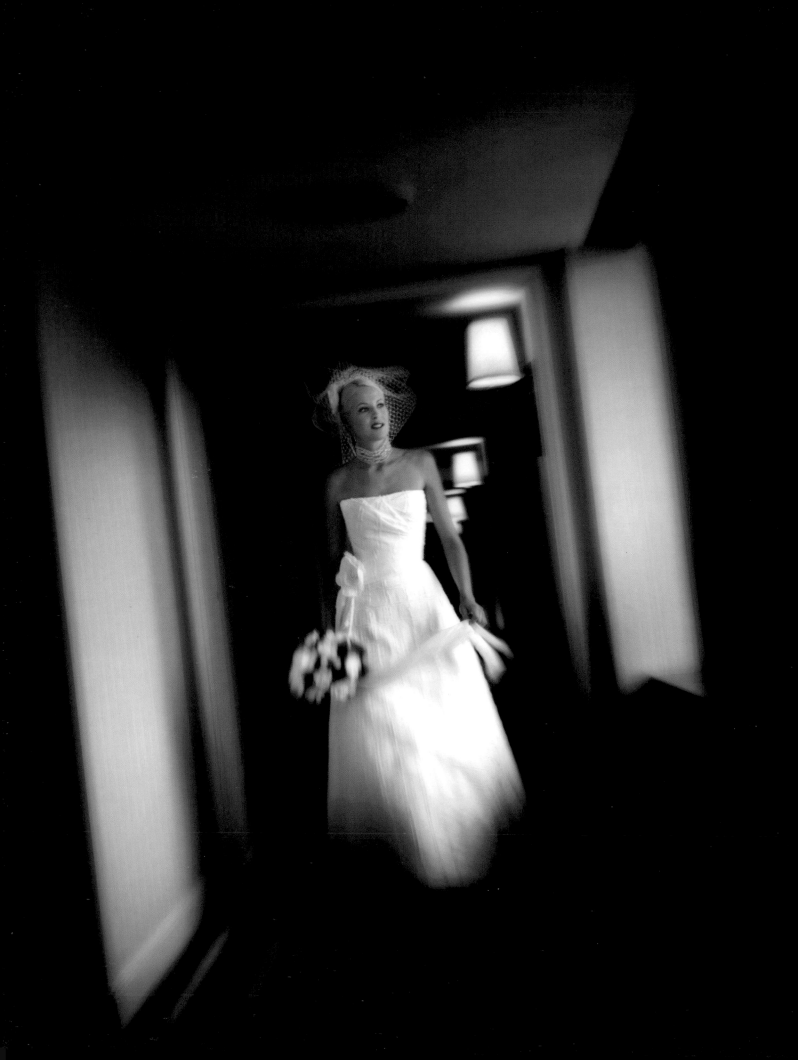

Many professional camera systems offer interchangeable viewfinder screens. One such screen is a grid screen, which cuts the frame into thirds, vertically and horizontally, and greatly facilitates off-center positioning of the subject. The newer professional DSLRs offer an electronic frame grid that you can apply and remove at any time.

Direction

Regardless of which direction the subject is facing in the photograph, there should be slightly more room in front of the person. For instance, if the person is looking to the right as you look at the scene through the viewfinder, then there should be slightly more space to the right side of the subject than to the left of the subject in the frame. This gives a visual sense of direction.

Even if the composition is such that you want to position the person very close to the center of the frame, there should still be slightly more space on the side toward which the subject is turned. This principle still applies even when the subject is looking directly at the camera. He or she should not be centered in the frame, and there should be slightly more room on one side or the other to enhance the composition.

Pleasing Compositional Forms

The S-shaped composition is perhaps the most pleasing of all compositions. In this type of image, the center of interest usually falls on or near a rule-of-thirds line, but the remainder of the composition forms a sloping S shape that leads the viewer's eye to the center of main interest. Another pleasing type of composition is the L shape or inverted-L shape, a composition that is ideal for reclining or seated subjects.

These compositional forms, as well as the Z shape and C shape, are used not only in the design of individ-

Facing page—Because of the slow shutter speed and the diagonal orientation of the image, the bride seems to be moving rapidly toward the camera. Creating motion in a specific direction within the photo is one of the major tricks in building visual interest in the image. Photograph by Marcus Bell.

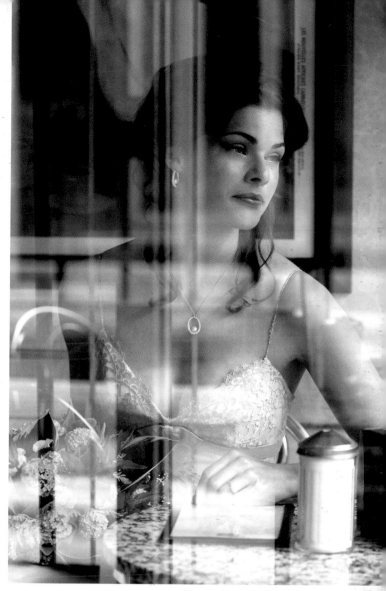

A bride sits at a New England neighborhood café, lost in her thoughts. The photographer, Claudia Kronenberg, liked the way the reflections seem to mirror the "far away" nature of this image.

ual photographs, but as we'll see in chapter 7, in the formation of cohesive and visually stimulating album-page layouts. Shapes in compositions provide visual motion. The viewer's eye follows the curves and angles and travels logically through the shape, and consequently, through the photograph.

Subject shapes can be contrasted or modified with additional shapes found either in the background or foreground of the image. The "lead-in line," for example, is like a visual arrow, directing the viewer's attention toward the subject (we'll talk more about lines on page 67).

Subject Tone

The rule of thumb is that light tones advance visually, while dark tones retreat. Therefore, elements in the picture that are lighter in tone than the subject can be distracting. Bright areas, particularly at the edges of the photograph, should be darkened either in printing, in Photoshop, or in the camera (by vignetting) so that the viewer's eye is not led away from the main subject.

The exception to this occurs in portraits where the subject is the darkest part of the scene, such as in a high-key portrait with a white background. This is really the same principle at work as above; the eye will go to the region of greatest contrast in a field of white or on a light-colored background. Regardless of whether the subject is light or dark, it should dominate the rest of the photograph either by brightness or by contrast.

Focus

Whether an area is in focus or out of focus greatly impacts the amount of visual emphasis it receives. For instance, a subject may be framed in green foliage, yet part of the sky is visible in the scene. The eye would ordinarily go to the sky first. But if the sky is soft and out of focus, the eye will revert back to the area of greatest contrast—hopefully the face. The same is true of foreground areas. Although it is a good idea to make them darker than your subject, sometimes you can't. If the foreground is out of focus, however, it will detract less from a sharp subject.

Similarly, rendering various portions of the face in and out of focus can present a visual treat. Photographers will often shoot with the fastest lens they own (f/1.2 or f/1.4) at close distances to create startlingly

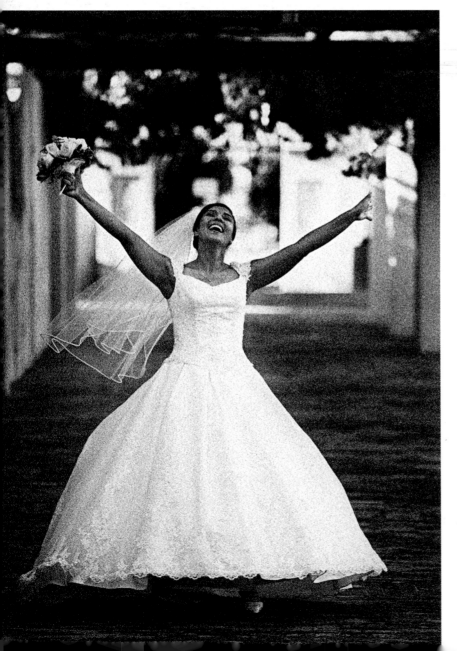

Fernando Basurto created this joyous portrait of a bride in the midst of a spontaneous self-celebration. Notice the beauty of the unifying shapes in this image—the triangle of her wedding gown mirrored by the "V" created by her outstretched arms. All of these nice diagonal lines are safely enclosed in a box of verticals and horizontals close to the frame edges.

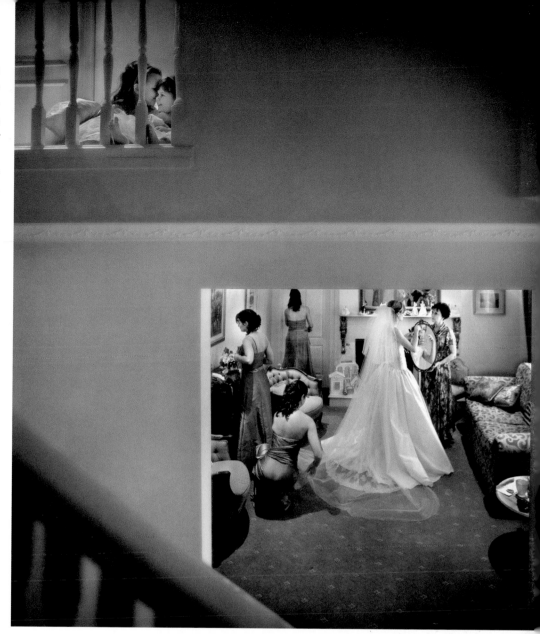

Two square shapes mimic each other in this composition. Each square contains a different story unfolding. The stories, as well as the shapes, play off of each other in an unusual way. Straight and diagonal lines are also prominent in this award-winning image by Marcus Bell.

thin bands of focus. Additionally, the ability to create defocused areas of a scene in Photoshop has added to the popularity of selective focus.

Creative control of focus is a way of riveting attention on a singular trait of your subject. Whether it is done conventionally or in Photoshop, it can be quite effective.

Lines

To master composition, the photographer must be fluent in all the elements of artistic creation, including both real and implied lines within the photograph. A real line is one that is obvious—a horizon line, for example. An implied line is one that is not as obvious, like

the curve of the wrist or the bend of an arm. Further, an implied line may jump from shape to shape, spurred by the imagination to take the leap.

Real lines should not intersect the photograph in halves. This splits the composition into two separate photos. It is better to locate real lines at a point that is one-third into the photograph. This creates a pleasing imbalance—the photo is "weighted" to the top or bottom, left or right.

Lines, real or implied, that meet the edge of the photograph should lead the eye into the scene and not out of it, and they should also lead toward the subject. A good example of this is the country road that is widest in the foreground and narrows to a vanishing point on

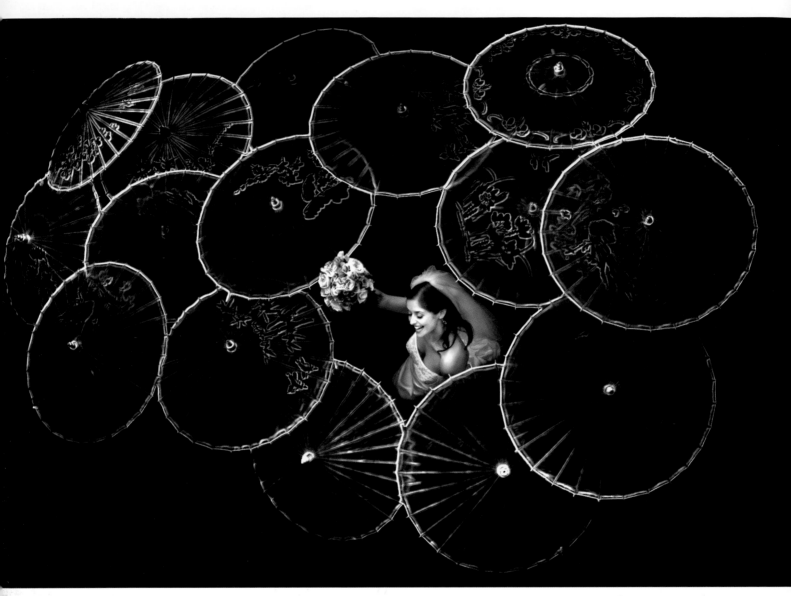

The reception was scheduled almost immediately after the marriage ceremony, so Yervant had very little time to take the wedding party portraits. "I had to think fast and come up with something both artistic and spectacular," he said. "The only common components among the fifteen bridesmaids were the Asian umbrellas they used to keep themselves cool under the hot sun," he says. "They were very pretty and colorful, and they made beautiful images, but I felt that a well-crafted, black-and-white image would have an even stronger impact than color—especially if I finished it in my signature black-and-white art style." And this is what he did, using his own Photoshop Action set called Yervant B&W.

the horizon, where the subject is walking. These lines lead the eye straight to the subject—and, in fact, resemble a pyramid, one of the most compelling visual shapes.

Shape

Shape is nothing more than a basic geometric form found within a composition. Shapes are often made up of implied and/or real lines. For example, a classic way of posing three people is in a triangle or pyramid shape. In any good portrait, the lines and positioning of the body, specifically the elbows and arms, create a triangular base for the composition. Shapes, while more dominant than lines, can be used similarly in unifying and balancing a composition.

Shapes often come into play in composing group portraits, in which small numbers of people are com-

posed to form a unified portrait. Sometimes, in these instances, shapes may be linked, having a common element in both groups. For example, two groups of three people in pyramid shapes can be linked by a person in between.

The number of possibilities is infinite, involving shapes and linked shapes and even implied shapes, but the point of this discussion is to be aware that these shapes and lines are the prevalent tools used in the design of well-composed images, and that they are vital tools in creating strong visual interest within an image. Many professional photographers have told me that they were largely unaware of the role of contrasting or complementary shapes within the design of a photo-

graph. While this is not a psychoanalytical profile, suffice to say that when photographers who are fluent in the language of design find and successfully integrate design elements, it can literally be an unrecognized aspect of their photography.

Tension and Balance

Just as real and implied lines and real and implied shapes are vital parts of an effectively designed image, so are the "rules" that govern them—the concepts of tension and balance. Tension is a state of imbalance in an image—a big sky and a small subject, for example, is a situation having visual tension. Balance is where two items, which may be dissimilar in shape, create a har-

This is a beautiful example by Yervant of tension and balance in the same image. The composition is symmetrical—the bride centered between two touching bridesmaids, and dynamic—it is off-center, built on a diagonal line caused by tilting the camera toward the diagonal. The bride's pose is dynamic and charming, forming an S-shaped curve in the center of the image.

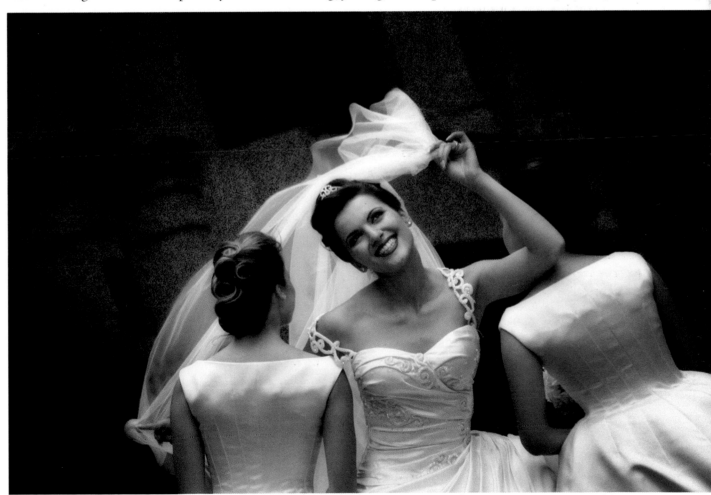

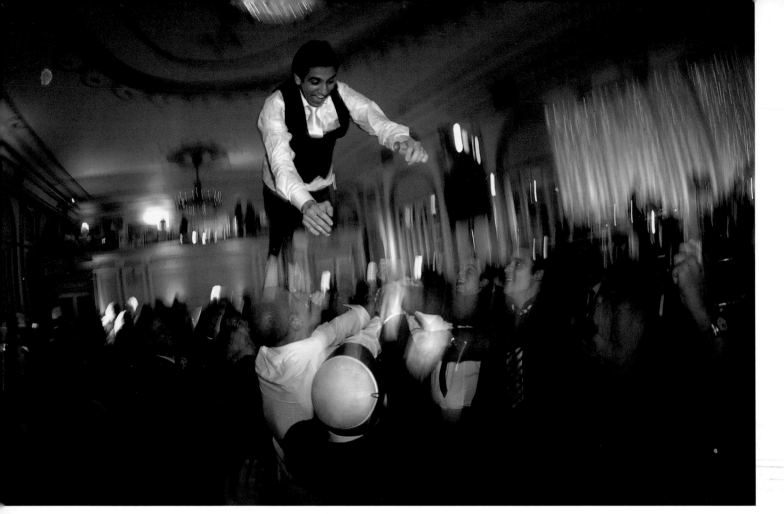

Sometimes the action is fast and spontaneous; all that even the best the photographer can hope to do is set the basic settings for flash and camera exposure and hope for the best. That's what Michael Greenberg did when this troop decided to toss the groom into the air. Michael metered for the room light and synchronized his TTL flash exposure to balance with it. He held the camera and flash over his head and fired off a few frames hoping for the best! The result is a groom who looks like a superhero flying through the air. (Nikon D2X; 10.5mm f/2.8 fisheye; 1/20 second at f/4)

mony in the photograph because they have more or less equal visual strength.

Although tension does not have to be "resolved" within an image, it works side by side with the concept of balance so that, in any given image, there are elements that produce visual tension and elements that produce visual balance. This is a vital combination of artistic elements because it creates a sense of heightened visual interest. Think of it as a musical piece with varying degrees of harmony and discord coming together to create a pleasing experience.

Tension can be referred to as visual contrast. For example, a group of four children on one side of an image and a pony on the other side of the image would seem-ingly produce visual tension. They contrast each other because they are different sizes and they are not at all similar in shape. But the photograph may still be in a state of perfect visual balance. For instance, these two different groups could be "resolved" visually if the larger group (the children) was wearing bright clothes and the pony was dark colored. The eye then sees the two units as equal—one demanding attention by virtue of size, the other demanding attention by virtue of brightness.

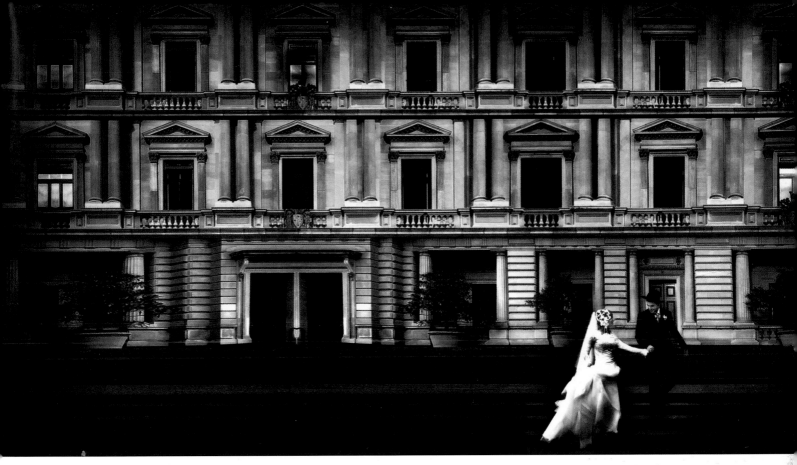

The horizontals and verticals in this image are architecturally perfect. In the face of all that symmetry, though, you have the off-center couple composed of anything but vertical and horizontal lines. This is what makes this image so compelling, the contrast between straight and crooked. Photograph by Yervant.

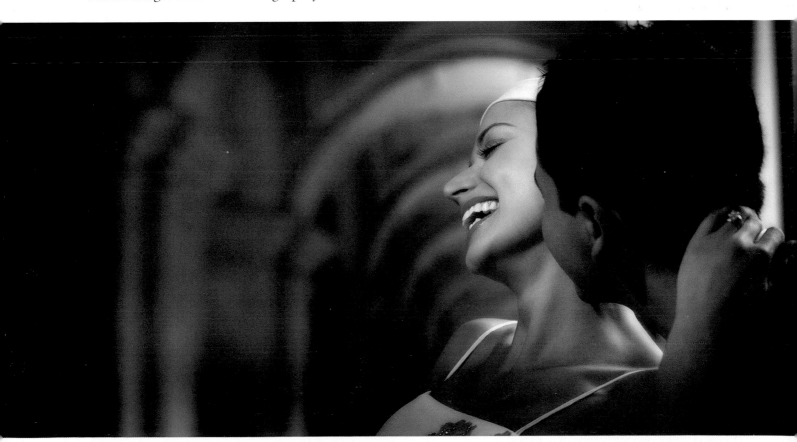

Here is another example where the photographer intentionally offset the couple and allowed the dynamic vaulted arches to balance the couple compositionally. Photograph by Yervant.

5. POSING FOR "FORMALS"

Even as a wedding photojournalist, there are a number of formals that must be made at every wedding. These are posed, controlled portraits in which the subjects are well aware of the camera. When creating these, the principles of good posing and composition are essential. For those times (and because any good wedding photographer not aware of the traditional rules of posing and composition is deficient in his or her education) the basics are included here.

In any photojournalistic wedding coverage, up to 15 percent of the images may be groups and formals. Gatherings of this type bring together people from the

Here is a formal portrait of a candlelit bride that breaks a number of consistent posing rules. Instead of leaning forward, sitting on the edge of chair, the bride is all the way back in the chair, her weight shifted back so that the pose actually adds size to her thighs. But because the bride is "model" thin, there are no ill effects. The portrait uses candlelight, but that is not really the source of illumination; a hot light at head height (to camera left) actually illuminated the full set and bride. Note the lack of grain in this ISO 1600 image made with a Nikon D700 and AF Nikkor 35mm f/2.8. Photograph by Cherie Steinberg Coté.

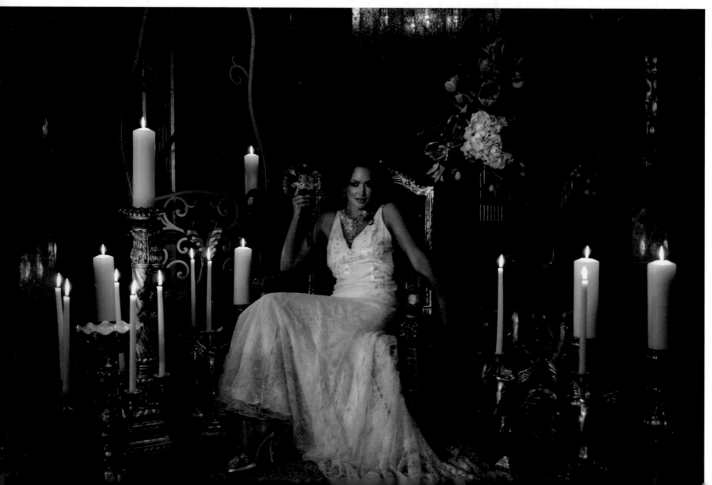

Cherie Steinberg Coté used good posing technique in this formal portrait of the groom and groomsmen. There is an air of relaxation and everyone looks great. Notice how well the hands are posed; showing either one hand or no hands at all simplifies things greatly. The photograph was made at ⅟₆₀ second at f/8 with a raised hot light illuminating the gentlemen. The background was underexposed by about two stops to darken it to a dusk-like reading.

couple's lives who may never be assembled together again, so it is imperative that pictures be made to commemorate the event. Also, brides and families want to have a formal remembrance of the day, which may include the formal portraits of bride alone, groom alone, bride and groom together, bride and bridesmaids, groom and groomsmen, full wedding party, family of the bride, family of the groom, and so on. These images are something that almost every couple expects the photographer to make on the day of their wedding. (*Note:* Group portraits will be treated in further detail in chapter 6.)

As you will see, however, the "formals" done by a contemporary wedding photojournalist differ greatly from the stiff "boy–girl, boy–girl" posing of the tradi-tional wedding photographer, where everyone is looking directly into the camera lens. So much imagination goes into the making of these images—preserving a look of naturalness and spontaneity that is in keeping with the photojournalistic spirit—that it's often impossible to tell that the photographer actually staged the moment.

Most importantly, the fact that these pictures are posed and highly controlled doesn't seem to diminish their popularity among brides. The images have a certain style and elegance, regardless of whether or not the subjects are "looking into the camera." (Notably, however, the wedding-photojournalism purists have somewhat cynically termed this approach to photography "faux-tojournalism.")

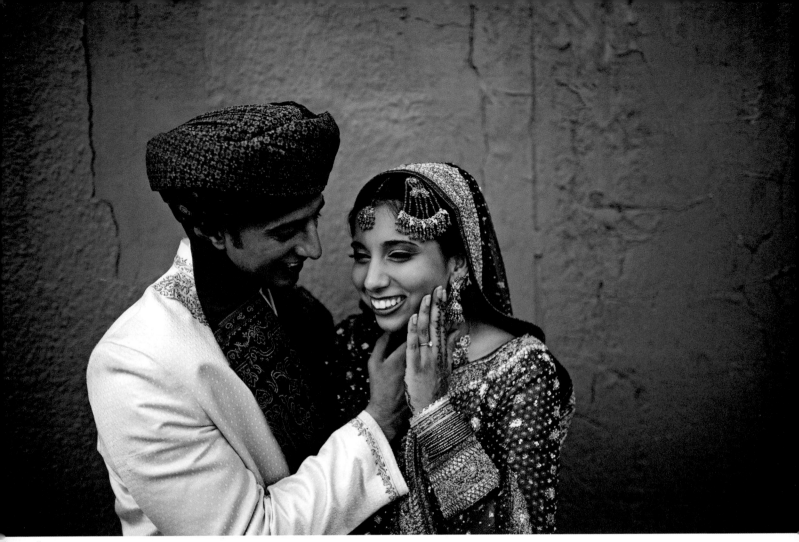

This uncharacteristic formal portrait of bride and groom is by Jesh de Rox, whose sole aim is to release the emotion of any situation. Here he captured a lovely couple enjoying their day and themselves. The bright green wall adds a serenity to the image that is quite pleasing.

Posing Principles

Although the rigors of formal posing will not be seen in these photos, a knowledge of posing fundamentals will increase the likelihood of capturing people at their best. No matter what style of photography is being used, there are certain posing essentials that need to be implemented, otherwise your technique (or lack of it) will be obvious. The more you know about the rules of posing and composition, and particularly the subtleties, the more refined and flattering your wedding images will be. And the more you practice these principles, the more they will become second nature and a part of your overall technique.

The Head and Shoulders. One of the basics of good portraiture is that the subject's shoulders should

be turned at an angle to the camera. With the shoulders square to the camera, the person looks wider than he or she really is. Simultaneously, the head should be turned a different direction than the shoulders. This provides an opposing or complementary line within the photograph; when seen together with the line of the body, this creates a sense of tension and balance. With men, the head is often turned the same general direction as the shoulders (but not exactly the same angle), but with women, the head is usually turned toward the near shoulder for the classic "feminine" pose.

Face Positions. The face should be viewed from an angle; this is generally much more attractive than a full-face portrait. There are three basic head positions (relative to the camera) in portraiture. With all of these

head poses, the shoulders should be at an angle to the camera.

The Seven-Eighths View. If you consider the full face as a head-on "mug shot," then the seven-eighths view is produced when the subject's face is turned just slightly away from camera. In other words, you will see a little more of one side of the subject's face. Usually, you will still see both of the subject's ears in a seven-eighths view.

The Three-Quarters View. This is when the far ear is hidden from the camera and more of one side of the face is visible. With this pose, the far eye will appear smaller because it is farther away from the camera than the near eye. It is important when posing subjects in a three-quarters view to position them so that the smaller eye (people usually have one eye that is slightly smaller than the other) is closer to the camera. This way both eyes appear, perspective-wise, to be the same size in the

This is a beautiful formal portrait of the bride in which she has been offset to the far left of the frame to allow the beams of light on the wall to balance the composition. She is in a three-quarters view, approaching a profile. The light is vintage Rembrandt lighting (note the diamond-shaped highlight on her near cheek). The line of her eyes follows the line of her near shoulder for a wonderful dynamic element. Note, too, that the photographer had her move her left elbow out from her body and slide her left hand forward to produce a space under her arm, which not only produces a delicate triangular shape but also slims the arm and helps provide a base for the composition. Photograph by Jim Garner.

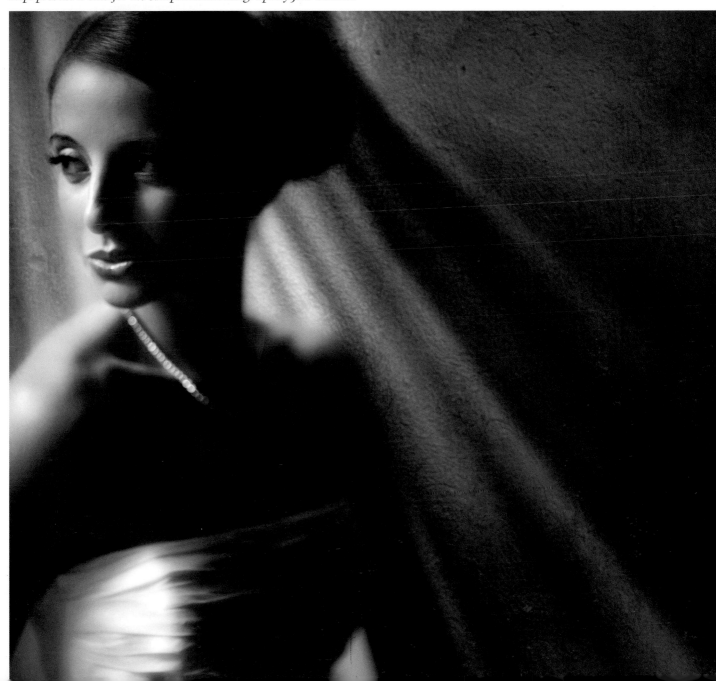

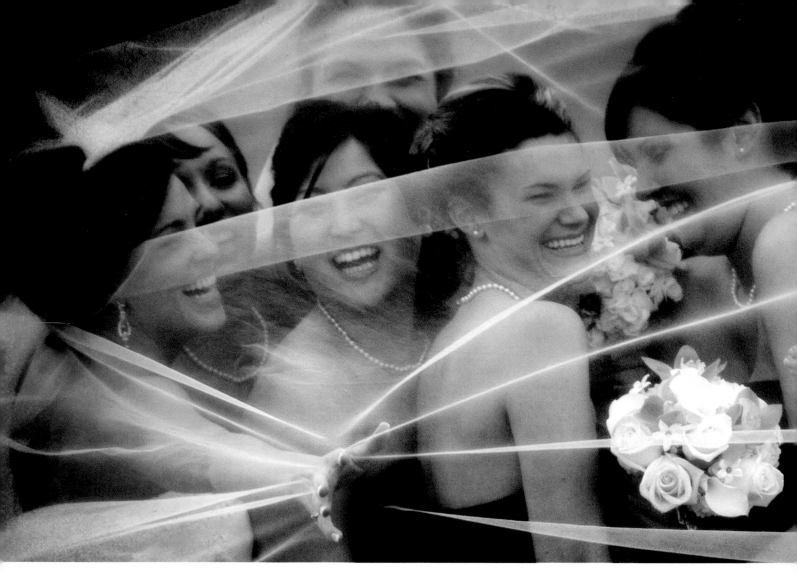

This is an intriguing group portrait by Jim Garner. Notice that the composition has a natural arch to it and that Jim only shows three hands in the composition. The veil provides an overlay of dynamic lines, starting with the bride's fingers on the veil. To keep the depth of field shallow, the photographer made the image at 1/3200 second at f/2.8 with an EF 70–200mm L USM lens on a Canon EOS 1-Ds Mark III. The spontaneity and fun are results of the photographer creating a moment for the subjects to act silly.

photograph. It is important to note that you do not have the luxury of much time in posing groups of people at a wedding, but when photographing the bride and groom, care should be taken to notice all of the subtleties.

The Profile View. In the profile, the head is turned almost 90 degrees to the camera. Only one eye is visible. When photographing profiles, adjust your camera position so that the far eye and eyelashes disappear.

Knowing the different head positions will help you provide variety and flow to your images. In group portraits, you may need to incorporate more than one of the head positions. At times, you may end up using all three head positions in a single group pose. The more people you have in the group, the more likely that becomes.

The Gaze. The direction the person is looking is important. If the subject is aware of your presence, start by having the person look at you. If you step away slightly and engage your subject in conversation, allowing you to hold the subject's gaze, you will create a slight rotation to the direction of the face. You can also have the person look away from you until you best utilize the light and flatter your subject. One of the best ways to

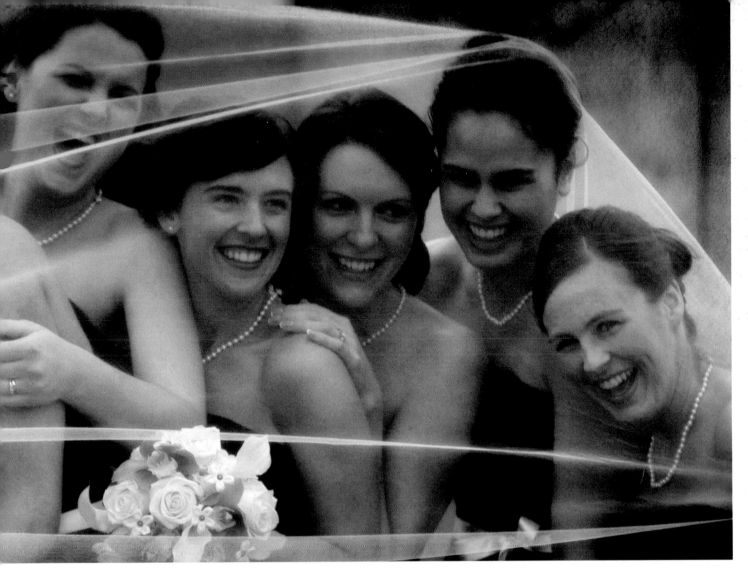

enliven the subject's eyes is to tell an amusing story. If they enjoy it, their eyes will smile—one of the most endearing expressions that people can make.

One of the best photographers I've ever seen at "enlivening" total strangers is Ken Sklute. In almost every image he makes, the people are happy and relaxed in a natural, typical way. Nothing ever looks posed in his photography—it's almost as if he happened by this beautiful picture and snapped the shutter. One of the ways he gets subjects "under his spell" is his enthusiasm for the people and for the excitement of the day. His positive attitude is contagious, and his affability translates into attentive, happy subjects.

The Arms. The arms should not be allowed to fall to the subject's sides, but should project slightly outward to provide gently sloping lines and a triangular base for the composition. This is achieved by asking the subjects to move their arms away from their torsos. Remind them that there should be a slight space between their upper arms and their torsos. This triangular base in the composition visually attracts the viewer's eye upward, toward the face.

The Hands. Hands can be strong indicators of character, just as the mouth and eyes are. However, hands are very difficult to photograph; in many portraits, they are closer to the camera than the subject's head and thus appear unnaturally large. One thing that will give hands a more natural perspective is to use a longer lens than normal (an 80–200mm in the 35mm format). Although holding the focus on both the hands and the face is more difficult with a longer lens, the size relationship between them will appear more natural. If the hands are slightly out of focus, it is not as crucial as when the eyes or face of the portrait are soft.

One should avoid photographing a subject's hands pointing straight into the camera lens. This distorts the size and shape of the hands. Always have the hands at an angle to the lens and, if possible, try to bend the wrist to produce a gentle sloping line. When possible, photograph the outer edge of the hand. This produces a natural, flowing line and eliminates distortion. As generalizations go, it is important that the hands of a woman have grace and the hands of a man have strength.

The Feet. Another basic rule of thumb is that no one should be standing at attention, both feet together. Instead, the front foot should be brought forward slightly. The subject's weight should generally be on the back leg/foot. This has the effect of creating a bend in the front knee and dropping the rear shoulder slightly lower than the forward one. When used in full-length bridal portraits, a bent forward knee will give an elegant shape to the dress. With one statement, "Weight on your back foot," you have introduced a series of dynamic lines into an otherwise static composition.

Facing page, top—Here is a wonderful family group portrait done on the streets of New York in a location that photographer Emin Kuliyev seems to love. The light is open shade, but it filters in from behind the photographer. The cobblestone street gives the portrait a textural feel and the full-length poses with such an attractive group are perfect—all are relaxed and look great. The photographer is a gifted photojournalist, but also more than capable of relaxing a large group like this into being themselves.

Facing page, bottom—Here's another uncharacteristic pose, and yet look at how many posing elements are "right." The groom's foot points out at an angle, instead of straight into the camera; his other foot is lost in a dark shadow; his hand is angled to the side for a good rendition; the bride's elbow forms a V-shape that draws your eye to their faces; her elbow is out from her body, slimming the arm; and so on. A lot of good posing elements are included in this otherwise "casual" formal. Photograph by Kevin Jairaj.

As you can see, this is a formal group gone mad. Is it less appealing to the bride and groom than the cookie-cutter version that it started out as? Doubtful. This is full of life and craziness, encapsulating the couple's joy on their wedding day. Photograph by Jim Garner.

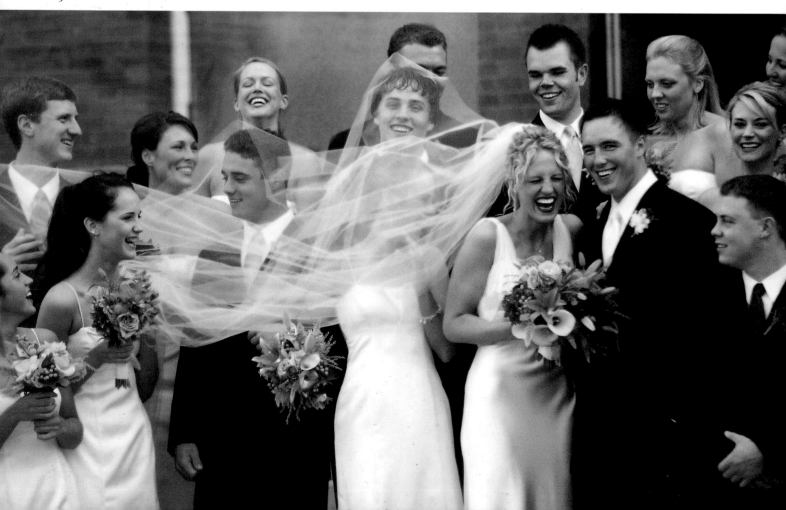

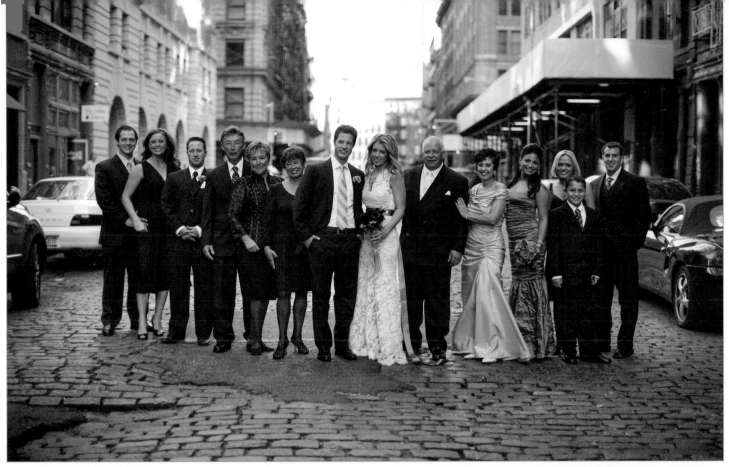

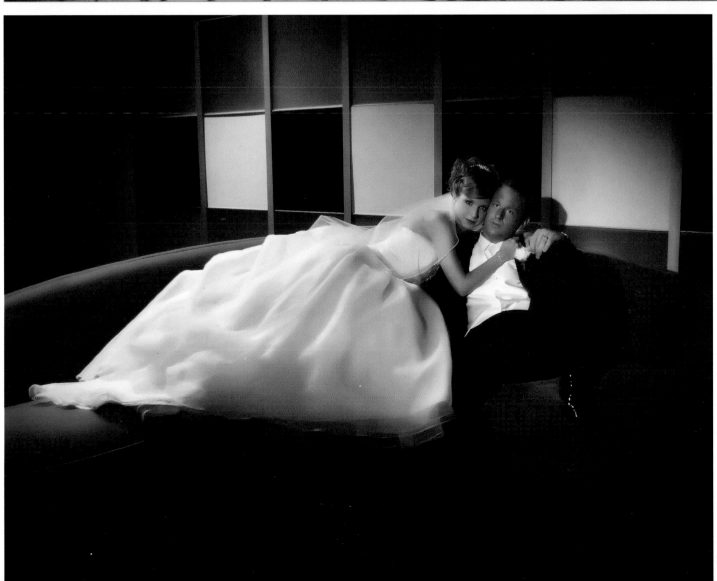

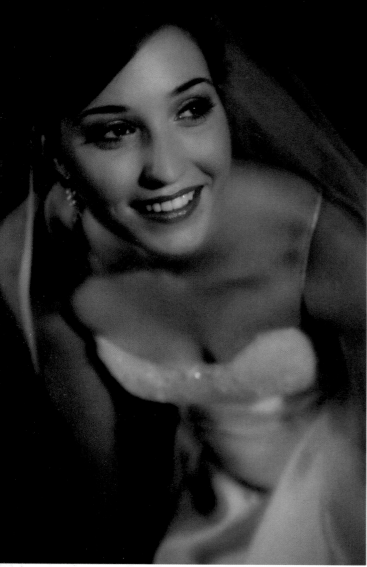

This is a good example of a head-and-shoulders formal. The head/neck axes are great, and the pose is between seven-eighths and three-quarters. The lighting is also excellent; a small video light created the main light and it was feathered (angled away to use the dynamic edge of the light) to produce excellent highlight detail. A blue-gelled light was used to create a festive blue highlight on the dress and in the shadows. Photograph by Jim Garner.

Additionally, the subject's feet should be diagonal to the camera. Just as it is undesirable to have the hands facing the lens head-on, so it is with feet. Feet look stumpy when the toes point directly at the camera.

Portrait Lengths

An additional consideration when designing portraits is how much of the subject to include. Generally, a variety of portrait lengths will be required, from full-length im-

ages (to show the special attire for the day) to head-and-shoulders images (concentrating on the emotional expressions on the subjects' faces).

Full-Length Portraits. A full-length portrait shows the subject from head to toe. Whether they are standing or sitting, it is important to angle the person to the lens—usually at 30–45 degrees to the camera, with their weight on their back foot.

Three-Quarter-Length Portraits. A three-quarter-length portrait is one that shows the subject from the head down to a region below the waist. Such portraits are usually best composed by having the bottom of the picture fall mid-thigh or mid-calf. Never break the portrait at a joint—a knee or ankle, for example (or an elbow, in the case of shorter views). Crop between joints instead. When you break the composition at a joint, it produces a disquieting feeling in the image.

Head-and-Shoulders Portraits. In a head-and-shoulders portrait, all of your camera technique will be evident, so the focus is especially critical (start with the eyes) and the lighting must be flawless.

With close-up portraits, it is especially important to tilt the head and retain good head-and-shoulders positioning. The shoulders should be at an angle to the camera lens, and the angle of the person's head should be slightly different. Often, head-and-shoulders portraits are of only the face, as in a beauty shot. In this case, it is important to include a dynamic element, such as a diagonal line, which will create visual interest.

Don't be afraid to fill the frame with the bride's or the couple's faces. They will never look as good as they do on their wedding day!

Camera Height

When photographing people with average features, there are a few general rules that govern camera height in relation to the subject. These rules will produce a normal, undistorted perspective.

For head-and-shoulders portraits, the rule of thumb is that camera height should be level with the tip of the subject's nose. For three-quarter-length portraits, the

camera should be at a height midway between the subject's waist and neck. In full-length portraits, the camera should be the same height as the subject's waist.

In each case, the camera is at a height that divides the subject into two equal halves in the viewfinder. This is so that the features above and below the lens/subject axis will be the same distance from the lens, and thus recede equally for "normal" perspective. When the camera is raised or lowered, the perspective (the size relationship between parts of the photo) changes. This is particularly exaggerated when wide-angle lenses are used.

While there is little time for many such corrections on the wedding day, knowing these rules and introducing them into the way you photograph people will make many of these techniques second nature.

SCHEDULING THE IMPORTANT FORMALS

In your game plan, devote about ten minutes for the formal portraits of the bride and groom singly. The bride's portraits can be done at her home before the wedding, and the groom can be photographed at the ceremony before everyone arrives. Generally, you will have to wait until after the wedding ceremony to photograph the bride and groom together.

Formal Portraits of the Bride

In the bride's portraits, you must reveal the delicate detail and design elements of her gown. Start with good head-and-shoulders axis, with one foot forward and her weight on her back leg. Her head should be dipped toward the higher shoulder, which places the entire body into a flattering "S-curve"—a classic pose.

This has become a very popular group portrait in most albums. The bride and her maids are scurrying off somewhere, laughing and having fun and seemingly moving quickly. The photographer, Kevin Jairaj, tilted the camera as an afterthought between frames, which gave the image a strong diagonal and elevated the state of motion.

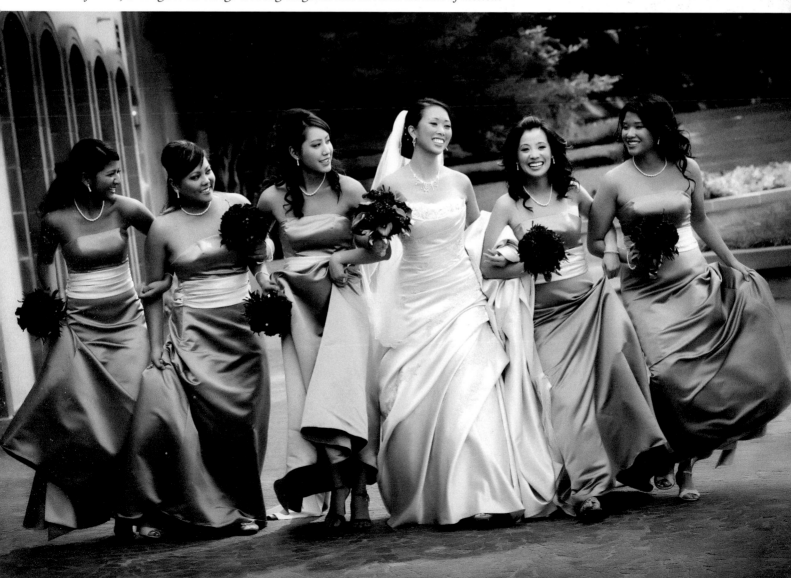

The bouquet should be held on the same side as the foot that is placed forward and the other hand should come in behind the bouquet. Have her hold the bouquet slightly below waist level, revealing the waistline of the dress and still creating a flattering bend to the elbows.

For a portrait that reveals the back of the dress, which is often quite elegant, turn the bride around and have her gaze back at you. If the gown has a full train, you should also devise a pose that shows it in its entirety, either draped around to the front or behind her. (*Note:* Be sure to have someone help the bride with her gown; you don't want to be responsible for the train dragging through any flowerbeds!) And don't forget about the veil; shooting through the tulle material of the veil for a close-up makes a good portrait.

If you photograph the bride outdoors in shade (or indoors using natural light—such as on a portico or porch), you will probably need an assistant to hold a reflector close to the bride. Bouncing light into her face will give a sparkle to her eyes and fill in any unflattering shadows caused by the directional lighting.

Formal Portraits of the Groom

Generally speaking, the groom's portrait should be less formal than the bride's. Strive for a relaxed pose that

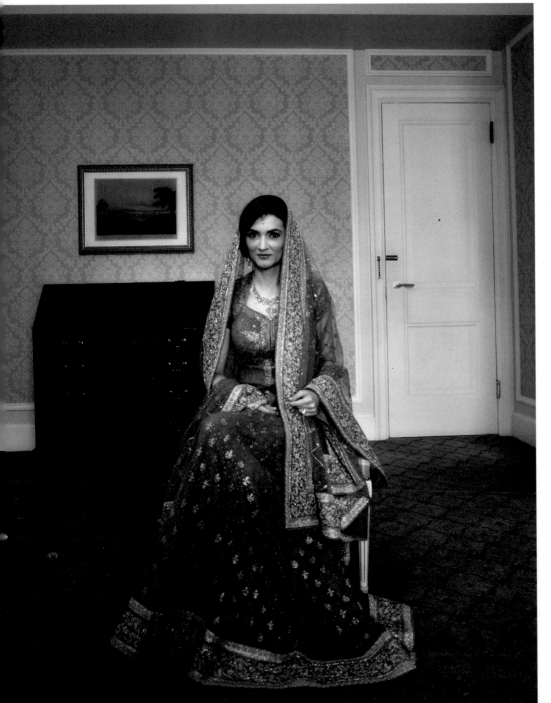

Here is an uncharacteristic but charming bridal portrait done by Michael Greenberg. Done in monotone, the austere surroundings and formal treatment—note that all the elements of the room are square and architecturally correct—and the bride's beautiful Indian attire make this a memorable image. The pose is attractive, yet her hands make her appear to be a little nervous, Her eyes and self-confident smile are the most dynamic elements of the portrait.

Above—This is a wonderful close-up of the bride by Dan Doke. His band of focus is surprisingly shallow, even though the image was made at f/8 with a 50mm lens on an Canon EOS 5D. The reason for this is that Dan was very close to the bride—and he decided to blur selective regions of the portrait in Photoshop. The final version, also toned in Photoshop, is quite soft and romantic.

Right—Jim Garner created this handsome portrait of the groom. Although the shoulders are somewhat straight-on to the camera, the tight crop tends to minimize the effect. The head tilt is toward the low shoulder (a typically masculine style of posing) and he is positioned back in the frame, off center, with the line of his eyes matching the long line of his left shoulder for good visual dynamics. (EOS 5D; EF24–70mm f/2.8L USM lens; 1/160 second at f/2.8; ISO 800)

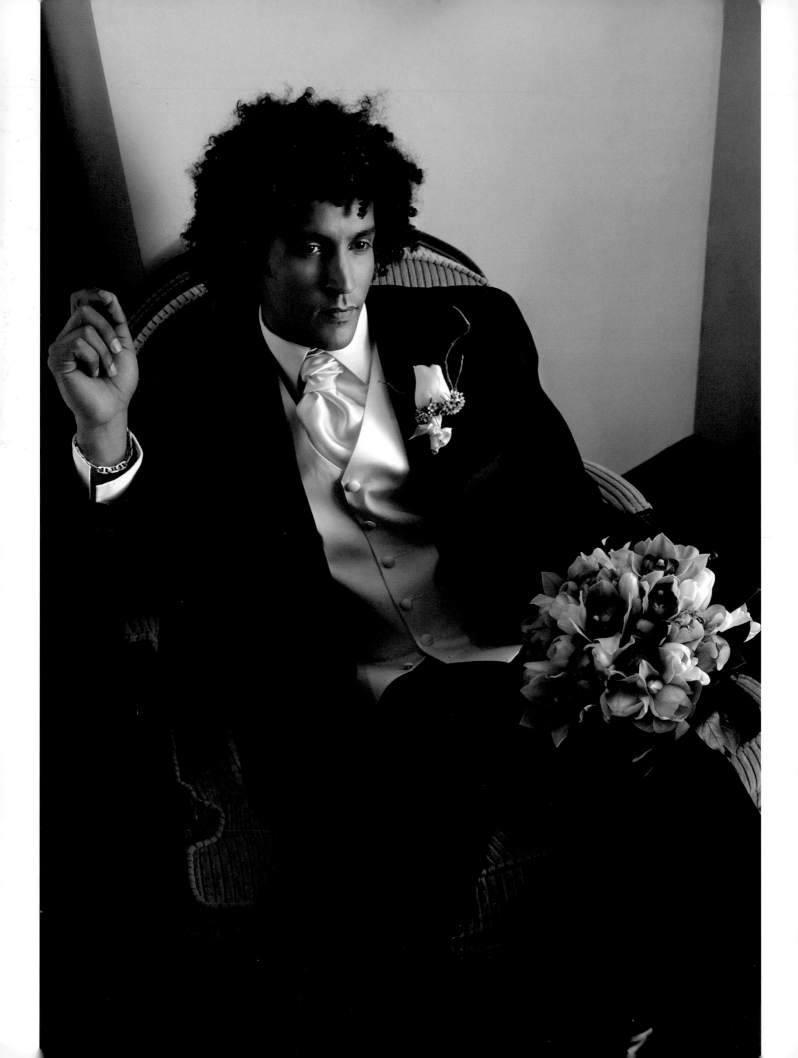

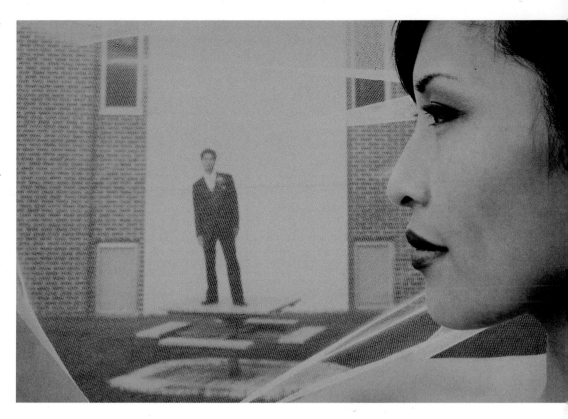

shows his strength and good looks. A three-quarter-length pose is ideal, since you are less concerned about showing his entire ensemble than you are about the bride's.

If the groom is standing, use the same "weight-on-the back-foot" guideline you employed in the bridal portrait. The front foot should be pointed at an angle to the camera. With the shoulders angled away from the camera lens, have the groom tilt his head toward the lower shoulder in the classic "masculine" pose.

Side lighting often works well for the groom's portrait, and a classic pose with the arms crossed is usually a winner. Remember, if using this pose, to show the edge of the hand. Don't let him grab his biceps; this will make him look like he's cold.

Facing page—This is an impressive three-quarter-length portrait that says a great deal about the introspective groom and this quiet moment before his wedding. As you can see, very few formal elements of posing are included and he is completely unaware of the photographer. Yet the pose is great and everything about the portrait, from the light to the way his clothes seem to shimmer, is perfect. Photograph by Michael Greenberg.

Another good pose for a groom is one with his hands in his pockets in a three-quarter-length view—but have his thumbs hitched on his pants pockets so that you can break up all of the dark tones of his tuxedo. Alternately, you can also have the groom rest one foot on a stool, bench, or other support that is out of view of the camera. He can then lean on his raised knee and lean forward toward the camera.

If the groom has cuffs and cuff links, adjust his jacket sleeves so that these show and look good. It's always a good idea to check the groom's necktie to make sure it's properly tied.

A pleasant smile is better than a serious pose or a "big smiley, laughing" pose. Although there are no hard and fast rules here, "strong" and "pleasant" are good attributes to convey in the groom's portrait. Men's fashion magazines are a good source of inspiration for these contemporary looks.

Formal Portraits of the Bride and Groom

The most important formal portrait is the picture of the bride and groom that is taken immediately after the

Top left—*In this more formal portrait by Nick Adams, the bride is far forward of the groom, allowing the pose and directional light (from camera right and a backlight from camera left) to define the elegant gown. Notice that her weight is on her back foot, her front foot is extended, her body is twisted a little to provide a nice S-curve, the head/neck axis is good, and the hands are nicely posed with subtle breaks at the wrists. Nick warmed the tint in RAW file processing.*

Left—*In this wonderful portrait by Mauricio Donelli, the groom faces the camera, while the bride is posed in contrasting diagonal lines. Beyond the posing, the image displays a release of heartfelt emotion by the couple. Donelli used a softbox close to the couple to produce wraparound light. No fill was used.*

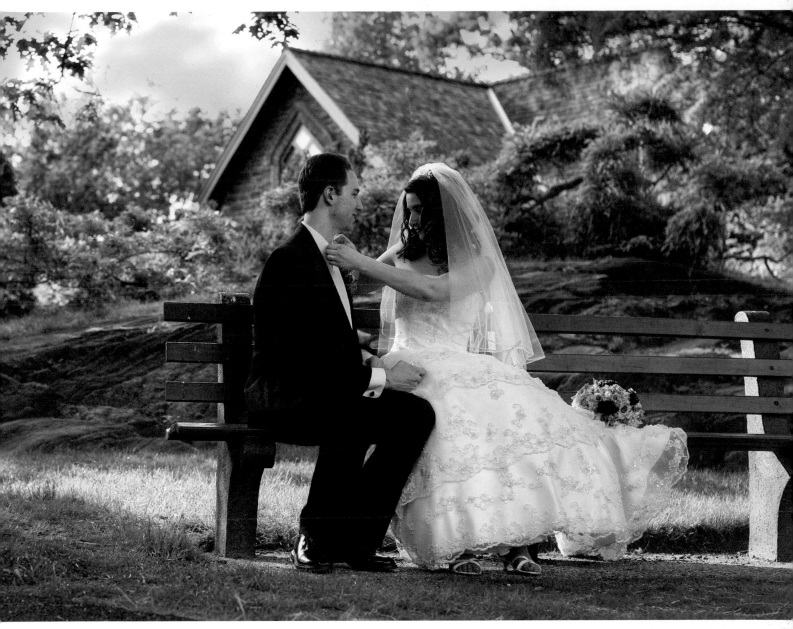

The photojournalistic formal portrait isolates a wonderful moment; posing is secondary. This image was made with a 50mm lens and exposed for ¹/₃₂₀ second at f/3.2 with a silver reflector filling the shadow sides of the couple. Photograph by Emin Kuliyev.

marriage ceremony. Take at least two portraits, a full-length shot and a three-quarter-length portrait. These can be made on the grounds of the church or synagogue, in a doorway, or in some other pleasant location, directly following the ceremony. Have your assistant ready (with reflectors, flash, or whatever other gear you will need to make the portrait) and waiting in the predetermined location. Then, take no more than five minutes making these portraits.

The bride should be positioned slightly in front of the groom. This keeps her in better perspective, relative to the groom, and allows her dress to be seen more fully in the portrait. The bride and groom should be posed facing each other, but each subject should also remain at a 45-degree angle to the camera. Their weight should be on the back legs, and there should be a slight bend in the knee of the bride's front leg, giving a nice line to the dress. They will naturally lean into each other. The

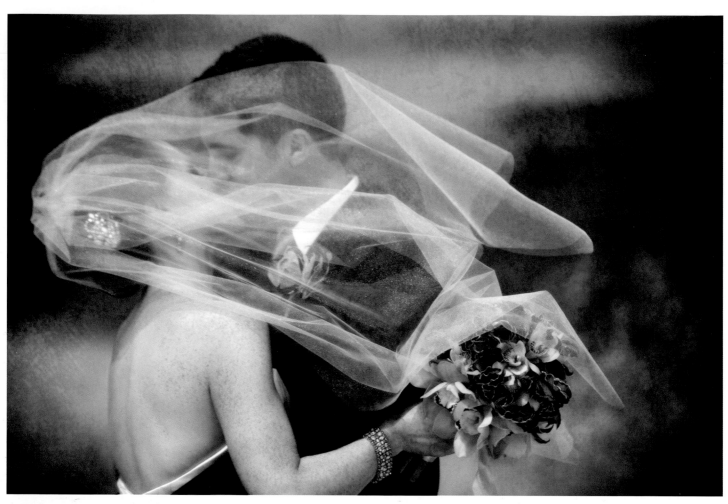
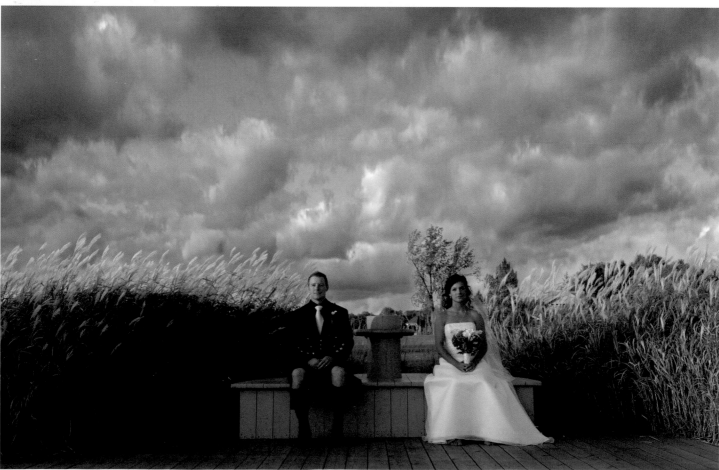

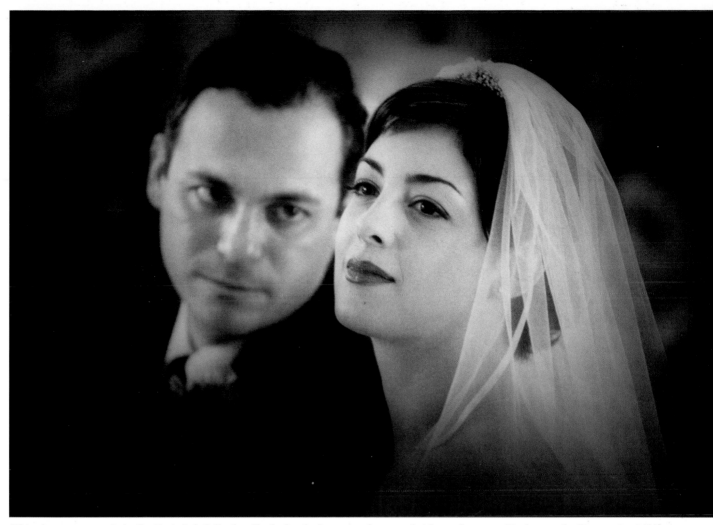

This elegant portrait by Joe Buissink fully details the level of emotion between bride and groom. To the couple, Joe was invisible at this moment.

Facing page, top—While some might argue that this is not a formal portrait at all, it is the fine art, emotion-filled, kind of photograph brides crave. A texture layer was used in postproduction and parts of the layer were minimized with the eraser tool so that the couple's features weren't obscured. Photograph by Jim Garner.

Facing page, bottom—This is one of my favorite formals by Michael Greenberg. The symmetry and rigid straight-on posing give the image an "American Gothic" feeling to it. Michael photographed the image with a wide-angle zoom set to 23mm at an exposure of ¹⁄₁₀₀ second at f/11, using the small aperture to create plenty of depth of field from the foreground to the buildings at the back of the scene.

groom should place his hand in the center of the bride's back, and she should have her bouquet in her outside hand (the other hand can be placed behind it).

Vary your poses so that you get a few with them looking at each other, a few looking into the camera, etc. This is a great time to get a shot of them kissing. As noted previously, very few images like this get made on the wedding day, because the couple is usually so busy attending to details and guests.

For more information on creating portraits of the couple, see chapter 6.

6. GROUP PORTRAITS

*F*ormal group portraits fall outside the area of interest of most photojournalists. However, they are still an integral part of almost every wedding. Most wedding photojournalists don't exhibit their formal groups, but they do include them in their albums—usually because brides expect certain group portraits. Even purists will oblige the request for these images, but they will add the special twist that takes the images out of the realm of traditional wedding coverage.

Types of Groups

You will want to photograph the groom and his groomsmen, the bride and her bridesmaids, as well as the complete wedding party in one group. Depending on the wishes of the bride, you may also need to photograph family formals, extended families, or a giant group shot including all of the guests.

Opt for something completely unexpected. Incorporate the environment or architecture, or ask the group to do something uncharacteristic. Even though this is a "posed" shot, it does not have to represent a pause in the flow of the wedding day; it can be fun. You can get a wonderful group image if you exercise a little imagination.

Backgrounds

While it might be tempting to find a great background and shoot all of your groups using it, the effect will be

Groups should be fun. Here, Marcus Bell gets photographed by the groomsmen with their point-and-shoot digital cameras.

Today's bridal group portraits are fun and unstructured. Noel Del Pilar made this group portrait using the sun as a high backlight and the sand as a robust fill-in source. As with all group shots, it is important that each person look good in these images.

Jim Garner wanted to create the illusion that this group was really airborne. He chose a very low camera angle and prepped the guys so that they would get maximum lift off the ground. He made it fun for them, as you can see. While not everybody got "good air," Jim helped the situation by cloning in some sky background beneath them to further enhance the illusion. This image was used as a double-truck bleed spread in the final album, occupying two full pages in the album.

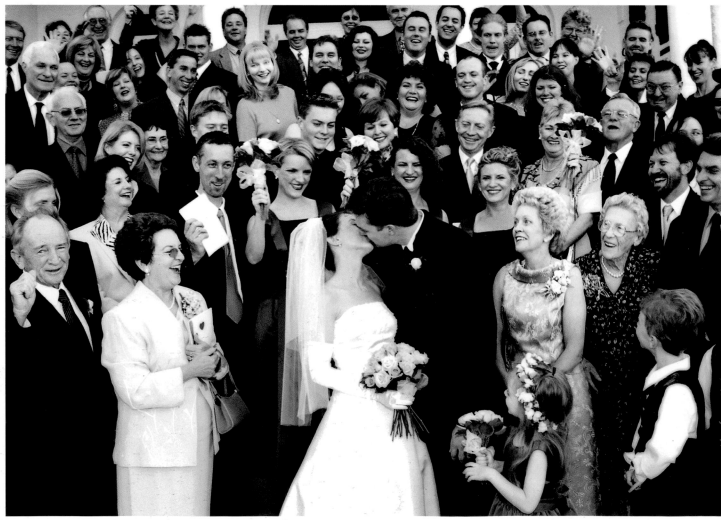

Facing page, top—Here, Jim Garner used a 70–210mm lens at 173mm and at f/2.8 to capture the bride very sharply and the rest of the bridesmaids as softer elements of the scene. The bride is ultrasharp; the bridesmaids and flower girl, while only a few feet away, are softer and secondary to the bride. Note, too, that the f/2.8 taking aperture completely defocused the background, which could have been distracting with a shorter focal length lens or smaller taking aperture.

Facing page, bottom—If you know a big group shot will be called for, make provisions. Sometimes a balcony or second-story location won't be available, so it's a good idea to take along a stepladder. Instead of having the group gawk at the camera, consider providing a focal point—like the bride and groom kissing to the delight of the crowd. Photograph by Marcus Bell.

Below—The dark suits and hats contrast against the light colored wall, creating a composition that resembles musical notes on a score. The boy's face, turned slightly toward the camera, adds an aura of solemnity to the observance. Bounce flash was fired at the taking aperture (f/2.8) to add highlights along the shoulders of the dark suits. This is an award-winning photograph by Michael Greenberg.

monotonous when viewed in the album. Look for several interesting backgrounds, even if they are only ten or twenty feet apart. This will add visual interest to the finished album.

Composition

Successfully designing groups of people depends on your ability to manage the lines and shapes within the composition. The more you learn to recognize these key elements, the more they will become an integral part of your compositions—and the more dynamic your group portraits will be. Please refer to chapter 4 to learn more about this important topic.

Groupings

Couples. The simplest of groups is two people. Whether the group is a bride and groom, mom and dad, or the best man and the maid of honor, the basic building blocks call for one person slightly higher than the other. A good starting point is to position the

mouth of the higher person parallel to the forehead or eyes of the lower person.

Although they can be posed in parallel position, a more interesting dynamic with two people can be achieved by having them pose at 45-degree angles to each other, so their shoulders face in toward one another. With this pose, you can create a number of variations by moving them closer or farther apart.

To create an intimate pose for two, try showing two profiles facing each other. One should still be higher than the other, allowing you to create an implied diagonal line between their eyes, which gives the portrait better visual dynamics. Since this type of image is usually fairly close up, make sure that the frontal planes of the subjects' faces are roughly parallel so that you can hold sharp focus on both.

Trios. A group portrait of three is still small and intimate. It lends itself to a pyramid or diamond-shaped composition, or an inverted triangle, all of which are pleasing to the eye.

Turn the shoulders of those at both ends of the group in toward the center of the composition to loop the group together, ensuring that the viewer's eye does not stray out of the frame. Once you add a third person, you will begin to notice the interplay of lines and shapes inherent in good group design. The graphic power of a well-defined diagonal line in a composition will compel the viewer to keep looking at the image.

Try different vantage points—a bird's-eye view, for example. Cluster the group together, use a safe stepladder or other high vantage point, and you've got a lovely variation on the small group.

Wedding photojournalists take great creative liberties in making the formal portrait of the bride and groom. This image by Jim Garner is illuminated fully by the candles on the table. The emotion between the couple is really the "subject" of the image—and the connection is as intense as the flames. The image was made with Canon's remarkable EF 24mm f/1.4L USM lens at an exposure of $\frac{1}{100}$ second at f/1.4, ISO 1000. In RAW file processing, Jim lowered the color temperature to 2426K, very close to candlelight.

The silhouette can be an elegant mode for capturing the bride and groom. The silhouette, by nature, emphasizes form over detail; to be effective, the pose must be almost dance-like with fluid body lines. Jim Garner made this beautiful image with a 70–200mm f/2.8 lens set to 105mm. The exposure, at ISO 800, was ¹⁄₄₀₀ second at f/2.8 against a perfect Pacific Northwest sunset.

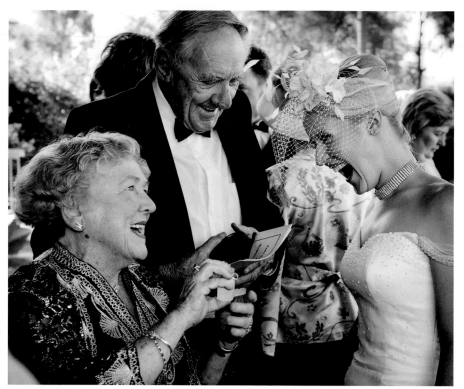

A moment like this is truly spontaneous, as if the photographer wasn't even there. But there are also good group dynamics at work. The three subjects form a pleasant pyramid shape, with the two women facing each other as if to contain the emotional response. Marcus Bell made this fine image using subtle backlight and weak flash-fill from the camera position.

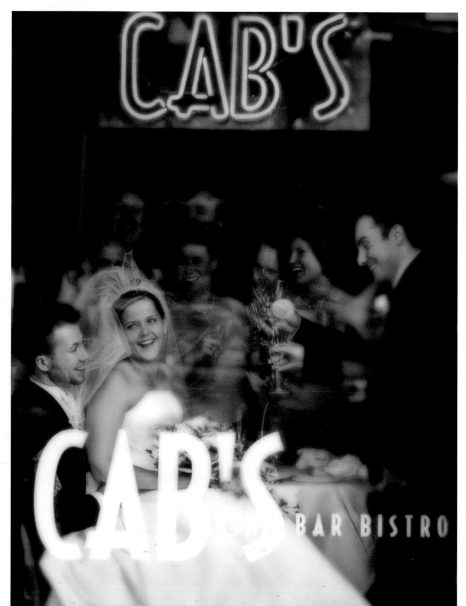

Jeff and Julia Woods captured the great camaraderie and friendship of this group of friends through a pub window—as if no one knew they were outside taking this picture. This is the essence of fly-on-the-wall photojournalism. The light is all window light, but you can see it drop off quickly in intensity the farther the person is from the window. The exposure was made at ¹⁄₁₀₀₀ second at f/2.8 with a 90mm focal length setting on a 70–210mm lens.

Even-Numbered Groups. You will find that even numbers of people are more difficult to pose than odd-numbered groupings. The reason is that the eye and brain tend to accept the disorder of odd-numbered objects more readily than even-numbered objects. (*Note:* As you add more people to a group, remember to do everything you can to keep the camera back parallel to the plane of the group to ensure everyone in the photograph is sharply focused.)

With four people, you can simply add a person to the existing poses for three described above. Be sure to keep the head height of the fourth person different from any of the others in the group. Also, be aware that you are now forming shapes with your composition—pyramids, extended triangles, diamonds, and curved lines.

Larger Groups. With five or six people, you should begin to think in terms of creating linked subgroups. This is when a posing device like the armchair can come into play. An armchair is the perfect posing device for photographing up to about eight people. The chair is best positioned roughly 30 to 45 degrees to the camera. Whoever will occupy the seat (usually the bride) should be seated laterally across the seat cushion on the edge of the chair, so that their weight does not rest on the chair back. This promotes good sitting posture and narrows the lines of the waist and hips, for both men and women. With one person seated, you can then position the others close and on the arms of the chair, leaning in toward the central person. Sometimes only one arm of the armchair is used to create a more dynamic triangle shape.

Hands can be a problem in groups. Despite their small size, they attract visual attention—particularly against dark clothing. They can be especially troublesome in seated groups, where at first glance you might think there are more hands than there should be. A general rule of thumb is to either show all of the hand

This is a group of eleven groomsmen taken by Kevin Jairaj. If you let your eyes wander across the group, you will see three groups of three guys, plus a grouping of two on the far right side. This is intentionally done to subdivide the large group, preventing it from becoming a "team" photo all on one plane. Instead, it is a moody, introspective image of the young men, beautifully done with stage lighting and carefully composed to give the image rhythm and unity.

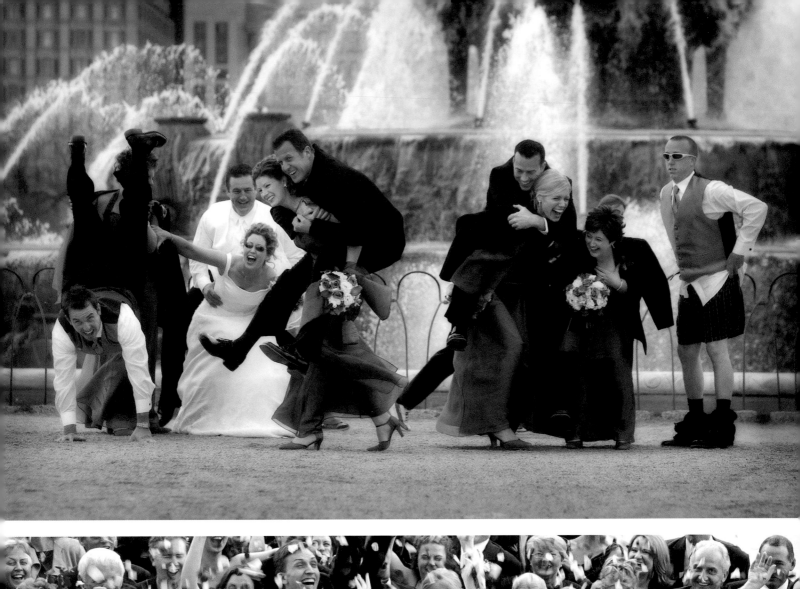
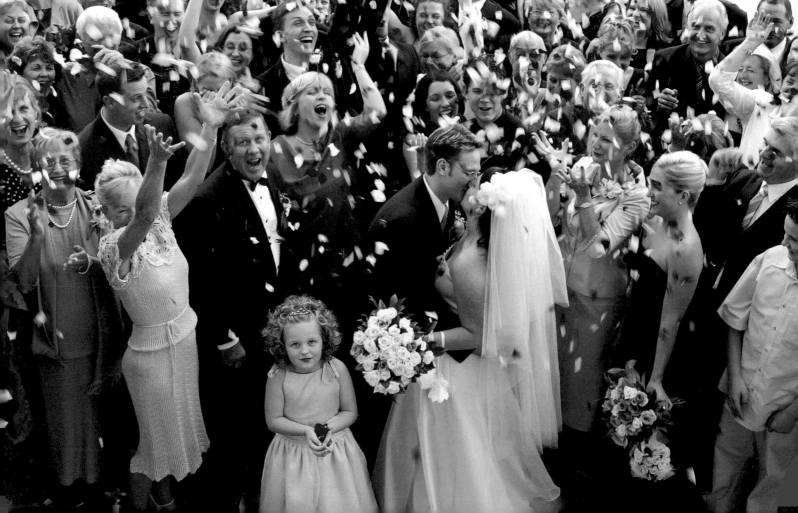

PANORAMIC GROUPS

If you have the capability to include panoramic pages in your album, this is a great way to feature groups—especially large ones. These should be shot on an extra-wide format, like 6x9cm or 6x17cm. Your camera technique will definitely show up with images this large, so be sure the plane of focus is aligned with your group and that everyone is in focus. Also, as needed, use the proper amount of fill-flash to lighten facial shadows across the group. Generally speaking, if you use fill-flash across a wide group, it will take several flash units spaced across the group and fired at the same aperture/output. The flash output should be one stop less than the ambient light reading. For example, if the daylight exposure reading is 1/250 second at f/5.6, your flash units should be set to fire at f/4 for adequate (but subtle) fill-in flash.

JB and DeEtte Sallee are masters at producing the panoramic group photo. This one is exceptional and covered two full pages in the couple's album. The camera is perfectly parallel to the buildings so they record architecturally straight and true. Tripod-mounting the camera helps in regulating camera positioning so that straight lines remain straight. The horizon line is leveled, as well.

Facing page, top—What a wild and crazy group this is! It is completely unchoreographed in a wacky, vaudevillian way—groomsmen piggy backing bridesmaids, who buckle under the weight; guys dropping their trousers—it's completely out of control. Yet, this is what it's all about: having fun on a once-in-a-lifetime day. The photograph was made, and no doubt inspired, by the photographers, Jeff and Julia Woods.

Facing page, bottom—Big groups like this one require big distractions. Otherwise, everyone will simply gawk at the camera. The photographer, Marcus Bell, choreographed "the kiss" to the great enjoyment of the large group. Marcus positioned himself above the group on a perch so he could fire away at 8 frames per second. Yes, there are those few looking at the camera, including the flower girl still holding her rose petals in the foreground, but for the most part the image is a huge success and a brilliant way to captivate a very large group.

or show none of it. Don't allow a thumb, or half a hand, or a few fingers to show. Hide as many hands as you can behind flowers, hats, or other people. Be aware of these potentially distracting elements, and look for them as part of your visual inspection of the frame before you make the exposure.

Really Big Groups. In really big groups, the use of different levels helps to create a sense of visual interest and lets the viewer's gaze bounce from one face to another (as long as there is a logical and pleasing flow to the arrangement). The placement of faces, not bodies, dictates how pleasing and effective the composition will be.

Having the guests wave to the camera usually results in too many faces being lost behind raised arms. However, this is a good time for the bride to throw her bou-

It's hard to imagine a more jubilant group portrait than this one by Jim Garner. There are twenty people in the bridal party and notice the number and type of stories happening within the portrait simultaneously. Garner is a master at creating a moment in which his subjects completely relax and are themselves. What bride wouldn't want this image in her album?

quiet. Ask her to throw it over her head into the crowd behind, mainly upward and slightly to the rear. Alternately, you might simply ask the couple to kiss and have all the guests watch them—as Marcus Bell did in the image at the bottom of page 98.

When you are photographing large groups, an assistant is invaluable for getting all of the people together and helping you to pose them. Keep in mind that it also takes less time to photograph one large group than it does to create a series of smaller groups, so it is usually time well spent (provided that the bride wants the groups done in this way).

Focus and Depth of Field

As your groups get bigger, it's important to keep your depth of field under control. The stepladder is an invaluable tool for larger groups; it lets you elevate the camera position and more easily keep the camera back parallel to the group for the most efficient focus. Another trick is to have the back row of the group lean in, while the front row leans back slightly. This creates a shallower subject plane that makes it easier to hold the focus across the entire group.

If you are short of space, use a wide-angle lens or a wide-angle camera (like the Brooks Veri-Wide, a 35mm panoramic camera with a rotating shutter). Wide-angle coverage results in the people at the front appearing larger than those at the back, which may be advantageous if the wedding party is at the front of the group. Make sure everyone is sharp. This is more of a certainty with a wide-angle lens and its inherent depth of field. Focus at a distance one-third of the way into the group. This should ensure that everyone is sharp at f/5.6 or f/8 with a wide-angle lens.

After You've Snapped the Shutter

Many wedding photographers will tell you that the best groups and formals are often taken seconds after you've told the people, "Thanks, I've got it." Everyone relaxes and they revert to having a good time and being themselves. This is a great time to fire off a few more frames—you might get that great group shot or formal portrait that you didn't get in the posed version.

7. WEDDING ALBUMS AND SPECIAL EFFECTS

*L*ike any good story, a wedding album should have a beginning, a middle, and an end. For the most part, albums are laid out chronologically. However, there are now vast differences in the presentation—primarily caused by the digital page-layout process. Often, events are jumbled in favor of themes or other methods of organization. There still must be a logic to the layout, though, and it should be readily apparent to everyone who examines the album. The wedding album has changed drastically, evolving into more of a storytelling medium. Still, album design is basically the same thing as laying out a book, and there are some basic design principles that should be followed.

Basic Design Principles

Title Page. An album should always include a title page, giving the details of the wedding day. It will become a family album, and having a title page will add an historic element to its priceless nature.

Left and Right Pages. Look at any well designed book or magazine and study the images that appear on the left- and right-hand pages. They are decidedly different, but have one thing in common: they lead the eye into the center of the book, commonly referred to as the "gutter." These photos use the very same design elements that photographers use in creating effective images—lead-in lines, curves, shapes, and patterns. If a line or pattern forms a "C" shape, it is an ideal left-hand page, since it will draw the viewer's eye toward the gut-

A title page can be done for both bride and groom. Yervant often uses a giant initial capital letter as a symbol in the opening pages. This is one for the groom.

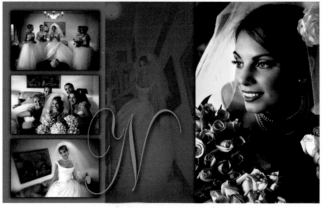

Here is the bride's opening page. As you can see, Yervant chose to make the pages quite different, incorporating elements special to each individual. The common thread is the initial capital letter and the color coordination on the pages.

Left—Negative space is a big consideration when shooting for the album. This beautiful image by Jerry Ghionis has the bride looking to her right, making it a beautiful left- or right-hand page If a right-hand page, it directs the viewer to turn to the next page of the album. The negative area to the left could be used for cut-ins (a series of photos), type, or a single image. Once one begins thinking in these terms, good album design is always in the forefront of your creativity and guides the way you create and edit images.

Below—When the photographer thinks in terms of album design when shooting, you get images like this one by Jerry Ghionis. The great direction provided by the groom's pose and the veil's windward direction create a great left-to-right dynamic. The image could be used in the album to lead the eye to the right-hand page, or (if used on a spread) to direct the viewer's eye to the next sequence of pages.

There are some interesting design elements going on here. The left-hand page seems to be directing the viewer to the left—but analyze the bride's left arm, which forms an arrow shape pointing to the right-hand page. The same symbol is seen in the large portrait of the bride, her elbow pointing to the left-hand page. The two similar poses mimic each other, forcing the eye into a ping-pong match between the pages. Design elements are usually subtle and don't hit you over the head, although this scenario is quite obvious. Photograph and album design by Yervant. This is a page design treatment taken from Yervant's Page Gallery album design templates.

ter and across to the right-hand page. If an image is a backward "C" shape, it is an ideal right-hand page. Familiar shapes like hooks, loops, triangles, or circles are used in the same manner to guide the eye into the center of the two-page spread and across from the left to the right-hand page.

There is infinite variety in laying out images, text, and graphic elements to create this left and right orientation. For example, a series of photos can be stacked diagonally, forming a line that leads from the lower left hand corner of the left page to the gutter. That pattern can be mimicked on the right-hand page, or it can be contrasted for variety.

Even greater visual interest can be attained when a line or shape starts on the left-hand page, continues through the gutter onto the right-hand page, then moves back again to the left-hand page. This is the height of visual movement in page design. Visual design should be playful and coax the eye to follow paths and signposts through the elements on the pages.

Variety. When you lay out your images for the album, think in terms of variety of size. Some images should be small, some big. Some should extend across the spread. Some, if you are daring, can even be hinged and extend outside (above or to the right or left) the bounds of the album. No matter how good the indi-

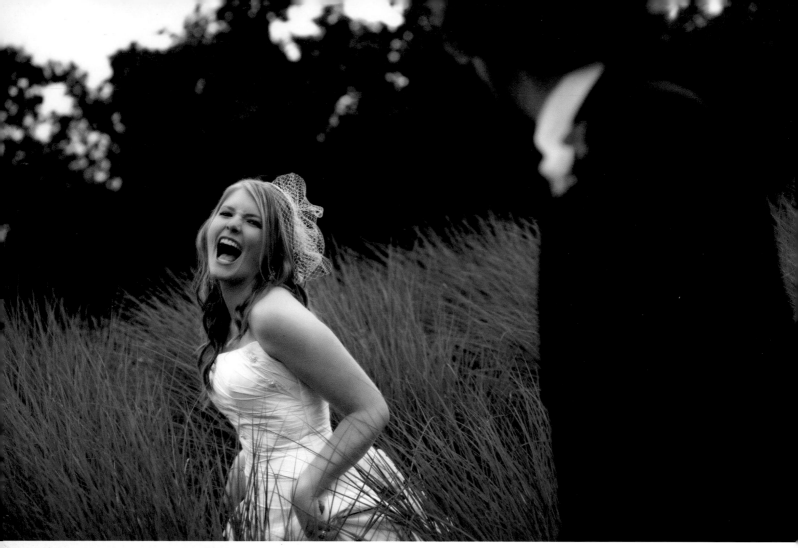

Above—One must always remember where the gutter is in the album—dead center in the middle—and compose images accordingly. In this Jerry Ghionis image, the bride looks back to the right-hand page from the left-hand page. It's a beautiful double-truck (two page) bleed treatment in the making.

Left—In this Yervant image, the large close-up image on the left and the smaller image on the right are in perfect balance because they include the same strong diagonal component. It is an interesting juxtaposition that gives liveliness to the album design. The two images contrast (create tension between one another) because they are of different sizes and treatments—one is very sharp, one is very soft and moody.

vidual photographs are, the effect of an album in which all the images are the same size is static.

You can introduce variety by combining black & white and color, even on the same page. Try combining detail shots and wide-angle panoramas. How about featuring, on facing pages, a series of close-up portraits of the bride as she listens and reacts to the toasts? Don't settle for the one-picture-per-page approach; it's momotonous and boring.

Visual Weight. Learn as much as you can about the dynamics of page design. Think in terms of visual weight, not just size. Use symmetry and asymmetry,

contrast and balance. Create visual tension by combining dissimilar elements. Don't be afraid to try different things. The more experience you get in laying out the images for the album, the better you will get at presentation. Study the album pages presented here, and you will see great creativity and variety in how the images are combined and the infinite variety of effects that may be created.

Reading Direction. In Western civilization, we read from left to right and top to bottom. We start on the left page and finish on the right. Therefore, good page design starts the eye at the left and takes it to the right, and it does so differently on every page.

Traditional Albums

Many wedding photojournalists still prefer to use traditional wedding albums, either because their clients re-

quest them or because they feel that traditional albums represent a hallmark of timeless elegance.

Post-Mounted Albums. Album companies offer a variety of different page configurations for placing horizontal or vertical images in tandem on a page, or for combining any number of small images on a single page. The individual pages are then post-mounted, and the final album can be as thick or thin as the number of pages. Photos are inserted into high quality mattes, and the albums themselves are often made of the finest leathers.

Bound Albums. A different kind of album is the bound album, in which all the images are permanently mounted to each page, and the book is bound professionally by a bookbinder. These are elegant and very popular. Since the photos are dry-mounted to each page, the individual pages can support any type of lay-

This is most decidedly a right-hand page. The area to the left lends itself to cut-ins or scene-setters. What is unique is that the bride's gaze is upward, which runs counter to the left-to-right horizontal mindset of the wedding album. Contrast and purposeful misdirection are good things in an album because they add visual unexpectedness. Photograph by Jerry Ghionis.

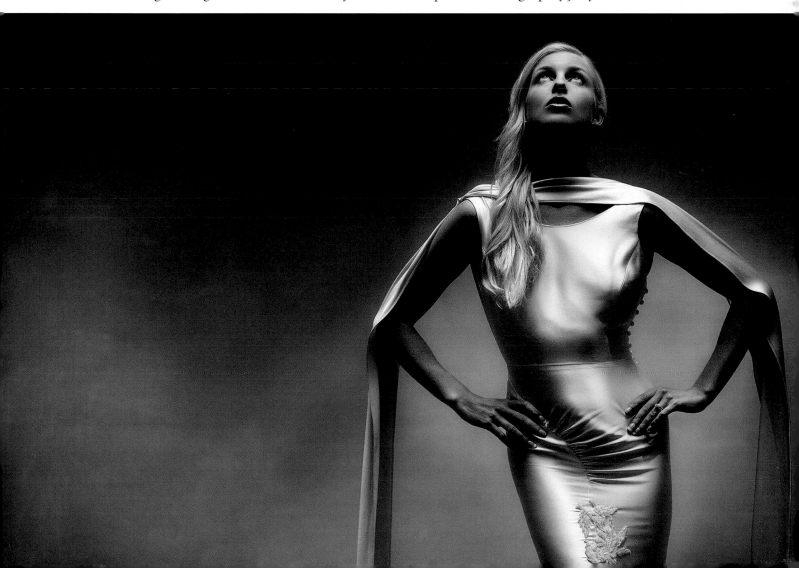

out from "double-truck" (two bleed pages) layouts to a combination of any number of smaller images.

Library Binding. Another form of album uses conventional photographic prints made to the actual page size. These prints are then mounted, trimmed, and

Here is a selection of magazine-style and book-style albums, complete with dust jackets, from GraphiStudio, an Italian album designer that is popular with wedding photographers.

Here is a GraphiStudio die-cut magazine-type album with flush bleed pages and embossed cover with a photographic inset in rich leather. This is the top of the line, so far as albums go.

bound in an elegant leather album that is actually a custom-made book. If you want to create album pages with multiple images, your lab must prepare these prints to size before submitting them to the album company for binding.

Magazine-Style Digital Albums

In recent years, there has been a backlash against traditional drop-in album types. While elegant, the contemporary wedding photojournalist does not want to see his or her stylish images placed in anything but the most contemporary album concept.

Covers. Companies like Albums Australia offer everything from stainless steel covers to exotic woods—like pearwood with a golden spine of leather imprinted with autumn leaves. Or perhaps the cover should be something artistic like "fusion," a brushed metal cover that can be accented with a spine that resembles modern art. Or how about a clear cedar cover with a leather spine that is emblazoned with monarch butterflies? Or maybe something hot, like Chili Red Leather? What could be more classically modern than the black & white photo cover with an elegant black leather spine? These are just a few of the myriad cover combinations it is possible to create with Albums Australia's TDA-2 software—and you get to see exactly what the album will look like before placing the order.

Layout. Digital output allows the photographer or album designer to create backgrounds, inset photos,

CREATIVITY COUNTS

Wedding photojournalism seems to be bringing the best and brightest artists into the field because of its wide-open level of creativity. Martin Schembri, who produces elegant, magazine-style digital wedding albums, is as much a graphic designer as a top-drawer photographer. Schembri assimilates design elements from the landscape of the wedding—color, shape, line, architecture, light and shadow—and he also studies the dress, accessories, etc. He then works on creating an overall work of art that reflects these design elements on every page.

and output the pages as complete entities. Sizing the photos does not depend on what size or shape mats you have available; you can size the photos infinitely on the computer. Once the page files are finalized, any number of pages can be output simply and inexpensively. Albums can be completely designed on the computer in programs like QuarkXPress, Photoshop, or InDesign, or with software specific to the album manufacturer.

These magazine-style albums feature dynamic layouts with a sense of design and style. Images are not treated as individual entities, necessarily, but are often grouped with like images, organized by theme rather than in chronological order. This affords the photographer the luxury of using many more pictures in varying sizes throughout the album. Collages and other design techniques are common in the magazine-style album, and you will often see type used sparingly throughout.

Charles Maring suggests sampling the colors of the images using the eyedropper tool in Photoshop. When you click on an area with the eyedropper, the color palette displays the component colors in the CMYK and RGB modes. You can then use those color readings for graphic elements on the page you create with those photographs, producing an integrated, color-coordinated design. If using a page-layout program like InDesign, those colors can be used for color washes on the page or for background colors that match the Photoshop colors precisely.

Storytelling. Perhaps the most attractive feature of the digitally produced magazine-style albums is that they are an ideal complement to the storytelling images of the wedding photojournalist. Because there are no boundaries to page design or the number of images used on each page, the album can be designed to im-

Here's a good example of a gatefold page layout that extends the width of the album to beyond panoramic dimensions. Album by Albums Australia.

This is a very wide panoramic album by Yervant. Open, the album is 25 inches wide—each page is 12.5 x 6.25 inches, which allows for a wide spectrum of storytelling possibilities. Notice that the pages have flow from one scene to the next, like a storyboard. This is intentionally done to treat the eye to a journey across the expanse of both pages.

Here are two of David Williams' "Detail Minis." Sometimes these are album pages, sometimes they are large prints suitable for framing. One is loosely organized around the venue of the wedding, the other is based around the bride getting ready. They are all random shots made with a 50mm f/1.4 lens shot wide open. Williams will sometimes use a small video light to add what he calls "a kiss of light."

part many different aspects of the overall story. The difference between the standard drop-in album type and the magazine-style album is almost like the difference between an essay and a novel. The first tells the story in narrative terms only, the latter illuminates the story with greater nuance and complexity.

David Anthony Williams. Wedding and portrait photographer David Anthony Williams has created a genre of pictures that he produces at weddings called "Detail Minis," which are a series of shots loosely arranged by theme, color, or subject matter. He carries a camera with him specifically for doing the minis. It's a 35mm DSLR with a 50mm f/1.4 lens. He shoots this lens wide open on all of the minis and uses primarily fast ISOs (800 and higher), so that he can shoot in any light.

The "Detail Minis" Williams shoots are sometimes incorporated into double-truck image panels with larger, more conventionally made images; other times, the minis are alone on a page grouped in sixes or twelves as part of a window-pane treatment. They add a flavor to the album that is unsurpassed because, invariably, the minis are things that almost no one else even noticed. There is no theme too far-fetched for him to photograph.

Charles Maring. Charles Maring, well known for his award-winning wedding albums, believes that each page of the album should make a simple statement or tell a story within the overall wedding story. Instead of cluttering pages, he tries to narrow his focus and utilize the images that make the best statement of the moment. He likes to think more like a cinematographer,

Marc Weisberg devotes a lot of time on the wedding day to details and assembles them in a magazine-type layout.

This shows the user-interface of Yervant's Page Gallery. On the bottom are the imported images available to be placed into the layout. On the top left you can see a layout of a two-page spread with a total of four images. On the top right you can see one of the images that has been selected to add a black border to it.

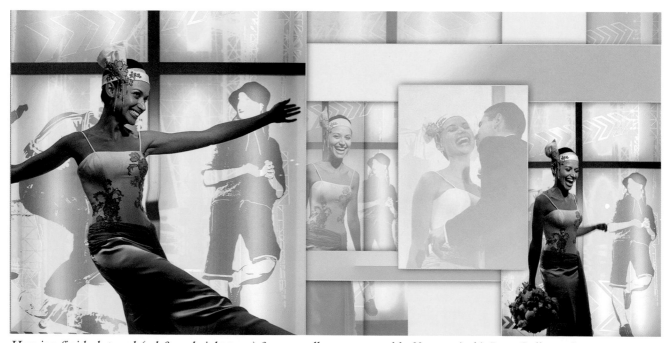

Here is a finished spread (a left and right page) from an album generated by Yervant in his Page Gallery software.

MINI ALBUMS

Photographer Martin Schembri also creates what he calls a "mini-magazine" album—a miniature version of the main album that is small enough for brides to pop in their handbags to show all of their friends. Because they are so portable, the mini albums get far more exposure than a large, precious album. It also works as a great promotion for the photographer.

Here is a collection of various albums offered by Albums Australia, including mini (purse-size) albums for the bride, so she doesn't have to lug the big, expensive album with her to show her friends her wedding pictures.

analyzing the images he sees on the computer monitor and reinventing the feelings of the moment.

Maring thinks of the album as a series of chapters in a book. He uses a scene setter to open and close each chapter. Within the chapter, he includes a well-rounded grouping of elements—fashion, love, relationship, romance, preparation, behind the scenes, ambience, etc. These are the key elements he keeps in mind while documenting the wedding day in his photographs.

Design Templates. To streamline the album-design process, many photographers like to use pre-designed page templates. Australian photographer Yervant has designed a popular software package called Yervant's Page Gallery, which includes hundreds of different, ready-to-use templates. These incorporate artistic designs and layout options designed by Yervant, who is one of the highest-profile wedding photographers in the world. All you have to do is choose an image file, then the software will crop, resize, and position the image into your choice of layout design, all within a few

minutes. Page Gallery is strictly for use by photographic studios that become registered and licensed users. It is not available to labs except by special licensing arrangement, meaning that if you purchase the software, you don't have to worry that every other wedding photographer on the block will be putting out similar albums. For more information, visit www.yervant.com.

The Design Factor. Charles Maring sees digital technology producing a whole new kind of photographer. "I consider myself as much as a graphic artist and a designer as I do a photographer," he explains. The majority of Maring's images have what he calls "layers of techniques that add to the overall feeling of the photograph." None of these techniques would be possible, he says, without the creativity that Photoshop and other programs, such as Corel Painter, give him. "Having a complete understanding of my capabilities has also raised the value of my work. The new photographer that embraces the tools of design will simply be worth more than just a cameraman," he says.

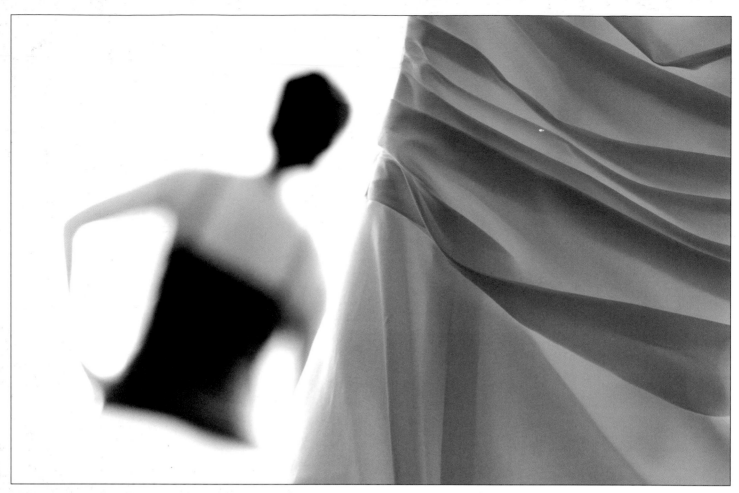

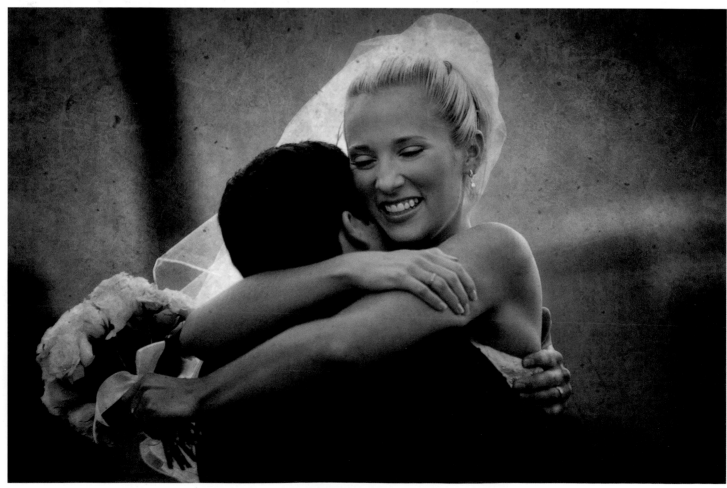

Black & white infrared can produce a striking page in the wedding album. This beautiful example is by Marc Weisberg.

popular is called "sloppy borders," which calls for the lab to print the files with the same look that was produced in film photography when milled, oversize negative carriers were used to allow the edges of the frame to show.

A wide range of edge treatments are available as plug-ins. Extensis Frame Effects operate in page-layout

Facing page, top—Marc Weisberg used selective focus to create an image that would work well on any album page. Marc used an 85mm f/1.8 lens, which has inherently shallow depth of field at its widest apertures, to front-focus on the gown, allowing the bride to go out of focus, almost as if she were a mirage.

Facing page, bottom—This is a popular special effect that calls for using textured layer elements and varying their opacity in the final rendering. These layers are available from a variety of photographers, including Jesh de Rox (http://enlighten.jesh derox.com/#texture). Photograph by Michael Schuhmann.

programs like Quark or InDesign. Photoshop also has a full range of border treatments that are accessed by going to the Actions menu and activating Frames.atn.

Cross-Processing. In film photography, cross-processing meant color slides were processed in C-41 (negative) chemistry, or color negatives were processed in E-6 (color slide) chemistry. Not much of this is done anymore, but the look of cross-processing remains a popular digital effect. It reverses tones and creates a blue or green cast in the image. Tiffen makes several cross-processing filters, which are available in the company's Dfx suite of digital filters (www.tiffen.com).

Infrared Photography. Infrared (IR) film is very grainy and renders green foliage in shades of white or light gray. It also does some beautiful things with light-colored skin tones, producing a milkiness that resembles marble. Black & white infrared film must be

Here is a close-up look at the book binding techniques found in these albums.

handled carefully—the camera must be loaded and unloaded in total darkness. It is probably best to devote one camera body exclusively to IR film, so that you do not have to bring along a light-tight changing bag. The correct shooting ISO is a matter of testing, as is filtration. Most often, black & white infrared is used with a #25 Red filter to darken skies and lighten foliage.

Digital cameras block most IR because it is known to contaminate the visible light being captured on the digital media, thus degrading image quality. Most digital cameras use an IR cutoff filter that blocks all of the infrared radiation. Employing an IR pass filter (Wratten filter #87) to block some or most of the visible light, but yet transmit the infrared radiation, you can produce an effect much like black & white infrared—minus the grain. As with IR film, skin tones are fabulous and quite different than when recorded normally in digital. The drawback to this technique is that long exposures are required, meaning a tripod-mounted camera and bright sunlight—which, oddly enough, does not produce excessive contrast in the final images.

There are also a number of software treatments to produce black & white infrared that do not require the tedium of using the IR Pass filter.

Hand Coloring. Another special effect is hand coloring prints, either with Kodak Retouching Colors or Prismacolor pencils. Often, prints to be hand colored are printed in black & white or with one predominant color visible. The remainder of the print is hand colored. When complete, the image may be scanned (for a digital album), or used as is (for a conventional album). Both styles require patience to perfect. Again, however, this is a technique that can also be accomplished in Photoshop.

Panoramics and Gatefolds. Regardless of which album type you use, adding panoramic format images can add great visual interest—particularly if using the bleed-mount digital or library-type albums. Panoramics should not be done as an afterthought, since the degree of enlargement can be extreme. When shooting panoramics, be sure to offset the bride and groom so that they don't fall in the gutter of a two-page spread.

One of the more interesting aspects of digital albums is the gatefold, which is created using a panoramic size print on the right- or left-hand side, hinged so that it folds flat into the album. Sometimes the gatefold can be double-sided, revealing four page-size panels of images. The bindery can handle such pages quite easily, and it provides a very impressive presentation—particularly if it is positioned in the center of the album.

Albums Australia is a digital album manufacturer that offers gatefolds as a standard feature of their TDA-2 album design software (TDA stands for "total design ability"). This is a drag-and-drop program with full preview capability that lets you design your digital album using just about any page configuration you can imagine. Additionally, the program also features all of the materials variations that the company offers, such as the different colors and styles of leather cover binding and the interior page treatments.

Tilting the Camera. A very popular (and sometimes overused) technique with wedding photojournalists is

tilting the camera. This can be especially effective when used for wide-angle shots—so much so, in fact, that with certain shots it cannot be determined whether the photo is truly a vertical or a horizontal image. Tilting the camera helps improve page dynamics, providing a built-in diagonal line within the composition. You will see lots of tilted shots on digital album pages as "guideposts" leading you to other places within the layout.

Fine Printing

Robert Cavalli is a master printer in every sense of the word. He has an intuitive sense for improving an image and has worked with some of the finest photographers in the world to realize their visions, creating collaborative works of fine art.

Cavalli uses printing techniques that vary from simple approaches to elaborate techniques that might include darkroom vignetting, heavy diffusion, split contrast (areas of the print with differing contrasts), masking to reveal hidden detail in a negative, texture screens, flashing (exposing part of the print to raw light), soft borders, and a myriad of other self-conceived techniques.

Cavalli is a master in the conventional darkroom, but has also been combining traditional and electronic means of improving an image. Of the fusion, he says, "One approach I've used involves scanning a print and then using the computer for efficient digital manipulation to enhance the final outcome. At this point either a computer-generated print can be produced or a sec-ond 4x5-inch negative is made to create a silver-based image. Combining mediums yields the best that chemistry can achieve, while taking advantage of computer technology. Regardless of the techniques used, the ultimate worth of a print is in the lasting impact it has on the viewer."

Cavalli is so well respected that a recent WPPI print exhibit, which featured only prints that earned an Honorable Mention or above, included dozens of Cavalli's prints—he lost count at seventy-five!

Here is a leather and metal cover merged in a magazine-style binding.

GLOSSARY

Balance. A state of visual symmetry among elements in a photograph.

Bleed. A page in a book or album in which the photograph extends to the edges of the page.

Bounce flash. Bouncing the light of a studio or portable flash off a surface, such as a ceiling or wall, to produce indirect, shadowless lighting.

Burning-in. A darkroom or computer printing technique in which specific areas of the image are given additional exposure in order to darken them.

Color temperature. A measurement, noted in degrees Kelvin, describing the color of a light source or film sensitivity. Color films are balanced for 5500°K (daylight), 3200°K (tungsten), or 3400°K (photoflood).

Cross-processing. Developing color negative film in color transparency chemistry or vice versa (developing transparency film in color negative chemistry).

Depth of field. The distance that is sharp beyond and in front of the focus point at a given f-stop.

Dodging. A darkroom or computer printing technique in which specific areas of the print are given less print exposure by blocking the light to those areas of the print, making them lighter.

Double truck. Two facing bleed pages. Usually, this is created so a panoramic or long horizontal image can run across the two pages, going to the edges of the pages.

Dragging the shutter. Using a shutter speed slower than the X-sync speed in order to capture the ambient light in a scene.

Feathering. Deliberately misdirecting the light so that the edge of the beam of light illuminates the subject.

Fill card. A white or silver-foil-covered reflector that is used to redirect light back into the shadow areas of the subject.

Fill light. A secondary light source used to fill in the shadows created by the main light.

Flash-fill. A flash technique that uses electronic flash to lighten the shadows created by the main light source.

Flashing. A darkroom technique used in printing to darken an area of the print by exposing it to raw light.

Flashmeter. A handheld incident light meter that measures both the ambient light of a scene and, when connected to an electronic flash, will read either flash only or a combination of flash and ambient light. They are invaluable for determining outdoor flash exposures and lighting ratios.

Full-length portrait. A pose that includes the full figure of the model. Full-length portraits can show the subject standing, seated, or reclining.

Gatefold. A double-sided foldout page in an album that is hinged or folded so that it can be opened out revealing a single or double page panoramic format.

Gaussian blur. A Photoshop filter that diffuses a digital image.

Gutter. The inside center of a book or album where the pages are bound together.

Head-and-shoulders axis. Imaginary lines running through shoulders (shoulder axis) and down the ridge of the nose (head axis). The head-and-shoulders axes should never be perpendicular to the line of the lens axis.

High-key lighting. A type of lighting characterized by low lighting ratio and a predominance of light tones.

Hot spots. (1) A highlight area of the negative that is overexposed and without detail. Sometimes these areas are etched down to a printable density. (2) The center of the core of light that is often brighter than the edges of the light's core.

Incident light meter. A handheld light meter that measures the amount of light falling on its light-sensitive dome.

Lead-in line. In composition, a pleasing line in the scene that leads the viewer's eye toward the main subject.

Lighting ratio. The difference in intensity between the highlight side of the face and the shadow side of the face. A 3:1 ratio implies that the highlight side is three times brighter than the shadow side of the face.

Low-key lighting. Type of lighting characterized by a high lighting ratio and strong scene contrast as well as a predominance of dark tones.

Main light. The light source that is used to establish the lighting pattern and define the facial features of the subject.

Perspective. The appearance of objects in a scene as determined by their relative distance and position.

Prime lenses. Fixed focal-length lenses as opposed to zooms (variable focal length lenses).

Reflected light meter. A meter that measures the amount of light reflected from a surface or scene. All in-camera meters are of the reflected type.

Reflector. (1) Same as a fill card. (2) A housing on a light that reflects the light outward in a controlled beam.

Rembrandt lighting. A lighting pattern characterized by a triangular highlight on the cheek on the shadow side of the face. This is created by placing the main light at approximately a 45 degree angle to the subject and angling it down toward the face.

Rim lighting. A lighting pattern wherein the main light is placed behind the subject and illuminates the edges of the subject's features. This is most often used with profile poses.

Rule of thirds. A format for composition that divides the image area into thirds, horizontally and vertically. The intersection of two lines is a dynamic point where the subject may be placed for the most visual impact.

Seven-eighths view. Facial pose that shows approximately seven-eighths of the face. It is almost a full-face view as seen from the camera.

Softbox. A diffused light source housed in a box-shaped reflector. The bottom of the box is translucent material; the sidepieces of the box are opaque, but they are coated with a reflective material such as foil on the interior to optimize light output.

Slave. A remote triggering device used to fire auxiliary flash units. These may be optical, or radio-controlled.

Straight flash. The light of an on-camera flash unit that is used without diffusion (*i.e.*, straight).

TTL-balanced fill-flash. An exposure system that reads the flash exposure through the camera lens and adjusts flash output relative to the ambient light for a balanced flash/ambient exposure.

Tension. A state of visual imbalance within a photographic composition.

Three-quarter-length portrait. A pose that shows the subject from the face down to somewhere below the waist.

Three-quarters view. A facial pose that allows the camera to see three-quarters of the facial area. The subject's face is usually turned 45 degrees away from the lens so that the far ear disappears from camera view.

Umbrella. A fabric device, shaped like a rain umbrella, that is used to diffuse light.

Vignette. A semicircular, soft-edged border around the main subject. Vignettes can be either light or dark in tone and can be included at the time of shooting or created later in printing.

Watt-seconds. A numerical system used to rate the power output of electronic flash units. It is primarily used to rate studio strobe systems.

X-sync speed. The shutter speed at which focal-plane shutters synchronize with electronic flash.

Zoom lens. A lens with multiple focal lengths (as opposed to a prime lens).

THE PHOTOGRAPHERS

Nick and Signe Adams. Nick and Signe Adams started Nick Adams Photography in St. George, UT, in 2002. They have been winning awards since they first became WPPI members. They maintain a boutique-type studio business in an historic section of St. George. View their website at www.nickadams.com.

Fernando Basurto *(APM, AOPA)*. Fernando is a wedding photographer who does business in historical uptown Whittier area of Southern California. Specializing in wedding photojournalism Fernando has created some of the most powerful and passionate wedding images of today. His work can be seen at www.elegantphotographer.com/.

Stuart Bebb. Stuart Bebb is a Craftsman of the Guild of Photographers UK and has been awarded Wedding Photographer of the Year in both 2000 and 2002. In 2001 Stuart won *Cosmopolitan Bride* Wedding Photographer of the Year. He was also a finalist in the Fuji Wedding Photographer of the Year. Stuart has been capturing stunning wedding images for over twenty years and works with his wife Jan, who creates and designs all the albums.

David Beckstead. David Beckstead has lived in a small town in Arizona for twenty-two years. With help from the Internet, forums, digital cameras, seminars, WPPI, Pictage and his artistic background, his passion has grown into a national and international wedding photography business. He refers to his style of wedding photography as "artistic photojournalism."

Marcus Bell. Marcus Bell's creative vision, fluid natural style and sensitivity have made him one of Australia's most revered photographers. It's this talent combined with his natural ability to make people feel at ease in front of the lens that attracts so many of his clients. Marcus' work has been published in numerous magazines in Australia and overseas including *Black White, Capture, Portfolio Bride,* and countless other bridal magazines.

Joe Buissink. Joe Buissink is an internationally recognized wedding photographer from Beverly Hills, CA. Almost every potential bride who picks up a bridal magazine will have seen Joe Buissink's photography. He has photographed numerous celebrity weddings, including Christina Aguilera's 2005 wedding, and is a multiple Grand Award winner in WPPI print competition.

Mark Cafeiro. Mark graduated from the University of Northern Colorado with a degree in Business Administration with special emphasis in Marketing. He is the owner of several photography businesses, including Pro Photo Alliance, an on-line proofing solution for labs and professional photographers, and his own private wedding, event, and portrait business.

Bambi Cantrell. Bambi is a decorated photographer from the San Francisco Bay area. She is well known for her creative photojournalistic style and is a highly sought-after speaker at national photographic conventions and schools. She is the author of *The Art of Wedding Photography.*

Robert Cavalli. Robert Cavalli is well known as master print maker whose lab, Still Moving Pictures in Hollywood, CA, attracts the finest portrait and wedding photographers in the country. He is also an accomplished photographer in his own right, holding an MA from the prestigious American Film Institute in Los Angeles.

Michele Celentano. Michele Celentano graduated the Germain School of Photography in 1991, then spent the next four years assisting and photographing weddings for other studios. In 1995 she started her own business photography, and in 1997 she received her certification from the PPA. She has since become a nationally recognized speaker on wedding photography and relocated her business from New York to Arizona.

Jessica Claire. Jessica Claire graduated from North Carolina State University and has studied with photographers all over the country, from North Carolina to Hawaii. She is an

award-winning photographer and a highly sought-after speaker at conventions and trade shows.

Mike Colón. Mike Colón is a celebrated wedding photojournalist from the San Diego area. Colón's natural and fun approach frees his subjects to be themselves, revealing their true personality and emotion. His images combine inner beauty, joy, life, and love frozen in time forever. He has spoken before national audiences on the art of wedding photography.

Noel Del Pilar. Noel is an award-winning wedding photographer from San Juan, Puerto Rico. After fifteen years of photographing weddings, he has established a reputation as a wedding photographer on the cutting edge; his embrace of wedding photojournalism has helped transform the look of wedding photography in Puerto Rico today. Noel specializes in destination weddings and is a preferred vendor of some of the best hotels in Puerto Rico.

Jesh de Rox. Jesh de Rox is a Canadian photographer from Edmonton, Alberta who burst onto the wedding photography scene at the WPPI 2006 convention, where 38 of his entries scored 80 or above. He now teaches extensively all over the country and has a growing wedding business. He is the author and designer of Fine Art Textures, for sale to other photographers for enhancing their artwork, available at www.jeshderox.com.

Dan Doke. Daniel has a drive for perfection, abundant creativity, and special eye for light and form. He is a modern photographer with traditional skills, who draws on his experience in commercial, fashion, and portrait photography to create memorable wedding images.

Mauricio Donelli. Mauricio Donelli is a wedding photographer from Miami, FL. His work is a combination of styles, consisting of traditional photojournalism with a twist of fashion and art. His weddings are photographed in what he calls "real time." His photographs have been published in *Vogue, Town & Country,* and many national and international magazines. He has photographed weddings around the world.

Bruce Dorn and Maura Dutra. These award-winning digital imagemakers learned their craft in Hollywood, New York, and Paris. Maura has twenty years' experience as an art director and visual effects producer, and Bruce capped a youthful career in fashion and advertising photography with a twenty-year tenure in the very exclusive Director's Guild of America. They have earned a plethora of industry awards for excellence in image-making, and now teach worldwide.

Jim and Katarina Garner. Jim and Katarina Garner started photographing weddings in 1999. By fusing editorial fashion photography with a more relaxed, candid approach, Jim and Katarina provide each couple with an amazing collection of images, all while allowing the bride and groom to truly enjoy their wedding celebration.

Jerry Ghionis. Jerry Ghionis of XSiGHT Photography and Video is one of Australia's leading photographers. In 1999, he was honored with the AIPP (Australian Institute of Professional Photography) award for best new talent in Victoria. In 2002, he won the AIPP's Victorian Wedding Album of the Year; a year later, he won the Grand Award in WPPI's album competition.

Greg Gibson. Greg is a two-time Pulitzer Prize winner whose assignments have included three Presidential campaigns, daily coverage of the White House, the Gulf War, Super Bowls, and much more. Despite numerous offers to return to journalism, Greg finds shooting weddings the perfect genre to continually test his skills.

Alfred Gordon. Al operates a full-service studio and has photographed weddings throughout the Southeast. In addition to holding numerous degrees from PPA and WPPI, he received the coveted Kodak Trylon Gallery Award twice and has images in the coveted ASP Masters Loan Collection.

Michael Greenberg. Michael Greenberg was born in Russia, studied to become a concert pianist, lived in Israel, got a medical degree and worked as a computer programmer before settling down with a Toronto photography studio. Weddings happened almost by accident. "I did my first wedding. It was my sister's," he says. He did three more weddings that year, then twelve the next, then a hundred. Now he's almost completely booked for a year in advance!

Jeff and Kathleen Hawkins. Jeff and Kathleen operate a high-end wedding and portrait photography studio in Orlando, FL, and are the authors of *Professional Marketing & Selling Techniques for Wedding Photographers* (Amherst Media). Jeff has been a professional photographer for over twenty years. Kathleen holds an MBA and is a past president of the Wedding Professionals of Central Florida (WPCF). They can be reached at www.jeffhawkins.com.

Gene Higa. Gene Higa travels the world doing what he loves: photographing weddings. He is one of the most sought-after wedding photographers in the world. Originally from Los Angeles, Gene makes his home in San Francisco, but calls the world his office. He has been commissioned to photograph weddings in Spain, the Philippines, Peru, India, Italy, Greece, Mexico, Jamaica, Thailand and on and on. For more, visit www.genehiga.com.

Kevin Jairaj. Kevin is a fashion photographer turned wedding and portrait photographer whose creative eye has earned him a stellar reputation in the Dallas/Fort Worth, TX area. His web site is www.kjimages.com.

Claudia Kronenberg. Claudia Kronenberg is the owner of CKP, Inc. and a master of multitasking. She shoots weddings and portraits, handles marketing and business for the studio, as well as breaking out into the national speaking world. Her passion for her profession is unparalleled.

Emin Kuliyev. Emin is originally from Russia, a large town in Azerbaijan. He has been photographing weddings in New York for more than six years and he has trained under many respected photographers from around the world. He started his own wedding studio in the Bronx in 2000. Today he is a well respected and award-winning wedding photographer.

Charles and Jennifer Maring. Charles and Jennifer Maring own Maring Photography Inc. in Wallingford, CT. His parents, also photographers, operate Rlab (resolutionlab.com), a digital lab that does all of the work for Maring Photography and other discriminating photographers. Charles Maring was the winner of WPPI's Album of the Year Award in 2001.

Dennis Orchard. Dennis Orchard is a member of the British Guild of portrait and wedding photographers, and has been a speaker and an award-winner at numerous WPPI conventions. His unique wedding photography has earned him many awards, including WPPI's Accolade of Lifetime Photographic Excellence.

Joe Photo. Joe Photo's wedding images have been featured in numerous publications such as *Grace Ormonde's Wedding Style, Elegant Bride, Wedding Dresses,* and *Modern Bride.* His weddings have also been seen on NBC's *Life Moments* and Lifetime's *Weddings of a Lifetime* and *My Best Friend's Wedding.*

JB and DeEtte Sallee. Sallee Photography has only been in business since 2003, but it has already earned many accomplishments. In 2004, JB received the first Hy Sheanin Memorial Scholarship through WPPI. In 2005, JB and DeEtte were also named Dallas Photographer of The Year.

Martin Schembri (*M.Photog. AIPP*). Martin Schembri has been winning national awards in his native Australia for 20 years. He has achieved a Double Master of Photography with the AIPP. He is an internationally recognized portrait, wedding, and commercial photographer and has conducted seminars on his unique style of photography all over the world.

Michael Schuhmann. Michael Schuhmann of Tampa Bay, FL, is an acclaimed wedding photojournalist who believes in creating weddings with the flair of the fashion and bridal magazines. He says, "I document weddings as a journalist and an artist, reporting what takes place, capturing the essence of the moment." He has been the subject of profiles in *Rangefinder* magazine and *Studio Photography & Design* magazine.

Kenneth Sklute. Kenneth began his career in Long Island, and now operates a thriving studio in Arizona. He has been named Long Island Wedding Photographer of The Year (fourteen times!), PPA Photographer of the Year, and APPA Wedding Photographer of the Year. He has also earned numerous Fuji Masterpiece Awards and Kodak Gallery Awards.

Cherie Steinberg Coté. Cherie Steinberg Coté began her photography career as a photojournalist at the *Toronto Sun,* where she had the distinction of being the first female freelance photographer. She currently lives in Los Angeles and has recently been published in the *L.A. Times, Los Angeles Magazine,* and *Town & Country.*

Alisha and Brook Todd. Alisha and Brook Todd, from Aptos, California, share their passion for art in their blend of documentary and fine-art photography. They are award-winning photographers in both PPA and WPPI competitions and have been featured in numerous wedding and photography magazines.

Marc Weisberg. Marc Weisberg specializes in wedding and event photography. A graduate of UC Irvine with a degree in fine art and photography, he also attended the School of Visual Arts in New York City before relocating to Southern California in 1991. His images have been featured in *Wines and Spirits, Riviera, Orange Coast Magazine,* and *Where Los Angeles.*

Joel and Rita Wiebner. The Wiebners are a husband and wife photography team, based in Lancaster, PA, who pride themselves on creativity, their playful nature, and their closeness with their clients. In 2007, they opened their first wedding and portrait gallery space in the art district in downtown Lancaster.

David Anthony Williams (*M.Photog. FRPS*). Williams operates a wedding studio in Ashburton, Victoria, Australia. In 1992, he was awarded Associateship and Fellowship of the Royal Photographic Society of Great Britain (FRPS). In 2000, he was awarded the Accolade of Outstanding Photographic Achievement from WPPI. He was also a Grand Award winner at their annual conventions in both 1997 and 2000.

Jeffrey and Julia Woods. Jeffrey and Julia Woods are award-winning wedding and portrait photographers who work as a team. They were awarded WPPI's Best Wedding Album of the Year for 2002 and 2003, two Fuji Masterpiece awards, and a Kodak Gallery Award. See more of their images at www.jwweddinglife.com.

Yervant Zanazanian (*M. Photog. AIPP, F.AIPP*). Yervant was born in Ethiopia (East Africa), where he worked after school at his father's photography business (his father was photographer to the Emperor Hailé Silassé of Ethiopia). Yervant owns one of the most prestigious photography studios of Australia and services clients both nationally and internationally.

Regina and Denis Zaslavets. Denis and Regina are originally from Odessa, Ukraine. She has resided in the U.S. for 27 years and Denis only three years. They own Assolux Photography, a small studio where they do portraiture for adults and children, formal engagements, and family portraits—but weddings, which they cover as a team, are their main passion.

INDEX

A

Adobe InDesign, 107, 112, 115

Adobe Photoshop, 10–11, 107, 113, 116

Albums, wedding, 101–13
approval by the couple, 112–13
bound, 106–7
covers, 106
creativity in design, 106, 111–12
left and right pages, 101–3
library binding, 106
magazine-style, 106–13
miniature, 109, 111
post-mounted, 106
reading direction, 105
storytelling, 107–11
templates, 111
title page, 101
traditional, 105–6
variety of images, 103–4
visual weight, 104–5

Albums Australia TDA-2 software, 106, 116

Anticipating moments, 19–20

Arms, posing, 77

Assistants, 16–19

Autofocus, 28–31
multiple-area, 29–30, 31
predicative, 30–31

Awareness of your surroundings, 23–24

B

Backgrounds in group portraits, 90–93

Barebulb flash, 39

Borders, adding to images, 113–15

Bounce flash devices, 38–39

Bouquet toss, 59–60

Bride and groom, portraits of, 85–89
posing, 87–89
timing, 87

Bride, photographing, 49–51, 81–82
arrival at church, 52
back of the dress, 82
before the ceremony, 49–51
bouquet, 82
exit shots, 54–55
formal portraits, 81–82
outdoors, 82
veil, 82

C

Camera height for correct perspective, 80–81

Camera, tilting, 116–17

Cavalli, Robert, 117

Ceremony coverage, 52–56
bride's arrival, 52
ceremony, 52–53
exit shots, 53–56
procession, 52

Children at the wedding, 61

Colón, Mike, 36

Composition, 62–71, 93
balance, 69–70
contrast, 66–67
direction, 65
group portraits, 93
lines, 67–68
pleasing forms, 65
rule of thirds, 62–65
shape, 68–69
subject tone, 66
tension, 69–70

Concentration, 55

Consultation, 43

Contrast, 66–67

Corel Painter, 111

Couples, posing, 85–89, 93–94

Cross-processing effect, 115
Cutting the cake, 59

D

Depth of field in group portraits, 100
Detail shots, 52, 57, 109
 at the reception, 57
 before the wedding, 52
 "Detail Minis," 109
Digital revolution, 10
Digital SLRs, 27–33
 autofocus, 28–31
 ISO settings, 31–33
 LCD screen, 31
 manufacturers, 28
Dressing for success, 20

E

Emotion, capturing, 20–21
Engagement portraits, 47–49
Enjoying yourself, 25
Equipment, 27–42
 bounce flash devices, 38–39
 digital SLRs, 27–33
 flash, 37–41
 lenses, 28–29
Evolution of wedding
 photojournalism, 8–11
Eyes, direction of gaze, 76–77

F

Face positions, 74–76
 profile view, 76
 seven-eighths view, 75
 three-quarters view, 75–76
Feet, posing, 78–80
Film photography, 10, 27
First dance, 59

Flash, 37–42, 57
 barebulb, 39
 bounce devices, 38–39
 falloff, 39
 flashmeters, 41
 off-camera, 38
 on-camera, 37–38
 remote triggering, 41–42, 57
 studio systems, 39–41
 TTL, 37–39
Flashmeters, 41
Flightcheck software, 112
Focal-length factors, 28–29, 37
Focusing group portraits, 100
Formal portraits, *see* Posing for
 "formals"

G

Gatefold images, 116
Groom, photographing, 51–52,
 82–85
 before the ceremony, 51–52
 couples, 93–94
 cuffs, 85
 expression, 85
 formal portraits, 82–85
 lighting, 85
 necktie, 85
Group portraits, 16, 72–89,
 90–100
 backgrounds, 90–92
 bride and groom, 85–89
 depth of field, 100
 chair as a posing tool, 97
 composition, 93
 even-numbered groups, 97
 focus, 100
 hands in, 97–99
 large groups, 97–100
 panoramic images, 99

(Group portraits, cont'd)
 photojournalistic approach to,
 72–73
 trios, 94
 types of groups, 90

H

Handcoloring, 116
Hands, posing, 77–78, 82, 85,
 97–99

I

Idealization, 15, 21–22
Image sensors, 28, 29, 37
 Foveon X3, 28
 size of, 29, 37
Infrared photography, 115–16
ISO settings, 10, 31–33, 56

K

Kodak Retouching Colors, 116

L

Lenses, 28–29, 33–37
 focal length and chip size, 37
 manufacturers, 29
 pre-digital, 28–29
 prime, 35
 telephotos, 36–37
 vibration reduction, 36
 wide-angles, 35–36
 zoom, 33–35
Lighting at the reception, 60–61
 pole lighting, 60
 videographer's lighting, 60–61
Light modifiers, 38–39, 41, 42, 57
 bounce flash devices, 38–39
 reflectors, 42
 umbrellas, 41, 57
Light stands, 42
Location scouting, 43–47

M

Maring, Charles, 107, 109–12

Meters, light, 41

N

Noise, 33

O

Observation, powers of, 13–15

P

Panoramic images, 99, 116

People skills, 24–25

Pole lighting, 60

Portrait lengths, 80

 full-length, 80

 head-and-shoulders, 80

 three-quarter length, 80

Posing for "formals," 16, 72–89

 arms, 77

 bridal portraits, 81–82

 bride and groom together,

 85–89

 camera height for correct

 perspective, 80–81

 eyes, direction of gaze, 76–77

 face positions, 74–76

 feet, 78–80

 groom's portraits, 82–85

 hands, 77–78

 head and shoulders, 74

 photojournalistic approach to,

 72–73

 portrait lengths, 80

Pre-ceremony coverage, 49–52

 bride, 49–51

 detail shots, 52

 groom, 51–52

Preparation, 19–20, 43–61, 56, 81

 bride and groom, meeting with,

 43

(Preparation, cont'd)

 engagement portraits, 47–49

 formals, planning time for, 81

 for reception coverage, 56

 importance of, 19–20

 location scouting, 43–47

 timeline, developing a, 47

Printing, 117

Prismacolor pencils, 116

Q

Quark XPress, 107, 112, 115

R

Reaction time, 20

Reception, photographing, 56–61

 bouquet toss, 59–60

 couple leaving, 60

 cutting the cake, 59

 detail shots, 57

 first dance, 59

 key players, 57

 lighting at, 60–61

 photojournalistic approach,

 56–57

 room overviews, 56

 scheduled events, 57

 table shots, 60

Reflectors, 42

Reggie, Denis, 9–10

Remote triggering, flash, 41–42, 57

Rings, photographing, 60

Romance, 25

Rule of thirds, 62–65

S

Schembri, Martin, 111

Special effects, 99, 113–16

 borders, 113–15

 cross-processing, 115

 gatefolds, 116

(Special effects, cont'd)

 handcoloring, 116

 infrared, 115–16

 panoramics, 99, 116

 tilting the camera, 116–17

Storytelling, 15–16

Studio flash systems, 39–41

 modifiers, 41

 monolights, 40

Style, 23

T

Table shots, 60

Tiffen Dfx filters, 115

Timeline, developing a, 47

Traditional wedding photography,

 12–13

U

Umbrellas, 41, 57

Uniqueness, 22–23

V

Vendors, networking with, 48

Videographer's lighting, 60–61

W

Williams, David Anthony, 109

WPI, 8–9

WPPI, 8–9

Y

Yervant's Page Gallery, 111

Z

Zanazanian, Yervant, 111

GROUP PORTRAIT PHOTOGRAPHY HANDBOOK

2nd Ed.

Bill Hurter

Featuring over 100 images by top photographers, this book offers practical techniques for composing, lighting, and posing group portraits—whether in the studio or on location. $34.95 list, 8.5x11, 128p, 120 color photos, order no. 1740.

RANGEFINDER'S PROFESSIONAL PHOTOGRAPHY

edited by Bill Hurter

Editor Bill Hurter shares over one hundred "recipes" from *Rangefinder's* popular cookbook series, showing you how to shoot, pose, light, and edit fabulous images. $34.95 list, 8.5x11, 128p, 150 color photos, index, order no. 1828.

THE BEST OF WEDDING PHOTOGRAPHY, 3rd Ed.

Bill Hurter

Learn how the top wedding photographers in the industry transform special moments into lasting romantic treasures with the posing, lighting, album design, and customer service pointers found in this book. $39.95 list, 8.5x11, 128p, 200 color photos, order no. 1837.

CHILDREN'S PORTRAIT PHOTOGRAPHY HANDBOOK

Bill Hurter

Packed with inside tips from industry leaders, this book shows you the ins and outs of working with some of photography's most challenging subjects. $34.95 list, 8.5x11, 128p, 175 color images, index, order no. 1840.

THE BEST OF WEDDING PHOTOJOURNALISM

Bill Hurter

Learn how top professionals capture these fleeting moments of laughter, tears, and romance. Features images from over twenty renowned wedding photographers. $34.95 list, 8.5x11, 128p, 150 color photos, index, order no. 1774.

100 TECHNIQUES FOR PROFESSIONAL WEDDING PHOTOGRAPHERS

Bill Hurter

Top photographers provide tips for becoming a better shooter—from optimizing your gear, to capturing perfect moments, to streamlining your workflow. $34.95 list, 8.5x11, 128p, 180 color images and diagrams, index, order no. 1875.

THE PORTRAIT PHOTOGRAPHER'S GUIDE TO POSING

Bill Hurter

Posing can make or break an image. Now you can get the posing tips and techniques that have propelled the finest portrait photographers in the industry to the top. $34.95 list, 8.5x11, 128p, 200 color photos, index, order no. 1779.

MASTER POSING GUIDE FOR WEDDING PHOTOGRAPHERS

Bill Hurter

Learn a balanced approach to wedding posing and create images that make your clients look their very best while still reflecting the spontaneity and joy of the event. $34.95 list, 8.5x11, 128p, 180 color images and diagrams, index, order no. 1881.

THE BEST OF FAMILY PORTRAIT PHOTOGRAPHY

Bill Hurter

Acclaimed photographers reveal the secrets behind their most successful family portraits. Packed with award-winning images and helpful techniques. $34.95 list, 8.5x11, 128p, 150 color photos, index, order no. 1812.

THE BEST OF ADOBE® PHOTOSHOP®

Bill Hurter

Rangefinder editor Bill Hurter calls on the industry's top photographers to share their strategies for using Photoshop to intensify and sculpt their images. $34.95 list, 8.5x11, 128p, 170 color photos, 10 screen shots, index, order no. 1818.

THE BEST OF PROFESSIONAL DIGITAL PHOTOGRAPHY

Bill Hurter

Digital imaging has a stronghold on photography. This book spotlights the methods that today's photographers use to create their best images. $34.95 list, 8.5x11, 128p, 180 color photos, 20 screen shots, index, order no. 1824.

THE BEST OF PHOTOGRAPHIC LIGHTING
2nd Ed.

Bill Hurter

Pros reveal the secrets behind their studio, location, and outdoor lighting strategies. Packed with tips for portraits, still lifes, and more. $34.95 list, 8.5x11, 128p, 200 color photos, index, order no. 1849.

EXISTING LIGHT
TECHNIQUES FOR WEDDING AND PORTRAIT PHOTOGRAPHY

Bill Hurter

Learn to work with window light, make the most of outdoor light, and use fluorescent and incandescent light to best effect. $34.95 list, 8.5x11, 128p, 150 color photos, index, order no. 1858.

MASTER LIGHTING GUIDE
FOR WEDDING PHOTOGRAPHERS

Bill Hurter

Capture perfect lighting quickly and easily at the ceremony and reception—indoors and out. Includes tips from the pros for lighting individuals, couples, and groups. $34.95 list, 8.5x11, 128p, 200 color photos, index, order no. 1852.

JEFF SMITH'S POSING TECHNIQUES FOR LOCATION PORTRAIT PHOTOGRAPHY

Use architectural and natural elements to support the pose, maximize the flow of the session, and create refined, artful poses for individual subjects and groups—indoors or out. $34.95 list, 8.5x11, 128p, 150 color photos, index, order no. 1851.

THE SANDY PUC' GUIDE TO
CHILDREN'S PORTRAIT PHOTOGRAPHY

Learn how Puc' handles every client interaction and session for priceless portraits, the ultimate client experience, and maximum profits. $34.95 list, 8.5x11, 128p, 180 color images, index, order no. 1859.

MINIMALIST LIGHTING
PROFESSIONAL TECHNIQUES FOR LOCATION PHOTOGRAPHY

Kirk Tuck

Use small, computerized, battery-operated flash units and lightweight accessories to get the top-quality results you want on location! $34.95 list, 8.5x11, 128p, 175 color images and diagrams, index, order no. 1860.

ADVANCED WEDDING PHOTOJOURNALISM

Tracy Dorr

Dorr charts a path to a new creative mindset, showing you how to get better tuned in to a wedding's events so you're poised to capture outstanding images. $34.95 list, 8.5x11, 128p, 200 color images, index, order no. 1915.

JEFF SMITH'S GUIDE TO
HEAD AND SHOULDERS PORTRAIT PHOTOGRAPHY

Jeff Smith shows you how to make head and shoulders portraits a more creative and lucrative part of your business—whether in the studio or on location. $34.95 list, 8.5x11, 128p, 200 color images, index, order no. 1886.

THE PHOTOGRAPHER'S GUIDE TO
MAKING MONEY
150 IDEAS FOR CUTTING COSTS AND BOOSTING PROFITS

Karen Dórame

Learn how to reduce overhead, improve marketing, and increase your studio's overall profitability. $34.95 list, 8.5x11, 128p, 200 color images, index, order no. 1887.

PROFESSIONAL WEDDING PHOTOGRAPHY

Lou Jacobs Jr.

Jacobs explores techniques and images from over a dozen top professional wedding photographers in this revealing book, taking you behind the scenes and into the minds of the masters. $34.95 list, 8.5x11, 128p, 175 color images, index, order no. 2004.

ON-CAMERA FLASH
TECHNIQUES FOR DIGITAL WEDDING AND PORTRAIT PHOTOGRAPHY

Neil van Niekerk

Discover how you can use on-camera flash to create soft, flawless lighting that flatters your subjects—and doesn't slow you down on location shoots. $34.95 list, 8.5x11, 128p, 190 color images, index, order no. 1888.

CREATIVE WEDDING ALBUM DESIGN WITH ADOBE PHOTOSHOP

Mark Chen

Master the skills you need to design wedding albums that will elevate your studio above the competition. $34.95 list, 8.5x11, 128p, 225 color images, index, order no. 1891.

JERRY D'S EXTREME MAKEOVER TECHNIQUES FOR DIGITAL GLAMOUR PHOTOGRAPHY

Bill Hurter

Rangefinder editor Bill Hurter teams up with acclaimed photographer Jerry D, revealing the secrets of creating glamour images that bring out the very best in every woman. $34.95 list, 8.5x11, 128p, 270 color images, index, order no. 1897.

ELLIE VAYO'S GUIDE TO BOUDOIR PHOTOGRAPHY

Learn how to create flattering, sensual images that women will love as gifts for their significant others or keepsakes for themselves. Covers everything you need to know—from getting clients in the door, to running a succesful session, to making a big sale. $34.95 list, 8.5x11, 128p, 180 color images, index, order no. 1882.

THE KATHLEEN HAWKINS GUIDE TO SALES AND MARKETING FOR PROFESSIONAL PHOTOGRAPHERS

Create a brand identity that lures clients to your studio, then wows them with great customer service and powerful images that will ensure big sales and repeat clients. $34.95 list, 8.5x11, 128p, 175 color images, index, order no. 1862.

MASTER GUIDE FOR PHOTOGRAPHING HIGH SCHOOL SENIORS

Dave, Jean, and J. D. Wacker

Learn how to stay at the top of the ever-changing senior portrait market with these techniques for success. $34.95 list, 8.5x11, 128p, 270 color images, index, order no. 1883.

500 POSES FOR PHOTOGRAPHING BRIDES

Michelle Perkins

Filled with images by some of the world's most accomplished wedding photographers, this book can provide the inspiration you need to spice up your posing or refine your techniques. $34.95 list, 8.5x11, 128p, 500 color images, index, order no. 1909.

500 POSES FOR PHOTOGRAPHING WOMEN

Michelle Perkins

A vast assortment of inspiring images, from head-and-shoulders to full-length portraits, and classic to contemporary styles—perfect for when you need a little shot of inspiration to create a new pose. $34.95 list, 8.5x11, 128p, 500 color images, order no. 1879.

PHOTOGRAPHING JEWISH WEDDINGS

Stan Turkel

Learn the key elements of the Jewish wedding ceremony, terms you may encounter, and how to plan your schedule for flawless coverage of the event. $39.95 list, 8.5x11, 128p, 170 color images, index, order no. 1884.

AVAILABLE LIGHT
PHOTOGRAPHIC TECHNIQUES FOR USING EXISTING LIGHT SOURCES

Don Marr

Don Marr shows you how to find great light, modify not-so-great light, and harness the beauty of some unusual light sources in this step-by-step book. $34.95 list, 8.5x11, 128p, 135 color images, index, order no. 1885.

The
bags

Start with embellishing a store-bought bag, learn how to make basic bag shapes, and graduate to creating a leather-fringed fake fur shoulderbag from scratch. These designs cover the full range of styles and materials—both traditional and contemporary—just right for any outfit.

*i*t takes just a couple of minutes to alter the appearance of a store-bought bag and make it one-of-a-kind. All you need to do is add a favorite brooch, a corsage, braids, and ribbons. Keep the bag shape and fabric as classic as possible, and you will find that you can use the same bag over and over again, in a multitude of ways.

shades
of gray

MATERIALS AND EQUIPMENT

- Store-bought satin evening bag
- 20 in (50cm) beaded ribbon
- 20 in (50cm) fringed wool braid
- Artificial silk flower
- Favorite brooch
- Matching threads
- Scissors

1 **FLOWER**
Bend the stem of the artificial flower around the bow on the bag. Stitch into place using a fine needle.

1 **BRAIDING**
Measure the width of the decorative arc on the bag. Take twice the amount of beaded ribbon and fold the ends to the center.

2 *Stitch the ends of the ribbon in place to secure.*

3 *Place the ribbon over the arc and stitch carefully to the top and sides of the arc.*

4 *Take a piece of fringed wool braid. Wind it up into a ball, stitching the base as you go, until you get to the size of pom-pom you require.*

5 *At the cut edge, turn over ⅜ in (1cm). Stitch to finish the pom-pom and attach it to the center of the bag.*

1 **BROOCH**
Pin the brooch to the bag to conceal the bow.

*t*he bright style of this embellished raffia bag will add a ray of sunshine to any outfit. The simple embroidery stitches, sewn in different-colored wool, and the fun pom-poms hide the fact that this bag began life as a kitchen plant-pot holder.

MATERIALS AND EQUIPMENT

- Raffia plant-pot holder
- Green yarn (1 skein)
- Orange yarn (1 skein)
- Pale yellow yarn (4 skeins)
- Red yarn (1 skein)
- Wool needle
- 10 pieces of card, 3 in x 3 in (8cm x 8cm)
- 16 necklace beads
- Metal handbag handle
- Scissors

easter *basket*

1 Take the raffia plant-pot holder and stem stitch the stems of the decorative flowers in green yarn with a wool needle.

2 Using a straight stitch, embroider the petals in orange and red yarn, working from the center outward. Using green and pale yellow yarn, stitch the grass close to the base of the bag.

3 Using a straight stitch, make six-pointed stars in orange and red yarn at random points around the bag.

4 To make each pom-pom, take two squares of card. Find the center by drawing a line through each corner.

5 Using the compass draw one large circle, followed by one small circle. Cut out the two circles from the card.

6 Place the two pieces of card together and wind the wool around the card, until the inner circle is almost full. With a sharp pair of scissors, cut through at the outer edge, to fluff out the yarn.

7 Carefully pull the two pieces of card apart to reveal the center, and tie a piece of yarn tightly around the center to secure. Cut the card from the pom-pom.

8 Sew the pom-poms onto the center of each flower.

9 Unscrew one end of the metal handle and thread on the necklace beads. Screw the end back on. Blanket stitch the handle to the top edge of the bag.

10 Blanket stitch some pale yellow yarn around the top edge of the bag.

*R*evamp a worn-out linen bag with this quick and easy makeover. You won't even need a sewing machine—all you'll need is a little imagination. This witty take on the famous nursery rhyme, *Baa Baa Black Sheep*, shows how you can find inspiration in the most unlikely of places.

three *bags* full

MATERIALS AND EQUIPMENT

- Old linen bag
- 37 in x 7 in (95cm x 20cm) stretch sheepskin fabric
- 12 in x 7 in (31cm x 20cm) white felt
- 3 in x 3 in (7.5cm x 7.5cm) black felt
- 4 in x 4 in (10cm x 10cm) light blue felt
- 20 in (50cm) Bondaweb
- White thread
- Red thread
- Eyelet punch
- Scissors

1 Measure around the base and top of the bag. Cut 2 sheepskin panels for the top, 1 panel for the bottom, and 2 panels to cover the base of the handles —all 4 in (20cm) wide.

2 With the right sides of the bag and the top sheepskin panels together, use running stitch to attach the panels along the top of the bag. Remember to turn in the end seams of the panels first. Using slip stitch, attach the sheepskin to the inside of the bag.

3 With right sides together, stitch on the handle panel to secure it to the bag.

4 Pull the sheepskin panel over the handle and slip stitch it to the inside of the bag.

5 Tack a line of red stitches around the bag, 2 in (5cm) from the base.

6 With right sides together, stitch the sheepskin panel around the base of the bag in line with the red stitches. Stitch together the side seam.

7 Fold under the seam allowance and slip stitch the sheepskin fabric to the base of the bag.

8 Iron Bondaweb to the back of the white, black, and blue felt. Draw and cut out white sheep, black heads, and white and blue clouds onto the Bondaweb. Peel the Bondaweb backing off the sheep shapes and clouds. Iron them onto the bag. Mark the sheep eyes with a punch (or sew eyes with white thread). Peel the backing off the heads and stick onto the sheep.

*t*ough and colorful, this fabric was originally marketed as kite material. Yet it is perfect for a sporty backpack. If you add a fluorescent stripe down the middle, as shown here, the user of this bag will be easy to spot in the dark. Increase or decrease the measurements to make the bag as roomy as you wish.

Stitch point

Fold line

Stitch point

Grain

Center stitching line

Body (cut 2)

Place to fold of fabric

1 square equals 2 in (5cm)

sporty sack

1 Use the pattern to cut out the main bag—once in the pink fabric and once in the yellow fabric—adding an extra inch (2.5cm) for the seams.

MATERIALS AND EQUIPMENT

- 16 in (40cm) pink rayon (standard width 36 in/90cm)
- 16 in (40cm) yellow rayon (standard width 36 in/90cm)
- 3 ft (1m) fluorescent tape
- 5ft (1.5m) pink cord
- 5 ft (1.5m) yellow cord
- Matching thread
- Scissors

2 Place the two pieces of kite fabric together. Tack and stitch straight through the center. Remove the tacking stitches.

3 Open out the fabric. Tack and stitch the fluorescent tape in place over the central seam. Remove tacking stitches.

4 Fold the bag upward with the right sides together. Use a cool iron to press the sides lightly together at the base.

5 Fold some fluorescent tape in half to form a loop and cut at an angle. Repeat.

6 Position the loops of tape at the base of the bag, and tack into place.

7 Machine the side seams, leaving a gap for the drawstring. Turn the bag through to the right side and take out the tacks.

8 Fold the bag over at the top. Machine a double row of stitches in contrasting thread at the top edge.

9 Feed the cord through one base loop and through the top casing, and knot at the base loop. Repeat with some contrasting cord for the other side of the bag.

MATERIALS AND EQUIPMENT

- 12 in (30cm) quilted silk fabric (standard width 36 in/90cm)
- 12 in (30cm) black lining fabric (standard width 36 in/90cm)
- 12 in (30cm) iron-on interfacing (standard width 36 in/90cm)

- Corrugated plastic card
- Two tassels
- 5 ft (1.5m) cord (optional)
- Matching thread
- Scissors
- Craft knife
- Cutting board

*r*eminiscent of an Edwardian-style smoking jacket, this elegant evening purse is deceptively simple to make, yet utterly sophisticated. The basic shape can be tailored to suit your outfit. Here, the fabric is an offcut of pre-quilted silk, jazzed up with antique, black tassels—perfect for that little black number. However, taffetta, velvet, organza silk, or beaded fabric would work equally well.

1 square equals 2 in (5cm)

1 Use the pattern to cut out the main purse fabric, adding an extra inch (2.5cm) for the seams. Cut the lining to the same measurements.

tantalizing tassels

2 Cut out a piece of lightweight iron-on interfacing to the same main pattern and iron it to the wrong side of the fabric.

3 On the lining, sew a small hem at the bottom of the fabric.

4 Keeping the right sides together, tack and stitch the lining and fabric together. Turn through to the right side and press. Remove the tacking stitches.

5 Using the pattern, cut out two pieces of corrugated card.

6 Slot one piece of card into the top section, pushing through to the top. If the fabric is too tight, trim the card to fit snugly. Using a piping foot, machine a line of stitching to hold the card in place, making the flap.

7 Machine stitch a second line 1 in (2.5cm) away from the last stitching line. Insert the second piece of card, and use the piping foot to machine stitch a line below the card, fixing it into position.

8 Turn over the seam allowance of the bottom edge of the fabric and stitch the lining down using a slip stitch.

9 Fold the bottom section over the middle section and tack both sides in place. Machine a line of stitches down both sides. Stitch two decorative tassels to the inside of the bag. Add an optional piece of cord for a shoulder bag.

*b*ridesmaids are easy to overlook when it comes to accessories, but providing them with tailor-made bags can make all the difference. Using beautiful fabric that complements your wedding scheme, add pretty beading and velvet and they'll no doubt want to use them again. If you have any fabric left over, make matching handkerchiefs—they'll come in handy on the Big Day!

Body (cut 2)

Grain

1 square equals 2 in (5cm)

1 Use the pattern measurements to cut out the back and front of the main bag—in the silk fabric, the organza, and the lining fabric—adding an extra inch (2.5cm) for the seams.

2 Cut out a piece of lightweight fusible interfacing to the same pattern, and iron it on to the wrong side of the silk for the back and the front.

wedding belles

MATERIALS AND EQUIPMENT

- 12 in (30cm) pink paper taffeta (standard width 36 in/90cm)
- 12 in (30cm) printed organza (standard width 36 in/90cm)
- 12 in (30cm) lining fabric (standard width 36 in/90cm)
- 12 in (30cm) fusible (iron-on) interfacing
- 16 in (40cm) bead fringing
- 16 in (40cm) velvet ribbon
- Matching thread

3 Tack the organza pieces to the right side of the silk for the back and the front. Pin and tack some beaded fringing to the bag as shown.

4 Position some velvet ribbon over the top edge of the beading. Tack the top and bottom of the ribbon to the bag.

5 Keeping the right sides together, tack and stitch the sides and base of the bag, taking care not to trap the beads in the side seam. Trim seam allowance to ¼ in (5mm).

6 To make the handles, cut two strips of silk and organza 12 in x 1.5 in (30cm x 4cm). With the right sides together, fold them in half lengthways. Machine stitch down the long edge. Trim the seam to ¼ in (5mm).

7 Turn the bag through to the right side. Press with a cool iron. Using a machine, topstitch along both lengths of material close to the edge, and topstitch again close to the previous line of stitching. Place the handles to the right side of the bag and tack to secure them.

8 Tack and stitch along the seams of the lining fabric, leaving an opening at the bottom as shown above. Trim and press.

9 Slip the lining over the bag with the right sides facing. Tack along the top edge, just above the top of the ribbon edge. Machine stitch in place. Remove tacking stitches.

10 Turn in the lining seam, and stitch. Slip the lining back into the bag. Tack along the edges of the ribbon to secure the lining, beads, and ribbon. Machine stitch to finish.

MATERIALS AND EQUIPMENT

- 8 in (20cm) purple slubbed silk (standard width 36 in/90cm)
- 8 in (20cm) gold pleated metallic organza (standard width 36 in/90cm)
- 8 in (20cm) gold lining fabric (standard width 36 in/90cm)
- 40 in (1m) gold cord
- 4 large purple glass or plastic teardrop beads
- 12 medium bronze beads
- Pot of small bronze glass embroidery beads
- Matching threads
- Sticky tape

1 square equals 2 in (5cm)

1 Using the pattern, cut out four pieces of gold fabric for the main body of the bag, four purple shapes for the purple panels, and four pieces of lining fabric adding an extra inch (2.5cm) for the seams.

a t first glance, the pattern for this opera bag looks unusual, but it makes a wonderful teardrop shape, mirrored by the purple teardrop beads. Take your pattern to the store with you, so that the fabric can be cut in the most economical way.

drama queen

2 Pin and tack the organza to the gold lining on all four pieces, with the wrong side of the organza to the right side of the gold fabric.

3 Pin, tack, and machine stitch the side seams and bottom seams of the four pieces of the main bag. Remove all pins and tacking stitches. Trim and press the seams open.

4 Turn over the top edge of organza, mitering the corners at the peak of the corner.

5 To make the purple lining, pin, tack, and machine stitch the purple silk panels to ½ in (1.25cm) from the top edge. Remove all pins and tacking stitches. Trim and press the seams open.

6 Cut the gold cord in half. Place the ends of the cord to the inside of the bag. Catch stitch the cords into place.

Tip Before cutting the cord, wrap some sticky tape around the area to be cut, to prevent the cord from fraying.

7 Slip the lining into the bag, with the wrong sides matching. Turn under the top edge and slip stitch the lining to the main bag.

8 Add 4 in (10cm) of small bronze embroidery beads onto bronze-colored thread. Using a separate needle and thread, catch stitch the line of beads onto the edge of the purple panels at every fifth bead. Repeat this until all the purple edges have been piped.

9 To finish, string a purple drop bead then three copper beads onto some thread and stitch to the bag at each seam point.

*t*he perfect accessory for a race meet or a summer picnic, this bold bag makes a witty statement. The novelty turf is available already made up from garden centers and novelty stores, but you can add your own personal touch, such as a fluttering butterfly or two.

MATERIALS AND EQUIPMENT

- 1 square patch of novelty turf (including flowers) 10 in by 10 in (25cm x 25cm)
- 10 in (25cm) silk lining (standard width 36 in/90cm)
- 2 decorative butterflies (on wire)
- 20 ft (6m) of green satin ribbon
- 14 in (35cm) of transparent tubing (from a hardware store)
- Leather punch
- Matching thread

green
pastures

1 Bind the top and bottom edges of the novelty turf with green ribbon. Knot and stitch the ends to hold them in place.

2 Fold the turf in half, and bind the sides together. Knot and stitch the ends to hold them in place.

3 Using the leather punch, make a hole at the end of each tube.

4 Stitch the transparent tubing to the top of the bag.

5 Bind the butterflies to the turf square, using the attached wire.

6 Cut 10 in x 10 in (25cm x 25cm) square of lining fabric. Fold in half and stitch up the sides with a French seam.

7 Fold over the top edge and stitch a double hem.

8 Push the lining into the bag and slip stitch along the top edge.

*e*xpress yourself with a feather boa and fancy brooch. Keep your outfit simple and you can really push the limit with your accessories. The materials used for this stylish bag are simple and economical, but the overall effect is luxurious and one-of-a-kind.

feathered friend

MATERIALS AND EQUIPMENT

- Hardback book the size of bag you intend to make
- Galvanized wire 11 in x 12 in (28cm x 30cm) from a hardware store
- Thin black feather boa 11 in (28cm) long
- 11 in (28cm) purple organza lining (standard width 36 in/90cm)
- 20 in (50cm) rubber tubing (from bicycle store)
- 2 butterfly catches
- Leather punch
- Fine wire gauge 24 (0.5mm)
- Pliers
- Metal file
- Wire cutters
- Matching thread
- Optional brooch

1 Following the pattern, cut the galvanized wire into three pieces with pliers.

Main body (cut 1)

Side (cut 2)

Grain

1 square equals 2 in (5cm)

2 Fold the large piece of galvanized wire over the book to make a "U" shape.

Tip Make sure your book is not larger than the wire.

3 Attach the two side pieces to the main bag with galvanized wire, oversewing the pieces together. Wear away any sharp edges with a metal file.

4 Make a hole at both ends of the rubber tubing with a leather punch. Place the handle ends to the outside of the bag, and secure them in place with butterfly catches.

5 Using the pattern, cut out the lining fabric, adding an extra inch (2.5cm) for the seams. Machine stitch the side seams and the base line. Trim and neaten the seam allowance, using a zigzag stitch on your machine.

6 Turn the top edge of the lining by ⅓ in (1cm) and tack it into place. Using matching thread, oversew the lining to the top edge of the bag along the folded edge.

7 Cut the boa to fit the top of the bag. Stitch the ends together and bind with thread. Stitch the boa to the organza at 1 inch (2.5cm) intervals. To finish, add a favorite brooch.

*t*here's something flirty and French

about the style of this bag, but the materials are deceptively down-to-earth. Gray wire mesh and gray rubber cord, available from a hardware store, are the basic ingredients, lifted by bright red rosebuds and an artificial rose.

red, red rose

1 Cut out two pieces of galvanized wire from the pattern.

MATERIALS AND EQUIPMENT

- Piece of 20 in x 8 in (50cm x 20cm) galvanized gray wire
- Piece of 2.5 in x 9 in (6cm x 23cm) gray wire mesh
- 20 rosebuds
- 1 artificial rose
- 8 in (20cm) organza lining (standard width 36 in/90cm)
- 40 in (1m) silver raffia braid
- 60 in (1.5m) gray rubber cord (available from a craft store)
- Gauge 24 (0.5mm) gray fine wire
- Small piece of red ribbon

Grain ↕ · Center line · Main body (cut 1)

↕ Center · Base (cut 1)

1 square equals 2 in (5cm)

2 Bend the larger piece of galvanized wire into an oval shape.

3 Overlap the back join by ½ in (12mm) and stitch together the two ends with gray wire. Turn up the bottom edge by ⅓ in (1cm).

4 Take the smaller piece of mesh and turn up the edge by ⅓ in (1cm).

5 Attach the base to the body of the bag, with the base edge overlapping the body of the bag by ⅓ in (1cm). Stitch together with gray wire using a running stitch.

6 Decorate the bag with the rosebuds and an artificial rose. Pin and stitch in place using gray wire. Tie the red ribbon in a bow around the rose stem.

7 Cut the rubber cord into three pieces and plait to form the handle.

8 Turn the top edge of the main bag in by ⅓ in (1cm). Stitch the handles using gray wire to the inside of the side seams.

9 Before lining the bag, stitch the raffia braid with gray wire onto the bottom edge.

12 Push the lining into the bag. Turn under the seam allowance. Pin and tack the lining in place around the top edge.

10 Cut a piece of organza 20 in x 8 in (50cm x 20cm) to make up a lining.

11 Stitch the two short edges of the lining to form the seam. Trim and press open. Attach the base of the lining to the main body. Trim the seam and press open.

13 *On the right side* of the bag, pin on the raffia braiding. Use a running stitch to attach the lining and braid simultaneously to the main bag. Remove all pins and tacking stitches.

_i_nspired by a favorite tribal necklace and offcuts of ethnic fabric found on vacation, this bag was designed as a sentimental tribute to fond memories in the sun. The bright bag is reinforced with suede corners to give it extra strength. Make sure in advance that your necklace is robust enough to be used as a handle.

Main body (cut 2) Grain

Base (cut 1)

Cutting line for suede fabric

Grain

1 square equals 2 in (5cm)

ethnic chic

1 Use the pattern measurements to cut out the fabric for the back and front of the main bag, adding an extra inch (2.5cm) for the seams. Cut out the suede panels, using pinking shears on one edge only. Cut some interfacing using the pattern and iron it onto the wrong side of the main fabric.

MATERIALS AND EQUIPMENT

- 12 in (30cm) yellow printed fabric (standard width 36 in/90cm)
- 12 in (30cm) matching lining (standard width 36 in/90cm)
- 12 in (30cm) heavy iron-on interfacing (standard width 36 in/90cm)
- 2 pieces of 14 in x 4 in (36cm x 10cm) suede (width 36 in/90cm)
- Beaded necklace 25 in (64cm) long
- 2 magnetic fasteners
- Matching thread
- Pinking shears
- Scissors

2 Place one suede panel onto the right side of the main fabric with the non-pinked edge along the bottom edge. Tack and machine a double row of stitches along the pinked edge. Remove the tacking stitches.

3 Keeping the right sides together, stitch the side seams of the main fabric. Trim and press the seams open.

4 Cut out the fabric and two layers of interfacing for the base, adding an extra inch (2.5cm) for the seam. Iron two layers of interfacing onto the wrong side of the fabric.

5 Turn the main body of the bag inside out. With right sides together, tack and stitch the base to the bag. Snip into the corner, trim excess fabric off seams, and remove tacking.

6 Turn the bag through to the right side. To insert the magnetic fasteners, first mark their position on the fabric. Make small incisions where the fasteners are to be attached, and push them through. Press back the ends to secure.

7 Fold over the top edge of the bag, tack along the top edge 1 in (2.5cm) from the edge, and stitch along the tacking line. Remove the tacking stitches.

8 Make up the lining. Use the measurements on the pattern, but just ½ in (2mm) smaller. Place the lining onto the inside of the bag, and attach it to the bag using a slip stitch.

9 Stitch the ends of the necklace securely into the inside of the side seams.

*t*his stylish fake fur and velvet shoulder bag will remind you of warm, winter mufflers on the coldest of days. Reusing a thin patent leather belt for the shoulder strap is a witty touch, but you could use thick leather cord instead. By keeping the bag fairly simple, the different textures of the piece are the main attraction.

winter warmer

Main body (cut 2)

Piping points

Fold line

Cutting line for lining

Grain

Cuff (cut 2)

Grain

Top

Belt point

Fold line

1 square equals 2 in (5cm)

MATERIALS AND EQUIPMENT

- 20 in (50cm) black velvet (standard width 36 in/90cm)
- 8 in (20cm) fur fabric (standard width 36 in/90cm)
- 24 in (60cm) black leather piping
- Patent leather belt (large)
- 12 in (30cm) lining fabric (standard width 36 in/90cm)
- Iron-on interfacing
- Matching thread
- Ruler or tape measure
- Scissors

1 Use the pattern to cut out the back and front of the main bag from the velvet fabric, adding an extra inch (2.5cm) for the seams.

2 Cut out a piece of lightweight iron-on interfacing to the same main bag pattern and iron it to the wrong side of the velvet.

3 Tack and machine stitch the darts on the back and front of the bag. To reduce bulkiness, press the darts of one piece toward the outer seam and the darts of the other piece toward the center.

4 On one piece of velvet, tack on the leather piping to the wrong side. Fan the piping outward at the top, so that it is hidden in the seam when the fabric is turned the right way around.

5 Place the right sides of the two main pieces of material together and tack. Machine stitch along the previous tacking line, using a piping foot, from the top of one side to the top of the other. Remove all tacking stitches and trim the seam allowance to ¼ in (5mm).

6 Cut out the fake fur fabric to the cuff template, adding an extra 1 in (2.5cm) for the seams.

Tip If you machine stitch a fake fur fabric, use a larger stitch on the machine. When complete, using a pin, tease out the threads on the right side and secure.

7 Keeping right sides together, pin and whipstitch down both side seams of the facing, leaving a small opening for the handles.

8 Turn the cuff through to the right side and attach to the top of the velvet bag, tacking along the top edge. Using a large stitch, machine around the entire top edge of the bag. Trim to ½ in (1cm), remove tacking stitches, and turn through to the right side. Turn the cuff over onto the bag.

9 Cut the belt in half. Punch a hole at each end. Put each end through the openings on the sides. Stitch the ends to the bag's seam. To secure the cuff, stitch through the facing seam. Cross-stitch the bottom of the cuff to the interfacing.

10 Cut out the lining following instructions on the pattern. Tack and stitch the darts, and hand stitch the lining into the bag. Remove all tacking stitches.

*t*here's no limit to the creative force you can unleash when making your own bags. Go freestyle with the odds and ends of earrings, brooches, and beads sitting at the back of your jewelry box. They're just going to waste at the moment, so it's time for some stylish recycling.

MATERIALS AND EQUIPMENT

- Spool of brass wire, gauge 14 (1.6mm)
- 16 in x 20 in (40cm x 50cm) offcut of toning organza
- Beads, buttons, earrings, brooches, odd bits of necklaces
- Fine wire, gauge 28 (0.3mm)
- Matching thread
- Wire cutters
- Small pliers
- Adhesive

gilded cage

1 Using the small pliers, bend the brass wire into loops and circles, making two oval shapes about 8 in x 6 in (20cm x 16cm).

2 Make a long strip 14 in x 2 in (35cm x 5cm) to form the base and side panels, looping and bending the wire to your liking using the pliers.

3 *To make the handles, bend the brass wire into a three-sided square using the pliers.*

4 *Slip two large beads onto the handles and fold up the ends with the pliers. Attach the handles to the main bag. Then slip the beads back over the ends of the wire and glue into place.*

5 *Join all three pieces together with the fine wire.*

6 *Thread beads, baubles, and anything else you have hiding in your treasure box, onto the fine wire and twist it around the brass wire loops, knotting the ends.*

7 *Fold the lining fabric in half. Tack and machine stitch the side seams together, using a French seam. Push the lining into the bag.*

8 *Turn over a double hem at the top edge of the lining and hand stitch. Using the wire, gather the top of the lining as you stitch it to the brass wire.*

\mathcal{W}ool makes a warm, cozy, and flexible bag material, and is easy to use, even if you are a beginner at knitting. Personalize your bag with decorative mirrors for an Asian feel, or use decorative embroidery stitches in contrasting thread.

MATERIALS AND EQUIPMENT

- 2 knitting needles, size 7 or 8
- Poodle or bouclé yarn
- Approximately 60 small Indian decorative mirrors
- 1 large Indian decorative mirror
- 12 in (30cm) matching lining (standard width 36 in/90cm)
- Matching thread
- Scissors
- One large, flat button, the same size as the large mirror

mirror, mirror

1 Cast on enough stitches, depending on your wool, to make a 12 in (30cm)-wide piece of fabric.

2 Knit one, purl one to a length of 26 in (65cm). Cast off.

3 With the right sides together, fold up and whip stitch the side seams using the wool.

4 Cast on stitches to make the handle, 2½ in (6cm) wide. Knit one, purl one to a length of 32 in (81cm) and cast off. Use some wool to hand stitch the handle onto the side seams of the main bag.

5 To make the looped fastener, cast on stitches equivalent to ¾ in (2cm) wide. Knit one, purl one to a length of 12 in (30cm). Attach the loop to the right side of the bag with wool.

6 Catch stitch the decorative mirrors onto the back and front of the bag.

7 Glue the large decorative mirror onto a large button and stitch into position as a catch for the loop fastener.

8 Cut the lining fabric to 12 in x 26 in (30cm x 65cm). Tack and machine stitch the side seams, trim and press them open.

9 Turn over the top edge by ⅓ in (1cm). Push the lining into the bag and slip stitch the top edge into place.

*C*rochet need not be limited to yarn or string… why not create a copper wire and green glass bead bag to stand out from the crowd? The technique is so simple and the materials long-lasting that you won't be able to keep this design to yourself for long.

MATERIALS AND EQUIPMENT

- No. 6 crochet hook
- 100 green glass beads
- Gauge 28 (0.3mm) diameter copper craft wire
- 1 ft (30cm) green rubber tubing
- 60 small copper colored glass embroidery beads

copper
crochet

1 Feed about 100 green glass beads onto the copper wire.

3 Begin to crochet. Add one bead into every second stitch on every second row (so that the beads appear in alternate spaces). Crochet to a length of 20 in (50cm).

2 Push the green beads down the copper wire and cast on 20 stitches using a No. 6 crochet needle.

6 Feed about 30 small copper beads onto the remaining wire. Wrap the beaded wire around the tubing to hide the stitches, and knot to finish.

4 Fold the crocheted piece in half and whip stitch the side seams using copper wire.

5 Stitch the tubing to the outside of the side seams with a needle and wire.

MATERIALS AND EQUIPMENT

- 12 in (30cm) jade silk (standard width 36 in/90cm)
- 16 in x 1½ in (30cm x 4cm) jade silk
- 12 in (30cm) wadding interlining (standard width 36 in/90cm)
- 12 in (30cm) Vylene (standard width 36 in/90cm)
- 12 in (30cm) lining (standard width 36 in/90cm)
- Matching thread
- Scissors

S haped like a corset worn in a Parisian chorus line, this jade green evening bag is made even more sumptuous with a rose corsage created from complementary shades of green organza ribbon. The delicate silk of the bag is strengthened with wadding interlining, and the whole piece is given a lift with some simple quilting.

Facing (cut 2)

Grain

Lining cutting line

Grain

Main body (cut 2)

1 square equals 2 in (5cm)

french fancy

1 Use the pattern to cut out the silk fabric for the back and front of the main bag, adding an extra inch (2.5cm) for the seams. Cut out the Vylene for the back of the bag only, using the same pattern.

2 Cut out the Vylene and wadding for the front of the bag using the pattern, adding an extra inch (2.5cm) for the seams. Use the template to mark up the quilting lines on the Vylene.

4 Working with the wrong side up, quilt using a straight stitch on the machine.

5 Keeping the right sides together, place the back and the front together. Tack and stitch them into place. Trim the seam allowance.

6 Make the straps by folding the long edges of a strip of fabric 16 in (40cm) long by 1.5 in (4cm) wide to the center. Fold the long edges into the center once more. Tack and machine stitch along the edges. Repeat this to make four straps.

3 Sandwich the wadding between the silk and the Vylene. Tack all the way round, and also through the center.

8 Cut some facing fabric and iron-on interfacing using the pattern. Iron these together. Cut out the lining fabric from the pattern, adding an extra inch (2.5cm) for the seams.

9 Machine stitch the facing to the lining, keeping the right sides together. Trim and press open.

7 Pair the straps, two by two, and tack into position at the top edge of the bag by the second row of quilting.

11 With the right sides together, place the lining over the bag. Tack and stitch into place around top edge. Trim, and turn the lining through to the inside of the bag. Remove tacking stitches.

10 Keeping right sides together, tack and stitch the side seams. Trim and press open. Remove the tacking stitches.

12 Tack along the top edge. Press, and machine two rows of stitching, close together, around the top edge of the bag.

13 Pull the lining back out of the bag. Turn under the seam allowance along the unstitched edge. Tack and stitch into place. Return the lining back into the bag.

14 As an optional decorative feature, stitch on a corsage made from matching light and dark green organza ribbons.

*i*nstead of relying on more traditional fabrics such as silk, satin, or leather to make a bag, create your own evening bag from knitted wire and fake pearls. By using the spool-knitting technique learned in your childhood, you can quickly transform your bag into a unique piece of jewelry.

knit and pearl

MATERIALS AND EQUIPMENT

- 2 knitting needles (size 8)
- Gauge 28 (0.3mm) diameter purple craft wire
- Gauge 28 (0.3mm) diameter silver craft wire
- Old costume jewelry (fake pearls, brooch, earrings)
- 6 in (15cm) silver lamé lining (standard width 36 in/90cm)
- Wooden cotton spool
- 6 thumbtacks
- Hammer
- Crochet hook
- Matching threads

1 Cast on 25 stitches with the purple craft wire.

2 Knit one, purl one to a length of 20 in (50cm). Cast off.

3 Fold up the knitted rectangle and hem the side seams with wire, using a whip stitch.

4 Knit a 1 in (2.5cm) continuous border in silver wire, 11 in x 1 in (28cm x 2.5cm).

5 Attach the silver border to the top edge of the bag with the silver wire, using a whip stitch.

6 Decorate with pearls, beads, brooches, and baubles of your choice.

7 Cut out a piece of silver fabric, 5.5 x 20 in (14cm x 50cm).

8 Fold the fabric in half and join the sides together with a French seam.

9 Turn over the top edge of the bag. Slip stitch the silver fabric to the cuff edge, as shown.

10 To make the handle of the bag, take a wooden cotton spool and hammer 6 thumbtacks into a circle around the hole.

11 To spool knit, cast on by passing the silver wire around the front of a thumbtack, loop it around the back of the same tack, turning the loop in a counterclockwise direction. Move in a clockwise direction to the next tack and wind the wire around all the thumbtacks.

12 Cast a second stitch onto the first thumbtack. Using a crochet hook, pick up and lift the lower of the two stitches and pass it over the top stitch. Drop this into the hole of the spool. Continue knitting until you have a strip 20 in (50cm) long.

13 To cast off, pick the stitches off the spool with a crochet hook. Secure by threading the ends of the wire into the loose stitches and knot.

14 Catch stitch the handle to the side seams of the bag, using the silver wire.

*R*emember being caught in a fall breeze with the leaves swirling around your feet? The clever use of cut-out leaf motifs gives this felt shopper a three-dimensional edge that is bound to be a talking point. Easy to use, felt is a hard-wearing alternative to silk, yet looks just as appealing—perfect for trips to the store.

falling leaves

1 square equals 2 in (5cm)

Facing (cut 2)

Place to fold of fabric

Main body (cut 2)

Grain

Place to fold

Grain

Base (cut 1)

MATERIALS AND EQUIPMENT

- 16 in (40cm) brown felt (standard width 54 in/140cm)
- 4 in (10cm) orange felt (standard width 54 in/140cm)
- 16 in (40cm) lining (standard width 36 in/90cm)
- 2 small pieces of iron-on interfacing (standard width 36 in/90cm)
- 40 in (1m) leather cord
- Matching thread
- Ruler or tape measure
- Scissors
- Craft knife
- Cutting board

Leaf template (at 50%)

1 Using the pattern, cut out the body and the base of the bag from brown felt. Cut out the facing and 2 strips for the handles, 25 in x 2 in (64cm x 5cm), from the orange felt. Add an extra inch (2.5cm) for the seams.

2 Cut out a piece of lightweight iron-on interfacing to the same main bag, handles, and facing templates and iron them on to the wrong side of the fabric.

3 Using the leaf template, cut out 9 leaves in brown felt.

4 Cut a piece of light orange contrasting felt larger than the leaves. Machine a line of straight stitch through the center of the leaves to hold the two pieces in place.

5 Using the brown leaf as a guide, trim the orange leaves about ¼ in (5mm) larger than the brown leaf.

6 Pin the leaves on to one side of the bag as illustrated. Tack and machine stitch them in place using a narrow zigzag stitch.

7 Taking both main parts of the bag, place the right sides together. Tack and machine stitch the side seams. Trim and press open. Remove tacking stitches.

8 On the right side, machine a double row of stitching.

9 Pin, tack, and machine stitch the base into the bag, keeping the right sides together. Snip into the corners.

10 Using the pattern, make up the lining as shown in steps 7, 8, and 9, but make it 1/12 in (2mm) smaller. Turn the bag through to the right side. Drop in the lining and tack around the outer edge.

11 Take the leather cord, and cut each end at an angle with a craft knife. Reinforce the ends of the felt handles with iron-on interfacing.

12 Wrap the orange felt around the leather cord and tack it into position. Using a piping foot, machine stitch as close to the cord as possible. Repeat the stitching to reinforce the seam. Trim the felt close to the stitch line. Remove tacking stitches.

13 Place the handles to the right side of the bag.

14 Keeping the right sides together, machine stitch the side seams of the contrasting felt facing. Trim the seam allowance and press open. Neaten the lower edge with a row of zigzag stitching.

15 Attach the facing to the bag. Tack and stitch into position. Remove tacking stitches.

16 *Turn the facing over to the wrong side and tack through the seam allowance, so that the handles sit correctly. Stitch through the well of the seam line to keep the facing in place. Put another row of stitching 1 in (2.5cm) below this line.*

*t*his personalized patchwork bag can be made from a single piece of material or any leftover remnants found in the workbox. You can customize it further with decorative braid, ribbon, motifs, even sequins, buttons, and beads. Here, the bag has been personalized with ribbon and braid bought in Nepal, and will serve as a useful souvenir of a happy trip.

patchwork perfect

MATERIALS AND EQUIPMENT

- 12 squares in all, 9 in x 9 in (23cm x 23cm), 6 different colors/patterns
- Strip of fabric 4.5 in (12cm) long
- 18 in (46cm) lining fabric
- 5 yds (4.5m) ribbon
- 5 yds (4.5m) fine braid
- Matching thread
- 4 decorative motifs

Cuff (cut 2)

Cut 2

Cut 2

Cut 2

Grain

Main body (cut out x 2 in panels according to color)

Main body (cut out in panels x 2)

Cut 2

Cut 2

Cut 2

Base line

1 Sew the squares, right sides together, in 2 rows of 3 squares. Repeat for the back.

2 Disguise the seams of the patchwork with fine braid.

3 Attach the decorative ribbon to the central panel on the front and back.

4 Tack and stitch together the right sides of the side seams. Trim and press open. Then tack and machine stitch the bottom seam. Remove all tacking stitches and turn right side out.

5 On the right side, machine the fine braid down the side seam using a zigzag stitch.

6 With the bag inside out, flatten the corner. Stitch across the corner and trim off the edge.

7 Take the fabric for the top panel and, with the right sides together, stitch the side seams. Trim the seams and press open.

8 Attach the top panel, with the right sides together. Trim and press the panel upward.

9 Hand stitch the ribbon to the outside top of the bag.

10 Machine stitch 2 lengths of ribbon together to make the handles. Machine stitch along both edges of the handles. Repeat for second handle.

11 Attach the ribbon handles to the outside of the bag using catch stitch.

12 Hand stitch the decorative motifs into position.

14 Use the main pattern to cut out the lining fabric. Machine stitch the seams to the base, with the right sides together. Turn the lining inside out, push it into the bag, and slip stitch the lining to the inside top of the bag.

13 Turn over the top edge of the bag and tack into place. Press.

MATERIALS AND EQUIPMENT

- 18 in (46cm) gold satin (standard width 36 in/90cm)
- 18 in (46cm) black lace (standard width 36 in/90cm)
- 9 in (23cm) black lining (standard width 36 in/90cm)
- 9 in (23cm) buckram (standard width 36 in/90cm)
- 9 in (23cm) domette (standard width 36 in/90cm)
- 18 in (46cm) Petersham ribbon (½ in/12mm wide)
- 36 in (90cm) beaded ribbon
- 18 in (46cm) bias binding
- 1 hair band
- 1 large silk rose
- 2 small roses
- Black and gold feather trim
- Matching threads
- Florist's wire
- Fabric glue

*t*his fabulous flower, feather, bead, and lace bag is a work of art in its own right. Admirers will never guess that the design was inspired by a humble flower pot! Easy to make, yet ever so sophisticated, this evening bag was created without a sewing machine.

belle *époque*

1 Use the pattern to cut out all the shapes from the buckram fabric leaving a 1 inch (2.5cm) seam allowance. Take the buckram for the main bag and overlap the back by ³⁄₈ inch (1cm). Tack and stitch together with running stitch.

2 Take some medium-weight florist's wire and use blanket stitch to attach it to the top edge of the bag. Cut a strip of bias binding 16 inches (40cm) long. Place it over the raw edges of the bag, top and bottom, and tack it into place.

3 For the cuff, use blanket stitch to sew some medium-weight florist's wire along the side edges and the bottom.

4 Bind all four edges of the cuff with bias binding, snipping and mitering the corners.

5 For the lining, use the pattern to cut out all the shapes from the domette. Cut on the bias, leaving a 1 inch (2.5cm) seam allowance.

6 Cover both shapes with domette, butting rather than overlapping the edges at the back of the bag. Trim off the seam allowance at the join and whip stitch to secure.

7 Turn over the surplus domette, top and bottom, for both the cuff and the bag.

8 Using the pattern for the main bag, cut out a piece of satin and a piece of lace, leaving a 1 inch (2.5cm) seam allowance. Tack the two pieces together, placing the wrong side of the lace to the right side of the satin.

9 Fold in half and, with the right sides together, hand stitch the back join with a slip stitch, using a fine needle. Trim and press open.

10 Place the fabric over the main body of the bag and pull it into position. Turn the seam allowance at the top and bottom up into the bag, and glue it to the insides.

12 Cover the base with domette. Repeat with the satin and lace.

11 Take the base and snip into the seam allowance at intervals. Turn up the snipped seam.

13 Slip the base into the main body of the bag, ³⁄₁₆ inch (0.5cm) from the bottom edge. Use large running stitches to secure it in place. Make sure that the stitches are hidden within the lace pattern.

14 Using the cuff pattern, cut out one piece of satin and one piece of black lining, leaving a 1 inch (2.5cm) seam allowance. Place the satin over the domette. Turn under the seam allowance on both sides and the base, and glue to the reverse side.

15 Attach the lining to the inside of the cuff. Trim and turn under the seam allowance, securing with a hem stitch. Trim the lining along the top edge, almost to the edge of the buckram.

16 Attach the main cuff to the bag using whip stitch along the top edge.

17 Fold the top of the satin cuff over to the inside of the bag, gluing the edge down to secure it.

18 Use a slip stitch to attach the beaded ribbon to the outer edge of the cuff, taking care to miter the corners.

19 Take a plastic hair band and use a warm iron to press out the curve.

20 Cover the hair band with a bias strip of satin and glue together the long edges down the inside of the hair band. Glue a strip of ribbon over the join.

23 Decorate with assorted flowers and feathers of your choice.

22 Cut out the lining to the main pattern. Hand stitch the center back join and base of the lining, and slip stitch it to the top inside of the bag.

21 Attach the hair band to the inside of the bag with a catch stitch.

*M*ade of waterproof mesh with colored leather trimmings, this bag has a stylish utilitarian feel, and its foldaway central flap cover makes it practical for all-weather use. You can vary the decoration according to taste: for a different look, use felt instead of leather for the trimmings, and try geometrical shapes with bright or seasonal colors.

MATERIALS AND EQUIPMENT

- 32 in (80cm) opaque mesh (standard width 36 in/90cm)
- 5 in (12.5cm) red leather (standard width 54 in/140cm)
- 5 in (12.5cm) green leather (standard width 54 in/140cm)
- Ruler or tape measure
- Clicking knife or scalpel
- Cutting board
- Awl
- Double-sided carpet tape
- Pinking shears
- Scissors

all meshed up

1 square equals 2 in (5cm)

Facing (cut 2) — Grain

Handle position

Flap (cut 1)

Main body (cut 1)

Grain

Grain

Place to fold

Base line

Place to fold of fabric

1 Use the pattern to cut out the main bag, flap cover panel, and facing from the mesh material, adding an inch (2.5cm) for the seams. Cut out the leather handles: two strips 22 in x 2 in (55cm x 5cm) from the red and 22 in x 1 in (55cm x 2.5cm) from the green. Make the flower stems from thinner strips of green leather, and the flower heads from red leather cut in circles with the pinking shears.

2 Tie a knot in the middle of each stem. Pierce the center of each flower head with the awl and fix two pieces of carpet tape on the back. Run both the stem ends through the hole in the flower head so that the knot shows on the right side, then fix carpet tape to the back of the stems.

3 Position the flowers on the front of the bag using the tape to hold them in position. Machine stitch a single line up one strand of the stem and down the other, holding the head out of the way.

4 Make the handles by folding the red pieces over lengthways so they meet in the middle. Fix a strip of carpet tape to the back of each piece of green leather. Press this down on the back of the red pieces so the join is completely covered, and machine stitch. Pin in position on the bag and machine stich.

5 Neaten the edges of the inside flap cover by turning over ½ in (1cm) seam allowance on three sides, wrong sides together, leaving the top edge unturned. Machine stitch. Place over the center of the front body of the bag right sides together, with the unturned edge at the top, and machine stitch just above the seam line, ½ in (1cm) from the edge.

6 Make the facing by sewing the two strips right sides together at their narrow edges. Turn up the hem wrong sides facing ½ in (1cm) at the bottom and machine stitch all around it.

7 With right sides of the front and back body of the bag together, sew up the side seams. Fold out the bottom of the bag, making sure the center of the base falls in line with the side seams, and machine stitch along the base on both sides.

8 Turn the bag right side out and position the facing along the top edge, right sides together, with the unturned edge of the facing to the top of the bag. Machine stitch on the seam line all around the top of the facing and bag.

9 Turn back the facing to the inside of the bag and machine stitch all around ½ in (1cm) from the top to give a firm, straight edge. Trim all thread ends to finish.

MATERIALS AND EQUIPMENT

- 20 in (50cm) corduroy furnishing fabric (standard width 54 in/140cm)
- 20 in (50cm) lining material (standard width 36 in/90cm)
- 20 in (50cm) iron-on interfacing (standard width 36 in/90cm)
- 30 in (80cm) decorative braid
- 4 in (10cm) suedette or felt (standard width 54 in/140cm)
- 12 in x 3 in (30cm x 8cm) piece of corrugated plastic card
- 6 brass studs
- Matching threads
- Pinking shears
- Scissors

*t*ough and versatile, corduroy furnishing fabric is perfect for a hard-wearing tote bag. The suedette patches lift the design, making it more individual. Here, the bag is a neutral color, however you could make a bolder statement in red, pink, or orange, or a sleekly sophisticated version in black and gray.

carried away

1 square equals 2 in (5cm)

1 Use the pattern to cut out the corduroy fabric for the main bag, adding an extra inch (2.5cm) for the seams. Cut out the iron-on interfacing to the same pattern and iron on to the wrong side of the main bag fabric.

2 Cut out the corner patches in suede, using pinking shears on the curved edges.

3 Pin, tack, and stitch the suede corners to the cord fabric as shown above.

4 Cut out the cord pocket using the pattern. Machine stitch the cotton tape along the top edge of the pocket. Fold the tape down onto the right side. Machine stitch down the two short edges of the tape. Trim and turn through.

5 Miter the corners of the pocket to prevent bulkiness. Turn the seam in on three sides. Machine stitch along the bottom edge of the tape.

6 Pin, tack, and stitch the pocket to the bag. Machine a double row of stitching around all three sides of the pocket.

7 Pin, tack, and machine stitch the side seams of the main bag, with the right sides together. Trim the seams and press open.

8 Tack and machine stitch the bottom edge of the side panel to the base. Repeat for the other side panel. Turn through to the right side.

9 An optional feature would be to cover the side seams with a piece of decorative braid. Slip stitch into place.

10 Fold ¼ in (5mm) along each long edge of the handle fabric. Bring the two folded edges together. Tack into place and machine stitch along both long edges. Then machine another three rows of stitching between the two outer rows.

11 Pin the handles to the top edge of the bag. Tack and stitch two rows into place.

12 Turn over the top of the bag to make an automatic facing 4 in (10cm) in from the top. Machine a row of stitching around the top of the bag.

13 Cut out a piece of corrugated plastic board ¼ in (5mm) smaller than the central section of the template. Mark the positions of the base studs. Using a leather punch, punch out 6 stud holes. Drop the plastic board into the bag.

14 Push a pin through each stud hole from the inside to show the position of the stud. Push the stud through the bottom from the outside, where the pin pokes through. Inside the bag, open up the stud prongs over the board.

15 Using the template, make up the lining $\frac{1}{12}$ in (2mm) smaller than the main bag. Sew the side and bottom seams. Drop in the lining and slip stitch 1 in (2.5cm) away from the top edge.

MATERIALS AND EQUIPMENT

- 20 in (50cm) Indian silk (standard width 36 in/90cm)
- 20 in (50cm) matching lining (standard width 36 in/90cm)
- 20 in (50cm) wadding interlining
- 20 in (50cm) Vylene
- 3 ft (1m) plastic tubing
- 3 ft (1m) novelty crinolyn tubing
- 10 in (26cm) zipper
- Craft knife
- Cutting board
- Dressmaker's carbon paper
- Matching threads
- Scissors

pretty in pink

S hopping bags needn't be drab and boring, as this vibrant silk shopper shows. The luxurious quilting and pretty sheen of the pink silk will survive the most critical of store assistant's scrutinies. And once you have mastered the quilting technique, no fabric will be safe!

Quilting guide

1 Cut a square of silk, wadding, and Vylene 1 in (2.5cm) larger than the pattern, for the back, sides, and front of the bag.

Facing (cut 2)
Grain
Fold
Main body (cut 2)
Grain
Place to fold of fabric
Grain
Place to fold or piece together
Cutting line
Zipper panel (cut 1)
Grain

2 Mark up the quilting lines on the Vylene, as shown on the quilting guide. Use carbon paper to transfer your design to the Vylene.

3 Sandwich the wadding between the silk and the Vylene. Tack through the materials, as shown above.

4 Working with the wrong side up, quilt the fabric pieces using a straight stitch on the machine. Remove the tacking stitches.

5 Place the pattern back onto the quilted fabric and cut, leaving a ¾ in (2cm) seam allowance.

6 Keeping right sides together, place the front to the side. Tack and stitch into place. Repeat for the back, attaching the back to the sides. Remove the tacking stitches.

7 Trim the seam allowance to ¼ in (5mm) and press. To hold the seam in place, catch stitch the seam allowance to the interfacing.

8 Take 20 in (50cm) of plastic tubing and slip it into the novelty crinolyn. Pull the crinolyn over the tube, and finish and stitch the ends, holding the tube in place. Trim off excess crinolyn.

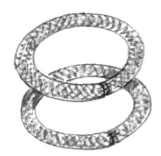

9 Bring the tube ends together and stitch the two ends to form a circle.

10 Cut two strips of silk material 2½ in (6cm) wide by 2½ in (6cm) long, on the bias. Iron on some woven interfacing, cut on the bias, to strengthen the strips. Fold the two edges to meet in the center. Wrap this over the joined ends of the handle loops, to conceal the join. Tack in place.

11 Attach the handles to the bag at the center. Tack and machine stitch them into place.

12 Using your pattern, cut out the zipper placket. Fold in the turnings along the two edges of the material. Pin and tack the zipper along one long edge. Then tack the other piece of material onto the other side of the zipper.

13 Using a zipper foot, machine the zipper into place. Machine stitch another row of stitches ¼ in (5mm) in from the zipper edge, to hold the zipper tape in place. Remove all the tacking stitches.

14 Cut the facing material from the silk, using the pattern. Add an extra inch (2.5cm) for the seam. Iron some medium-weight iron-on interfacing to the facing material. With the right sides together, machine stitch the side seams. Trim and press open.

15 Attach the zipper placket to the facing by tacking and machine-stitching along the lower edge of the facing (match the notches). Remove the tacking and trim the seam.

16 Keeping the right sides together, place the facing on the bag. Tack along the top edge. Then, using a piping foot, machine stitch around the top of the bag. Trim and turn facing through to the inside of the bag. Remove the tacking stitches.

*g*o wild with this unusual cheetah print bowling bag made from furnishing fabric. You may find that the fabric styles in the furnishing section are better suited to bag designs, especially those that are going to see a certain amount of wear and tear. If you have enough fabric left over, why not make a matching purse?

bowled over

MATERIALS AND EQUIPMENT

- 16 in (40cm) animal print furnishing fabric (standard width 54 in/140cm)
- 16 in (40cm) matching lining (standard width 36 in/90cm)
- 16 in (40cm) iron-on interfacing (standard width 36 in/90cm)
- 4⅓ in x 8 in (22cm x 40cm) corrugated plastic board
- 3 ft (1m) leather cord
- 18 in (46cm) open-ended zipper
- 6 in (15cm) fine leather cord
- 1 brass toggle end
- Matching thread
- Craft knife
- Cutting board
- Scissors

1 Use the pattern to cut out the pieces of fabric for the main bag, adding an extra inch (2.5cm) for the seams. Cut out the iron-on interfacing for all pieces using the same pattern.

Main body (cut 2)

Grain

Place to fold of fabric

Zipper panel

Cutting line

Grain

Place to fold of fabric

Base (cut 1)

Grain

Place to fold of fabric

Grain

1 square equals 2 in (5cm)

2 Using an open-ended zipper, pin and tack it onto the right side of the placket fabric. Machine along the stitch line and trim the seam allowance. Fold over to the right side. Repeat for the other side of the zipper. Zip the two pieces together.

3 Place the pattern for the zipper placket centrally over the zipper and mark the new seam lines.

4 Keeping the right sides together, stitch the two end sections of the placket to both ends. Trim the seam allowance and press.

5 To make the handles, cut some leather cord in half (about 18 in/0.5m for each handle). Cut the ends diagonally using a craft knife.

6 Fold the handle fabric down the long edges. Wrap around the leather piping. Using a double thread, whip stitch the two folded edges together.

7 Place the handles to the side panels of the bag (the position is marked on the template). Tack into place. With the right sides and matching notches together, tack and stitch the side panels to the zipper placket. Trim excess material and remove tacking stitches.

***Tip:** Avoid sewing over the leather cord, as this may break your machine.*

8 Turn the bag back to the right side. Tack the seam allowance to hold in place.

9 Using your base pattern, cut a piece of corrugated card ¼ in (5mm) smaller than the original pattern. Place the card onto the fabric for the base.

10 Tack a piece of lining on top of the card and tack around the edge. Using a piping foot, stitch around all sides as close to the card as possible. Remove the tacking stitches.

11 Keeping the right sides together, tack and stitch the base to the main bag. Trim any excess seam allowance and turn through to the right side.

Tip: Keep the zipper open to ensure you can turn the bag through.

12 Using the pattern, cut out the lining pieces ¹⁄₁₂ in (2mm) smaller than the main bag, adding a seam allowance.

13 Begin by lining the zipper placket. Turn in the long edges of the lining piece and tack and machine stitch into place. Then add on the end sections of the zipper placket and then the side sections of the bag. Finish off by adding the base piece of the lining.

14 Place the lining into the bag and slip stitch it to the zipper tape.

Variation

To make a drawstring purse

1 Cut out two squares of fabric. With right sides together, tack and stitch 3 sides, leaving a gap of 1 in (2.5cm) near the top. Miter the corners. Trim and turn through.

2 Turn over and stitch along the top edge to form a casing for the leather cords. Thread 2 leather cords through the casing, in opposite directions. Finish ends by knotting the cord, threading on the bead, and knotting the end.

15 To make the zipper tab, take a piece of fine leather cord. Loop it over the zipper pull. Slide the toggle over the leather cord. Knot the cord, trim, and pull the end back into the toggle.

MATERIALS AND EQUIPMENT

- 16 in (40cm) striped silk (standard width 36 in/90cm)
- 16 in (40cm) contrast lining (standard width 36 in/90cm)
- 1 in x 1½ in (2.5cm x 4cm) black lining (standard width 36 in/90cm)
- 3 ft (1m) black webbing
- 28 in (70cm) black leather piping
- 30 in (80cm) beaded cord
- 12 in (30cm) and 7 in (18cm) zippers
- Matching thread

*t*his jazzy striped silk bag will suit any outfit. It has the full range of rainbow colors, which are also reflected in the beaded side seams. However, you could also use plain silk or taffetta or other patterned fabrics, such as ticking, striped cotton, or linen. If you have some fabric left over, why not make a matching change purse?

over the rainbow

Body (cut 2) Body (cut 2)

Pocket position

Grain Central seam Grain

1 square equals 2 in (5cm)

1 Cut out the silk for the main bag to the pattern, adding an inch (2.5cm) for the seams. Cut two sections with vertical stripes and two with horizontal stripes. Cut a length of fabric for the handle, with the stripes running lengthways.

2 Tack and stitch the center front and center back seams. Trim and press open. Remove the tacking stitches.

3 To make the pocket lining, cut a piece of black lining fabric 1 in x 1.5 in (2.5cm x 4cm). Fold in half and press to mark the center line.

4 Using the center line as a guide, place the lining over the right side of the back section. Then tack along the center, using a zipper foot. Stitch down both lengths of the tacking, and across both ends. Remove the tacking stitches.

5 With a sharp pair of scissors, cut along the fold line and into the corners. Turn through to the wrong side and tack along the stitched edge.

6 Place the zipper centrally down the zipper opening. Then tack and stitch zipper into place. Remove the tacking stitches.

7 On the inside, fold over the lining and stitch around the three sides of the pocket bag (made in Step 3).

8 *Cut out the lining fabric for the main bag using the pattern. Keeping the right sides together, tack and stitch the two pieces of lining to the top edge of the bag. Trim and turn through. Tack around the curved edge.*

9 *Unzip the main zipper. Pin and tack each side of the zipper to the front and back of the bag. Machine stitch in place using a zipper foot. Remove the tacking stitches.*

10 *Tack the beaded braid around the outer edge of the main bag material.*

11 *Place the right sides of the main fabric together. Pin and tack around the whole bag, using a piping foot. Machine stitch the fabric to the points where the braid exits at the top of the side seams.*

12 *To add the strap, fold and tack the pre-cut strap fabric down the two long edges. Place the webbing on top. Tack and machine stitch down the two long edges. Remove the tacking stitches.*

14 Stitch the lining seam, leaving an opening at the base of the lining. Trim the seam allowance. Turn through.

13 With the right sides together, tack and stitch the straps to the bag. Trim and turn to the wrong side. Turn the bag through.

15 Hand stitch together the opening. Push the lining back into the bag. Turn in the two lining edges at the base of the strap and slip stitch.

little red pony

*t*he witty pony pattern and soft panne velvet of this roomy shopper give it a jazzy edge over shop-bought bags. You'll find that a simple shape can be the best option if you have a wild pattern that you want to show off to its best advantage. There's no need to use real leather for the side panels—here, a mock snake fabric works just as well.

MATERIALS AND EQUIPMENT

- 20 in (50cm) panne velvet, pony pattern (standard width 54 in/140cm)
- 4 in (10cm) black mock snake material (standard width 54 in/140cm)
- 60 in (1.5m) black leather piping
- 6 studs
- Corrugated plastic board 15 in x 3 in (40cm x 8cm)
- 20 in (50cm) iron-on interfacing (standard width 36 in/90cm)
- 14 in (36cm) zipper
- Matching threads
- Pinking shears
- Scissors

Place to fold of the fabric

Base line

Main body (cut 1)

Grain

Piping point

Facing cutting line

Piping point

Zipper tab

Grain

Side panel (cut 2)

Cutting line

Zipper panel (cut 2)

1 square equals 2 in (5cm)

1 Fold the panne velvet in half lengthwise. Use the pattern to cut out the main bag, adding an extra inch (2.5cm) for the seams. Cut out the mock snake leather sections, adding extra seam allowance. Cut out the iron-on interfacing to the pattern, and iron it onto the velvet and mock leather.

2 Tack the leather piping around the sides of the bag beginning and ending at the point marked on the pattern.

3 Take the mock leather side panels and fold over the top edge by ¼ in (1 cm). With the right sides together, tack and stitch the side panels to the main bag. Trim and remove tacking stitches.

4 Keeping the right sides together, attach a piece of lining to each section of the zipper placket. Stitch along one long edge and the two short ends. Repeat for other side of the zipper. Trim and turn through.

5 Place the zipper centrally over the right side of the zipper placket. Stitch along the long edges using a zipper foot, as close to the zipper teeth as possible.

6 With right sides together, place the zipper plackets to the bag facing. Stitch along the tacking line and trim. Repeat for the opposite facing. Remove all the tacking stitches.

7 To make the handles, cut two mock leather strips using the pattern. Iron the interfacing to the wrong side. Fold both long edges into the wrong side and tack into place.

8 Tack and machine stitch a 1 in (2.5cm)-wide ribbon onto the wrong side of each handle.

9 Keeping the right sides together, place the handles on the top edge of the bag, as marked on the pattern. Tack into place.

10 Undo the zipper and attach the facing to the main bag, with the right sides together. Machine stitch along the top edge, curving down to the top of the mock leather side panels. Turn over and tack around the outer edge.

11 Cut a rectangle 15 in x 3 in (40cm x 8cm) from corrugated plastic board. Mark the positions of the base studs. Using a leather punch, punch out 6 stud holes. Drop the plastic board into the base of the bag.

12 Push a pin through each stud hole to mark the position of the stud. Push the stud through the bottom, right side, where each pin emerges through the fabric. Open up the stud prongs over the board, inside the bag, to secure it in place.

13 Machine stitch over the original stitching line holding the facing and zipper together.

15 Fold in the
turnings
and slip stitch along the zipper
placket, and sides.

14 Make up a lining
from pieces cut using
the pattern, just ¹⁄₁₂ in (2mm) smaller,
but remember to leave some seam
allowance. Tack and machine stitch
together. Drop the lining into the bag.

16 Cut four crescent-shaped tabs using
the template. Place over the zipper
ends. Tack and stitch into place. Trim close to stitching
line and remove all tacking stitches.

*U*se offcuts of fabric left over from sewing cushions, curtains, and clothes to make a colorful appliquéd bag for more informal occasions. You can create some really interesting combinations of texture, pattern, and color if you experiment.

floral appliqué

MATERIALS AND EQUIPMENT

- 12 in (30cm) floral fabric (standard width 36 in/90cm)
- Offcuts of velvet, spotted fabric, turquoise fabric, and slubbed silk
- 12 in (30cm) piece of lining (standard width 36 in/90cm)
- 4 in (10cm) Bondaweb
- 40 in (1m) plastic ribbon
- 12 in (30cm) iron-on light-weight interfacing (standard width 36 in/90cm)
- 4 in (10cm) medium weight iron-on interfacing (standard width 36 in/90cm)
- 6 in x 10 in (15cm x 25cm) corrugated plastic card
- Matching threads
- Scissors

1 *Using the pattern, cut out all the pieces for the main bag, adding an extra inch (2.5cm) for the seams. Cut out all the pieces in the interfacing material and iron them on to the wrong side of the main parts of the bag.*

	Cuff (cut 2)	Facing (cut 2)
Main body (cut 2) ← Grain →	↔ Grain	↔ Grain
Base (cut 1) ← Grain →		
Place to fold / Place to fold of fabric	Fold	Fold

1 square equals 2 in (5cm)

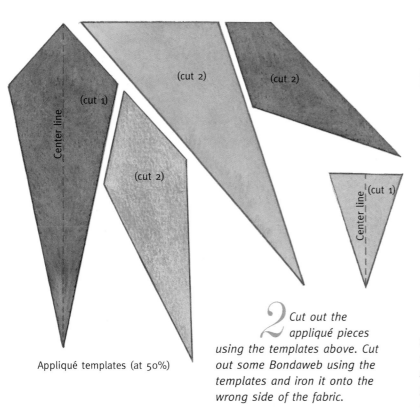

Appliqué templates (at 50%)

(cut 1)

Center line

(cut 2)

(cut 2)

(cut 2)

Center line (cut 1)

2 Cut out the appliqué pieces using the templates above. Cut out some Bondaweb using the templates and iron it onto the wrong side of the fabric.

3 Pin, tack, and machine stitch the patches onto the main bag using a close zigzag stitch (twice), following the order shown above. Remove all pins and tacking stitches.

4 Add a decorative zigzag machine stitch to the center of the last three panels.

5 With the right sides together, tack and machine stitch together the side seams of the main bag. Trim and press the seams open.

6 For the base of the bag, take the corrugated plastic card and sandwich it between the base fabric and the iron-on interfacing. Iron around the edges, using a low heat.

7 With the right sides together, tack and machine stitch the base to the bag. Remove all tacking stitches and snip into the corners.

8 To make the cuff, cut out the spotted fabric from the pattern, adding an extra inch (2.5cm) for the seam. Cut out the same amount of medium-weight fusible interfacing, and iron on.

9 With the right sides together, machine stitch the side seams of the cuff. Trim and press open.

10 With the right sides together, place the cuff and the main bag seams together. Tack and stitch into place. Remove all tacking stitches. Trim and press open.

11 Using the cuff pattern, cut some velvet fabric for the facing, adding an extra inch (2.5cm) for the seams. Repeat Step 10. Trim and press the seams open.

12 Cut the plastic ribbon in half. Position the handles on the top of the bag, 5 in (12cm) away from the side seams. Tack into place.

13 With the right sides together, position the facing on the bag. Tack and hand stitch in place. Remove all tacking stitches. Trim the seam allowance and turn through to the right side.

14 Edge stitch along the top edge to keep the facing in place.

15 Turn the bag to the right side. Tack and stitch through the seam line of the cuff. Cut out the lining using the main pattern. Tack and machine stitch the side seams and the base. Remove all tacking stitches. Trim the seam allowance.

16 Push the lining into the bag. Turn over the top edge of the lining and slip stitch it to the stitch line.

MATERIALS AND EQUIPMENT

- 20 in (30cm) fake fur fabric (standard width 54 in/140cm)
- 8 in (20cm) leather or mock leather piece (standard width 54 in/140cm)
- 20 in (30cm) matching lining (standard width 36 in/90cm)
- 1 ft (3m) leather wrapped cord
- 10 in (26cm) zipper
- Matching thread
- Leather needle
- Sticky tape
- Craft knife
- Cutting board
- Scissors

Davy Crockett

Witty and tactile, this Davy Crockett shoulder bag will turn heads wherever you go. The rough texture of the fake fur begs to be stroked, and the unusual leather cord handle and leather fringing give the bag that Wild West touch.

1 square equals 2 in (5cm)

1 Use the pattern to cut out the fake fur fabric for the back and front of the main bag, adding an extra inch (2.5cm) for the seam allowance. For the leather sections, place the pattern right side up on the leather skin.

2 Lay the two strips of leather down the length of the zipper. Tack and machine stitch into place. Stitch two more rows an equal distance from the first row.

3 Place your pattern back on top of the zipper and tack around the original seam allowance.

4 Working on the wrong side of the bottom piece of leather, use a pen and ruler to draw lines an equal distance apart. Carefully cut up the lines to within ½ in (15mm) of the top.

5 Place the leather side of the fringe to the right side of the fake fur. Tack along one edge.

6 Attach second piece of fake fur, sandwiching the leather fringe between the two right sides of the fur. Machine stitch along the tacking line, using a leather needle in your machine.

7 With leather side to the right side of the fake fur, tack and stitch the side seams of the side panels to the main bag. Then tack and stitch the base seam.

8 To make the handle loops, cut two 20 in (50cm) lengths from the 1 ft (3m) of leather wrapped cord. Tack one to the top of each side panel, with the cut edges facing upward.

Tip: Before you cut the braid, bind the area you are going to cut with sticky tape. Cut through the center (this will prevent it from unraveling).

9 Turn the bag inside out. With the right sides together, pin, tack, and machine stitch the zipper into place along both long edges. Stitch down the short edges with a double row of stitching to reinforce the handles. Trim down the seam allowance.

10 Take the cord handle loops that you stitched into the bag (Step 8). Turn over the end loop, and slide through a pencil or pen to hold into place while stitching the loop to the cord.

11 Thread the remainder of the leather cord through the two loops. Stitch the two cut edges together. Wrap with sticky tape to hold them in place.

12 From the remaining leather, cut two rectangles using the shoulder guard template. On one piece, turn in ¼ in (5mm) of the shorter edges onto the wrong side of the leather.

13 Place the wrong side of the smaller piece onto the right side of the larger piece, and machine stitch down the center.

15 Cut the lining fabric to the main bag pattern. Tack and stitch all seams together. Place the lining into the bag and attach it with a slip stitch to the top seam line.

14 Slip the two cords onto the leather shoulder guard. Tack, and using a piping foot, machine stitch as close to the cord as possible. Trim off any excess leather as close to the stitching line as possible.

16 Place the lining into the bag and attach it with a slip stitch to the top seam line.

spring flowers

MATERIALS AND EQUIPMENT

- 16 in (40cm) mock leather furnishing fabric (standard width 54 in/140cm)
- 16 in x 16 in (40cm x 40cm) piece of white crinolyn (standard width 36 in/90cm)
- 2 "D" rings
- Rainbow thread
- Matching thread
- Leather needle
- Magnet catch
- Craft knife
- Cutting board
- Scissors

*f*inding a hard-wearing bag in a light style with delicate detailing would normally be a tough task. However, if you combine see-through mesh with mock leather furnishing fabric, and apply a few tricks of the trade, you will have a smart bag to take you through spring to summer.

1 square equals 2 in (5cm)

1 Use the pattern to cut out the mock leather fabric for the main bag. Note that the leatherette needs to be folded in half before cutting. Using the same pattern, cut out one layer of crinolyn. Add an extra inch (2.5cm) to both leatherette and crinolyn for the seams.

2 Using the template, draw the outline of the cut-out leaf motifs onto the wrong side of the mock leather. Cut out the pattern with a craft knife and cutting board.

Template for
main bag cut-outs

3 On the base line of the crinolyn, turn up a ¼ in (6mm) hem and machine stitch.

4 Place the wrong side of the crinolyn to the wrong side of the cut leatherette piece. Pin and tack into place.

5 Using rainbow-colored thread, machine on the right side around all the edges of the pattern with a medium close zigzag stitch.

8 Tack and stitch the side seams of the facing material, with right sides together. Trim and neaten.

6 With the right sides of the bag together, tack and machine stitch the side seams. Trim and neaten.

7 Pull the bag through to the wrong side. Flatten the end of the side seam as shown, and machine stitch 1 in (2.5cm) from the pointed end. Trim off any excess material and neaten. Turn the bag through to the right side.

9 Keeping the right sides together, stitch the facing to the top edge of the bag. Trim the seam allowance and turn over to the wrong side.

10 Tack along the top edge and machine a row of stitching. Remove the tacking stitches.

11 Using the template, cut two handle plackets. Fold the end of each placket over a "D" ring and, using a piping foot, stitch as close to the "D" ring as possible.

12 Place the placket over the side seam. Tack and stitch into place. Repeat for the second handle placket.

13 Cut two strips of mock leather 4 in x 1 in (11cm x 2.5cm) each. Taper each end on one strip only. Trim the other strip to the point of the taper. With the wrong sides together, place the shorter strip on top of the longer one. Machine two rows of stitches all the way around.

14 Slide the tapered end through the "D" ring and fold it back on itself. Stitch securely into place. Repeat with the other end of the strap.

15 For an optional tab to close the bag, cut two pieces of mock leather from the pattern, adding a 1 inch (2.5cm) seam. Insert the magnetic fastener to one piece, as shown.

16 With the wrong sides together, tack and stitch around the outer edge of the tabs. Trim close to the machine stitch line.

18 Tack and machine stitch the facing into place 1 in (2.5cm) from the top edge. Trim the facing.

17 Place the tab to the center of the facing, with the right sides together. Tack and make a double row of stitching to hold it in place. On the opposite side, insert a magnetic catch for the fastener.

19 Using the templates, cut out the flower motifs and machine stitch the pattern with rainbow thread and a medium close zigzag stitch.

Tip Start stitching from the center and move outward.

Flower templates

Variation

SUN, SEA, AND SAND
*For a summery feel, change the theme of your bag
with this simple mesh "wave" cut-out and these
shell and starfish motifs. Use a medium close
zigzag stitch with the rainbow thread on the
dotted lines of the motif templates. Attach the
motifs to the bag with a catch stitch.*

20 *Catch
stitch the
flower motifs onto the bag.*

suppliers list

Sewing Machines

Patchwork Plus
36 Jordan Street
Skaneateles, N.Y. 13152
United States
Tel. 315-685-6979

Dave's Bernina Sew Center
268 West Center Street
Provo, Utah 84601
United States
Tel. 801-374-5520

Singer Authorised Dealers
280 Ottawa N
Hamilton
ON
Canada

Sewing Equipment

Scissors, needles, and thread

Lydia's Sewing Center
518 Madison Street
Huntsville, Ala. 35801
United States
Tel. 256-536-9700

Nancy's Sewing Center
216 Belmont Avenue
Belfast, Maine 04915
Unites States
Tel. 207-338-1205

Baron's Fabric and Sewing Centers:

Camarillo Store:
379 Carmen Drive
Camarillo, Calif. 93010
United States
Tel. 805-482-9848

Woodland Hills Store:
22635 Ventura Boulevard
Woodland Hills, Calif. 91364
United States
Tel. 818-224-2746
www.baronsewfab.com

Marye Anne's Studio
3462 River Trail
Stevensville
Ontario LoS-1SO
Canada

Sewing Materials

Fabric

Felsen Fabrics Corporation
264W 40th Street
New York, N.Y. 10018
United States
Tel. 800-335-7367
www.fabrics4u.com

The Cotton Patch
1025 Brown Avenue
Lafayette, Calif. 94549
United States
Tel. 925-284-1177
www.quiltusa.com

European Textiles
Ottawa Street N.
Hamilton, ON
Canada

Wool

The Knitter.com
PMB 404
6525 Gunpark Drive #370
Boulder, Colo. 80301
United States
Tel. 303-530-1845

Philosopher's Wool
Company
Inverhuron
Ontario NOG 2To
Canada
Tel. 519-368-5354
www.philosopherswool.com

**Sewing
Embellishments**

Beads

Woodstock Bead Emporium
54 Tinker Street
Woodstock, N.Y. 12498
United States
Tel. 845-679-0066
www.beademporium.com

The Bead Man
317 NW Gilman Boulevard
Issaquah
Seattle, Wash. 98027
United States

Crafty Cat Beads 'n' Things
Gift Shop
#103-1980 Cooper Road
Orchard Plaza
Kelowna, BC VIY 8K5
Canada
Tel. 250-763-2181
www.craftycat.com

Buttons

The Button Shoppe
4744 Oakfield Circle
Carmichael, Calif. 95608
United States
Tel. 888-254-6078
www.buttonshoppe.com

Patti's Antiques
73 Poquonock Avenue
Windsor, Conn. 06095
United States

Ribbons

Queen Ann's Lace
Crafts and Quilts
715 East Vine Street
Kissimmee, Fla. 347443
United States
Tel. 407-846-7773
www.queenannslace.com

Elsie's Exquisites
22691 Lambert Street
Ste. 513
Lake Forest, Calif. 92630
United States
Tel. 714-837-1885

Sequins and Braids

Costumes Quarterly.com
2400 E. Colonial Drive
Suite 28F
Orlando, Fla. 32803
United States
Tel. 407-898-3646
www.costumesquarterly.com

Associated Fabrics
Corporation
104 East 25th Street
New York, N.Y. 10010
United States
Tel. 212-689-7186
www.afcnewyork.com

Mary Jo's Cloth Store Inc.
1-85 Exit 21
401 Cox Road – Gaston Mall
Gastronia, N.C. 28054
United States
Tel. 704-861-9100

*Many of the sewing centers
listed stock a full range of
sewing materials.*

index

All Meshed Up 90
All That Glitters 40
appliqué 112–13

backstitch: hand 23
 machine 26
backpack 42–3
beads 17
 projects using 48–9, 62–3, 66–7, 72–5
Belle Époque 84
blanket stitch 24
blind-hemming stitch 26
Bowled Over 100
bowling bag 100–103
bridesmaid's bag 46–7
buttons 30

Carried Away 92
chain stitch: hand 25
 machine 26
clasps 30
Copper Crochet 66
corduroy 16
 project using 92–5
cotton 16
crocheted bag 66–7

Davy Crockett 116
denim 16
Drama Queen 48
drawstring purse 103

Easter Basket 36
embroidery 36–7
Ethnic Chic 58
evening bag 44–5, 68–71, 72–3, 84–9

fabrics 14–16
facings 19
fake fur 15
 projects using 60–1, 116–19
Falling Leaves 76

feather stitch: hand 25
 machine 27
Feathered Friend 52
felt 16
 projects using 38–9, 76–9
flat seam 28
Floral Appliqué 112
French Fancy 68
French seam 28
furnishing fabric 92–5, 100–103, 120–3

Gilded Cage 62
Green Pastures 50

hem stitch 27
herringbone stitch 25

ironing 10

Knit and Pearl 72
knitted bag 64–5, 72–5

leaf motifs 76–7
leather 16
 projects using 90–1, 116–19
 seams for 29
linings 18
Little Red Pony 108

making over an old bag 34–5, 38–9, 40–1
mesh 90–1
 crinolyn 120–3
 wire 16, 54–5
metallic fabrics 15
 project using 48–9
Mirror, Mirror 64

narrow finish seam 29
necklace (as handle) 58–9
needles: hand 10, 24
 for leather 16
 machine 10, 27

novelty turf 16
 project using 50–3

opera bag 48–9
Over the Rainbow 104

Patchwork Project 80
pattern 20
 to scale up 21
 to transfer 12, 13
pencils 13
pile fabrics 15
 seams for 29
pins 10
Pretty in Pink 96

quilting 68–9, 96–7

raffia bag 36–7
Red, Red Rose 54
ruler 13

satin 15
 project using 84–9
scissors 12
seam: to construct 28
 to finish 29
sequins 17
setsquare 13
sewing machine 10
Shades of Gray 34
shopper 76–9, 96–9, 108–11
shoulder bag 60–1, 116–19
silk 15
 projects using 48–9, 96–9, 104–7
 quilted 44–5
slip stitch 23
spool knitting 74
Sporty Sack 42
Spring Flowers 120
stitches: hand 22–5
 machine 26–7

suede cloth 16
tacking 22
tailor's chalk 13
tailor's tacks 21, 22
Tantalizing Tassels 44
tape measure 13
thimble 11
threads 11
Three Bags Full 38
top stitch 27
tote bag 92–5
tracing paper 12
tracing wheel 13
trimmings 17
 projects using 34–5, 40–1, 44–5, 46–7, 62–3, 80–3, 84–9
tubing 16
 projects using 50–1, 52–3, 66–7, 96–9

velvet 15
 projects using 60–1, 108–11
Wedding Belles 46
weights 13
Winter Warmer 60
wire: brass 62–3
 copper 66–7
 craft 72–5
 galvanized 52–3, 54–5
wire mesh 16
 project using 54–5

zigzag stitch 27
zipper, to insert 31

Zippers

There are three basic types of zippers—conventional, open-ended, and invisible. For most bags you would use the open-ended variety. An open-ended zipper should be inserted before any facings or hems are started. Use the zipper foot on your machine to insert the zipper or, if you are sewing by hand, use a half back stitch and double thread for strength.

Tips
- Before any zipper is sewn in, the seam should be semi-finished and then tacked open.
- Match the color of your zipper to the fabric you are using, or use one a shade darker.
- Always match the zipper length to the size of the opening.

Zippers are made in many different weights and sizes, and whether you use metal or nylon is a matter of personal preference as both are of equal strength. Nylon zippers are usually lighter in weight and more flexible than metal, and are available in a wider variety of colors. But you may choose a colorful chunky zipper and make it into a feature of your bag.

An open-ended zipper is the most practical choice when making a bag.

The easiest way to insert a zipper is to place it in the center of an open seam, with an equal amount of fabric on each side.

Pin the zipper in position with the teeth over the seam opening. Tack ¼ in (5mm) in from the zipper and remove the pins.

Using a zipper foot, stitch close to the tacking line. Begin at the top of one side and work around the zipper. Remove the tacking.

fastenings

Zippers, buttons, and bows—whatever fastening you choose, make sure it is appropriate for the fabric and the purpose for which you intend to use the bag you are making. Fastenings are not just a way of securing your bag; they can also be made into a decorative feature and add a professional finish.

Creative clasps

Any bag—especially smart day bags or glitzy evening bags—will benefit from the addition of a unique clasp. Look out for beads, glass balls, colored studs, and ornate buttons taken from old bags discovered at the bottom of your wardrobe or in garage sales. Glass diamanté clasps and tassels will add sparkle and glamor to evening bags. For a contemporary look, be creative with plastic or rubber tubing and shiny metal chains.

Buttons

Although they come in a huge variety of shapes, sizes, and materials, buttons are made in basically two types—shank and sew-through. The shank has a solid top, with a shank beneath to accommodate thicker fabrics and prevent the button from pressing too hard against the buttonhole. You can also buy button blanks to cover in matching or contrasting fabrics.

Sew-through buttons have either two or four holes through which the button is sewn on. A zigzag sewing machine can be used to sew on these buttons.

Stitch the thread over a toothpick, to add "give", then wind the thread at the base.

Use a button foot to machine on a button, adding a toothpick between fabric and button for "give."

Tips
- A four-hole button may have to be sewn with two separate stitchings.
- A button foot is included in some machine accessory boxes.
- Use contrasting colored thread to sew on buttons.

Narrow finish seam

The narrow finish seam is used only on lightweight or semi-transparent fabrics. It is an inconspicuous way of joining fine fabrics and can be finished either by hand or by machine.
1. Place the two pieces of fabric together with the right sides facing. Pin, tack, and stitch along the seamline. Remove all tacking stitches.
2. To finish by machine, trim the seam allowance to ¼ in (5mm) and zigzag over both.
3. To finish by hand, fold the seam allowances in to meet each other, as shown. Tack the folds together, press and slip stitch neatly. Remove all tacking.

Seams for vinyl and leather

To ensure that puncture marks from pins do not spoil your finished bag, pin or tack only in the seam allowance or hold the edges together with paper clips. Use a specially coated presser foot on your machine to stop the fabric from sticking when it is stitched. Use wedge-shaped needles and change them frequently. Flatten seams open with a mallet.

Seaming pile fabrics

Stitch seams in the direction of the pile. Care must be taken to exert the correct amount of pressure on the fabric while stitching. The longer and denser the pile, the greater the need to reduce bulk from the seams.

Finishing a seam

Seams can be finished by hand stitching the edges using overcast stitches, or by cutting along the seam allowance with pinking shears, as shown above.

seams

Finished seams add a professional touch to any bag. They help to neaten edges and stop them from fraying. Plain seams help to create the shape of your bag and should be almost invisible when pressed. Decorative seams emphasize the lines of shaping and are often used as a strong design feature. The choice of seam will depend on the weight of the fabric you are using and the purpose of the bag you are making. The machine should be adjusted correctly to the fabric for stitch length, tension, and pressure. Seams should be back stitched at the beginning and end for reinforcement.

Constructing a seam

To construct a basic seam:
1. Pin the seam at regular intervals, matching the pattern's notches and other markings. Place the pins perpendicular to the seamline, with the heads toward the seam edge. Tack close to the seam line, removing the pins as you go. With many simple seams pinning and machine stitching is sufficient.

2. Position the needle in the seamline, ⅜ in (1cm) from the end. Stitch forward along the seamline, close to but not through the tacking. Remove any pins as you stitch. Remove all tacking stitches. Press the seam flat in the direction it was stitched, then press it open.

Special seams are used for particular types of fabric. A velvet seam is used for any fabric that has a pile. A hairline seam is used on fine fabrics where a normal seam would show through and look untidy.

Flat seam

The flat seam is used to join fabrics of normal weight. To make a flat seam, follow the basic instructions for Constructing a seam (left).

French seam

The french seam is a narrow seam, which encloses the raw edges of the fabric. It is used on fabrics which fray easily, such as fine, semi-transparent fabric. Do not use this seam on heavy fabrics, as the result will be bulky. The finished seam should be no wider than ¼ in (5mm). It is always pressed to one side.

1. Place the two pieces of fabric with the wrong sides facing. Pin, tack, and stitch about ⅜ in (1cm) from the raw edges. Trim both the seam allowances to ⅛ in (3mm).

2. Refold so the right sides are together and the seam is at the edge. Pin, tack, and stitch along the seam again, this time ¼ in (5mm) from the edge.

Feather stitch

The feather stitch is decorative as well as practical and it can be used for faggoting, embroidery, or quilting. Feather stitch, when used at o stitch width, may also be used for the straight reverse stitch. This stitch may either be built into your machine or can be produced by the insertion of a separate stitch pattern cam.

Hem stitch

Fully automatic machines have built-in hem stitching capabilities; others can produce hem stitching through the insertion of special cams. Decorative hemming is a process which can be created in the fabric by the use of a wing needle. The best fabrics for using wing needles are very fine fabrics such as organza or lawn.
1. Fold up the hem allowance and turn under the hem edge. Draw threads of fabric from above the hem edge.
2. Zigzag along both edges of the drawn-thread section.

Top stitch

Machine stitches made from the right side of the fabric for decorative or functional reasons, sometimes both, is called top stitching. This is usually a plain straight stitch, set at a longer than usual stitch length. It is sometimes advisable to tighten the top tension for this stitch. The thread can be ordinary sewing thread or a heavier thread such as a silk buttonhole twist. The thread color can match or contrast, according to the effect you want to achieve.

Zigzag stitch

For any zigzag stitching, always use a zigzag foot. Consult your machine manual for the best stitch settings.

Tip
Machine needles have different points designed for various fabric weights. The most commonly used are sharp-point for woven fabrics, ball-point for stretchy fabrics, extra fine points for twill, denim, and heavy linens, and wedge-points for leather and vinyls. The finer the weight of the fabric and thread being used, the finer the needle should be.

machine stitches

Before beginning any machine stitching, remember the golden rules:
• Check the tension on your machine, and use the correct machine foot.
• Practice on a small piece of fabric first to test the combination of needle, thread, and stitch length.
• Have plenty of new, sharp needles on hand.

Blind-hemming stitch

Also named blind stitch, this zigzag stitch pattern is used primarily for blind hemming by machine. It can also be used to stitch seams and to finish seams (see Seams on pages 28–29).

For fabrics that do not fray easily, such as woollens and jerseys, it is not necessary to fold under the hem edge. The hem allowance is left flat before being folded back for stitching. The stitch pattern

usually comprises 4 to 6 straight stitches followed by 1 zigzag. Some machines form a blind stitch comprising several narrow zigzag stitches followed by 1 wider zigzag.

To blind-hem stitch fabrics that fray, it is necessary to fold under the hem edge before stitching, as shown below. This ensures that the raw edge of the hem is enclosed with the hem allowance.

Chain stitch

Available on some machines, the chain stitch consists of a series of interlocking stitches made from a single thread. It is made by fitting a chain stitch needleplate. The upper thread twists around the empty bobbin case and the bobbin thread is not used.

Back stitch

The back stitch is used to secure the beginning and end of a row of machine stitching. Back stitching eliminates the need to tie thread ends.

Chain stitch

Chain stitch forms a line on plain- and even-weave fabrics. Chain stitch can be used as an outline stitch, and is very useful for defining curves and intricate shapes.
1. Working vertically, bring the needle out at point (A), insert it back in the same place, and bring it out again at point (B), taking the thread under the point of the needle before pulling it through.

Herringbone stitch

The herringbone stitch can be used on plain- and even-weave fabrics to make an attractive, crossed zigzag line. It makes a rich border, particularly if a metallic thread is used for the interlacing. It is used for catching up hems and as a decorative embroidery stitch.
1. Working from left to right, take small stitches from *right* to *left,* first at the top and then at the bottom.

Feather stitch

The feather stitch is a decorative embroidery stitch that is often worked over a seamline in patchwork or appliqué where a series of stitches are worked on alternate sides of a given line. Mark the line the stitching is to follow on the right side of the fabric.
1. Working from top to bottom, bring the needle out at point (A), insert it at point (B), and bring it out again at point (C), taking the thread under the point of the needle before pulling it through. Repeat in reverse at the other side.

Other decorative stitches include stem stitch, couching stitch, French knots, satin stitch, and cross stitch.

decorative
hand stitches

Decorative stitches can be used sparingly for a subtle finish, or more obviously to highlight a particular feature. Use one type of stitch for low-key impact, or a range of stitches for a unique and special finish. Blanket stitch, feather stitch, and many different embroidery stitches can all be used to enhance the loveliness of your bag. However, always ensure that the stitches complement the type and style of bag you have made, and that they are suitable for the weight of fabric.

Tips
- Crewel or chenille needles are used to embroider fabric. They have larger eyes than ordinary sewing needles to accommodate a thicker thread.
- Crewel needles are used for fine and medium-weight embroidering.
- Chenille needles are suitable for use with heavier threads and fabrics.
- Always use a fine needle if you are embroidering on a light, delicate fabric.

Blanket stitch

Blanket stitch is ideal to use around the edges of appliqué shapes, for hemming, or as a decorative stitch in embroidery. It can also be used as a buttonhole stitch if worked closely. The stitches should be evenly spaced and equal in length.
1. First bring the needle up through the fabric at point (A).
2. Then bring the needle down at point (B).
3. Lastly, bring it up again at point (C), with the thread under the needle. Pull the needle through to form a loop.

Back stitch

To make back stitches, you'll be working from left to right.
1. Bring out the needle at point (A), then insert the needle at point (B) coming out at point (C) at an equal distance.
2. Repeat for the next stitch with the needle entering at point (B).
3. The needle should enter the point made by the third emerging stitch from point (A) of the previous stitch.

Slip stitch

Slip stitch is mainly used when sewing in linings or hemming by hand.
1. Begin by running the needle through the folded edge of the lining. Bring the needle out and pick up a couple of threads from the above fabric.
2. Return the needle into the folded edge and repeat until complete. Fasten off any loose threads and lose the thread through the fabric.

basic
hand stitches

1

Tacking

Use the tacking stitch to hold and join two pieces of fabric together before sewing. Prior to tacking, pin the fabric with right sides together. Knot the thread at one end.

1. As shown above, stitch evenly along the seam line, using stitches about ⅛ inch (5mm) in length. After machine sewing the seam, remove the tacking stitches.

Tailor's tacks

Tailor's tacks (see left) are used when transferring pattern lines to a double layer of fabric. Use a double length of thread in a contrasting color.

1. To begin, make a stitch through the double-layered fabric, pull the thread through, leaving about $\frac{1}{12}$ inch (1.5mm) length of thread on the top side. Insert the needle again into the first point of the stitch and pull through to form a loop of thread. Continue all around the pattern.

2. When completed, carefully cut through the loops. Ease the two layers of fabric apart and snip the under threads. Gently open out the two fabrics and you will have a thread mark of each piece of fabric.

1

2

Quick tailor's tacks

To make quick tailor's tacks, use a double thread in a contrasting color from the fabric you are using.

1. With a large tacking stitch work around the pattern.

2. When completed, snip into the thread at the center.

3. Open the two fabrics and snip the under threads.

1 Scale up the pattern: count the squares on the pattern and draw it up on paper to the actual size of the bag you wish to make—one square equals 2 inches (5cm).

2 Using scissors, carefully cut out your pattern.

3 Pin the pattern onto the fabric. Draw a line around the pattern using tailor's chalk to mark it onto the fabric.

4 Cut out the fabric, leaving an extra inch (2.5cm) for a seam allowance.

5 Make some tailor tacks around the edge of the pattern to show where the stitch line is.

6 Pull off the pattern, and clip through the tailor tacks, leaving tack tufts on both pieces of fabric.

Tip: To make sure your tailor tacks don't drop out, use bright thread to stitch around the sewing line and leave a tail at least ½ inch (12mm) long at each end.

*t*he quickest way to create a mess or end up with a disaster is to miss out on the planning stage. Many of the designs in this book have a pattern attached, and it is essential to understand how these work and their importance to successful bag making.

making and using a pattern

The grid of the pattern shows one square as 2 inches (5cm). Follow the steps on the following page to find out how to scale up the pattern and use it to cut out your fabric. Remember that the materials and equipment list for each design is specific to the size of bag the author has made. You will need to measure the fabric for your bag accordingly.

Grain: *direction of warp on fabric*
Warp: *threads running from top to bottom*
Weft: *threads running from left to right*

Main body (cut 2)
Grain
Place to fold of fabric
Zipper panel
Cutting line
Grain
Place to fold of fabric
Base (cut 1)
Grain
Place to fold of fabric
Grain

EQUIPMENT

- Paper
- Pencil
- Tailor's chalk
- Ruler
- Scissors
- Pins
- Needle
- Bright thread

Iron-on facings

Facings are often forgotten or deliberately left out of many home
sewing projects because they are considered unnecessary. But facings,
and iron-on varieties in particular, are important, as they will give support and
rigidity to the main fabric and design of your bag. Generally, the more structured
and detailed your design is, the greater need there is to include good, iron-on
facings. They will add to the overall finish and appearance of your handbag, even
though they are "behind the scenes."

Always apply the facing before inserting the lining. Facings will help to give shape
to your bag, and also support and stabilize specific areas such as cuffs, flaps, hems,
and edges. They will also prevent stretching.

Facings can be light, medium, or heavy in weight and
should be compatible with the main fabric of
your bag. Iron-on facings are generally
recommended for use on fabrics that can
withstand high iron temperatures. Use a
damp pressing cloth when applying iron-
on facing. Fusing time is generally
between 10 and 20 seconds.

FACINGS

1 Fusible woven interlining—adds extra
 thickness and body to fabric.
2 Fusible non-woven interlining—soft
 and firm synthetic fiber.
3 Flat domette—black or white fabric
 suitable for mounting silk, satin,
 and cottons.
4 Wadding—synthetic fabric for a
 padded effect mainly for quilting.
5 Felt—to give extra body and firmness
 in stitch detailing.
6 Buckram—white fabric with a coarse
 grain giving a rigid effect.
7 Fusible canvas—suitable for thicker
 fabrics for a tailored look.
8 Vilene—fusible and non-fusible, used
 for simple, easy styling.
9 Acetate by the sheet—mainly used for
 strengthening the base of the bag.

Tips

• The softer or lighter in weight the main fabric is, the more support it will need from
 iron-on facings.
• Always use sew-in facings for fabrics such as velvet, fake fur, synthetic leather,
 mesh, and vinyl.
• Iron-on or fusible facings have a shiny resin or "sugary" appearance on the side
 that bonds with the fabric.
• Test a small piece of iron-on facing with a small piece of your fabric before
 applying the main facing.
• Use a dark facing on dark fabrics.

linings
and facings

A good lining will give a neat, finished look to your bag and will also hide any untidy seams and edges. Linings should be chosen with almost as much care as the main fabric of your handbag. Your choice of lining material will depend on the type of bag you are making and also on the type of main fabric that you are using. A shopping bag will need a strong lining, which is easily cleaned. But for an exotic evening bag, you could have a shiny, silky fabric such as satin, which will complement the general effect of your bag.

Remember, whenever you open your bag the lining is on display. And so the color and texture should be in keeping with the main fabric of the bag—avoid clashing colors or strongly contrasting patterns unless that is the look you want. Don't think that you can reuse old scraps of leftover material to line your bag—this is a big mistake.

The lining seams are sewn in the same way as the seams of the main fabric. Press open the lining's seam allowances and leave the zipper area open with seam allowances pressed back. Hand stitch the seam allowances of the lining along both sides of the zipper tape.

FABRICS

Linings come in a wide range of lightweight materials such as silk, satin, taffeta, and rayon. They should be smooth, opaque, and durable, and ideally with an anti-static finish.

embellishments

Applying sequins with the stitches showing

Applying sequins with invisible stitches

Stitching individual beads

Stitching beads in a continuous line

A well-placed glass droplet, bright beads, scattered sequins, or tassels can give a professional finish to a newly completed bag or revitalize a tired old bag. Dig deep into the corners of your jewelry box and sewing bag. There are no limits when it comes to embellishing, so use your imagination.

SEQUINS AND BEADS

Sequins and beads can be used to create stunning single motifs. Sequins can be applied so that the stitches show or so they are hidden (see left). If you want them to show, choose an attractive twisted silk or stranded embroidery cotton.

Beads can be applied individually or in a continuous line (see left). The stitches should not show on the right side of the fabric. Some beads have only a tiny hole, so you may need a special beading needle to stitch them in place. Use a fine, strong thread, and secure the beginning and end of the thread firmly.

TRIMMINGS

Contrasting braids, cords, fringes, or ribbons can be used as finishing touches. When buying trimmings, add a bit extra to the length for experiments, turning corners, and joining lengths. Trimmings can be added into a seam at the construction stage, or slip stitched by hand when you have finished your bag.

HANDLES

Handles can also be used as embellishments. Twisted rubber, plaited cord, or ethnic necklaces, can add to the unique finish of your bag. Or look out for old bags in the attic or at garage sales—just remove the handles and attach them to your bag.

Corduroy

Furnishing fabrics

Wire mesh

Felt

Hard-wearing fabrics

LEATHER

There are many synthetic fabrics that imitate leather. Common names include buckskin, patent, and suede.

Tip

Stitching—Leather can be stitched only once as any removed stitches leave holes. Wedge-point needles should be used; these penetrate the leather and minimize tearing. Use a specially coated presser foot to prevent the leather from sticking. Pressing—Seams should be pressed open, using fingers or a dry iron set at a low temperature. Adhesive may be required to hold seam allowances flat.

SUEDE CLOTH

Suede cloth is a woven or knitted fabric of cotton, wool, artificial fibers or blends, usually napped and shorn to resemble suede.

COTTON

Cotton comes in a vast range of weights from flimsy muslin and lace to canvas and blankets. Cotton is often blended with other fibers to enhance its qualities such as strength and moisture absorbency.

FELT

Felt is a non-woven fabric comprised of wool, fur, or hair fibers that have been meshed together by heat, moisture, and mechanical action. Felt is not a strong fabric and can tear easily.

DENIM

Denim is a strong, hard-wearing twill-weave cotton or cotton-blend fabric.

CORDUROY

A heavy cotton, ribbed pile fabric, corduroy has a smooth velvet-like nap.

Other hard-wearing fabrics include canvas, brocade, vinyl, worsted, frieze, hessian, moleskin, and furnishing fabrics such as chintz.

Novelty materials

From bright green plastic turf (see pages 50–51) to wire mesh and rubber tubing (see pages 54–57), there is an amazing range of outrageous and extraordinary materials available for your new bag. A visit to your local hardware store or even to a garden center may give you some brilliant ideas. Just let your imagination run rampant and experiment with different materials, textures, and colors.

Light-use fabrics

FUN FUR OR FAKE FUR
Fun or fake furs, usually acrylic, are made to resemble real animal fur. They may be dyed different shades and patterns, and also are sold in strips for trimming.

VELVET
Velvet is a fabric with a short, closely woven pile made from silk, cotton, and synthetics. It has a soft texture and lustrous, rich appearance. Common types include:
Velveteen—similar to velvet, nearly always made from cotton.
Crushed velvet—pile is pressed flat in one or several directions, making it shimmer.
Panne—pile is flattened in one direction to give a lustrous sheen. Often available with printed designs as well as plain colors, and is both stretchable and washable.
Tip
When stitching together velvet or other pile fabrics such as synthetic furs, the pile should lie in the same direction. Stitch in the direction of the pile. After stitching, pull the pile out of the seam with the point of a pin.

SATIN
Satin is a sleek fabric with a lustrous sheen.
Tip
When working with slippery fabrics such as satin, place a layer of tissue paper between the two layers to be sewn. The tissue will help them grip together enough to sew. Simply remove the tissue after you have completed the seam.

SILK
Silk fabrics have a sheen and are lightweight. They have a delicate appearance, but are quite strong.

METALLIC FABRICS (LAMÉ, LUREX)
Metallic fabrics are available in stunning colors and textures. If the fabric you choose is flimsy, strengthen it with iron-on interfacing.
Tips
Stitching—Any metallic fabric can be stitched only once as removed stitches will leave holes. Use a very fine needle and change it regularly.
Pressing—Use a dry iron at a low temperature; steam may tarnish metallic fabric. Open seams with the tip of the iron and, elsewhere, use a pressing cloth with only light pressure.

Other light-use fabrics include: sateen, taffeta, voile, velour, gauze, lawn, and organdy.

Fake fur

Velvet

Silks, satins, lace, and beaded fabrics

Metallic fabrics

fabrics

Leather and fake fur

Knitted wool

Before you buy

Having decided to make your own bag, you now have to choose your fabric. The choices are almost endless—from leather and suede to denim and felt, from velvet and silk to rubber and metal fiber fabrics.

Of course, the type of bag that you want to make and what you plan to use it for will influence your choice. If you want a bag for everyday use or for shopping trips then a strong, hardwearing material such as heavy-duty cotton, suede or leather is ideal. But if you want a pretty, sophisticated evening bag for occasional use, then a lighter fabric such as satin, silk, or organza would be more appropriate.

At the store

The color and pattern of the fabric is a matter of personal preference and may depend on your budget. Some fabrics require special stitching or pressing because of their structure or finish, so it is worth asking about any special requirements before buying. Other fabrics need careful handling, and may involve more time or expertise. For example, leather, taffeta, and metallic fabrics can be stitched only once—removed stitches will leave holes. Silks and slinky fabrics are difficult to cut and handle while sewing. It is also worth remembering that small prints, especially dark colors, hide any stitching imperfections, are easier to sew, and require no pattern matching. Fabrics are sold at standard widths that will be large enough to accommodate the handbag patterns in this book: 36 in (90cm) for cottons, silks, satins, and 54 in (140cm) for wool, felt, and furnishing fabrics.

If you want your bag to complement a particular outfit, wear the outfit or take it to the fabric store to check that the color matches or contrast works well. Finally, check the raw edges of your chosen fabric for excessive fraying. If it frays badly, allow ¼ in (5mm) extra on the seam allowances when cutting out.

Rayon

Quilted silk

Indian silk

Tracing wheels

Tape measure

TRACING WHEEL

When a tracing wheel is rolled over the wrong side of the tracing paper, the colored wax is transferred to the fabric beneath. A tracing wheel is used when transferring designs from a grid or drafted pattern.

TAPE MEASURE

Use a flexible tape measure that is made from waxed cotton.

SETSQUARE AND RULER

A setsquare will give you an accurate right angle for drafting patterns and enlarging grid patterns. You will need a ruler for drawing straight lines and for quilting.

PENCILS AND CHALK PENCILS

Use soft lead pencils for drawing patterns—HB, B, and F—and keep them sharpened. Chalk pencils can be used to make quick marks on the fabric that can be brushed away on completion.

TAILOR'S CHALK

Tailor's chalk is used for drawing around the paper pattern onto the wrong side of the fabric.

WEIGHTS

Small metal weights can be used when working with delicate fabrics as pins may easily mark the fabric.

Place the weights on the pattern to secure its place over the fabric. Draw around the entire shape with tailor's chalk.

Tailor's chalk

Scissors

You will need different types of scissors—a pair for cutting paper only, a pair of sharp dressmaking scissors for fabric only, and a pair of small embroidery scissors for detailed work and for trimming threads.

 You will also need a pair of pinking shears. These can be used for neatening seams and for decorative edges when working with non-grain materials such as leather, suede, felt, and plastics.

Tracing paper

Tracing paper is usually waxed on one side and may be colored white, red, blue, or yellow. It is used for drafting patterns from a grid when enlarging.

Embroidery scissors

Paper scissors

Pins

Needle threader

Needle threader

Needle threaders are useful when threading different thicknesses of thread or wool.

Threads

It is worth paying a little more for good quality thread. Cheap thread will break and fray with use. It is also important to match the thread with your fabric exactly. Many types of threads are available according to the type of fabric and its thickness. Tacking thread is far easier to break than sewing threads, and comes in a range of colors, not just in black and white.

Thimble

A thimble is useful when tacking, hand stitching, or decorative stitching. A metal thimble provides the best protection.

Thimbles

equipment

Before you start

It's a good idea to collect together in advance some essential tools that you will need, regardless of the bag you plan to make or embellish. A well-stocked sewing kit will help you to work more quickly and efficiently.

SEWING MACHINE

A sewing machine is faster and easier to use than stitching by hand. Modern machines provide simple, useful stitches such as straight stitch, zigzag, and reverse stitch that can also be quite decorative. It is advisable to use attachments for bindings, a zipper foot, and Teflon feet when working with plastic or leather.

Before sewing, check that the bobbin is loaded with the correct thread and also check the stitch tensions and length on a spare piece of doubled fabric.

STEAM IRON AND IRONING BOARD

A steam iron should be used throughout the process of making your bag, not only at the final stages. Always iron or press fabrics first before cutting out the pattern. The base of the iron should be kept clean and the ironing board fitted with a padded cover that should be cleaned or changed regularly.

NEEDLES AND PINS

Always use sharp, stainless steel pins as these will not rust. For finer fabrics, use lace pins. Pins with glass heads are useful as they can be seen easily on fabric—plastic heads will melt if they come in contact with your iron. You will need an assortment of needles for hand sewing and for your machine in your sewing tool kit. There is a wide range of needles available for use with different types and thickness of fabric.

For hand sewing, needles come in different lengths, numbered sizes, eye sizes, and fineness. These include betweens, sharps, embroidery/crewels, and darners. Sizes range from 1 to 24—the smaller the number of the needle, the shorter and thicker it is. For embroidery there are three basic types: crewel, chenille, and tapestry. Each one has a particular use, and the choice of needle depends on the embroidery technique being worked.

Machine needles should also be chosen according to the type and thickness of fabric that you are using. These needles are numbered by size and lettered to indicate the shape of the tip, and they should be changed regularly.

Sewing machine

Pins

Needle and thread

als

Many of the bags in this book have been made with basic sewing techniques—some of the designs can even be created without a sewing machine. Before you start, check your sewing kit. You will find that you already have much of the equipment that you need to make the designs in this book: pins, needles, thread, and scissors, for starters. Don't discount the more unusual materials, such as offcuts, costume, and household materials. The fun in making your own bags comes from using your imagination and creating something from nothing!

The essenti

jewelry case for odds and ends you never wear. Most objects—even galvanized wire and rubber tubing—can be recycled to make a unique bag for you or for your friends.

This book begins with a look at the essential equipment, materials, and techniques that you will need to make these bags, and we will show you how to use the patterns for each design (see pages 20–21).

The section on bags contains 30 projects, each one explained in simple illustrated steps, with tips from the author. Beginning with embellishments to store-bought bags, this section also includes a couple of makeovers to revitalize old favorites. The next section introduces designs for bags that are simple to make and require only basic skills. More challenging projects follow, including those that include simple knitting and crochet. Finally, some advanced projects explain how to insert zippers and pockets, how to work with an advanced quilting pattern, and how to use real and fake leather, as well as a range of furnishing fabrics.

Happy handbagging!

Introduction

*a*ccessories can make or break an outfit, and a
handbag can provide that special finishing touch
to whatever you're wearing. Not since the late 1960s have handbags been so
popular; people have taken to bags with a passion. So whether you
are after a sturdy shopper or an exotic and glamorous
evening bag, it makes sense to create your own bag
to reflect your individual style.

Bags are much simpler to make
than you might think. You probably already have
most of the equipment at home in your sewing
basket, and some of the designs in this book can be
made without a sewing machine. Use offcuts of fabrics
from clothes or soft furnishing projects, and check out your

nts

The
bags 32

Shades of gray 34

Easter basket 36

Three bags full 38

All that glitters 40

Sporty sack 42

Tantalizing tassels 44

Wedding belles 46

Drama queen 48

Green pastures 50

Feathered friend 52

Red, red rose 54

Ethnic chic 58

Winter warmer 60

Gilded cage 62

Mirror, mirror 64

Copper crochet 66

French fancy 68

Knit and pearl 72

Falling leaves 76

Patchwork perfect 80

Belle époque 84

All meshed up 90

Carried away 92

Pretty in pink 96

Bowled over 100

Over the rainbow 104

Little red pony 108

Floral appliqué 112

Davy Crockett 116

Spring flowers 120

Suppliers 126

Index 128

A Quarto Book

Copyright © 2002 Quarto Inc.

First published in the United States of America in 2002 by

 krause publications

700 E. State Street • Iola, WI 54990-0001

Please call or write for our free catalog of publications. Our toll-free number to place an order or obtain a catalog is 800-258-0929.

ISBN 0-87349-389-3

Library of Congress No. 2001099538

QUAR.BAGS

This book was conceived, designed, and produced by Quarto Publishing plc
The Old Brewery
6 Blundell Street
London N7 9BH

SENIOR PROJECT EDITOR Nicolette Linton
SENIOR ART EDITOR Elizabeth Healey
TEXT EDITORS Jean Coppendale, Alice Tyler
DESIGNER Julie Francis
ILLUSTRATORS Terry Evans, Coral Mula, Kate Simunek
PHOTOGRAPHER Colin Bowling
INDEXER Pamela Ellis

ART DIRECTOR Moira Clinch
PUBLISHER Piers Spence

Manufactured by Universal Graphics, Singapore
Printed by Midas Printing International Limited, China

9 8 7 6 5 4 3 2 1

AUTHOR'S ACKNOWLEDGMENTS
With special thanks to Katie for designing a range of beautiful bags through the eyes of a jeweler, and to Caroline Darke for her fabulous bag on page 90.

conte

The essentials

Introduction 6

Equipment 10

Materials 14

Techniques 20

Handmade
bags

Terence
Terry

krause
publications

700 E. State Street • Iola, WI 54990-0001

Handmade
bags

Arts Literacy for Business

Richard S. Gurin

President and Chief Executive Officer, Binney & Smith, Inc.

The challenges our nation will face in the next few years and how we address them will determine what kinds of lives our children and their families can expect to enjoy in the next century. As a businessman, I am particularly concerned about the ability of our present educational system to adequately train our children to compete in the global marketplace. Just why am I concerned? Consider this:

- Eighty percent of Americans agree that there is a need for educational reform in this country, yet fewer than 25 percent believe this need affects their children or their school.

- Similarly, 80 percent of the parents in America rate our schools at C or below, yet 72 percent give their own child's school an A or a B.

How can this be? According to Ted Hershberg, a professor of public policy and history at the University of Pennsylvania, the contradiction can be explained by a combination of three factors: where people live, the performance of their community schools, and the way in which media markets and media coverage are organized.

Hershberg reports that about 25 percent of Americans live in cities, about 25 percent live in rural areas, and the remaining 50 percent live in the suburbs. Since the largest media outlets are based in the largest cities and the media tends to cover the news from the city outward, public perception is shaped by what people see on television, hear on the radio, or read in the newspaper.

Information disseminated through the media about the problems of urban education, Hershberg explains, make parents in suburban schools feel good about the superiority of their own schools. But he goes on to say that parents should not be comparing suburban and urban schools. Instead, they should be concerned with how their children rank against students in other developed nations. In this era of a global economy, it is foreign students that clearly represent the competition of the future.

To give you a better idea of how American students will compete, let me share with you the findings of a Hudson Institute study published more than six years ago and known as *Workforce 2000*. Based on our current educational system, the research project evaluated the functional skills of prospective individuals entering the work force between 1985 and 2000 and compared them to the skills that jobs in the twenty-first century will require. For leaders in the business community, the results and predictions are frightening:

- Seventy-eight percent of the prospective employees will have functional skills qualifying them only for the bottom 40 percent of the available jobs.

- Only 5 percent of the prospective

5

employees will have the skills required for the top 40 percent of the jobs.

How could these findings be so dismal? One factor is technology, which is dramatically changing the world we live in and the way we do business. Educational instruction, for the most part, has not adapted to reflect how technology has changed society and our day-to-day lives. In business, for example, thanks in part to technology, "fast and flexible" are the credos of successful companies when it comes to responding to the needs of their customers.

In order to compete, business needs an up-and-coming work force that has been trained to be flexible, has the ability to learn quickly, and is adept at solving problems in new and unique ways. We need to provide our kids with a high-quality education that gives them the skills necessary to be more competitive and to think creatively. I believe the best way for our children to learn how to see and think creatively is through arts education. It's not art for art's sake, or even cultural appreciation. The economic future of our country depends on our ability to develop innovative ways of learning.

Using the arts as a way of teaching and learning can lead to world-class quality and competitiveness. But don't take my word for it. Look at our successful international competitors, the Japanese, who place an emphasis on the arts. They're the same people who are leading the world's most productive industries.

During the last five years, our company, Binney & Smith, has participated in many research projects, in literally thousands of interviews, and in focus groups and other forms of research regarding the learning process. What we learned probably will be no surprise to you:

- Learning happens best when kids have fun, and the arts are fun for kids. The arts can serve as catalysts for learning other subject areas across the curriculum. The arts can also be studied and enjoyed for their own sake.

- Art activities enhance learning capability. For children age five or younger, learning is an art-like experience. In fact, 30 to 50 percent of a preschool child's day is spent on art-like activities and in hands-on learning. Moreover, according to recent research studies, later academic success correlates with preschool experiences.

- The arts are the core of our American culture and central to an understanding of and appreciation for the multicultural society in which we work and live.

Under our present system and with pressure from the business community, we are beginning to focus on improving instruction in math, science, and other traditional disciplines. But, quite candidly, it's not enough. By working together, the arts community in partnership with the business community needs to help other business leaders understand that arts instruction, which emphasizes teamwork, communication, creative thinking, self-esteem, imagination, and invention, will enable us to develop a world-class work force for tomorrow.

You'll be happy to know that we are gaining some important allies in this crusade for the arts. Recently the *Harvard Business Review* republished Dr. Abraham Zaleznik's classic 1977 article, "Managers

and Leaders: Are they Different?" The article's conclusion was that we have plenty of managers and bureaucrats, but we need to develop leaders. In his 1992 retrospective on his article, Dr. Zaleznik said: "Vision, the hallmark of leadership, is less a derivative of spreadsheets and more a product of the mind called imagination." Isn't that what the arts teach? He goes on to say: "Business leaders have much more in common with artists … and other creative thinkers than they do with managers."

I suggest to you that this advice is every bit as vital to those who formulate curricula in our primary schools, where young people first develop their academic, social, and business-life leadership capabilities.

Balancing the Elements of Arts Literacy

Joseph W. Polisi
President, The Juilliard School

Creation is the act of invention, of producing new ideas to touch individuals through experiences such as those found in music, dance, drama, and the visual arts. This process, if done seriously, requires thought, organization, and, above all, imagination. The process must be engaging, substantive, and fun. Most important, it must immerse the students in the process—not for success or failure, but to experience the texture of creation.

There is an important thread of commonality between creation and performance. Both creators and performers must grapple with the same materials; they must make their ideas come alive. Above all, our students must understand how to become communicators. Their task is not to reproduce efficiently, but to energize their commitment to the experience—to personalize their view of art and present it effectively to others.

We've all seen students concentrating and focusing. We know when they are growing before our very eyes, or when they are opting for business as usual. Through creation and performance, arts standards will be realized by the fourth-grade clarinetist, the sophomore dancer, the senior sculptor, and the children in the kindergarten-class play. Students' motivation and directed activities make art become real. These young people will remember this reality throughout their lives if we teach it correctly.

In turn, the historical and aesthetic context of the students' art experiences will allow them to understand that they are not creating or performing in a vacuum. Much occurred before their birth, and that legacy influences all that they experience today. This aspect of the standards, I believe, will allow America's students to begin to understand and respect the many elements that make up this nation's ethnic and artistic mosaic.

We must be deeply committed to the process of bringing the arts back to America's schools. What we are working toward is not the creation of something new, but the restoration of what existed and flourished no less than thirty years ago in our nation's primary and secondary schools. I am a product of the New York City School System as it existed thirty years ago. My fondest and most important memories of what formed me, not only as a musician but as a human being, go back to junior and senior high school musical activities. These programs took me all around the city for rehearsals and performances in school auditoriums and in Avery Fisher Hall.

I am deeply troubled by the fact that the infrastructure for music education that I assumed was in place in New York no longer exists. Currently, there is not even a person designated to specifically deal *only* with music programs in New York City.

The public school systems of this nation have been battered by poverty, drugs, and

crime and have suffered from financial deprivation and lack of passionate leadership. I have read about teachers of the arts who feel that the proposed standards are beyond the reality of the present-day environment in our public schools. Clearly, the key to the success of this program will be intelligent and flexible implementation. The proposed standards relate to the acquisition of lifelong learning skills, and I trust that we will succeed in realizing the lofty goals we have set for ourselves.

Arts Literacy across American Culture

Arturo Madrid

Murchison Distinguished Professor of the Humanities
Trinity University, San Antonio, Texas

My training is not in the arts. I am much more at home in the world of image and metaphor, of rhetorical devices, of literary genres, and thus do not enter gently into this territory. Notwithstanding, I will venture some thoughts on the issue of cultural diversity and its implications for standards.

I recently participated in a Spanish language instruction conference in San Antonio, Texas. While there, I wandered around the grounds of the 1968 Hemisfair, now home to a number of cultural institutions including the Institute for Texas Cultures and the Museum of Mexican Arts. It was a beautiful spring weekend, and a number of events featuring dance and music were taking place. Later that day, I toured two exhibitions in the galleries of the Museum of Mexican Arts.

I found myself thinking about the implications of these various events and activities for the standard-setting process we are involved in. The teachers and scholars I was interacting with at the language conference were concerned with providing the best instruction possible to their students. As is the case in all discussions of language pedagogy, there was animated debate concerning usage and status, about what is considered acceptable and appropriate and what constitutes standard Spanish, given the great number of variations that exist. At the heart of the debate was the issue of standards and having students achieve certain standards— that is to say, levels of competency. Informing that debate were the tensions of norms and variations. Who decides what the norms should be? By what criteria should variations be judged? How should usages be explained and justified?

My noonday sortie through the grounds of the Hemisfair provoked other related questions. The music and dance of Texas have multiple manifestations, given the great number of cultural traditions that have existed there. Tejano music, the latest rage, is influenced not only by the musical traditions of North Africa and the Iberian Peninsula but also by those whose origins are to be found in the cultures of pre-Columbian Meso-America. To these have been added two additional cultural strains of European origin: German and Polish polkas and Cajun melodies and rhythms. How will we teach about the richness of these discrete yet intertwined traditions without trivializing them by focusing on their exotic dimensions or without falling into the black hole of explaining every individual manifestation?

The dances I witnessed being performed by schoolchildren posed a different but no less challenging set of questions. Like music, dance is found in all cultures and is deeply integrated into the mores and manners of cultural groups. In some ways, dance is more static than music and is more culturally conservative.

For example, high value is given to reproducing folk dance as traditionally and authentically as possible. Many of these dances are courtship dances, in which the relationship between males and females is traditional and held constant. How do we teach about dance and its relation to culture? How do we avoid giving status to the values that influence folk dances as opposed to the rich and varied forms they take? How do we make evident and explicit continuity in the dance art form?

Still another aspect of my brief stroll through the Hemisfair grounds illustrates the complexities we face in trying to establish useful and meaningful standards. Featured in the galleries of the Museum of Mexican Arts were two exhibitions: an exhibition of bark paintings, which have their origins in the pre-Columbian civilizations of Mexico, and an exhibition of paintings in the tradition of the Mexican painter Rufino Tamayo. How do we connect the two? Both are authentic expressions of a rich and complex culture. Both have important artistic dimensions, yet are significantly different artistic expressions. How will our standards help shape the understanding of these two different expressions, as well as others that spring from Hispano–Meso-American culture?

Since part of our task is coming to terms with the social change that is reshaping American society and its institutions, it is important to restate and underscore what we are addressing when we speak of cultural diversity and its relation to the institutions of American society. First and foremost, we are talking about the need to make the historical experience and cultural expression of American populations that have been central participants in the evolution of American society—African Americans, Asian Pacific peoples, American Indians, and Latinos—a formal and integral part of the American experience and culture. Second, we are talking about the equally important yet significantly different challenge of incorporating into American society and its institutions peoples and groups from throughout the world who bring with them ways of being and doing, values, and beliefs that are sometimes in conflict with those that inform American society.

The first goal is a function of a domestic political struggle carried out by the groups in question. It is a necessity because American history and culture cannot be either properly or fully understood without including the life experience or the artistic expression of these groups: African Americans, Asian Pacific peoples, American Indians, and Latinos. The second goal, on the other hand, is driven by global social and economic forces and is shaped by communications technology. Today, the United States is home to peoples from virtually every part of the globe. Because of the revolution in communications, these population groups are in immediate and constant contact with their cultures of origin. People from the entire world are now (at least potentially) our immediate neighbors, and multiple aspects of their culture, including their arts, are now part of our national life.

The implications of these two goals for education in the arts are related yet different. In the case of the first goal, it is important to include in the curriculum the artistic expression of historically Ameri-

11

can communities. In the case of the second goal, the presence of the world community in our midst requires us to acknowledge the existence of artistic traditions that are very different from those we consider ours.

The challenges before us are to foster pluralism yet avoid the black hole of particularism, to recognize differences yet seek out commonalities, and to value tradition yet celebrate innovation. We can set standards that are neither exclusivist nor elitist. We can be inclusive without falling into relativism. But in order to do so we must be clear as to what is at issue when the subject of cultural diversity is introduced into the discussion of standards.

Integration: The Arts and General Literacy

Libby Chiu
Director of Institutional Advancement, Boston Conservatory

We have had some philosophical struggles regarding the basic concepts of integration. Some members of the National Committee for Standards in the Arts were concerned because cross-disciplinary approaches have a tendency to water down the arts and to lessen the energy of the individual art forms. Also, when one forces connections that are not reasonable, it becomes unworkable for the practitioner—the teacher.

Other members felt that integration is an appropriate instructional mode for the teachers who do not have an opportunity for retraining or for basic training in the arts. Furthermore, integration is a reality in that some school systems have already mandated such an approach in the curriculum. An integrated format will help ensure that the arts become basic in the curriculum, even if it is by mandate.

There was a belief among some committee members that integration of the arts is a sound pedagogy, as current research in multiple intelligences shows that one can use more than one pathway to learn a subject and understand that subject thoroughly. Also, integration already comes naturally in some aspects of the arts, such as in artistic problem solving and in design that involves correlation with mathematical calculations.

After arriving at a consensus that integration in the arts is indeed an appropriate approach in arts education, committee members discussed the definition of integration.

First, there is the issue of terminology. In early-childhood teaching, for example, "integration" is an educational methodology—a tried-and-true methodology that already exists. In other grades, the term implies the need for cooperative planning or retraining of teachers, and for staff-intensive and labor-intensive efforts, which are sometimes troubling for people. Recommended substitutions for "integration" included "correlation" when arts are integrated with one another but are correlated with other subjects, and "commonality" when students can be taught to relate one area to another to reinforce the learning process. The distinction between integration and interdisciplinary education was also discussed, but to no conclusive end.

Second, there is the issue of the actual instructional delivery of integration. Some members cautioned the committee against being too facile in adopting integration in the arts as a pedagogy. Other members did not want to extend the public's expectations of learning from other courses to the idea of learning as if by osmosis. Integration is not using one subject to teach another, and the mere listing of coincidences among the arts does not accomplish much. Rather, integration implies a combination of knowledge and skills to put things together in a true mixture. In order for this exercise to be meaningful,

13

students need to know the particular discipline before they can integrate it with anything else.

The format of the standards can respond in many ways to this issue of integration of instructional delivery. An opening statement could address commonality among the arts in general, but the standards for each discipline would debate how this statement applies. Common sets of terms across disciplines and subjects could be developed. Examples illustrating what it means to find commonality could be carefully selected and included. One option would be to show how different disciplines promote the same skills, such as the use of the methods of observation by both scientists and artists to arrive at conclusions. The standards themselves could express the need to understand the relationship between the arts and work in various fields.

One draft of the statement introducing the standards said: "The standards are based on the premise that each of the arts has its own integrity as a discipline, and that this integrity is the basis for making connections among the arts and with other disciplines. Although the arts may often be used to facilitate and enrich the teaching of other subject matter, they must be taught for their innate value as well. Connecting the arts to other subject matter is essentially an instructional task and not a dimension of standards."

Some may think that this introductory statement is a cop-out, but I believe that, pedagogically speaking, it is appropriate for the committee to set standards and not to direct the instructional mode. Within the standards themselves, there are several categories: perception and analysis, cultural and historical context, and creation and performance. It is within these categories that teachers and practitioners using the standards can apply the concept of integration of an instructional mode. The committee hopes that the final document will be one that both specialists and generalists can use without either artistic compromise or intimidation.

Potential of the Standards for Arts Literacy

Leilani Lattin Duke
Director, Getty Center for Education in the Arts, Los Angeles

The arts education community is being asked to do something that has never been done before: to identify what every student should know and be able to do in one or more of the visual and performing arts upon graduation from high school. This is a daunting challenge because of the consequences the standards are expected to have in helping achieve national education reform. Arts educators have never been requested or expected to come to consensus on the fundamental skills and ideas that children should know about the arts.

The responsibility for developing standards is all the more challenging because it is taking place in a fishbowl, under the public scrutiny of parents, federal and state education policymakers, and teachers. The substance and rigor of the arts standards will be compared with that of standards being developed for science, history, and other subjects named in the National Goals for Education adopted by the state governors. I believe, however, that the potential consequences that national standards can have on establishing a firm place for the arts in general education are so compelling as to overshadow the challenges presented in their development.

The standards can be expected to have far-reaching impact. They can, if respected for their content, serve to influence and possibly transform curricula, national and state assessments in the arts, teacher education, teacher certification, college-entrance requirements, high school graduation requirements, and state curriculum guidelines for visual and performing arts. If we are shortsighted about the potential impact that the national standards can have in these areas, we place the arts at risk of not being included on the national education reform agenda as an equal with other subjects. Why? Because standards are seen by the governors, the administration, parents, and education policymakers as one of the engines driving education reform.

These influential stakeholders perceive standards as a means not only for delineating the goals and expectations for what students should know and be able to do in the arts, but also for embracing a vision of what arts education can be rather than reinforcing what already exists. These education stakeholders expect that standards will give them the confidence to believe that the arts do, indeed, live up to our assertions that they teach ideas and skills not taught by any other subject in the curriculum. These groups will expect the standards to improve arts education by reflecting what is fundamental and essential for students to learn. They will expect the standards to reinforce and strengthen arts education already in the curriculum, and they will expect these standards to help make a compelling case for adding arts education to the curriculum when it is absent.

We need not be put off by professional or intellectual challenges inherent in writ-

ing the standards. Standards evolve from a consensus of many voices, and each version is better than the last. We need not be put off by the realities of today's tight school budgets or limited instructional time. As new models of curriculum integration are developed and proven, there can be a time and a place for the arts if our voices are effective.

We need not be averse to drafting rigorous standards because of issues of access and equity. The standards we finally develop will probably best serve arts education if they explicitly and implicitly reflect the qualities we attribute to serious works of art in each of the visual and performing arts: imagination and creativity, substance, focus, point of view, excellence, and hard work and effort. To reflect less would demean arts education.

The standards have already gone through several alterations on their journey to articulate some of the qualities just mentioned. They will continue to go through several more alterations before they are ready for public dissemination. Once published, they will still continue to be subjected to critiques and changes, as well they should be. For if standards are to be just that—"standards"—they will evolve and change to reflect new content and pedagogy over the years. In other words, the journey has just begun. The exciting part is that it should never end if arts education is to demonstrate its value and significance to the educational development of all children.

16

Questions and Answers: Consensus Issues

The Place of the Arts in the Curriculum

Why arts education?

■ The simplest way to answer this is to follow the classical Greek thought: if education is to create useful citizens, then the arts are necessary because they allow us to think about the higher values of life in a very tangible way. They bring meaning to experience. They help us to reflect. They also help us to project.

The arts allow us to express ourselves as the unique living forms that we are, as human beings. Because we live in a world that is complicated by extraordinary tensions among people, in order to create a sense of responsible citizenry, we have to appreciate each other's higher values.

The sciences and mathematics and history really only give us a prelude for doing something. The arts allow us, when we are educated in them, to do that something creatively.—*Roger Mandle*

The primary goal of setting the standards is that every child receive an adequate education in the arts. The arts are not for the elite, not only for the gifted and talented. Do you think the committee is keeping this always in front of them?

■ Yes.—*A. Graham Down*

How may we employ these standards to establish, once and for all, the arts as an equal partner in American curricula? (We, of course, all know that the arts are actually more important than that other stuff.)

■ I think it begins by having a credible document, one that unites the arts professionals, the art education community, and the advocates for the arts education community, that is to say, artists and appreciators of the arts. The document would have to be adopted and accepted by local communities, so local communities will have to receive inspiration for and assistance from decisionmakers in those communities. It seems to me also, though, that the way in which this ultimately will become more than a credible document—in which the standards will actually be tested in implementation—is the way in which they really affect the other disciplines taught in schools. The standards imply that what students do achieve, in these areas, has an effect on the students' achievement in other areas. Perhaps not as measurable, but it certainly has the implication.

Those of us in the arts, as this question quipped, really believe that immersion in them helps in many other areas of students' learning. We've seen it demonstrated; we know that it happens. But it really is going to take more than just an assumption. It's going to take some push.—*Roger Mandle*

■ At a Getty conference, I heard some of the people who were on the assessment committee talking about the failure of multiple choice and SATs in our educational system, and saying that the kinds of assessments that we in the arts have always done—portfolios, process portfolios, performance assessment—are very valid ways to assess. I can see the arts being the leaders in using those assessment tools; teachers of other subject matter could come to us to find out how we have used these tools successfully in assessing what students have learned and how they have progressed.

I see this as putting us naturally, organically, into central place. And I think it's extremely exciting. I think we could be the leaders, instead of on the fringe. —*Shirley Ririe*

18

■ Assessment is one area in which the arts have an edge. As the assessment techniques that the arts have traditionally used become recognized by other content areas, a way opens for us to move to a central place.—*Joan Peterson*

What steps are being taken to ensure that the needs of children are driving standards development, and not the political desires and aspirations of various groups?

■ Our hope is to share these standards with many members of the arts education field and with groups and individuals outside of the field—school board members, superintendents, and parents. Through this, we will begin to get a perspective that goes beyond the authoring committees and the representatives of the national

standards committee.—*Joan Peterson*

■ We're at a key moment in the development of these standards. There is "agendaism," and people do have different points of view. But in the artistic process, and in great art and literature, there is the theme of the reconciliation of opposites. There comes a point where you have to let go of all the work you do on a play or a piece of music, and you move to a place where those opposites are reconciled. That, I believe, is the point where we are now.

I think we're going to get beyond that point by focusing on what our students need to know and be able to do. We'll have that wonderful payoff. That's really what we must keep in mind, particularly at this critical juncture.—*Edward Gero*

■ There are various perspectives among professional organizations, and there are certainly different theories and practices in the education of our students. Each of the protagonists in the drama of education would name "the child" as the reason he or she holds a particular perspective. I have seen this in the work that's been undertaken on these documents.

I would also say, however, that I've seen a very definite recent response of groups who previously had very strong and perhaps unbending perspectives. These groups have made an effort to try and move the standards forward.

One of the strengths of the national committee, I think, is that many of us don't wear those kinds of hats and we stand aside from those kinds of battles. We have tried to make sure that people who come from certain camps as to the

way they treat issues of language and of curricula—and as to the way they interpret the needs of the student—would come together and have a way of getting beyond those issues. If there is one important by-product of this consensus-building process, I think it is that some of those barriers seem to be coming down.—*Roger Mandle*

■ We need to focus on content rather than on methodology. Too often methodologies of teaching become secular religions—fundamentalisms of their own. We then have a kind of holy war among proponent of various techniques. We waste time and energy propagandizing and fussing with one another.

I don't sense a tremendous disagreement over the content of the standards. We all recognize that there is work *in* art, work *about* art, and that there are relationships back and forth among historical, analytical, and cultural aspects. If we keep the standards focused on substantive content, and don't present them in a way that imitates a particular method of organizing and presenting that content, then we will have created an umbrella under which proponents of various methodologies can continue to pursue the goal of student learning using their own favorite means.

There are many ways to teach. Everyone who's a teacher knows that, and no two teachers would agree down to the last fine point about teaching methodology—nor should they. Our job is to create an umbrella, and we can do it by focusing on content. If we accomplish that goal, what the various professional organizations might do, or what their follow-up might be, is almost secondary. We will have

diverse approaches to a common goal. —*Samuel Hope*

The introduction to the standards addresses the importance of arts education. Should some of this be included in the standards as well?

■ Some of the rationales are included in the standards now, both implicitly and explicitly. For example, they were included in an area called "Nature and Value of the Arts." At one point, a draft listed what we expected our children to feel about learning art, and so on. We found that some of those statements were repetitive, and that they might be more appropriate in other categories such as "Creation and Performance." So that material was absorbed into other areas.

If students are empowered by the arts education they receive, they will understand the importance of that education. That's what we're really writing the standards for in the first place. We're going to have another generation of Americans, finally, in which everybody knows the importance of arts education.—*Edward Gero*

■ One of the things that the standards need to do is draw a better connection among the arts, the mind, and civilization. If we can do that, then the specifics that we're asking for will begin to make sense and begin to resonate in a general cultural context.

In other words, when we think about mathematics, we think about mind, and we think about our technical civilization. When we think about history, we think about the past, our heritage, and their con-

19

nections with civilization. I think we need to make that kind of connection with the arts right up front, and then make sure that our standards reflect it.—*Samuel Hope*

■ For many, even the word "standards" is very threatening and exclusionary. In fact, if the arts have any value at all in our curriculum, it's to get beyond the questions of exclusion to inclusion, and to show, across interdisciplinary lines but also across cultures, how we can celebrate the positive values of culture. In the standards, it seems to me that we have to be very careful not to create barriers; instead, we should see the arts as a vehicle for inclusion.—*Roger Mandle*

To what extent do you think that the theory and philosophy are being taught, given the time spent on performance skills?

■ Our sense on the National Committee has been that the disciplines of art criticism and art history have not been taught to the same extent that performance has been taught. That realization really reflects more of a change in the last ten to twelve years, in which a more balanced or holistic approach in teaching art has been suggested.

When we talk about the nature and value of art, we're talking about aesthetics. We're not talking about advocating arts education. The reason that aesthetics is so important as a part of arts education is that it pretty much weaves art history and art criticism together in a way that is comprehensive and understandable. As we try to embrace more works of art from non-Western cultures, aesthetics takes on

even greater importance because it gives us the foundation from which to look at those cultures through the eyes of those cultures. Art history and art criticism don't give us that same grounding in trying to understand non-Western cultures.

Our typical art criticism and art history tends to look at art through Western eyes, through formal analysis, and through Western concepts of art history. So understanding the nature and value of art, to both create it and understand it, is one of the primary reasons that we have this particular discipline in visual art education.

The extent to which visual art educators understand the discipline of aesthetics and how best to teach it is problematic. Much more work has to be done. I don't think we've done a good job in calling on the scholars and asking them to help us translate the theory into practice. So there's a lot of work to be done, not only in terms of how new teachers are brought into understanding the discipline, but how we give in-service training to teachers who have been through the system.—*Leilani Lattin Duke*

■ I think it's important for all of us to remember that one of the great pressures on teacher preparation programs for specialist teachers in the arts is the increasing amount of work that is imposed at the state level, in what we might call the general professional education core. Education students are required to complete twenty or thirty semester hours more than that normally expected for a baccalaureate degree, all in the regular four-year time frame. When we object to this practice, we're saying depth is impossible when coverage is so great in a short time.

But the states, not teacher preparation institutions, are mandating this approach. I don't know many people opposed to more historical and theoretical work. Most would like more time for these subjects in the teacher preparation curriculum. But the problem comes from increasing state requirements for studies that have nothing to do with the arts.

So this is a difficult issue. My colleagues and I would appreciate hearing from people in the field about the proportion among theory and practice and requisite work in professional education. Even though we will not address that proportion in detail in the standards, practice on this question is related to what can we expect of teachers as they lead students to meet the standards.—*Samuel Hope*

Theoretical and Practical Bases

The achievement standards of grades 9–12 must indicate how good is good enough for students completing their secondary education. How is this being approached?

■ This is an extremely difficult task, but it's the nub and the heart of the whole project. If the standards are not to recycle mediocrity in the way so many minimum competency testing experiments a decade ago did, we must aim at least at the ceiling, if not at the stars.—*A. Graham Down*

■ It's fine to have aspirations toward the stars, but I worry about general classroom teachers who are trying to equate the stellar arts standards with the maximum standards for achievement in mathematics,

which may be to get all the concepts in a particular lesson. Therefore, they will be at sea somehow when grading the student who has reached a plateau of experience, expression, and competence that is, for that student, rather extraordinary. It may be a long distance from the stars, but it may be an exceptional move for that student to go that distance. We have to figure out ways of measuring the success of that individual student.—*Roger Mandle*

■ The National Assessment of Educational Progress program is working on a new assessment model. It's just at the very beginning stages, but is looking at different ways to assess the whole student. I was walking through the Library of Congress the other day. In one corner was the phrase, "They build too low who build beneath the stars." I know that in one small area with this particular effort, there's a larger effort. I think we are building toward the stars by increments.
—*Edward Gero*

How good is good enough for teachers?

■ Teachers can catch the spirit of all this very quickly. I've seen teachers become experts in my field after just a few lessons, because if they're good teachers, know their children, and catch the concept of space and energy, they can suddenly become art facilitators. I know it can happen, and I think teachers need some opportunities, because the opportunities can be very enlivening.

I think teachers would enjoy embracing a new facet of their own lives that has been missing in many instances. I think

21

we have a lot we can do there. It doesn't have to mean a lot of time investment, because bright teachers can catch it quickly.—*Shirley Ririe*

■ Certainly it's true that the arts impact lives. They are a good introduction to teaching, and for a classroom teacher who has not previously studied the arts, acting as a facilitator can be very powerful and worthwhile.

But I think we have to be extremely careful not to use rhetoric or craft policies that send the message that just anybody can teach the arts. No one would believe it if we said that a short workshop or a few lessons would render a person competent to teach math. For math teachers, we expect intensive preparation to develop mathematical knowledge and skills. The same is true for other basic subjects.

If we're going to meet the standards as they're drafted, we have to have people in place who have a great deal of knowledge about the various art forms. They may be called classroom teachers or specialist teachers or something else, but what matters is what they know and are able to do.

So while I applaud the notion of getting more people involved and getting more classroom teachers associated with an arts agenda, we need to think more about teacher competence than emotional involvement as we plan to implement these standards.—*Samuel Hope*

■ We want people to have in-depth knowledge. But I also believe, and I'm speaking from the context of having over five million kids in our public schools in California, that without the classroom teacher there will be a lot of students who will never have that in-depth exposure to the arts. I think that shows the need for sustained professional development, over time, to help that classroom teacher move to a new point. This may not be to the level of the specialist, but certainly to the point where that person could support and extend the work of the specialist and begin at least to do some of the beginning instructional work in the arts. Even that may not be the depth that we all want to have, but it may be the only thing some students receive.

So I would like to say we need both. We need the educated classroom teachers and programs to help that teacher gain appropriate knowledge, and we need the specialist. We need the arts organizations and their resources to join in this effort.
—*Joan Peterson*

Is there research related to both the framework and the standards to ensure that they are educationally sound? In other words, do we know that this will work?

■ This is a concern. One of the things that will unfold in the months and years after the standards are released is that they will need to be tested, both in the classroom and by people who can draw some statistical conclusions. In short, if there aren't standards for the standards, I think we may be considered suspect by our colleagues in other educational fields and by the boards of education who would allocate resources for us to meet the standards. I think we need to have some literature to back all this up.—*Roger Mandle*

Have experts in child development been consulted as to the appropriateness of the K–4 standards? Many of those listed in the draft seem inappropriate for students in kindergarten through third grade, at any rate. It is critical that our standards reflect what is best for students.

■　The standards deal, in effect, with exit standards at grade four, grade eight, and again at grade twelve. The standards have been characterized as a moon shot. Not everyone will be able to meet the standards, but in fact we need those high goals.—*Joan Peterson*

Will we legitimize our cause through the whole-brain education debate; that is, through the question of waking the sleeping genius through cross-brain processes?

■　Look, dance doesn't even exist in elementary school in the curriculum. If it were part of the basic curriculum for all elementary students, that presence would certainly change teaching and learning. I appreciate the difficulties of getting teachers trained for that purpose, but how could you possibly explore Howard Gardner's seven intelligences without dance?

I'm a very right-brained person, and I value that. I think that children who are like me need to be valued and need to be able to use that part of their whole selves. So yes, we do need to embrace those theories and think about those things. I think when we're thinking world-class excellence, high-level standards, we've got to go forward one step at a time.—*Shirley Ririe*

This question concerns interdisciplinary study and correlating the arts with other academic disciplines. Which content area did Leonardo da Vinci have to know first, before working, learning, and discovering in the others? Did he begin with physics, mathematics, anatomy, or visual arts?

■　I think that the simple answer is that he had to learn to see first, because it was through his development of a keen sense of observation that he began to explore the scientific aspects of his environment, as well as learning about them artistically. The arts helped him form his scientific projections, his engineering achievements, his speculations, and his thoughts about the world, and the arts were inexplicably linked to a particular vision he had about the earth.

There's a glorious drawing that he made of a dandelion; it swirls almost like a maelstrom. Then there are some other drawings that are related to this that show the conflagration at the end of the world. He saw everything in microcosm—he saw the details of the universe in leaves. And these perceptions were philosophical ideas as well as visual ones.—*Roger Mandle*

Are the standards being written within the bounds of what can be assessed easily, or do they include other things that children should know and be able to do?

■　In theatre, we think that metacognition—thinking about thinking—is important. We think that the ability to reflect on one's work is integral to the work. It is the teacher's charge, then, to help youngsters

develop a vocabulary to articulate their thoughts and feelings. Part of being an audience member is to be able to articulate a response to the event. This articulation can be assessed.—*Lin Wright*

■ I think it's important to point out that, by happy coincidence, the National Assessment for Educational Progress is developing procedures for adding the arts to the national assessment. That will take place in 1996. One of the reasons we began the standards project when we did was to come up with some standards that would help the national assessment.

We're not committed to any one set of evaluation techniques, but we recognize that if these standards are going to be helpful, they have to specify learnings that can be assessed in some way.

We certainly are not going to consider only those learnings that can be assessed easily, as the questioner puts it. We need to find ways to assess the things that are important. That's what we will try to do, and one group of people who have major responsibility for that are the people who are doing the National Assessment for Educational Progress. They are going to try to use the standards hat we are developing as the basis for their assessment.
—*Paul R. Lehman*

Integrity and Integration

How can one balance thorough study of one art sustained over years with superficial acquaintance with all of the arts?

■ I think if we ask the same question sub-stituting any other discipline for "the arts," it might yield some notion of balance. I would ask the question: how can you balance a thorough study of one branch of science over another, or one language over another, without connecting those related disciplines? I think it's impossible.

The question of depth and breadth applies to the arts as well. There is clearly an inherent overlapping in the arts disciplines. In theatre, for example, one needs to have a certain understanding of music as it relates to the entire production.

I think it's natural that the student working in one area will cross over. Practically speaking, the standards call for such connectedness, but that will probably happen outside the classroom.—*Edward Gero*

■ I would envision that all children on the elementary level would have experiences in all the arts in a very powerful way, as central to the curriculum. I was in a grant program many years ago that had this philosophy, and it really worked. In this program, the arts were central to all other learning, and seeing, hearing, feeling, touching, all of that kind of sensory perception was the key to education of the students.

You're always going to have overlap among the arts. You cannot be in dance without knowing music, visual art, and theatre. It's part of what you do. And you investigate, and you branch out.

I think in-depth experience would be so wonderful. I don't think that it's a threat. It allows us all to go deeper and to do more, and it allows children to have the opportunity to choose. Now they don't get the arts, so they don't value the arts, because

the arts aren't there for them to touch and understand. If the arts are there when the children are at the elementary level, then the focus will happen out of knowledge and judgment rather than out of a vacuum.—*Shirley Ririe*

Will the integrity of each of the art forms be upheld and maintained in the standards? And once the standards are adopted, how will they be maintained?

■ The answer to the first question is yes—because the task force authoring committees consist of individuals who passionately believe that the integrity of each of the art forms ought to be upheld through these standards.

Regarding the second question, the people who believe in the standards have the first responsibility of doing all they can to ensure that all decisionmakers know about the standards, so they can do their job of maintaining them. All of the individuals who make up the professional associations—and who have put their imprimatur on these standards—have a responsibility for maintaining these standards, and for advocating their consideration by state departments of education, by teacher certification panels, by state legislatures who are passing legislation for high school graduation requirements, and by college presidents and their faculties who are setting future college entrance requirements.—*Leilani Lattin Duke*

Section 2

ACHIEVING CLARITY

The View from the Task Forces

Gene Carter
Executive Director, Association for Supervision and Curriculum Development

There is a distinction to be made between standards and curriculum. Even within that distinction, there are today, depending on your perspective, some four kinds of standards. There are content standards, student performance standards, school delivery standards, and also system delivery standards. As we reflect on what the professional and scholarly organizations throughout the country are about today, we must remember that most of their focus is on national standards, primarily from the standpoint of developing content and student performance standards.

Broadly speaking, standards are goals, expectations, or outcomes. They represent what an educated person should know and be able to do. They are a destination, not a road map. They are essentially a moon shot—an idea that may not be entirely attainable in practice.

"Curriculum" has been defined in many ways, but can be viewed as the means to the actualization of the vision put forth by standards. Theoretically, curriculum and instruction can be whatever we want them to be as long as students make progress towards the goals that have been established.

Among the points to keep in mind as we develop standards are:

- Standards that are arrived at as a result of a process in which everyone is heard can only contribute to achieving the goals of excellence and equity.

- Our enthusiasm for setting standards in the arts should not be dampened by an awareness of the professional, philosophical, and intellectual problems, challenges, and opportunities that the process presents.

- We have to be aware of the situations that we have in many of the school districts throughout the country.

- Standard-setting initiates a national conversation about the values that we cherish most about what we want for our children, not only today, but as we approach the new millennium; and about that knowledge that we prize so highly that we cannot imagine a civilized society that lacks it.

- Cognition plays a central role; we must realize that subtlety and complexity continue to be important considerations and remember that complex thinking involves the capacity to remain flexible.

Finally, in transforming the schools of this country, we need to think about the teachers in our classrooms—kindergarten through the twelfth grade—and pay attention to the professional development within our schools. If schools are to be good places for students, they must be good places for teachers.

29

Writing Standards for the Visual Arts

Jeanne Rollins
Chair, Task Force for National Standards in the Visual Arts

Establishing educational standards in the arts is one megastep forward for significant arts education. The development of voluntary national standards may well become one of the most important factors in this century for achieving high-quality arts instruction for all students. An unprecedented number of individuals and groups are working together to identify and describe art content and achievement essential to developing a literate citizenry in a visual society. These people are expressing a new understanding about the importance of this task as they observe national efforts to institute educational reform to meet the challenges of today and prepare students for success in the twenty-first century.

Clear thought and description are paramount if the standards are to benefit both students and society. While development processes provide opportunities for discussing and gaining national agreement on essential art content, it is carefully articulated standards that will give evidence of substantive art content. By giving meaning, clarity in the standards will help establish the visual arts as necessary to the education of all students. Such standards communicate to decisionmakers what high-quality art education is and thereby correct misconceptions. The public, like art educators, will know that creditable art education is neither rote memorization of artists' names, styles, and dates nor mindless production of isolated, stereotypical media projects year after year.

The public will know that to truly understand and be able to use the power of visual images, students must develop their capacities to communicate effectively in the increasing visual world. This goal will be realized through comprehensive study that enables students to develop visual and other perceptual skills, to create visual works that effectively express their own thoughts and ideas, to understand various cultures and historical relationships, and to critically evaluate and judge the visual products that influence their daily lives.

The arts standards will also influence and support excellence in other areas, such as teaching, assessment, and resource development. We often think of standards as involving only curricular content— what students should know and be able to do. However, the standards are also important when designing and evaluating programs, resources, and policies. They can direct efforts toward improving student achievement. Such standards should not prescribe specific methodologies, strategies, techniques, and activities. Rather, they must support locally designed curricula that enable all students to successfully learn essential visual concepts and skills they will use today and tomorrow.

Furthermore, by identifying important and diverse purposes of art, the standards will help others recognize the need for self-directed involvement in visual learn-

ing for not only their own welfare but for that of society. They also learn that art knowledge can serve in two capacities—vocation and avocation. Visual arts skills are used daily and serve everyone well throughout their lives, whether they become businesspeople, homemakers, artists, or historians. The arts make tremendous contributions to the quality of each person's life when taught well.

Clarity in standards can break down barriers in art content. Is art history more important than what happens in the studio? Is the creation in the studio is more important than criticism, or is criticism the most important? In reality, it is integration of all of the essential art elements that enables students to make meaningful connections later in their lives. All students benefit from making art, studying it, thinking about it, and talking about it.

Integrated study in the visual arts focuses on higher levels of thinking. It helps students think and communicate in different and highly effective ways. It demands the use of careful thought and reason, and it requires flexibility and exploration of multiple solutions. By assessing and revising their own work, students become involved in critically and creatively reflecting, responding, and applying what they have learned. Development of these skills will serve all students well as they go through life.

To develop worthy standards and to gain consensus about what is essential in art education requires all our collaborative efforts. Visual arts standards must not be defined narrowly in terms of myopic views or individual preferences for a particular research study, a theory, or a program. Instead, art content and achievement that is essential to the well-being of all students must be clearly defined, and we must encourage the development of rigorous art programs through thoughtful interpretations and examples. Through such commitment, standards will be established to guide and support significant student achievement in the visual arts.

Writing Standards for Dance

Mary Maitland Kimball
Chair, Task Force for National Standards in Dance

Before voluntary, world-class standards in dance can significantly improve the quality of dance education for all students, dance must first be *in* the schools. Before we can implement standards for each of the arts or plan unique interdisciplinary projects, dance must exist as a part of the curriculum.

In my research into the scope of exemplary K–12 dance education programs in the United States, I found that isolated public and private schools had programs that were extraordinary. The 350 students who participated in the first National High School Dance Festival in Philadelphia in 1992 showed that the highest quality of instruction does exist. It does not exist for all children, however, and many students go through school with little or no experience in dance classes.

Dance has often been considered a unit of instruction within the physical education curriculum. Although physical educators in the past were required to study dance as part of their teacher preparation, this is generally not the case today. In many instances, the physical educator takes one or two courses in dance, and this instruction may cover only recreational forms of dance with an emphasis on narrow physical skills. Dance as an art form that includes physical, emotional, cultural, and cognitive areas is seldom explored.

As a learning experience, dance education must involve more than steps or physical fitness. Dance should embrace the synthesis of knowledge, skill, and feeling as an individual discipline and in alliance with other arts that share a similar philosophy.

The National Dance Association has defined dance education in many of its publications, and I want to share with you one description from the 1991 document *Dance Education: What Is It? Why Is It Important?*

> Dance is a way of perceiving, a body of knowledge, and a personal and social experience. Dance is a way of knowing self, others, and the world around us. Dance education allows individuals to communicate with others in a way that is different from the written or spoken word, or even from other visual or auditory symbols. Knowing and perceiving in dance occurs on both the conscious and subconscious levels.

> Forms and styles of dance help define particular societies and periods of history and contribute to the broad body of cultural knowledge. The cumulative knowledge of dance is a history of the world and its peoples.

> The act of dancing is not mindless doing, but involves exploration, sensing, concentration, focus, projection, and commitment. There is an active use of memory, translation, interpretation, application, analysis, synthesis and evaluation. Creating dances is a personal engagement in the forming process, finding new movement and/or organizing movement in new ways through use of individual resources.

Teachers facing world-class standards in dance education must be prepared to

meet the challenge. Teacher education programs should prepare the dance educator to acquire skills and knowledge in:

- many dance forms, including those of world cultures,
- improvisation,
- choreography,
- musical accompaniment for dance,
- stage production,
- dance history and theory,
- pedagogy,
- concepts and principles common to other art forms, and
- science and technology related to dance.

A limited number of states have dance certification. This number has fluctuated between fourteen and eighteen states in recent years, and some states certify for high school only. In Indiana, for example, I could not be hired to teach dance under a regular contract in a public school because, notwithstanding the fact that I have spent a lifetime in dance education and have taught some seven thousand K–12 students in special workshops and master classes in the schools, my degrees are in dance, not physical education. As we continue to work for teacher certification in dance as a discrete subject, states and school systems might explore alternative certification for highly qualified individuals in dance.

In states where dance is a component of another discipline, teachers traditionally receive insufficient preparation. There is a great need to provide in-service courses in dance education for such teachers already working in the schools. Classroom teachers and other specialists also need in-service training to supplement the instruction by qualified dance educators.

If we are to create and implement arts standards, we must consider the issue of teacher preparation—both preservice and in-service. This issue is inextricably bound to a comprehensive, developmentally appropriate, and sequential curriculum that recognizes dance as an educational process and a valid mode of learning. The dance educator should facilitate active learning and be innovative in the use of instructional strategies, including media technologies, as a part of the delivery system.

In dance, the body is the principal instrument of expression. In an increasingly technological age, dance is especially suited to keeping in touch with what is human. It is important that dance be part of the education of every child, regardless of whether the youngster desires to pursue a career in dance. Dance can serve as both a lens for perceiving and a language for communicating. Without dance education, individuals are not only denied access to a significant area of human knowledge but are hampered in their capacity to fully perceive the world, communicate with others, and understand the bodies in which they reside.

Because of its adaptability, dance offers one of the best ways to help exceptional students discover, develop, and share their talents and thereby more fully participate in society. In addition, many culturally disadvantaged children with limited facility for language have used dance to bridge the learning gap. Race, religion, socioeconomic status, gender, and physical and

mental fitness can all affect students' self-concepts as well as their attitudes toward others. Dance, because of its attention to the individual, provides encouragement for self-exploration, valuing of differences, and understanding of interpersonal relationships. This acknowledgement of diversity should be reflected in teacher preparation, in instructional materials and strategies, and in the development of world-class standards for dance.

Access to dance education is the responsibility of administrators and other decisionmakers. To achieve world-class standards in dance, it is important that people who are preparing for positions in school leadership, such as principals and superintendents, be required to study the theory and practice of arts education. Without a basic understanding of what is needed in order to achieve high outcomes in dance, many school leaders assume that sufficient dance education occurs through an infrequent unit of physical education or a movement experience in music class. School leaders must understand the need for including dance in the core curriculum by design, not by default. This means scheduling appropriate time allotments that allow for sequential learning under the guidance of qualified teachers.

Dance educators often spend a considerable amount of time dealing with misconceptions before they can get students (and sometimes school administrators) to the point where good programs can be implemented and high-quality teaching can take place. How many of these misconceptions are a part of your thinking?

■ Dance is an activity only for those people with natural talent, those with spe-

cific body shapes, those of certain ages, or those at a high socioeconomic level.

■ Dancing is for girls, and all boys who dance are sissies.

■ Attending dance performances is for only the few who can understand the art form.

■ Dance is just for exercise.

■ Dance is just for entertainment.

■ Dance is only done for fun and does not require thinking; therefore, it is not worthy of a place in the school curriculum nor as a career option.

■ Dance is only ballet (or tap, or MTV, etc.).

Have you given any of these excuses for not dancing?

■ I have two left feet.

■ I'm not creative.

■ I have no rhythm.

■ I'm not coordinated (or flexible, or graceful, etc.).

If you had met world-class standards in dance as a part of your education from kindergarten through the twelfth grade, what difference would it have made in your life?

When drafting the standards, the members of the National Dance Association Task Force were able to write what we felt all students should know and be able to do in dance, and there has been a consensus from the grassroots that we are on target. Standards for excellence in dance education have the potential for improving the quality of existing K–12 programs and for establishing models to introduce dance education where it does not currently

exist. High standards also have the potential to enhance the performance of students at all levels of achievement. To measure those levels, assessment and evaluation must be based on the standards and embedded in the curriculum. The methods of assessment should accommodate diverse learning styles and multiple intelligences.

We look forward to the implementation of the standards, to assessment in arts education, and to the impact that these arts standards will have on American students as the twenty-first century approaches.

Writing Standards for Theatre

Lin Wright
Chair, Task Force for National Standards in Theatre

In American society today, young people are in one sense surrounded by drama, particularly via film and television. On average, they watch television four hours a day. In addition, all students are introduced to dramatic works in their English and language arts classes, and most students are in a skit at some time during their school career. In spite of these opportunities to see film and television, read plays, and act in skits, very few children have the opportunity to see theatre or to work with theatre specialists to acquire the skills necessary for exercising aesthetic judgment in choosing theatre or films to view. Few have the opportunity to develop the skills to create and present drama. Theatre educators see the standards as a means of helping theatre specialists and classrooms teacher improve their teaching in our discipline.

In creating "world-class" standards for the year 2000, we started by reviewing the existing state curricula and the 1987 document of the American Alliance for Theatre and Education's *Model Drama/Theatre Curriculum.* We found that:

- Most current curricula focus on the teaching of acting.
- Theoretical content has been based on the Euro-American well-made play. Burnet Hobgood, in preliminary work for the *Arizona State University K–6 Drama Theatre Curriculum Guide,* suggested that the AATE model curriculum was "Aristotelian in a post-Brechtian world."

For at least the last decade, theatre educators have been criticized for being in a "production mode." The high school teacher, particularly, produces play after play, leaving little time to teach about the art of theatre. This state of affairs is as much due to administrators and parents who demand competitive events and "viewable" results as it is to the teachers. The committee perceived the standards as a means to educate both the public and teachers to the idea that theatre is a discipline with aesthetic theories, a history, and a literature; it is also a dynamic means of teaching cognitive, affective, and social skills.

Theatre creates a metaphor for society and helps us make meaning about what it is to be human. Therefore, in order for theatre to have meaning for our young people, it must be based on a world that the students know. We are committed to helping young people find their own cultural "voice" through drama and to helping them understand the voices of their peers in our multicultural society. We also perceive drama as a means of increasing global awareness. The theoretical basis as well as the content of the drama created and studied needs to be broadened beyond that in currently published curricula.

In theatre education, learning theory has been perceived as a guide to making decisions about materials and methodology. We must be sensitive to learning theo-

ries about multiple intelligences, active learning, metacognition, and transfer of learning.

We believe a good theatre program should include drama in many forms: ritual, theatre, film, performance art, and the electronic media of television, radio, and virtual reality. For students to be able to understand world drama, we must teach about ritual; to deal with modern society, we must teach about media as art forms and as tools for expression. Most young people are lucky if they see a good theatre production once a year; it is film or television that they experience daily. Drama is the base discipline, but the media for its transmission have exploded, and we are certain that more will be created within the decade.

How can we steer the field away from focusing on acting and yet keep the active learning thrust of creation and performance? This seemed particularly important since theatre is about performance, not text. Also, theatre is a collaborative art using contributions from several different kinds of artists. Students creating and performing theatre must use what John Gardener termed "multiple intelligences."

As students soon learn when they study theatre, many individuals are involved, and they do not think about the production in the same way. For example, a dramaturge is a researcher who seeks out information about the culture and history that surrounds the play so that the artists can make informed decisions about the drama they are to create and perform. The dramaturge also acts as the "outside eye" during the creation of a dramatic piece, questioning playwright choices of dramat-

ic elements and form. The playwright forms ideas about human beings and expresses these ideas in language. The actors interpret their own or the playwright's views of human existence and express these interpersonal and intrapersonal interpretations through voice and movement. Designers, technicians, directors, managers, and producers are all important to even the simplest dramatic event.

Current semiotic theory, theory about the importance of signs, has reminded us about the importance of all of the elements surrounding a performance: the posters, the program, the jacket on the videotape; the theatre lobby and the patrons in attendance; the absence of outsiders at the viewing of a video at home, how a couch feels; the theatre space itself, including the seats and how people feel there; and so forth. The list is long, and understanding the relationship of these elements to the dramatic event is essential to the creation and study of drama.

The theatre or other medium's audience plays several different roles that students need to understand and be able to fulfill with sensitivity. In the theatre, the interaction between the actor and the audience is essential to the event. The audience must fulfill its role in completing the communications loop from actor to audience to actor. Audience response to media is important, but it affects the artists through polled responses to pilot programs and attendance at and response to dramatic events. The movie *Star Trek V,* for example, was created in direct response to the favorable reaction to previous movies in the series at the box office and the fact

that VCR purchases were on the rise. Appreciation of a dramatic work is based on an understanding of the symbolic meaning of the various signs and interrelationship of signs—all the results of the artists' choices and their responses to the audience.

Given the complex nature of making and viewing theatre, film, and the electronic media, teachers need to stress the *collaborative nature* of the art form, to teach knowledge about and skills in each of the artistic and audience roles involved. At any given moment in the classroom, a student may be performing as several artists at once, for instance, as dramaturge, playwright, and director, but the thinking and skills of each artist are unique, and students need to know this.

Certainly students need a sense of the Aristotelian logic used in the creation of most Euro-American drama, but Susan Langer's view of art as a means of expressing feeling can open students and teachers to a search for form unique to their personal voice (feeling). We also assumed that students should learn the dramatic elements and at least the cultural or historical context of specific projects so that they can "deconstruct" what they view and what they create, discovering the artistic, historical, and cultural influences on the event.

Closely related to this kind of "knowing" is teaching the importance of signs and symbols and methods of interpreting these symbols. This may sound very sophisticated, but it is possible to find simple ways to help children understand what they do naturally—pretend—and to help them transfer this knowing to the more formalized metaphorical art of theatre.

Students need to become both culturally literate and *critically literate*—able to understand their own and other cultures to understand the similarities and differences. Students need to be able to honor their own and other people's voices. In the standards document we refer to "exemplary" texts and performances; this leaves to the local curriculum designers, the individual specialists, and the classroom teacher the opportunity to choose materials specifically to meet the cultural, social, and academic needs of their students. We perceive theatre as a social art form and encourage teachers to teach it in this manner.

Our draft standards reflected the roles of those who make theatre: playwright, actor, designer, technician, dramaturge, director, manager, producer, and audience. This format was subsumed under the more traditional categories that serve as a foundation for the standards: (1) creation/performance, (2) perception and analysis (theatre's theory and criticism), and (3) cultural and historical context. This was done in an effort to parallel the theatre document with that of the other three arts—dance, music, and the visual arts. These categories suggest an artificial separation of knowledge and skills between the roles and the basic categories of theatre. Short of a three-dimensional model, we have difficulty communicating the very integrated, collaborative nature that we perceive as essential to the art of theatre and to the teaching of that art. We continue to seek language to convey the idea that, as students create and perform in

theatre, film, and the electronic media, they use the perceptive and analytical knowledge and skills of the aesthetician as well as the knowledge and skills of the historian. As students fulfill the roles of responsive audience members, they use the knowledge gained as artists, aestheticians, and historians to understand and appreciate the theatre event.

Rather than specify what should be expected of children at each developmental stage, we were charged to write the standards document as *outcome* standards at the fourth-, eighth-, and twelfth-grade levels, which would then parallel a national testing program to be administered to students at these three grade levels. The sequencing of activities K–4 or 5–8 is to be the province of the local curriculum committees.

Specificity has been an issue, both as to curricular content and achievement standards. We need to emphasize the importance of sequential learning, and therefore need more than just broad guidelines. Achievement standards need to be specific, in part because one of our most important goals is better communication with other educators, such as English teachers and general classroom teachers, who help students understand what a joy theatre can be. Thus, the document has become more detailed as we have continued to work.

Educational standards and curriculum must grow with the art form as the art form grows with the society. Since theatre is a social art, it is particularly important for us to keep our standards and curricula current so that the discipline remains a living tradition that helps all students have fuller lives.

Writing Standards for Music

Paul R. Lehman
Chair, Task Force for National Standards in Music

When one thinks about developing national standards for K–12 arts education, the first question is whether it's a good idea in the first place, a question we have answered in the affirmative by our presence at this symposium and our investment of time in this project. We all have colleagues who don't share our view on this point, and as we proceed, we should try to address their concerns and allay their fears.

Most of the issues we've encountered are not discipline-specific, though they may apply differently in various disciplines. There are two issues, in my view, that are more troublesome than any others. The first is how high to set the standards. How good is good enough? We've agreed that these will be "world-class" standards, intended to reflect our aspirations and not the status quo. Even so, they should be achievable given reasonable time and support. It's not easy to reach consensus on what's achievable or what's realistic. At this very moment in some districts students are easily meeting standards that in other districts would be considered hopelessly unachievable.

Once we've decided how good is good enough, there's an even more difficult question: How do we *specify* how good is good enough? How do we write achievement standards that do indeed specify the student's level of attainment? Many of the achievement standards are not as explicit as standards ought to be. They say what the student is expected to do but they don't say how well it should be done. The achievement standards thus becomes essentially an expansion and explanation of the content standard. Given the nature of our subject matter, sometimes that seems to be all we're able to do.

The standards describe four levels of achievement: one for grade 4, one for grade 8, one for students in grade 12 who have elected one to two years of relevant course work beyond grade 8, and one for students in grade 12 who have elected three to four years of relevant course work beyond grade 8. In some cases, the achievement standards sound very similar from one level to the next. The nature of the task may be essentially the same, at least for the upper three levels, and sometimes for all four levels. How can we define these levels of achievement so that the progress from one to another is stated explicitly? Actually, the difference from one level to another often lies only in the sophistication and depth and insight reflected in the student's response and in the complexity of the music the student can deal with. It is, however, very difficult to describe explicitly the sophistication, depth, and insight expected in the student's response.

A third issue has to do with priorities. What should be included? What should be excluded? Our purpose is to achieve a consensus on these questions, but every-

one wants a few words inserted here or there to reflect a particular perspective. If a camel is a horse that was designed by a committee, our standards could easily resemble Dr. Doolittle's Pushmi-Pullyu. It's tempting to include everything everyone wants included, especially since there is no zero-sum limitation. Having something for everyone is nice under a Christmas tree, but it could be fatal for standards perceived as overladen with everyone else's idiosyncratic biases. Besides, in the school day there is a zero-sum limitation.

A fourth issue concerns attitudes and values. We teachers want our students not only to be skilled and knowledgeable in the arts, but also to value the arts and be involved with them throughout their lives. How can these noble goals be reflected in the standards? The fact is that attitudes and values are almost impossible to state as content or achievement standards. Try writing some. Attitudes and values develop slowly and cumulatively. You can't build a curriculum that will teach them directly. You can't write a lesson plan that will teach them directly. You can't test them directly. Attitudes and values are achieved as by-products of an instructional program. If we all do our jobs well, the attitudes and values will take care of themselves.

There are several apparent issues relating to format that are based more on appearance than on reality. For example, what we're calling standards are called outcomes by some school districts and some state departments of education. Others call them expectations, or objectives, or something else. The distinctions made among these terms are inconsistent and

based on subtleties of wording. As a result, an outcome can usually be made into a standard or vice versa simply by substituting a stock work or phrase at the beginning of the sentence.

In January 1993, the draft standards in music were published in the *MENC Soundpost,* and the Conference's 62,000 members were invited to offer comments and suggestions. Many respondents spoke of the issues I've cited already, but the single concern expressed most frequently by teachers was that there's no way in the world that we have time to teach all of these things.

As the idea of accountability creeps back into the debate on education reform, there is a deep-seated and completely understandable fear on the part of music teachers, especially elementary teachers, who may see their kids for only twenty minutes every two weeks, that they will be held accountable for achieving all of the learning outlined in the standards. Many teachers said, in effect, these standards are all great, but where's the standard that says that at least 125 minutes a week should be devoted to music in the elementary school? Where's the standard that says that music should be required through grade 8? Where's the standard that says that music should be taught by specialists and their work reinforced by classroom teachers?

The answer, of course, is that those questions pertain to opportunity-to-learn standards, and we are now dealing only with content and achievement standards. We'll deal with opportunity-to-learn standards through our various professional associations as soon as we have completed

the content and achievement standards.

Meanwhile, we can't overlook the plight of the teacher who said that the standards for K–4 are excellent and achievable *provided* that there is ample funding. In her state, she says, they are presently not achievable. This educator teaches nine hundred students a week. She teaches them in a trailer. And she shares her trailer with an art teacher. All she can do is introduce the basics, she says, and she can't teach movement, and one can see why.

The following words of one teacher summarize the dilemma seen by many teachers across the nation:

> With all of these wonderful new arts proposals (and they *are* noble, true, and correct) we *must* make provisions for the educators who are now working to capacity! For example, when I came to my school district twenty-one years ago, we had twelve students in the choir and one vocal music teacher. Today, we have a two-hundred–voice chorus, a sixty-voice select choir, and a sixty-five–voice eighth-grade chorus—and still one vocal music teacher!
>
> Preparing my students for concerts, assemblies, festivals, community performances and competitions—plus individualized instruction for soloists and ensembles—plus fund-raising—all keep me working a full schedule including lunch hours and after-school hours. It is rewarding and fulfilling, and our program is supported by our administrators, staff, board of education, and community. However—I must honestly tell you that we are not achieving every one of your proposed standards—nor could we ever! Does this make me a failure? I hope not, because I am working very hard.
>
> I believe that your vision *must* include provisions for increased funds and a mandate for more staffing. But many communities cannot afford this. Yes, your vision is comprehensive and "world-class," but please consider all of us who are now "in the trenches" fighting to give our students musical experiences that they will value throughout their lives. Don't dilute our present programs by heaping on even more responsibilities to our seriously understaffed and overworked arts educators.

All of us here want the arts programs in our nation's schools to be better tomorrow than they are today. To do that we have to grapple with the issues that we have identified in this symposium. Ultimately, we have to find a way to help our colleagues who are teaching nine hundred kids a week in trailers they share with other teachers. We need more time and more resources, but, meanwhile, we can expand our repertoire and our vision within the constraints we currently face.

Questions and Answers: Organizational Issues

Standards and Institutional Support

As an educator and a creative thinker, I applaud and celebrate the careful yet visionary work you've put into content and achievement standards. I also understand why you began here, for without goals, what are we working toward?

However, I think I speak for many in the trenches when I say that it cannot be overemphasized to you that publication of these standards will be completely useless to us without delivery standards. School boards and administrators don't think as creatively as you do. Can you tell them how, and more important, how much?

■ That's an important question to all music teachers. The original grant for the project, from the Department of Education, the National Endowment for the Arts, and the National Endowment for the Humanities, called for the development of content and achievement standards only. That's because the Department of Education and the two Endowments cannot allow themselves to be placed in a position of telling school districts how many minutes to spend on each of the arts or of mandating any specifics on how to implement the standards. That is not their job.

The first task is to develop the content and achievement standards. It's especially significant that the Department of Education is now underwriting standards in several subjects—including the arts. When all the standards are developed, they will have the imprimatur of the Department of Education, and in our case, the two Endowments.

However, our professional associations are proceeding or will proceed to develop our own delivery standards. We will make sure that everybody understands that the content and achievement standards need support. Delivery standards are not a part of this first project, but they will follow very closely.—*Paul R. Lehman*

■ We all realize that when we come to the implementation of standards, there are numerous systems that have to work together, perhaps congruently and even, if we're lucky, in an integrated way. The committee has not been charged with determining how various systems should work together to deliver the standards, but this question keeps coming up. Another recurring theme is values—values of the public and values of professionals and values of other groups. How are these delivery systems and value systems going to be connected or perhaps integrated to move the standards from vision to reality?

This question is critical when we mention values. We are talking about the values that make people believe that we ought to spend the time and money necessary to accomplish the work implied in the standards. There's no way around it. So

we have to be practical and realistic about issues of time and resources. When I say resources, I mean tangible resources, but also intangible resources such as will and commitment and understanding of why meeting the standards is important.

So we have to avoid the mistake that we Americans are often accused of, which is doing a technical job in one or two areas and expecting that that technical job will accomplish holistic goals. We have to be a bit more holistic. We're going to have to face the values–resources–standards connection as a community, whether we face it within this project or not.—*Samuel Hope*

Standards, Skills, and Curriculum

Why isn't there a section on fundamental skills that students need in order to create, perform, analyze, perceive, and appreciate the arts?

■ These so-called fundamental skills, in my view, exist in a synergistic relationship, rather than a cause-and-effect relationship, with the skills of creating, performing, analyzing, perceiving, and appreciating. I'm not an early-childhood expert, but my common sense tells me that when a student creates a composition on the piano, for instance, he or she needs certain kinds of gross and fine motor skills to make the keyboard work. By exploring the keyboard, the student hones those skills. So as the student learns to compose, he or she also learn gross and fine motor coordination.

When, for instance, you learn to make a collage, you need organizational skills. For dramatizing a story, you need

sequencing skills—and so on. So my sense tells me that the only starting skills you need are those that you're born with—seeing, hearing, tasting, smelling, touching, feeling, and intuiting. That's the baseline entry level into arts education. —*Edward Gero*

■ Beyond the natural abilities that we all have, we need to learn to communicate. We all learn to speak without studying English, but when we get to school, lo and behold, somebody tells us that we're going to study English because what we are learning naturally in our environment, while effective at a certain level, is not effective at higher levels of communication and thought. It seems logical, then, that the standards should have within them the possibility of focusing on the skills that enable us to move from our natural abilities to communication skills.

There's not total agreement about such a focus in the arts education community, on the committee, or anywhere else. But I think we have to include that focus if we wish to make the point that the arts are basic. Our questioner has an excellent point.—*Samuel Hope*

■ I think skills are implied in the way the standards are written, but skill development is something that I think states and individual districts must respond to. The fact that a given standard doesn't explicitly delineate skills does not mean that skills are not necessary and should not be developed at the local, district, and state levels.—*Shirley Ririe*

■ This question relates to the difficulty in deciding how specific to make the stan-

dards. How do you determine how many words to put in? Are some of those words red flags to some people? Are the connotations going to stop rather than open up the kind of thinking that we want at the state and local levels? I think we should be careful with language, because you can't do any of the arts without some skill-building. We really need to be precise about the words we use.—*Joan Peterson*

Within the context of national standards, will it be considered appropriate for individual arts educators to develop their own standards, even though some of these standards may not support the national standards?

■ National standards are voluntary, and always will be voluntary. To some extent, it would be an affront to teachers' sense of professional esteem to say that individual's own standards would be considered anything but appropriate. Of course it's appropriate for an individual teacher to do what they think they should do. The standards are suggestive, not prescriptive. —*A. Graham Down*

The national standards for mathematics have already been completed. How did the math committee deal with the issue of delivery standards while working on the content standards? This question asks that we consider the time to teach as well as funding.

■ They didn't, actually. Delivery standards are not as large an issue in math as

they are in music. There's no elementary school I'm aware of that tries to teach math in twenty minutes every two weeks.

If there were, it would be interesting to see how teachers would cope with that problem. Math teachers aren't fighting for every minute. They aren't fighting to get in the curriculum, because math is already in the curriculum, and it's firmly established. Furthermore, they don't need the specialized facilities that we need—like rehearsal rooms, instruments, and specialized equipment. They wouldn't agree necessarily, but from our point of view, they have it easy.—*Paul R. Lehman*

The national mathematics standards focus on the five great ideas of mathematics to bridge differences between disciplines. Is it possible for us to come up with a similar approach to art among our disciplines?

■ Indeed, the math standards were organized around five goals. The arts standards committee might well look at these, but I think that relates more to interdisciplinary work. What the committee has decided to do instead is to have some categories around which standards could be organized.

The National Council of State Arts Education Consultants surveyed the frameworks for arts instruction in all of the states, and looked for common content categories. We found that most states do use the same organizing categories—although they may use different language. For history, some states will use "cultural heritage," others will say "social and historical context." So, in fact, as a field, we have defined major ways to organize and

understand and explore instruction in the arts.—*Joan Peterson*

Standards and Political Sensitivities

How is the religious right reacting to the development of national standards? Are we informing the public and the politicians well enough so the fundamentalist objections to multicultural issues, different lifestyles, self-esteem, and critical thinking skills will be minimized?

■ The Puritans said it was okay to sing, otherwise there wouldn't be music in the curriculum. I don't know what it will take to move people around a little bit and have them rethink their preconceived notions, but that's the idea of education in the first place. We'd like to bring them along with us.—*Roger Mandle*

■ As an itinerant dance teacher, I've done a lot of touring and residency work in a variety of places, including places where there are very strong fundamentalist beliefs. When we call it movement instead of dance, we get by—so there are ways.

We bring the parents in and show them that we are doing, indeed, things that develop self-esteem, rather than lewd and lascivious dancing. I think there's a lot of education that needs to be done, and I really think that people in that category would embrace what we're about.
—*Shirley Ririe*

■ I think the National Committee and the managers of the project are making a conscious effort to avoid putting anyone's politics in the standards. There are extremes at both ends of the political spectrum. We have to make this as apolitical a document as possible, because people's politics are their own business. Our business is to teach subject matter and skills. Sometimes the symbols that are associated with knowledge and skills are a problem we have to address, but I think we have to be very careful to avoid a political or politicized approach to the writing of these or any standards for education.
—*Samuel Hope*

■ The problem is not that we would or wouldn't put politics into our standards, but rather that someone would read these standards with a political perspective. I think one of the things we have going for us is that these standards will stand on their measurability. We are trying to establish measurable standards, not have a lot of arm-waving.

One of the fundamental problems the arts have had in curricula is that the terms we use have been taken away from those of us who advocate the arts in general, and they have been redefined by people who try to place them in a particular perspective. I think that as the standards project gains its validity, it will be a much more secure basis from which educators can speak about these things to groups that are concerned and feel threatened.—*Roger Mandle*

Section 3

ACHIEVING EFFECTIVENESS

Views from the Field: Education, Business, and the Arts

Diane Ravitch

Former Assistant Secretary of Education
Office of Education Research and Improvement

The standards are one of the most exciting things happening today in American education. The schools and children have many needs—the children have social needs, the schools have financial needs, there are all kinds of problems and crises. We can't solve all of them with any one solution, but one thing we are working on, which is going to be very important for school improvement, is establishing standards about what children should know and be able to do and developing appropriate assessments to support those standards. If we continue using the existing tests, the new standards will not survive.

A reporter recently asked me to explain about what the standards are. I went through trying to explain the importance of letting children and parents and teachers know what is expected for good performance. I looked at my computer and saw the button for "reveal codes." I told the reporter that standards are like embedded codes. They tell kids what the secret of success is, what it is that you have to do to be good at whatever it is you're studying, what it is that the kids in the very best schools are learning, and what their teachers are doing.

Identifying these standards doesn't mean that you're going to be able to achieve them, but at least we should be able to identify them so that children and teachers and parents know what to aim for and so that we can begin to set the high expectations that we talk about all the time, but that seldom get translated into what occurs in the schools.

Implementation of these standards is the key to the success of everything that the different standard-setting activities are trying to do. A lot of people in the arts community were very unhappy about the fact that the arts were not identified specifically in the America 2000 goals as were math, science, history, geography, and English. The goals were written collaboratively by President Bush and Governor Clinton in 1989. There was a lot of awareness after 1989, and after the goals were announced, that the arts should not have been left out. I joined the government with Lamar Alexander in 1991, and we did two things. First, we scheduled a National Assessment of the Arts in Schools, which is now being developed. It will probably be given in 1996, which will give people plenty of time both to develop the assessment and also to prepare for the assessment. In this country we tend to teach what we test, so that it's very important that the arts become part of the regular schedule of assessments that are administered by the National Assessment of Educational Progress, and that's under way.

The second thing we did was to launch the standard-setting effort not only in the arts, but also in civics and foreign languages. None of these three subjects was mentioned in the goals. Now there will be

49

national standards in the arts, and the standards and the assessment will be critical in terms of putting the arts on the national agenda.

I think that the ground is fertile for the kind of push that all the arts organizations are mounting together.

The History and Future of the Standards

Louise Miller
Republican Floor Leader, Washington State Legislature

The first thirty-two years of my life were intimately involved with the arts. As a youngster, a young adult, and eventually a professional musician and educator, I studied, performed, taught, and lived my daily life with and for the arts.

In 1983, after serving five years as a local elected utility commissioner, I was elected to the legislature. This began a time of excitement and frustration as I began to watch the downward spiral of arts education in our public schools, and the dismal lack of understanding and support by state and national elected officials who have the control over our precious tax dollars for our public schools.

I know the decline started before that, but I was so involved in my own arts activities that the lightbulb didn't go on until the Seattle schools fired their elementary arts specialists and the well-funded suburban schools surplused stringed instruments, thereby killing all the orchestras.

The good news is that I think we've turned the corner. I finally see a glimmer of creativity leading into the next century. The vast majority of elected officials are just beginning to understand that the arts can provide multiple avenues to satisfy our children's educational needs. The arts motivate students; keep them involved in positive and self-satisfying activities; contribute to higher achievement scores, lower dropout rates, group participation skills, understanding of other cultures, and critical thinking skills; and build the self-esteem that comes from participating in the choir, the mural project, the school play, or the dance troupe.

This is a very slow evolution. At the annual meetings of the National Conference of State Legislatures (NCSL), an organization in which all legislative members from all the states can participate, they spend a good deal of their spare time listening to very high-quality music presentations, attending plays, visiting galleries and museums, and touring historical sites. Cultural awareness does not, however, seem to imply awareness of cultural politics. The committee that I chair—Arts, Tourism, and Cultural Affairs—and the Education Committee just woke up last summer to the fact that the President's America 2000 goals for education didn't include the arts. They all got copies of the original publication years ago, and some of them may have even read it, but nothing rang a bell until someone in the Arts Committee told the Education Committee, "we need a resolution."

A resolution from the National Conference of State Legislatures on the importance of arts as part of the core curriculum will provide a vote for a policy that will then be lobbied for in Congress by our staff in Washington, D.C. It means state legislature delegates will go back to their constituents in their respective states to

51

report on the issues that are of importance to the national organization.

This year, 1993, really can be a turning point nationally for arts education. Both the National Endowment for the Arts and the Clinton Administration have publicly affirmed that the arts should be an integral part of every child's learning.

The NCSL, with a grant from the Getty Foundation, has done a publication that all legislators have received. It's called "Reinventing the Wheel: A Design for Student Achievement in the 21st Century."[1] I guarantee that all legislators got this book, but I'll also guarantee that only about 1 percent have looked at it. It has a lot of very valuable information for legislators, for committee staff people, and for other policymakers. It gives a lot of good examples from other areas of the country that are already grappling with this problem. Ask your legislators if they have seen this publication. If they haven't seen it, then ask them to dig it out of their piles.

As a senior member of the Washington State Legislature, a ten-year member of our State Arts Commission, and present chair of the NCSL Arts and Tourism Committee, I'd like to focus a little bit on what we've found in our own state and what can motivate policymakers with the state checkbook to invest in the arts as core curriculum for our schools.

From our Start Arts Education Task Force project, supported by the National Endowment for the Arts, our own Arts Commission, our Superintendent of Public Instruction, and our Washington State Alliance for Art Federation, came the assessment that in the early 1980s, this nation and our state were on a back-to-

basics movement—reading, writing, math, science. The arts, traditionally viewed as nonacademic, noncognitive frills, were reduced or eliminated. The assessment revealed that basic arts education was sadly lacking in Washington state and in our nation. Indeed, in at least half of the schools, we found that 65 percent of the students were not enrolled in any arts classes at all.

Fewer than half the districts assessed reported that they had board-adopted educational goals with specific areas mentioning arts education. When asked what was the most important reason arts education was in the public school curriculum, less than half said it was part of basic education; 20 percent said it was because arts provided a means to increase creativity; 20 percent responded that it was because the arts provide a basis for conceptual development and thinking; and 7 percent said arts provide stimulation or reward for some students.

In the case of staffing at the middle, junior high, and high school levels, our statistics weren't much brighter. Nearly half the districts with middle schools or junior highs reported having less than a full-time music instructor and no visual arts instructor. At the high school level, half the districts reported having less than a full-time instructor in both art and music. Drama and dance were practically nonexistent. Yet our own Washington Administrative Code and the Revised Code of Washington said that "All students should be offered art and music, K–12."

We then created a Washington State Arts Education Action Plan based on the

assumption that all students are entitled to regular and in-depth instruction in the arts. The next step in our state came about as the result of a few legislators and our then-Governor, Booth Gardner, getting together to talk about education reform. If your state is involved in education reform, this is a key opportunity for people in the arts to get involved at the very beginning level.

We found our Arts Commission, our SPI's office, our Arts Coordinator, and the Washington Alliance for the Arts were ahead of the curve and already planning a strategy for making the arts a basic part of every student's K–12 education.

In early 1992 our governor appointed a blue-ribbon education panel, which, oddly enough, included educators as well as legislators and businesspeople; and, oddly enough again, was actually chaired by our governor, who attended most of the meetings. At the same time, in March 1992, then-Secretary of Education Lamar Alexander announced the America 2000 Arts Partnership. Voilà! In Washington, in December 1992, when they reported to the legislature, number two of the student learning goals, of which there were four, read like this, "Students should know and apply core concepts and principles of mathematics; social, physical, and life sciences; arts; humanities; and healthful living."

Good. Now we have a goal. But what motivates politicians? A few little excerpts should illustrate that.

The first one is from an article in our Seattle *Times* in February 1993. It was a survey by the Corporate Council for the Arts that charted the economic impact of

art in Seattle. They found out that in the 1991–92 fiscal year, $180 million came from the arts; 142 professional art groups were involved, and this included 8,800 full-or part-time jobs, with another $96 million in labor. In 1992, professional baseball got $99 million and had 2.1 million attendees, while arts attendance was four million.

At the same time the National Cultural Alliance Study found that a whopping 73 percent of those polled think that in spite of economic hardship, public and private support of the arts and humanities should not be curtailed. The survey also found that more than 90 percent of the respondents think the arts are especially valuable to children in their intellectual development and their sense of achievement and self-expression, but only 10 percent felt that elementary and high schools are doing an excellent job of promoting the arts and humanities.

Another excerpt from a very recent newspaper article in one of our other local daily newspapers says, "We want students to understand arts are not elitist. They are the core of our culture, something everyone can understand and use to express themselves."

Furthermore, it says, "Educators believe arts value goes beyond the easy-to-identify achievements of the very talented. Studies gathered indicate that when arts are an integral part of a student's education, the student's overall standardized test scores can go up by as much as 30 percent."

That's the kind of thing legislators really pay attention to: How much is in the economy, and how much better can our

students do if they're exposed to the arts.

The State's Arts Education Standards Project is already ahead of the legislature in our reform bill. We plan to have a guide in 1994 that will develop learning environment, the assessment, the assessment framework, and the discipline outcome from art educators, administrators, and professionals. All of these people are working together all over the state.

There are a couple of short things that you can take to legislators that will make a difference—and I'm borrowing this from South Carolina, because I think they did something very important in their strategy for developing what they called Target 2000. (U.S. Secretary of Education Richard Riley, of course, was their governor.)

They developed something called ABC, Arts in Basic Curriculum. It says, in part, "Three factors contributed to the inclusion of the ABC initiatives in Target 2000. Because arts advocates had not waited for legislative action before developing a strategy for arts education, they were ready with an ABC plan when Target 2000 was taking shape. Because arts advocates had made an effort to educate legislators about the arts and education, inviting them to community events and organization meetings, and finding out individual legislators' ties to the arts, the legislators were well informed about arts education. Rather than pitting themselves against science teachers, for example, or advocates of early-childhood education,

arts educators allied themselves with educators from other disciplines when the time came to push for legislative support."

As a result, Target 2000 incorporates the ABC initiatives, and there is an additional $1.3 million in the budget for arts education.

Finally, do not make the mistake of thinking that this will be an easy sell around the country. We can never let up. But as more examples from around the country provide data to make our case, we can gain the support needed, whether it be for discipline-based art education or arts in the basic curriculum. We must not only expose every child to the arts in a meaningful way, but also provide the specialized classes and trained artists to train teachers and students in the artistic disciplines. We can develop the strategies for implementing the standards and developing new assessment methods. The policymakers will come along—usually behind the curve, but with the dollars they will give us and the case we can make for educating the whole child to a high standard of excellence in the next decade, I think we'll see a big difference.

Note

1. "Reinventing the Wheel: Design for Student Achievement in the 21st Century" is available through the National Conference of State Legislatures, Denver Office, 1560 Broadway, Suite 700, Denver CO, 80202.

54

The Politics of Implementing the Standards

Robert Glidden
Provost and Vice President for Academic Affairs, Florida State University, Tallahassee

In dealing with implementation of the arts standards, we're not dealing with artistic or intellectual problems, but with political ones. If the task, the challenge, of developing standards is indeed a challenge, it may be an even greater one to sell them to the community.

My first concern is that the standards not be constricted by the ease of direct measurement. One of the problems in formal education is that that which can be measured is what is measured, and *that,* then, is what becomes important—not only to school officials, but to parents. So I hope we're not constricted by that which is easy to measure when we state these standards.

One of the issues we'll be dealing with in getting standards accepted is not just accepting these particular standards, whatever form they take when they're finalized, but the notion of national standards in general and whether people will accept that notion. They're going to have to be accepted by the arts teaching professionals. They're going to have to be accepted by the decisionmakers, that is, school administrators, school boards, legislatures, state departments of education, and so on. And certainly they're going to have to be accepted and understood by the public, especially parents, who will have great influence on the decisionmakers.

Will parents agree on standards in the arts for all children? It's easy for us to say that they will. I'm not so sure it will be that easy. Standards imply a certain rigor, not just fun and games. A lot of parents do not now associate the arts with rigor in schools. That's one of our problems.

The standards must be simple for all, they must be clearly understood, they must certainly emphasize function over method, and they must emphasize content over process. For some, an American Kodály or an American Orff method might be appealing, but we're much too culturally diverse to have a national method.

The reality is that we are not going to get the time in the schools to achieve standards in every arts discipline for every child. We cannot be naïve about that. If we want to do that, we're going to have to be very circumspect about the extent of those standards. We may even need choices for schools or districts, that is, a choice between whether they want to be comprehensive in a kind of standard for all the arts or whether they want to let given children choose specific arts in which they somehow achieve a little higher standard.

How do we convince all concerned, though? First, for teachers, there's going to have to be some kind of reward system. Incentives are what work, which will primarily mean recognition. If teachers subscribe to a set of standards and we want them to work to really achieve those, we're going to have to set up some kind of reward system that recognizes that.

Certainly there's going to have to be a lot of attention to groups such as the Music Educators National Conference and the other arts education groups to get teachers involved and invested in this process, because we're going to have to develop a sense of unity of purpose. I think the only way it will work will be with a spirit of service and cooperation, rather than one of monitoring and regulation.

How do we convince decisionmakers and the public? A national standards movement generally will help. If people expect that there are going to be national standards in other disciplines, it will certainly be easier for us to do the same in the arts. I think it will take a common-sense, practical approach. We need to sell people on the use of future leisure time; we need to sell them on the idea that the arts are an intellectual activity; and we especially need to sell them on the idea that skill in the arts in many instances involves the intellect.

That brings up another problem: How much are the arts alike, and what are the idiosyncracies? At least in music, I am quite certain that the development of intellect involves a certain level of skill. If you don't have any skill, you can't develop much of a musical intellect. So we'll have to sell that to the decisionmakers and the public. The difficult arguments will be that the arts are as important as other disciplines, that they deserve time and attention, and that skill is an important and essential component of real intellect.

For the music educators and the arts educators in general, we're going to have to convince them that it is possible to achieve these standards. I can understand the concerns of many teachers about the obstacles they face, but we cannot let that slow us down.

What we have is a kind of chicken-and-egg situation. We can't get the time without stating the expectations of the standards, and we'll never achieve the expectations or the standards without the time to do it. We cannot effectively state a set of delivery standards, however, without convincing decisionmakers about the outcomes of the standards. So there's going to have to be a little leap of faith here somewhere, and we're going to have to convince teachers that they will not be failures if they, at first, do not achieve every one of those standards with the very limited time that most arts teachers have in the schools.

There are a few things that higher education can do and should do: First, we need to accept the set of national standards when they're developed as basics for teachers in training. That's a given. But one thing that isn't such a given, although it will be very important, is that we ensure that all entrants, all individuals that we admit to any postsecondary education music-major curriculum, are measured for and really achieve whatever those standards are. It is the same in any of the other arts. One of the best carrots in the schools is what the colleges and universities require for admission. That is one definite way to get the message across.

We also need to stimulate research efforts in teaching and learning to determine more efficient ways to acquire the skills and knowledge that we will require. And we need to develop mechanisms and

forums through which individual researchers can team with others on research projects dealing with the standards. In other words, we need a system of rewards and recognition there as well. We need to encourage policy studies and forums that will enhance understanding and awareness of the arts and the values and logistics necessary for their implementation. We need to provide opportunities (and higher education can perhaps do this better than anyone else) for bringing together the various arts communities—the presenters, the advocates, and the educators for the promulgation of the standards.

Colleges and universities certainly have a responsibility for text materials—both for college methods courses and for use in the schools. There should be many methodological approaches, and ways to use technology, and so forth, for teaching the arts at all levels.

We should encourage the development of software, for example, for assisting in the learning of basic skills and knowledge. We should encourage and fund, if possible, workshops for in-service teachers regarding the standards. A simple thing that we can and probably should do is to develop programs within higher education that encourage, perhaps even require in some instances, those who aspire to teach music or the arts to serve as tutors for the general education courses—and for first-year students, elementary education majors, whomever—and base all of that on these standards.

In other words, if we want to sell this notion, if we want the standards to catch on, we need to somehow weave them into the fabric of everything that we do and make them really basic.

Structures for Implementing the Standards

Jeremiah Floyd
Associate Director, National School Boards Association

In his book *A Bag of Tools,* R. L. Sharpe wrote, "Isn't it strange that princes and kings/ and clowns that caper in sawdust rings,/ and common people like you and me/ are builders for eternity?/ (When we see who we really, really are?)/ Each is given a bag of tools, a shapeless mass/ A book of rules; and each must make, ere life has flown/ A stumbling block or a steppingstone."

It is this concept of removing stumbling blocks and providing steppingstones for our children that provides the rationale for the National School Boards Association's (NSBA) full support of the efforts of the coalition to develop and push for voluntary implementation of standards in art, music, theatre, and dance. To us, each of these areas of study is basic; we advocate four things that local school boards should do to ensure their implementation.

First, the school board must set the vision for the total school system. That vision should include specific reference to the four art disciplines. It is the school board that must assert, forcefully and unequivocally, that study and learning in these four art disciplines are the things that help make us whole as a people. That vision must address the question of the kind of education we want for our children and what we must do to be able to afford it. Any curriculum program that denies our children opportunities to learn in these areas, denies them the chance to develop their individual wholeness and endangers their future and that of our society.

Second, it is the school board, and only the school board, that can establish by policy the structure whereby a comprehensive vision for the school system and the community's expectations for their schools can be achieved. So we say, "Board members, do not be timid in this regard."

Third, the people have a right to expect a reasonable amount of accountability for the investment that they make in public education. This does not mean that every school activity in the arts must be a prize-winning one or that a first place trophy is expected every time. It does mean that these programs must have results-oriented evaluation components. How else can those who direct these programs craft strategies for change and improvement?

Fourth, we say to school board leaders that they must join hands with other people and stand up for children when social and political forces try to pressure school boards to cut out the so called fringes—in which they include the arts. These forces pontificate glibly about the need for the public schools to just teach the "three Rs"—reading, writing, and arithmetic. Let the parents take care of everything else, they say. But of course, that is a sure prescription for disaster. The twenty-first century will require much more of us. Our society cannot afford to heed their advice.

These four elements form the cornerstones of our advice to school board members. We talk plain talk: Set the vision that will meet the future needs of our people, and establish the proper structures that will make it possible for that vision to be realized.

Make sure that the professional staff creates, and the board adopts, broad-based assessment programs so that real accountability can happen. And finally, you are to be a forceful advocate for children—all children.

Paul Laurence Dunbar had the matter about right when, some time around the turn of the century, in his little poem, "My Sort o' Man," he wrote, "The man who simply sits and waits/ for good to come along/ ain't worth the time it takes/ to tell him that he is wrong./ For good ain't flowing around this world/ for every fool to 'sup';/ you've got to put your see-ers on/ and go and hunt it up."

He stated further, "I don't believe in 'ristocrats, never did you see/ the plain ole homelike sort of folks, is good enough for me./ No, I don't believe in 'ristocrats, I like the honest tan/ that lies upon the healthful cheek, and speaks the honest man./ I like to grasp the brawny hand, that labor's lips have kissed/ for he who has not labored here, life greatest pride has missed."

We dare not deny our children this one of life's greatest prides—the chance to study, learn, and enjoy the four disciplines of the arts.

The Standards and the Arts at the Local Level

Robert Lynch
President and Chief Executive Officer, National Assembly of Local Arts Agencies

My background is eight years of Catholic grammar school and four years of the Jesuits—not an artistically rich field to mine. The only music education that I really had began day one, first grade, at lunch time. John Philip Sousa's "Stars and Stripes Forever" came over the loudspeaker. We were told we couldn't begin to eat until the music began, and it played every lunch for eight years. There was about a two-year break for some Gregorian chant lessons.

What I am familiar with here is the world of local arts agencies, arts councils, city arts commissions, and mayors' offices of cultural affairs. There are 3,800 of these organizations across the United States with the goal of serving all the arts, all the various art forms, and all the people in a particular locale. They do the kind of programming that fills in the gaps, programming that is not already being handled by artists or arts organizations in the community. Therefore, they very often get involved with arts education, services to other arts organizations, grantmaking, and cultural planning.

What's interesting about the local arts councils is that they represent a movement that was considered unachievable when it began in 1949. In that year there were no local arts councils or city arts commissions or mayors' offices of cultural affairs in the United States, then one began in Winston-Salem, North Carolina. In 1965 there were a few hundred, but there was no public money at the local level for the arts.

Today, there's $600 millon worth of local investments, $206 million at the state level (if you collect all of the state arts agencies together), and $175 million at the federal level. So something happened, something that allowed these organizations to come into being, to make a case for themselves, to lobby, to get funded, to get recognized, and to grow.

When I took a survey recently, I found that 81 percent of those 3,800 members were involved in arts education in some way. Fifty-four percent of them do Artists-in-the-Schools programs; 40 percent are involved by helping with curriculum design in partnership with school systems; and 62 percent are involved with advocacy and lobbying, trying to get the case across to local decisionmakers. These are research people—generalists, not experts.

One thing they all have in common is frustration. They're frustrated because they don't have a single story or a single message related to arts education to bring to the local decisionmakers that is related to content and related to standards in arts education. They know how to lobby, they know how to get a message across, but they need the message from those who are involved in music education. They're also frustrated because there's not a united campaign in arts education or in the arts. All of us have to work together to promote

the arts in education.

Recently I had an opportunity to chair a subcommittee on advocacy and partnership for the Arts Education Partnership working group under the sponsorship of the Kennedy Center and the John Paul Getty Trust. It gave me the opportunity to think about implementation of arts education at the local level and of standards at the local level as well.

In looking at how to succeed in making arts education and standards for arts education a priority, one key is a unified national information plan about arts education and about the need for it in schools. There are some problems with this idea, though. First, this partnership of team players must be achieved among groups that have disagreed in the past. Second, several competing efforts to oversee or plan for arts education advocacy have evolved, and it may prove difficult to move them into one unified effort. It is, however, the only answer.

Third, there is a tendency among national gatherings of groups to come up with grandiose national scenarios that don't build from the bottom up—but local decisionmaking is where the real power is located. Fourth, no adequate amount of money has been identified or allocated to such a major effort. Without such money, most efforts will remain on paper.

We all recognize that funds are scarce out there for arts education. Our challenge is to convince people who control purse strings to spend their precious resources on our cause—arts education. Success in this has been achieved primarily where many voices have banded together in partnership. I was involved, along with the

Kennedy Center and the University of Massachusetts, in a study of successful partnerships for arts education recently. As a result of the study, a book was published called *Intersections: Community Art and Education Collaborations.* In that book, the community participants who thought that partnerships succeeded in implementing good arts education programming related nine elements of partnerships.

The first element is leadership and vision. The second is effective planning. Planning is understanding those obstacles and those building blocks. It is broad-based community representation. We can't sell it on our own. The local arts agency by itself is nothing—it's meaningless. It has to be the local arts agency in tandem with the education community, the business community, and the local government community.

The third element is teacher participation, fourth is artist participation, fifth is public awareness, and sixth is communication. All of those elements help raise the visibility of our cause at the local level. An awareness of the program as a catalyst is the seventh element, and the need to cite specific program design is the eighth. We can have standards, but we all recognize that those standards then need to be interpreted locally. With the guidance of local school committees, local teachers, and local partners, the plan for that particular community will come forward. Finally, we need an ongoing evaluation of the partnership.

We should recognize that all decisions will ultimately be made locally. Therefore, all partnerships and advocacy, whether

federal, state, regional, or local, must be directed toward the final outcome of affecting local decisionmaking. To motivate local leaders, an overall climate of support must be achieved at the local level.

How do you do this? You need to create more stakeholders in the process, more people buying in and believing. Identify who the local players are—and it's not just the ones that have been mentioned so far. Make sure that they are adequately informed of and made to believe in the value of arts education and of the standards and the benefits of those standards. They need to understand that they are included in whatever local process is undertaken to plan and establish arts education as a priority.

Both the state and the national community participants should be kept informed and urged to officially accept and endorse the concept of arts education as a local priority. "Officially" means a process where a resolution can be brought forward to a national entity for a vote. The same process exists not only for the National Conference of State Legislatures, but for school board organizations, for the U.S. Conference of Mayors, and for the League of Cities. You have those tools to bring that message forward and get it officially adopted. It's hard, but it's there.

A simple example of this multilevel approach for building support is a city council member who hears locally about the importance of the arts and the importance of the standards that we're talking about, and then has that concept reinforced when he or she goes and speaks to the state League of Cities organization or

comes to the National U.S. Conference of Mayors meeting.

If this information can be carried through for each of the various categories of local partners, then both a horizontal and a vertical advocacy campaign is achieved, which will lead to the successful adoption of the concept of arts education and standards as a local priority.

There are many ways of looking at who these local players are. If you look at it from the schools' point of view, you understand that there are teachers and principals and superintendents and school boards and PTAs, and they all have to be involved; if you look at it from the community point of view, you understand that there are city councils, city managers, mayors, taxpayers, and so on, and they all have to be involved; and then if you look at it from the arts point of view, you understand that there are local arts councils, local organizations, arts organizations, and artists, and they all need to be involved. At the same time you understand that each one of those groups exists at the local level, each one of those groups has its state information network, and each one of those groups has its national service organization. The picture can emerge pretty clearly of how we can get this message across and make it something that becomes a priority for everyone.

An excellent example of a partnership approach at the local level is in Richmond, Virginia, where the Richmond Arts Council took a look at all of those partners, brought all the partners together, and used some tools. They used a public opinion survey; a series of roundtable discussions with parents and teachers and students;

surveys that were distributed to all the principals and schools (and they got a terrific response); surveys of arts specialists in those schools; 139 arts organizations; community-based organizations; telephone interviews conducted with representatives of area university schools of education, art, dance, and theatre; and national, statewide, and local model arts and education partnership projects.

In taking all of those parts together, they came up with a plan. Similar cultural plans are being developed in fifty of the largest cities and in probably three hundred cities in the United States today, and that is how facilities get built and funds get allocated.

These arts education plans are another tool that should not be overlooked to build a broad base of support at the local level. Local community collaborative plans to develop arts-in-education partnership programs are very new. Historically, arts organizations and artists and schools have each charted out their own territory in arts education. While there may be individual partnership examples between a single artist and an arts organization or a school, communitywide collaboration at the local level is rare. However, I think it is a tool we can all benefit from.

How do we get this going? There must be at least one multiorganizational, deliberative forum that can arrive at a consensus and take action quickly. Although I'm not an arts education expert, as a national arts organization CEO, I'm on probably a dozen different committees and none of

them really talk to one another. It's extremely frustrating to try to figure out what one committee is saying and what the other is saying, what the competitions are, and what the collaborations are. One forum would bring all of that together to make that message move forward. On a related note, there must also be some kind of a resource center for easily accessible models and arguments and legislation examples and names of speakers and curriculum guidelines and so on.

Currently there is no clear and simple statement about an agreed-upon range of arts education choices that a local school system could adopt. The barrage of conflicting statements from all of the things that I've talked about so far only confuses local decisionmaking and makes people, like local arts agencies, back off and move on to another subject.

We can create alternative interactive presentations. We simply need to find ways to engage elected officials to bring them in and give them the experience of understanding that moment where the arts change your life and value is added to your life.

Great progress is being made on the development of standards and the development of a case for arts education. Implementing these ideas at the local level is another matter entirely. Let's help stop the Gregorian chant–only approach. Not really, but give me an alternative. I look forward to being part of a strong partnership commitment and a campaign that will do exactly that.

The Standards and the Arts in the School

Janie Ruth Hatton
Principal, Milwaukee Trade and Technical School

64

I fell in love with the muses in high school because I didn't have enough knowledge or sophistication in elementary school. I'm a product of the segregated south where I went to an all-black elementary school and an all-black high school, and, quite frankly, I'm proud of that. It could have been different, but I've learned so many things because of it.

We had the usual play where the little kids made tracks over to the high school to see the big kids. I remember seeing the marching band, and the band director was just a plain lady, Ms. Collie May Powell, who was very structured—we thought, mean. She was a homemaker, not a teacher or an educator, because the district did not have the money, or the will more than likely, to hire a professional to impact on young people's lives.

I went on to high school, and we had a music teacher by the name of John Puckett. When we would sing in music class, even though I tried to sing out loudly, "Lift every voice," the teacher would tell me, "Janie, just mouth the words." That was a great disservice to me. I knew that, and I will tell him that when I go home again.

As the principal of Milwaukee Trade and Technical High School, the largest high school in Milwaukee, I know that standards give a rhyme and reason to why we exist. When students from the world come together, they bring a set of cultural experiences to a table. We are not doing all we can do, though, to provide to young people and young children the experiences of knowing who they are and who their friends are based on a set of four important arenas, or disciplines: art, music, theatre, and dance. When I was a foreign language teacher, for example, I had a chance to see how the arts interrelate and make people very happy to know that they contribute much to the world.

Milwaukee's public schools, specifically the policies the board members have established, are moving in some of the right directions. Just this past November there was a board item stating that it will be a requirement for graduation that a unit of fine arts be integrated into the expectations for all students who will leave the Milwaukee public schools with a diploma or a certificate of attendance.

We lost a major initiative for Milwaukee on February 16. Our superintendent of schools proposed to the taxpayers of Milwaukee a referendum that would include a new school for young children. He proposed increased numbers of elementary schools where all children and all the arts specialists would have a room or a place just for the arts, and they would have computers so children could work with technology. We know that children learn best through the arts. Howard Gardner's information is not new to those of us who are practitioners.

Often when the taxpayers go to the poll they ask the question, "What are we getting out of this?" People see what we do as soft. The arts are not soft. They are very rigorous, they're demanding, and they require a set of skills unlike any other discipline.

Our school board has put a set of standards for accountability into place. I want to tell you plainly how we plan to implement it in our particular school. At our school we have a music department; we have a fine arts department based on the visual arts, and our graphic arts department includes a host of fine art instructors.

What we are faced with is the budget. How to implement anything into a building now with limited money is not going to be a unilateral decision. I have to make a conscious effort to talk to a mass of people—most important are the practitioners, the parents, the communities, and the students. Milwaukee Tech High School is housed in an impoverished, unattractive, industrial-like community. But next to us is the Milwaukee Ballet Company. There are urban renewal programs in which old buildings that have virtually just been eye sores have been converted by community action. One building has recently been reconfigured for studio artists to live in to do their work—and they will invite young people in.

What does that mean as far as other programs? We have to find out how to infuse the curriculum with the arts. In order to implement the standards once they have been adopted, we as principals must begin to take our messages to board members, to the legislature, and more important, to the grassroots—to the par-

ents. Our parents are looking to us for leadership. A passionate leader will be one who is knowledgeable and can verify what he or she purports will be done with the monies given to them to steward and to allocate for various programs.

To carry out the arts standards in our schools, where people think that trade and technical programs are the only things that matter, we have a big job to sell—even with the other practitioners. How do we talk to the chemistry teacher next door, for example, to impress upon that person that this is not about taking something away from him or her?

In our school district on Saturdays, many of the music teachers, in particular, have to work to teach music to kids who want to learn it. I think we have to change the scheduling. I also believe that we must begin to stop talking about the extended day, because we already have it. The students do not go home when the bell rings—they are there with you.

We also have to find out how to share resources. Places that are not in use during regular working hours must become part of the infrastructure of receiving teachers and students within the school day. If we cannot get the taxpayer, on one hand, to provide new schools or to build modifications of schools, then what about using the libraries, the visual art centers, the other art agencies, and the music halls? Why can we not bring the students and teachers there?

Let's redefine what a teacher is. The teacher who has gone to a four-year institution and proceeded to further degrees is, in fact, quite competent to implement the standards. If one does not practice one's

art, however, one cannot bring to the table the most up-to-date, the most valuable, and the most divergent types of instruction. So let's make room for the expert.

If you are a dance instructor, who says that your contract has to be so constraining that you must teach in the same building eight hours a day? You might want to allow the principal and the shared decisionmaking council to determine who enters the portals of a school and who will disseminate information and who will model the instruction. There is a host of professionals available, and often as many as 85 percent of them are unemployed. Employ the expert to couple with the classroom teacher—the student will benefit.

Classroom size is a problem for classroom teachers because students are bringing social havoc to the schools, not creating it in the schools. We can look at any school, be it public, private, parochial, or home, and still have social disorder on the agenda. I suggest that once the standards have been adopted and are being implemented, you will find fewer gang activities. Students who have been a part of the arts know how to articulate, they know how to speak, and they know how to stand and deliver. They are not shy about talking with or interacting with people.

When you're talking about getting employment or going on to higher learning, teamwork is the word. People in the arts are a different breed—they are the intellectuals who are stimulated by an acquired set of principles. The cognitive skills and the effective skills that we purport to teach are meaningless unless we find ways to change thinking. The standards that are being presented, being formatted, and that eventually will be implemented must change the thinking on the part of the people closest to the children—the teachers.

We need to have advocacy groups who don't just show a production and then send everyone home. They have to ask, "What would happen if the art department didn't create a foundation for the artists who do all the wonderful advertisements in this country?" and "What would happen if someone wanted a program and needed people to sing and dance and do a theatrical presentation?" The arts people can arrest a lot of what's happening in the world by simply saying "We are here, you know we are here, and we are important. If anything, we probably are the most viable of the disciplines because we incorporate and digest every aspect of life."

We have to put up, of course, with the political agendas. I see them as three Rs—reform, rationale, and references. *Reform* means that we must teach students, staff members, and community members that we need to learn how to learn. That's what's important. And we must promote a *rationale* of linkages, partnerships, and collaboratives, rethinking schools, providing access to learning points and learning stations, and correlating with other disciplines. Usually when students are higher-order thinkers, they haven't gotten there because they were just dipped in the higher-order thinking water well; rather they were exposed to experiences that helped set them on a course. The *reference* points must be the infrastructure. If the schools are not there, then what else can be called a school?

The Standards and Arts Partnerships

David O'Fallon
Staff Director, Arts Education Partnership Work Group
The John F. Kennedy Center for the Performing Arts

I had the occasion to talk with Governor Roy Romer of Colorado a couple of years ago when I was at the National Endowment for the Arts. It was a conversation about the importance of the arts to education. I'm delighted and thrilled, and surprised, to see some of the positions he has come to adopt. It's wonderful.

The task before us right now is to imagine the success of what we have set out to do. The standards are not an end in themselves. It would be a mistake to say that writing standards and even getting standards adopted is an end. The standards are a means through which to make some extremely important changes for our kids. If we cannot point out to parents, to the local decisionmakers, to the kids in the schools, and to the graduates the difference that is made by adopting standards, then we have no right to adopt standards.

We have to clarify for ourselves the purpose of these standards and to articulate that purpose. I look at the standards as an ongoing, extremely important conversation articulating the very best of what we do in the arts. Even when we have a final standards document, the document is only an occasion for the continuation of that conversation. Part of my challenge for implementation is to make absolutely sure the conversation actually happens.

We have some excellent reports from Music Educators National Conference, National Art Education Association, the National Endowment for the Arts, and the J. Paul Getty Trust. We have shelves full of terrific reports, but reports too often remain on shelves. You have to make a personal commitment to having the conversation and to creating the form in which the conversation occurs for implementation to succeed. We must make sure that the discussion of the importance of these standards doesn't stop with the document, but with the difference that is made because we adopt standards.

Another way to look at the documents, one that is utterly pragmatic, is as a vision of the very best of what we can accomplish. I think that our business is imagination and creation. We're beginning to discover things that help us articulate the incredibly complex nature of work in the arts. We can imagine the success of this venture, and that, I believe, can help with implementation.

I was at the University of Minnesota when by one vote a faculty committee decided not to include the arts in their entrance requirements. The impact that has is enormous. We have to be able to say to these people, "Imagine this with us. Imagine what the results of this work will do for the kids."

The group that I work with has produced a report, "The Power of the Arts to Transform Education." The two chairpeople of that working group are James Wolfensohn, chairman of The John F.

Poverty is a cycle. Wealth is a cycle. But there is a need to bridge the two, and it can happen. It doesn't cost a lot of money to do anything—it costs us human effort to get the money to do the things we need. People who are multimillionaires and people who are poor have one thing in common: They like the good life. The good life is predicated on our senses—how we feel, what we feel, what we hear, what we see, what we say, what we touch, and what we think.

The reform cycle should, first of all, look at the players. The players are the teachers. The teachers can articulate the vision and share it with the board members. The board members, when they change leadership roles, have the responsibility of providing a link to the incoming board members to promote sustaining that very program that they put in place so it is seen through to the end.

Ernest Hemingway wrote the one book that makes a difference in everything that I say and do, *For Whom the Bell Tolls*. For whom do the bells toll? They will toll for you and for me if we don't find a way to make the way for the young people. Mary McLeod Bethune said to young people when they entered her schools in Florida, "Enter to learn to serve with your hands, your head, and your heart." If we stand together, we can lead together.

Kennedy Center for the Performing Arts, and Harold Williams, the president of the J. Paul Getty Trust. Those two men have put enormous leadership and resources into the Working Group. Two of the recommendations in here are fundamental for the implementation of the standards.

One is, there had better be money for professional development for teachers, administrators, and artists through alternative certification and through all the other means so that, in fact, if we're going to pole-vault nineteen feet (a world-class standard) and not ten feet, we know how to build the pole, level the track, coach the participants, and so on. Second, to really implement standards—however they're finally articulated—new partnerships are absolutely essential. We'd better get absolutely serious about building partnerships. They're easier to talk about than they are, in fact, to put into place. We need the resources of the arts and cultural communities in partnership with the schools to effectively realize the national standards.

If realized, the benefits of these standards, the new knowledge and imaginative energy available in our children's lives will be worth the effort.

Questions and Answers: Implementation Issues

Reaching Teachers

How will we prepare new and current teachers to use the standards in their everyday teaching?

■ This is where higher education and public schools should continue the collaboration they have begun. In most urban areas, and possibly in most suburban and rural areas, such partnerships do exist. They seem to be ever-expanding, but they have been in the sciences, math, and language arts. I think that higher educational institutions should take responsibility to create training opportunities for teachers. Colleges and universities should take responsibility, obviously, in conjunction with the state departments of education and other institutions.—*Libby Chiu*

■ It would be very useful to have the departments of music around the country that are particularly active and strong in music teacher education look at the balance between performance and theory. I think it would be very useful to emphasize greater excellence in performance and to relate the skills that one acquires through the process of becoming a better performer to the teaching process.

I feel that over the years the music education curricula have too heavily emphasized theory and philosophy. I suggest that schools consider more practice.—*Joseph W. Polisi*

■ Difficult as the task of establishing standards is going to be, I don't think it is going to be a quarter as difficult as the task of implementing the standards. We will need to prepare teachers for the task ahead.

John Goodlad of the University of Washington has worked, in the last decade and especially in the last five years, on schools of education, teacher education programs, and the necessity for transforming schools of education, particularly those that are preparing teachers. Not an easy task. It is a task for a hundred years—we are talking about twenty-five years before we can turn schools of education around.

We are going to have to do it much sooner than that, and the first step is to begin to transform the schools of education in general, quite apart from schools that have music education programs, because much of the initial instruction is done by people who do not have specialized training in music.—*Arturo Madrid*

■ We have a system for delivering instruction, training, and competence for new teachers. We have operational capabilities. We have systems for professional development of current teachers; we have institutions of higher education; and we have workshops that take place at the Kennedy Center, the Lincoln Center, and other venues.

The question is: What is the content that we're going to put through our opera-

tional capabilities? What content are we going to address, and how are we going to help students and current teachers gain the skills, and in not a few cases, the knowledge they need to put these standards into place?

I think this question becomes complicated when one thinks about what we are actually trying to do. I don't think there is a national consensus yet about what arts education is for. If we can formulate a common position within the education community, then we can take it to the general public. Whatever such a common position might be, some institutions of teacher training will need to make considerable adjustments—though others won't have that many adjustments to make.

I'm not sure that we need to go forth crying that everything is terrible and that we need radical change in teacher preparation in order to meet these standards. Instead, we need to work so that the things we are doing in teacher preparation have a valuable relationship to what is expected in the classroom.

But this relationship has two basic values influences. In developing these standards, we have always expected that teachers would be engaged in the studies necessary to master the content. That is implied, at least, in the draft standards we have. However, what good does it do for a music educator, for example, to know a lot about music history when the reward system in the music education profession (as practiced in most elementary and secondary schools) provides little incentive for using that knowledge, or keeping up with it, or bringing it into the classroom? The reward system and the value system that surround much of what we do causes teachers to emphasize certain aspects of their professional competence over others. The education people receive is always placed in a context of local values. —*Samuel Hope*

■ It is possible to really turn people around. In one workshop (a field study), we had forty teachers, kindergarten through college level. Then we had twenty professional artist/teachers, who went into the classroom with the classroom teachers and helped them as resource teachers.

What happened in that workshop was phenomenal: the outcomes were so diverse. Each teacher took the experience to a different level and interpreted it in his or her own way. I think there's a lot of potential at the in-service level.—*Shirley Ririe*

■ In a school where there are extraordinarily limited resources and exceptional discipline problems, the teacher sometimes cannot find the time to get to an in-service program. I think we need to think about how we can help these teachers understand the value of this material—to think about how these teachers are going to use the standards, because not everyone will be able to attend one of these wondrous workshops or have three thousand dollars for a summer course.

I've been out there in those schools, and I've taught there myself. As I see it, if you've got a forty-five-minute class, and you're a visual arts teacher and working with plaster of paris, using the material, cleaning up, and moving to the next class takes every second. Your precious time is a fundamental issue. We have to think about how not to defeat these teachers

before they even start.

How can we reach people and help them be inspired by the standards as a new way of validating their work? I know if a document were dropped on my desk from someone who said this is the way it's going to be, and I then had to think about how to interpret my lesson plans in light of these new definitions, or ponder ways I could squeeze a standard into implementation by "grading" a student's performance on this plaster of paris project, I would really need some help.

We've got to think about how we can help, at a local level, these standards to have an effect, because otherwise, they will hover in space as lofty ideals that people may perceive as irrelevant to their work.—*Roger Mandle*

■ There are various models of in-service staff development programs. The Getty Center has six national projects. In California, we have three institutes on the visual arts, and a subject-matter project for each content area, which has a framework including the California Arts Project. These subject-matter projects are connected with the University of California, the California State University system, and the California Department of Education.

It is my hope that we can put these professional development resources on the Kennedy Center National Arts Education Information/Dissemination Network (now in development) and have access to what will work for a particular area, school, district, or region. We will then be able to build on some of the programs that are in place.—*Joan Peterson*

This standards project will only be

worthwhile if it is implemented, and that implementation must be done by teachers. How do we go about convincing our own arts educators that they must embrace and teach the standards?

■ Teachers working with teachers will be one avenue for change. One of the greatest preservice and in-service initiatives that you can do in the school district is to give the teachers the responsibility for implementing those activities.

Teachers who expect the standards to gather dust will find themselves lost in the shuffle, because each teacher of each art in each school in each community must become the vanguard for advocating the responsibility of the community to support them. A teacher who doesn't become an advocate could have several reasons for not being one. Are the teachers' jobs on the chopping block? What's the priority in the community? Has the community been assessed for its support of the arts? Does the community understand what the arts are about?

Not all communities necessarily relish art. Maybe their experiences tell them it's for enfranchised people, or the wealthy, or the persons who subscribe to certain magazines, or people who attend certain types of institutions outside the immediate community. Teaching teachers about this, and then making sure teachers are constantly assessing progress, will propel this mission.—*Janie Ruth Hatton*

Should we teach classroom teachers to instruct in all of the arts? Should we teach them how to use resources, including specialists? Or should we

teach teachers the value of discipline-based interdisciplinary instruction? Can we count on reform?

■ This issue brings us back to the question of what we want to do. Let us look at all four basic ways that we organize intellectually-based work: there is trying to find out how things work—the exemplar is science. There is what happened—the exemplar is history. Or what things mean—the exemplar is philosophy. The fourth is how to make new things or make things new—and the exemplar is art.

In school, we're teaching people how things work and to some extent what happened. We're not doing very much about what things mean, partly because youngsters not as ready to work philosophically as they will be later. And we all know that we're not doing as much as we should about the intellectual process of making things new or making new things.

So if we want to integrate the arts with present priorities, it's easy to do if we take the arts away from the intellectual function of making new things and making things new, and focus them on how things work and what happened. However, if we want to go in a new direction and open up a new level of skill for students—and provide an introduction to a mental process that our business friends are calling creative thinking—then the radical proposal would be to focus on the idea of helping students acquire the knowledge, skills, and techniques to make things new or make new things.

If we want to help students learn this intellectual skill, we need teachers who are able to demonstrate it themselves. We simply can't ask people to teach an intel-

lectual process they haven't learned. So it seems to me that if we want to start with integration, if that's our main goal, then it's pretty clear where the emphasis will have to be. For now, the emphasis will be on analysis and history. If we want to develop creative thinking, not simply as a creative process but as intellectually-based work, then we are talking about integration from a different base, an artistic base rather than a technical one. This requires studying the arts and integrating them according to the nature of the arts, not according to the nature of the other disciplines. Putting art at the center in this way, even if not exclusively, represents a radical proposal for many people in education.

So I think the answer depends on what you want to come out with at the end. What do you want to happen? Do you want people who are just sort of associated with the arts to the point where they like it and they'll support it? Do you want something more in the realm of real knowledge and skills? When we answer the question about desired outcomes, then we can answer the questions about integration.—*Samuel Hope*

How would you propose that dance instruction be delivered? That is, by certified dance teachers, or by physical education teachers?

■ We have some very good certified teachers on the high school level in a few instances, and that's working beautifully. Certainly the high schools for performing arts are flagships in that. But I feel we have to have specialists somehow in the schools. I think, realistically, that if classroom teachers have to give experiences in

73

the arts, they need help: they need people who know the arts and who can help them deliver the kind of standards that we're writing here.

There's got to be money. Qualified people simply don't exist—there aren't any, anywhere. There are only a couple of states, I think, that have an administrator—part-time or full-time—on the state level in dance. It's a gigantic problem, and there has to be a real shakeup in order for that implementation to take place. It is imperative that we find a way to do it.
—*Shirley Ririe*

Reaching Parents and the Public

How will parents respond to the standards?

■ The answer is up to everybody who is currently involved in the arts in the public school system. Parents will tend to follow the lead of the educators within a community to accept standards or to reject them. They look to teachers in every area to guide them on whether these are acceptable or not.

This is a great opportunity because one of the problems of American education is the fact there have been no standards—so schools of education prepared our teachers for one standard, the school boards asked for something else, the teachers would demand a third thing, then the legislature would cut off the money and nobody would have anything anyway.

Now we have an opportunity to have a national emphasis on the standards and then the autonomy within each district to implement them according to local needs.

Right now, the parents in your community—the PTA or PTO, the booster club, or whatever organizations exist—are the people you need to begin to soften up and get ready for this. Parents want music education; they want arts education. They want these things for their children, but they have never had anything to hang their hats on to go and fight for it before.

They've always had athletics. Sports have been a big hook for parents to go and fight and demand that schools offer these activities. But there has never been unification among the arts people. There has never been unification or an understanding nationally about what the arts are in education. Here is the chance.

But parents are going to respond only as enthusiastically as you, the teachers, prepare them to do. I know that is not your job, but I will tell you that without your cultivating that field, you are going to get weeds, and I would prefer that you get great flowers of enthusiasm.

Some of us have been going around the country trying to do that, trying to get parents ready to expect standards and to fight for them financially and as criteria in the school district. But without everyone's involvement with parents at the local level, they will not respond at all. I am here to tell you that they are not going to rush out and read the newspaper and say, "Gee, we want standards." They are not even going to know what they are. You are going to have to really do some homework in preparing the parents.

Once you have done this, the standards will be accepted with open arms, and the finest allies you can have are the parents of children in school today: they are not happy with education, and one of the rea-

sons is that they don't see the educational system making a holistic child. The arts will help solve that.

You and I know parents are ignorant when it comes to understanding school finances. The minute something needs to be cut, the arts are the first to go. Part of that is the fault of educators because you haven't let anybody know how important you are. The standards will help you validate your importance in this nation.—*Ann Lynch*

Can parents, community members, and administrators see this vision if their own backgrounds do not include arts education?

■　Yes. Because the vision is about our kids. The vision is about the world we want to live in and about the communities we want to have. It's about how we get along with each other. It's about being able to learn to talk, to have empathy, to have compassion, to relate.

When I sit down and talk to people about why they ought to involve themselves in arts education, I start with their investment in their own life, their kids, their hope for the community. The environmental movement has taught us a lot: we're comfortable with phrases like "a sustainable environment for society" and "a sustainable future."

We're trying to create a world in which we relate, we connect, there's hope, there's vision, we get along with each other. I don't know anybody who doesn't want to talk about that world. Then we say, "You know what? I have an enormously powerful tool to help you build, envision, imagine, and create that new

world."—*David O'Fallon*

Reaching Decisionmakers

How can we educate the present leadership in education, given its lack of substantive background in the arts?

■　I think it's unfair to say that the leaders don't have background in the arts, because if you look at the ages of a great number of them, these people did come from school systems where at one time the arts were a very vital part of education. This was during the early, good days of public education funding. That background just needs to be brought to the surface.—*Ann Lynch*

How will principals respond to the restrictions of scheduling when all subject areas have national achievement standards?

■　It seems to me that principals have been, in effect, downgraded rather than augmented by the school reform movement. I'm very distressed about this. I think the opportunity for a principal to define the culture of a school is the *sine qua non* of leadership at that level. All the discussion about site-based management can be just an opportunity to substitute process for something more intangibly important.—*A. Graham Down*

■　I've seen principals trying to respond to scheduling pressures, but the problem is larger than that. It's the board of education, the parents, and the way they come

together as a mix to understand what they want out of their schools for their students, their children.

It's difficult to see how anyone could make sense out of the volumes of information that are available to all teachers, administrators, and curriculum specialists. Yet day by day, curriculum and teaching go forward. That's because there is, I think, an overarching sensibility.

What we're trying to do with the standards is to get the importance of arts education involved in that sensibility, to get it to play its own role among the other criteria for site-based management of education. These are standards, I think, that will mean something in that context. They will only do so, however, if the community of teachers and artists helps support them. Thus, they will gain their own proper balance among the masses of other standards.—*Roger Mandle*

■ I think part of the answer lies in what principals think is important. It's a question of values. I don't think we're going to get very far in this debate unless we can demonstrate to more people that real intellectual development is associated with work in the arts. If you ask people whether they like the arts, most say yes. But liking the arts is not enough, obviously, to get the arts disciplines implanted into our national thinking as basic subjects in schools.

If we can get people to understand that the arts represent a way of thinking, over time we can make the case for the arts as basic. Otherwise, we will be stopped by the larger sense of practicality and the emphasis on technical means that drive the value system in our country.

The whole arts teaching enterprise, including content and process, needs to be associated with deep intellectual aspirations that can lead us to skills that do transfer from the arts to other fields. But we can only make the transfer if we actually develop knowledge and skills in the arts; we can't just talk about competence or cheerlead for it and have transfer. We must connect the arts to mind somehow, if we want to be thought of as a basic discipline in education by the general public. —*Samuel Hope*

■ At the National Gallery of Art, we had a fiftieth anniversary version of our National Teacher's Institute. The teachers were not art teachers, necessarily: they were teachers from all disciplines who came to the National Gallery for an intensive, weeklong workshop about the ways works of art can be used to develop curricula of all kinds. We invited principals to accompany the teachers who had been nominated to attend the workshop and receive an award by the state school systems. The principals came to help accept an award on behalf of their teachers, and they participated in the last days of the teacher-training workshops for the Institute. The presence of the principals had a profound influence on the ways the teachers received their awards. It certainly affected the principal's thoughts about the effect of these teachers back in their classrooms.

We kept in touch with our alumni, particularly through the special workshop. I have to say there has been a profound difference in the way these teachers have been received as colleagues in their schools. I think the ideas they're develop-

ing in their curricula are given much more attention by their principals and by the rest of the school than they were before this experience.—*Roger Mandle*

Some fellow educators and I were asked to provide music classes in a school for three hundred homeless children because, in the words of the principal, we know music builds self-esteem, we know music keeps kids in school, we know music builds community. This principal values music education, but the standards have little that speak to the reasons he sought music education. What do you think the standards will mean to him?

■ I think the standards will help this principal to clarify the mission of the school. Truly, the homeless children are particularly disenfranchised, and if a school can render any type of support to increase their self-esteem or reason for being, it has a responsibility to do so. We need to have as many people on the streets as possible to work with children, because homeless children often do not attend a traditional or an alternative school. So we need to have outreach programs, wherever they are.

Principals are also moving toward abandoning nonessential things such as teacher "duty time." These changes provide opportunities to use that time for high-quality education.—*Janie Ruth Hatton*

In my school district, the school board seems to become the enemy of children and programs such as the arts, because it is responding to a very powerful taxpayers' alliance. They say things like, "We really believe this is good for kids, but we just can't raise taxes one more time." What can we as teachers and parents do about this attitude?

■ One of the things we're discussing now is how to keep the arts from being presumed to be elitist; how we bring them into the core of the curriculum. We need to show how our classroom teachers can utilize art projects, dance projects, teaching songs of a culture, and so on, within the classroom—within the context of a social studies unit. At a conference held in San Francisco by the Getty Foundation, we saw some of these projects in place and in process. It was very exciting to me to see that there were ways we could do this.

I think you can take those issues to your taxpaying public, and show them how even the children who will not turn out to be in symphony orchestras can really benefit and be more excited and productive in their learning, and will actually come to school excited every day. If you can show how those students will stay in school and graduate, you can make a very strong case for including money for the arts. You can make a strong case for money for classroom activities, and for the specialists to assist the teachers in the classroom, and for more in-service training for teachers in order to expose them to interdisciplinary learning.—*Louise Miller*

Reaching Artists and Arts Organizations

What role should artists and arts organizations, such as theatres and museums, play in implementing the standards and in arts education in general?

■ We reform education because it will serve kids better; we don't just reform it to reform it. Theatres, performing arts centers, artists, and art organizations can be part of the conversation at every single level about what's working and about how to reach kids. I'd say three things to artists specifically: first, don't wait for an invitation. Go directly into the room, sit down at the table, and say, "You're glad I'm here. I bring you things you really need to have if we want to do a good job by our kids."

The second thing I'd say to artists and colleagues in the arts organizations is: if you think educational reform and standards and assessment and so on either won't affect you or will go away, you are wrong. President Clinton was part of the group that formed the national educational goals, so he owns these goals. The Secretary of Education also owns these goals. They will serve as a framework, and the standards are tied to the goals. When we talk about education in this country, we're going to be referring to this for many years to come, so people have to be familiar with these ideas.

The third thing I'd say is that you have to realize that education is an extension of the basic artistic mission of your work. It is not an add-on; it's not a part-time person; it's not a brochure.—*David O'Fallon*

■ It's been my experience that my colleagues are clamoring to get into the classroom. There are already, I think, programs in place. The Commonwealth of Virginia, for instance, has a program to reach out and identify artists. Those artists selected, based on academic excellence and so on, are offered to the schools.

The standards represent an opportunity to forge an alliance between the artist and the arts educator. We want to be there. We all have a vested interest in the outcome of the next generation of Americans, and I think maybe state organizations should be encouraged to seek out professionals.

Eighty-five percent of the members of my union are unemployed on any given day. We're waiting for the phone to ring. So I would encourage you and your state organizations to pick up the phone and call. We want to work; we want to be involved; we want to participate. We want this because the students are our museumgoers, our theatregoers, and our artists of the future.—*Edward Gero*

■ What we've done on the part of dance in Utah is to go to our state legislature, our arts council, and to businesses. We've created partnerships in the schools, and we have gotten ourselves into the schools by ourselves. We are not relying on the state Department of Education. We feel that dance needs to be taught, so we're finding ways to do it until it gets in the curriculum.

I don't think this is a substitute for a planned, sequential curriculum. But we are at least making some headway, and we are doing some great things. I think the artist should be remembered and designed into this project all the way through,

because there is a vitality that comes from the working artist being in the school. —*Shirley Ririe*

Dealing with Budgets and Bureaucracies

Are the standards too late in states that are facing severe financial problems, resulting in reduced funding or elimination of programs?

■ Funding, of course, is essential, but it seems to me that there are many, many ways that we can be creative to make things happen. I'm at a university that's facing cutbacks, and the word is, "the leaner, the better." If I were just addressing theatre, it seems to me that universities could make a great deal happen even without any extra funding by working with in-service programs.—*Lin Wright*

■ You cannot have the kind of significant programs that we are talking about without some change in funding for education in general and the arts in particular. However, there is a danger in making funding a condition for establishing national standards.

The standards are most valuable for providing focus on high-quality programming. They can become the catalyst for change in several areas—curriculum development, delivery assessment, professional development, and resources (including funding). Action in each of these areas is an ongoing process as we work to evaluate and improve student achievement in arts education programs.

Action on funding should have begun yesterday—and must continue until the standards are met by all students in all schools!—*Jeanne Rollins*

For teachers in states where curriculum guidelines are already closely defined, arts instruction must be integrated. How will the standards be implemented in these closely defined systems?

■ That comes down to a state decision. In California, we talk about integration of the arts with each other. We talk about correlation of the arts with other content areas. In order to really work in a cross-disciplinary way, you have to have the in-depth understanding of a content area, and the connection, also, of one of the arts to another.

I would say that a nationally agreed-to set of standards will have implications for states as they either develop or reevaluate their frameworks. This is because it makes every bit of sense that state frameworks be based on a national consensus that spells out what students should know and be able to do.

If you then look at what we've wrestled with in California for the last ten years in the way of systemic reform, it is enlightening. We have looked at aligning the textbooks and the resources with the framework, and also aligning the assessment of a content area with the framework.

Fortunately, when you get all those leverage points in place, it helps the delivery. When the standards are implemented, that will be an incentive for the earmark-

ing of additional resources, as basic as the resource of instructional time in the curriculum.

I think the arts at this point are served well by the fact that along with the development of national standards, we do have another project—the development of the National Assessment of Educational Progress in the Arts. Those involved in that project are looking carefully at the standards.—*Joan Peterson*

Will the final result of this coalition be a national curriculum to be adhered to, or will it be left up to each state to determine the level of participation?

■ It will absolutely be left up to every state. I don't think there was ever an intent or implication to have either a national curriculum or a national test; the idea is rather to set standards on which individual states could begin to develop the framework on which, in turn, they would base curriculum. I know that leaders in North Dakota requested a copy of the draft because they are in the process of writing, for the first time, a visual and performing arts framework. I know California is trying to get some money, even in the current budget crisis, to revisit our framework. One of the rationales is that there are now standards on which we can begin to evaluate our current framework. So it's not a national curriculum. That's a state and local responsibility.—*Joan Peterson*

If colleges and universities truly believe the arts are an integral part of an education, then should not literacy in at least one of the arts, including, perhaps, an acceptable level of proficiency at a level set by the standards, be required for admission?

■ I think they could be, if the arts will demonstrate the kind of rigor in schooling that brings people to that level, and if such a requirement could be universally applied. The problem right now is that if any state, college, or university made such a requirement, you wouldn't have all that many people who could actually meet it. If we develop these standards, and particularly if higher standards for twelfth graders are in place in the arts, I think there's no reason that kind of admission standard could not follow.—*Robert Glidden*

■ I think if you give people a few years' notice, literacy in the arts will become an admission requirement, along with foreign languages. You'll see a dramatic change in high schools.—*Dianne Ravitch*

Approaching Evaluation

What will the means of our assessment be? How will we know we've arrived?

■ We'll know we've arrived when the celebration for arts standards has a broader audience—when this room is packed to the gills, and when more Americans show up to be part of the process. I'm looking forward to the day when everybody is invited to the party and everyone can't wait to get there. That's when we'll know.—*Edward Gero*

■ We'll know we've arrived when a student who has struggled with being able to express him or herself, and who has labored with trying to explain the mastery of certain inherent understandings he or she acquired, could produce an explanation that would be recognized as achieving a level of competence. This level should be one that could be recognized as coming from someone who had promise, someone who could be fulfilled as a citizen, someone who could give forth an expression that really had content and meaning. That's how I think we would know about our success.—*Roger Mandle*

How will you assess learning in the arts in schools where there are no arts education specialist teachers?

■ When assessment shows tremendous differences between programs, and these differences are tied to the lack of instruction, it creates a pressure to have appropriate specialists.—*Diane Ravitch*

How will we identify, illustrate, and make known exemplary arts education models?

■ The professional associations have already been doing that through their publications. There's a lot of information in print and on video.

One of the recommendations of the Arts Education in Partnership Working Group was to create a National Information Dissemination Network for arts education. One of its tasks would be to serve as a clearinghouse: it would be a gathering place and a termination point using electronic media, E-mail, bulletin boards, and the like. Individual teachers or school administrators could actually get access to information about programs in the states or around the country. I expect that project to take a couple of years to get up and running, but it will provide more immediate access to some of these programs than we now have, when we have to wait for publications to come out and then talk about them.—*Leilani Lattin Duke*

81

PARTICIPANT BIOGRAPHIES

Gene Carter is the executive director of the Association for Supervision and Curriculum Development. Prior to holding that position, he was a classroom teacher, an assistant principal, a principal, an administrative assistant to the superintendent, a director of instruction, an assistant superintendent, and a superintendent. He is active in community and civic organizations and serves on the Board of Visitors of Old Dominion University and the boards of the MacArthur Foundation, the Southern Education Foundation, and the Norfolk Southern Corporation. Carter has also provided leadership training throughout the United States and has participated in international educational seminars in Germany, France, Sweden, Israel, the People's Republic of China, Hong Kong, South Korea, Japan, and Vietnam.

Libby Chiu is the director of institutional advancement at the Boston Conservatory. Prior to this, she was director of the Demonstration School at the University of Lowell, the deputy director of the Massachusetts Cultural Council, principal of Patrick J. Kennedy Elementary School in East Boston, and bilingual coordinator for Asian language programs in the public schools. She has written a commercially produced K-level Chinese language arts curriculum as well as an early-childhood Chinese/English social studies curriculum, both of which are used by the Boston school system and throughout the country.

She is coauthor of several other curriculum guides.

A. Graham Down is the president of the Council for Basic Education and is cochair of the Steering Committee to develop a framework for the projected 1996 National Assessment of Educational Progress assessment of arts education. Having graduated from Oxford and Cambridge Universities with degrees in education, history, and music, Down has been a history instructor and chair of the music department at the Lawrenceville School in New Jersey. At the same institution, he served as assistant director, associate director, and then acting director of the College Board's Advanced Placement Program, then eventually became the assistant director of program services for the New England regional office of the College Entrance Examination Board. Down is organist and director of music at Western Presbyterian Church in Washington, D.C. He is president of the popular "Music at Noon" concert series, and he currently serves on the boards of directors of the National Foundation for Advancement in the Arts, Inc., and the Washington Bach Consort.

Leilani Lattin Duke is director of the Getty Center for Education in the Arts in Los Angeles. The Center is an operating entity of the J. Paul Getty Trust and is

85

devoted to improving the quality of visual arts education in the nation's public schools for grades K–12. She started her career working for former U.S. Senator Jacob J. Javits and went on to spend eight years at the National Endowment for the Arts. She served as executive director of the California Confederation of the Arts until 1981, when she joined the Getty Center.

Jeremiah Floyd is an associate executive director of the National School Boards Association, responsible for the management and administration of the NSBA Office of Board Secretariat and Executive services. He serves as the principal administrative support and counselor to the president for committee appointments, speaking engagements, speech development, and liaison with external organizations on behalf of NSBA. Floyd has an extensive record of community and professional activities. He served as president of the Board of Education, School District 39, in Wilmette, Illinois, and as a member and vice-president of the Montgomery County (Maryland) Board of Education.

Edward Gero is an actor and educator. He enjoys a ten-year association with the Shakespeare Theatre in Washington, D.C., having appeared in forty of its productions. He received four nominations for the Helen Hayes Award for Outstanding Performances, and won the Helen Hayes Award in 1990 for his portrayal of Macduff in Shakespeare's *Macbeth*. He is founding instructor of the Shakespeare

Theatre acting classes. Gero serves as founding Director of the Ensemble, the newly designed undergraduate acting program of the Division of Dance and Theatre at the Center for the Arts at George Mason University. He spent eight years in New York City performing with the Classic Stage Company Repertory, South Street Theatre, Soho Rep, New Dramatists, Teatro Renascimiento, and The Forum of Italian-American Playwrights. His film and television credits include *Die Hard 2,* "Guiding Light," PBS's "Cover to Cover," and Columbia Pictures' *Striking Distance.* He is also a consultant for the Edison Project on Education Reform.

Robert Glidden is provost and vice-president for academic affairs at Florida State University, Tallahassee. Before that, he was dean of the School of Music there. Glidden was executive director of the National Association of Schools of Music and the National Association of Schools of Art from 1972 to 1975, and he is active in national affairs, having served as member and chairman of the Board of Directors of the Council on Postsecondary Accreditation, the organization that governs accrediting in all fields for higher education. He was recently elected to the Commission on Colleges of the Southern Association of Colleges and Schools. His honors include membership in the Pi Kappa Lambda national music honor society.

Richard S. Gurin has been president and chief executive officer of Binney & Smith, Inc., makers of Crayola and Liquitex brand art products, since 1987. His

previous positions include chief executive officer of Coca-Cola Mideast and president and general manger of Crush International USA, both subsidiaries of Proctor & Gamble, where he worked for twenty-two years. In 1990, he was appointed to the board of the American Council for the Arts in New York City and currently serves as Vice-Chairman of the Board. In December 1992, he was appointed chairman of the Advisory Council on Arts Education at the National Endowment for the Arts. In 1993, he was named to the National Cultural Alliance Leadership Council and the America 2000 Coalition Board of Directors.

Janie Ruth Hatton is principal of the Milwaukee Trade and Technical School and was named the first National Principal of the Year by the National Association of Secondary School Principals and chosen by a five-member panel chaired by former U.S. Secretary of Education Terrel H. Bell. Before becoming principal, Hatton, who has worked in education in Milwaukee since 1972, served as a community superintendent for the Milwaukee school district and as an assistant principal at the high school. She is the first female principal of the high school, which was established in 1906.

Samuel Hope is the executive director of the National Associations of Schools of Art and Design, Schools of Dance, Schools of Music, and Schools of Theatre, the national accrediting agencies for collegiate-level programs that prepare arts professionals. Hope is an executive editor of *Arts Education Policy Review* and an edi-

torial consultant for *The Journal of Aesthetic Education.* He holds degrees in composition from the Eastman School of Music and Yale University, and is published regularly as a policy analyst and futurist in education, the arts, and accreditation.

Mary Maitland Kimball is professor and director of dance at Indiana University–Purdue University at Indianapolis (IUPUI). She is immediate past president of the National Dance Association and chairperson of the Dance Task Force for National Standards in the Arts. In addition, Kimball is a member of the Steering Committee for the United States Department of Education and the National Endowment for the Arts "Arts in American Schools: Setting a Research Agenda for the 1990s." She is a recipient of the Robert Shellhamer Outstanding Educator Award, IUPUI; she was an honoree for Spotlight of Women in the Arts in 1992; and in 1993, she received an Honor Award from the American Alliance for Health, Physical Education, Recreation, and Dance.

Paul R. Lehman is professor of music and senior associate dean of the School of Music of the University of Michigan at Ann Arbor. He served as president of the Music Educators National Conference (MENC) from 1984 to 1986, and before that was chair of the Music Education Research Council and the National Commission on Instruction of MENC. In addition, he has served as music specialist with the United States Department of Education in Washington, D.C. The author of

more than a hundred books on standards, curriculum, teacher education, and measurement and evaluation, Lehman is the chairman of the Music Task Force for National Standards in the Arts.

Ann Lynch served as National PTA President from 1989 to 1991 and was active in the organization at the local, state, and national level for twenty-six years. She is currently director of public relations and marketing at Humana Hospital—Sunrise in Las Vegas. She is a member of the President's Education Policy Advisory Committee, the Nevada Governor's Commission on Educational Excellence, the Southern Nevada Drug Abuse Council, and cochair of Nevada 2000.

Robert Lynch has been the president and chief executive officer of the National Assembly of Local Arts Agencies (NALAA) since January 1985. NALAA was established in 1978 to strengthen and enhance the arts at the local level through leadership development, information, visibility, and advocacy services. As an advocate for the arts, Lynch has played a leading role in helping local arts agencies gain access to federal funding programs and in building a larger and stronger Locals Program at the National Endowment for the Arts. Under his direction, the NALAA has doubled its membership and almost quadrupled its income while expanding services by more than 400 percent.

Arturo Madrid is the Murchison Distinguished Professor of the Humanities at Trinity University in San Antonio, Texas. From 1984–1993, he served as founding

president of the Tomas Rivera Center, a national institute for policy studies on Latino issues. He previously served on the faculty and administration of the University of Minnesota and as director of the Fund for the Improvement of Postsecondary Education at the United States Department of Education.

Roger Mandle is president of the Rhode Island School of Design in Providence, Rhode Island. From 1988 to 1993, he served as deputy director of the National Gallery of Art in Washington, D.C. He was the associate director of the Minneapolis Institute of the Arts from 1967 to 1974, and for eleven years the director of the Toledo Museum of Art. He was chairman of the executive committee of the American Federation of the Arts (AFA) from 1987 to 1991, and is currently chair of the Exhibition Committee of the AFA. Mandle has served on the boards of more than thirty organizations and is currently the vice president of the American Association of Museums, and on the Education Advisory Committee and is a Presidentially-appointed member of the Council of the National Endowment for the Arts. He is a graduate of Williams College and New York University's Institute of Fine Arts.

Louise Miller is presently serving her sixth term in the Washington State Legislature and her second term as a Republican Floor Leader. As a professional musician, a public school teacher, and private teacher of instrumental music, she continues to have a vital interest in the fine arts. She is presently serving her tenth year on the Washington State Arts Commission

and is also the national chair of the Arts, Tourism, and Cultural Affairs Committee of the National Conference of State Legislatures (NCSL). Miller was recently selected for a three-year appointment on the National Endowment for the Arts (NEA) State Grants Panel.

David O'Fallon is presently staff director for the Arts Education Partnership Working Group of The John F. Kennedy Center for the Performing Arts, an advisory body created to make recommendations to the Secretary of Education and the U.S. Congress. O'Fallon served as director of the Arts in Education Program at the National Endowment for the Arts, where he worked closely with national and state arts and education associations. Previously, he was director of the University of Minnesota's Arts Leadership Institute. In addition, O'Fallon has experience as a theatre director, an arts center administrator, a K–12 English and theatre teacher, and a consultant in the development and management of policies and programs in education and the arts.

Joan Peterson, state arts consultant in California, earned her master's degree in education from Harvard University. She is a classroom teacher, art specialist, and arts administrator in California in grades K–8 and serves as policy board chair for The California Arts Project. She is chair of the National Council of States Arts Education Consultants task force on Standards in the Arts and a convener for the Student Assessment Consortium in Arts Education, sponsored by the Council of Chief State School Officers. Also a consultant in

visual arts with international schools in fourteen countries, Peterson has been honored by the National Arts Education Association as the Pacific Region Supervision and Administration Art Educator in 1993.

Joseph W. Polisi has been the president of The Juilliard School since 1984. Prior positions include dean of the University of Cincinnati College–Conservatory of Music, dean of faculty at the Manhattan School of Music, and executive officer of the Yale University School of Music. He holds numerous degrees, including a Doctor of Musical Arts degree. Polisi is an accomplished bassoonist and has appeared with the New York Philharmonic and the Chamber Music Society of Lincoln Center. He has written extensively for professional journals and has recorded a solo album of twentieth-century bassoon music for Crystal Records.

Diane Ravitch was the Assistant Secretary of Education for Research and Improvement until early 1993 and is now a Visiting Fellow at the Brookings Institution. An avid collector of American folk art and a former trustee of the Museum of American Folk Art, Ravitch is a historian of education and the author of numerous books about American education, including *The Schools We Deserve, The Great School Wars,* and *The Troubled Crusade.* She was also professor of history and education at Teachers College, Columbia, until July 1991.

Shirley Russon Ririe is the artistic codirector of the Ririe-Woodbury Dance Company and a national leader in the field

of dance education for children. She is currently the United States delegate to Dance and the Child International and is a consultant for the Association for Instructional Television. She serves on the National Advisory Committee for Young Audiences and was the first chairman of the Artist's Advisory Committee of the dance component of the National Endowment for the Arts's Artist in Education program. Ririe holds a master's degree from New York University and is a professor of modern dance at the University of Utah in Salt Lake City. She has choreographed more than sixty works and has performed leading roles in pieces by José Limon, Merce Cunningham, Helen Tamiris, and Alwin Nikolais.

Jeanne Rollins is director of fine art programs for the Texas Education Agency, prekindergarten–grade 12. She is president of the National Association of State Directors of Art Education, chair of the National Art Education Association Committee for Standards and Assessment, chair of the Consortium of National Arts Education Association's Visual Arts Task Force for National Standards in the Arts, and a member and past president of the Texas Art Education Association. Named outstanding art educator in the nation by the NAEA and outstanding art educator in Texas, Rollins has recently been honored by the State of Texas with the prestigious J. Warren Hitt Award. The State Board of Education has also recognized her for "many valuable services to the schoolchildren and other citizens of the state." Under her direction, the national award-winning state framework "Art Education:

Planning for Teaching and Learning" was developed. She served as national coordinator of the NAEA Los Angeles Convention and regularly plans and conducts state and regional conferences. In addition to being a professional educator, Rollins is an artist and a writer.

Roy Romer has been the governor of Colorado since 1987. Before becoming the state's chief executive, he was the state treasurer from 1977 to 1987, a member of the Colorado Senate from 1962 to 1966, and a member of the Colorado House from 1952 to 1962. In his second term as governor, Romer is placing additional emphasis on the quality of the Colorado educational system and the needs of the state's families and children. Romer is a member of the National Education Goals Panel and the National Council on Education Standards and Testing.

Lin Wright has taught children from K–12 and is now a full professor at Arizona State University and chair of the Department of Theatre. Her area of research is Theatre for Youth, and she has been president of the Children's Theatre Association of America. Currently, she is chair of the Theatre Task Force for National Standards in the Arts, the principal investigator for a K–6 longitudinal study of theatre behaviors, and heads the multicultural curriculum project of the International Center for Studies in Theatre and Education. She has been honored with induction into the College of Fellows of the American Theatre for a "lifetime of truly outstanding contributions to the field."

90